Sex Objects

Sex Objects

ART AND THE DIALECTICS OF DESIRE

Jennifer Doyle

University of Minnesota Press :: Minneapolis :: London

Chapter 2 was originally published as "Sex, Scandal, and Thomas Eakins's *The Gross Clinic,*" *Representations* 68 (Fall 1999); copyright 1999 by the Regents of the University of California; reprinted with permission of the University of California Press. Chapter 3 was originally published as "Tricks of the Trade," in *Pop Out: Queer Warhol,* edited by Jennifer Doyle, Jonathan Flatley, and José Esteban Muñoz (Durham: Duke University Press, 1996); reprinted with permission of Duke University Press. Chapter 5 was originally published in *The Art of Tracey Emin,* edited by Mandy Merck and Chris Townsend (New York: Thames and Hudson, 2002); reprinted with permission. Chapter 6 was originally published as "The Trouble with Men, or, Sex, Boredom, and the Work of Vaginal Davis," in *After Criticism: New Responses to Art and Performance,* edited by Gavin Butt (Malden, MA: Blackwell, 2005), 81–100; reprinted with permission of Blackwell Publishing.

Published by the University of Minnesota Press
111 Third Avenue South, Suite 290
Minneapolis, MN 55401-2520
http://www.upress.umn.edu

Library of Congress Cataloging-in-Publication Data

Doyle, Jennifer.
 Sex objects : art and the dialectics of desire / Jennifer Doyle.
 p. cm.
 Includes bibliographical references and index.
 ISBN 13: 978-0-8166-4525-1 (hc) 978-0-8166-4526-8 (pb)
 ISBN 0-8166-4525-6 (alk. paper) — ISBN 0-8166-4526-4 (pbk. : alk. paper)
 1. Sex in art. 2. Gay erotic art. 3. Feminism and the arts. 4. Sex (Psychology). I. Title.
 NX650.E7D69 2006
 700'.4538—dc22

 2005029343

Printed in the United States of America on acid-free paper

The University of Minnesota is an equal-opportunity educator and employer.

12 11 10 09 08 10 9 8 7 6 5 4 3 2

To my sisters

Contents

Illustrations

A Promiscuous Reader

WHEN I WAS TWELVE, a neighbor, a boy about fourteen years old, regularly left catalogs for pornographic videotapes in my family's mailbox, knowing that my younger sisters and I collected the mail when we got home from school. It was less a favor than an assertion of his sexual knowledge against the country bumpkin–like way my sisters and I occupied our own bodies.

We took the catalogs out of the mailbox, brought them inside, and retreated into our bathroom where we studied the pictures of naked men. Then we tore the catalogs into tiny pieces and flushed them down the toilet. The image that I remember most vividly is a photograph of the man I assume played the title role in a porn movie called *Moby Dick*. He, or, really, his *member,* was, as you might imagine given the title, huge. How did he get dressed? we wondered. Where did he put it? How did he manage to get anything done with that thing in his way? Adding another layer of the exotic to our experience of Moby Dick, the man in the picture was black, and he was pictured outdoors in a distinctly African-looking (desertlike) rural setting.

This cinematic homage to *Moby-Dick* hitched the pornographic to the anthropological—by way of, perhaps, the dry landscape of Southern California (porno capital of the United States, and my current home). The title was an ironic twist—the photographic negative for the infamously white Moby-Dick swimming in the ocean was imagined by this image as the sexual otherness of a black man's sex framed by the arid backdrop of desert sands.

Not long after our initial encounter with the ad for *Moby Dick,* the porn tape, my sister came home from school disturbed and titillated. "There's something wrong with Mr. R——" she began. I braced myself. Mr. R——, my home-room teacher and the school's science teacher, was the first man I ever remember

being aware of as gay. He was a smart, attractive, swishy man with a feathery lisp who wore fitted monochromatic sweaters and matching neatly pressed and tailored shirts, and loved the group Devo. Mr. R—— was the first person I read using a lexicon of homosexual identification. That lexicon was panicked, phobic, stolen from other, more "worldly" kids, mostly boys who whispered about how Mr. R—— was a "fag" because he loved the song "Whip It."

Mr. R—— was protective of me. I was a new student, precocious and somewhat morose. That year was distinguished not only by my school-yard introduction to a grossly inadequate schema for "reading" gay men but also by my perpetual sexual humiliation at the hands of pubescent male classmates who would, for instance, shout "cunt" and "whore" while throwing stones at me, or engage in only slightly more subtle games of sexual humiliation like the following: When the most abject boy-geek in the school walked into the classroom, the other boys would call his name, point to me, and assert loudly, "What's the matter? Does she give you a hard-on?"

This caused us both no small embarrassment. The juice in that particular ritual was provided by the ridiculous implication that anyone could be turned on by either of us. My embarrassment, however, was amplified by the fact that I had absolutely no idea what a "hard-on" was. Even though I had seen erect penises in the catalogs (and on the family farm), I had no idea that erections could be called "hard-ons." My own porn vocabulary was borrowed from my parents' copies of the Marquis de Sade and Victorian "erotica" that (like the porn catalogs) I read in secret. These books were animated by a more egalitarian vocabulary in which various parts of male and female bodies became "swollen," "engorged," "throbbing," "rampant," or "blood filled."

I was terrified that my response to this particular kind of teasing would give away my ignorance of the "hard-on," which was, for all I knew, something that *I* could have. Not knowing what a hard-on was (and not knowing whether it was something I was supposed to have) indicated more than a vocabulary problem: it revealed a fundamental flaw in my interests.

This particular teasing realized my dread: self-appointed custodian of my parents' library, secret but avid reader of Sade, I knew by instinct that the collective impulse to use sexual bullying to shame me was occasioned by my being the wrong kind of "smart."

One day this exchange between the boys, the boy-geek, and me happened in Mr. R——'s view. He sent me out of the room and, I assume, gave the boys a piece of his mind. All teasing stopped in his classroom. That day, as I walked out of the room, I felt as if, for the moment, I shared the burden of my shame with my teacher.

It was the first and only time a teacher took a stand against the boys-will-be-boys ritual sexual humiliation of girls and queer boys that was as much a part of my education as homework. It was also a moment when I felt somehow absorbed into a separate domain of knowledge: one shared between me and

Mr. R——, one roughly based on the same signifiers at the heart of the other kids' phobic lexicon, but processed differently.

In any case, when my sister whispered, "There's something wrong with Mr. R——," I thought she was going to say something about the whole gay–Devo thing, in which I was somehow implicated by knowing one thing (Mr. R—— was gay) and by not knowing the other (what a hard-on was). Instead, my sister took our conversation in a different direction.

That morning, she had worn her most prized possession to school for the first time: an L.L.Bean "whale" sweater. This was in New Jersey at the height and at the epicenter of *The Official Preppy Handbook* craze, when (against all reason) the iconography of old New England was worn as the badge of cool. My sisters and I were at that moment living in the awkward quarters of a family supported by an academic's salary. We never seemed to have the right clothes (which were, at that time, khakis, polo shirts, loafers, and L.L.Bean sweaters). The "whale" sweater, a hand-me-down from a neighbor, was one of the few "right" things any of us had. It was green wool and had a blue whale woven into the front.

"What's his name?" Mr. R—— had asked my sister. He pointed to the little whale sitting on her chest and asked, "Moby-Dick?"

My sister's sole point of reference for Moby-Dick was the picture illustrating the porn movie: a black man with the biggest penis we had ever seen. She said nothing and sank into her own hole of sexual humiliation—a hole dug in no small part by the feeling that she had somehow failed to wear the sweater correctly. Instead of allowing her to pass neatly into the fold, the sweater, on her, was an obscenity.

When she told me about this exchange, I was happy and relieved to explain that Moby-Dick was not *really* the name of a porn star with a gargantuan penis but a giant whale: Mr. R—— was referring not to the movie advertised in the porn catalog but to the title character of a masterpiece in American literature by Herman Melville. This seemed to alleviate her anxiety and mine. We had a good laugh over it.

I used to tell a slightly cleaned-up and more flattering version of "the Moby-Dick anecdote" to demonstrate my precocious expertise as a student of American literature—a confirmation of the fact that, even as a child (and even though I had never read it), I knew that *Moby-Dick* was not porn but literature; that Moby-Dick was not a black man but a white whale. It was a story about my younger sister's naïveté and the hilarity of confusing great literature with pornography. The punch line was underwritten by an unspoken exclamation, "How could anyone make such a mistake?"

A recuperation of adolescent abjection, the Moby-Dick anecdote was my first serious foray into what we might call camp conversation. Like much of Melville's writing, *Moby-Dick* is a perfect candidate for camp conversation in

which, as Gavin Butt describes it, "high-cultured learnedness—an 'elevated' discussion about the great figures of literature" slides into raunchy banter about outlaw sex.[1] The wit that animates the bitchy give-and-take of this kind of conversation establishes its actors as masters of the very high, the very low, and as not terribly interested in anything that falls too far in the middle. Camp can allow a simultaneous claim to dissonant fields of knowledge (like art and pornography), and it can facilitate the use of one field to manage oppressive forces bearing down on the other (cultural sophistication, for example, against social abjection). When it is most empowering and subversive, when it is most queer, camp fuses a kind of sex radicalism to a denaturalization of hierarchies of class and culture, putting a rare and hard spin on cultural fantasies about racial and ethnic difference as well.[2]

In his rousing treatise on the ethics of queer communities, Michael Warner observes that "in those circles where queerness has been most cultivated, the ground rule is that one doesn't pretend to be *above* the indignity of sex." He continues: "Only when this indignity of sex is spread around the room, leaving no one out, and in fact binding people in the room together, [does] it begin to resemble the dignity of the human."[3] Warner's portrait of this social performance of queer abjection underplays the fact that, as euphoric as they can be, such performances do not always yield a happy or, at its most intense, even a *humanizing* sense of community. A degree of physical risk animates the hysterical sublimity of these moments, and that sense of risk will vary in intensity, becoming painful, even intolerably so, depending on where your body puts you relative to the normal—depending on, for instance, how strongly you resemble, or are interpolated as, the abject (as female, butch, black, etc.). The performance of queer abjection is only as dignified as your ability to walk away from the indignity of disenfranchisement and into the category of the human.

The flip side of the sublimity of communal parachute drops into the territory of sexual abjection is the terror of falling alone. Everyone is talking about a novel or a sexual practice that you've never heard of, everyone is camping it up over something you can't find funny; someone makes a racist joke, someone says something really hateful about women; you find that you are the only Asian man in the room, the only drag queen, the only dyke; you are the only one who has known sexual violence, the only one who never graduated college, or the only person without a decent job or health insurance. Something happens and you are taken over by fear, isolation, embarrassment, or rage. A second ago you were seduced by the genius of your friends, but now you feel terrorized by the knowledge, experience, or privilege of others.

Maybe at this moment you beat a retreat, make a quiet exit. Or maybe you come back swinging—demonstrating your command over the indignities of being a sexual subject with a witty remark taken from Oscar Wilde, Flaubert, or Peggy Guggenheim. Maybe your righteousness puts the others in their place, but it kills the joy. Or maybe they rally around you and everything feels OK again.

In telling the abridged version of the Moby-Dick anecdote, I, in essence, recast

a story about sex, race, and class abjection as a story about the difference between literature and porn, in which I emerged as the bemused expert, the good critic restoring order to a chaotic universe. The story dispersed my nervousness about the different kinds of reading I was doing at the time (e.g., Henry Miller, the Marquis de Sade, Judy Blume, Byron, Judith Krantz, Jane Austen, Thomas Hardy, Isaac Asimov, Nancy Friday). All too often criticism about art becomes a way to manage anxieties about difference. Each time I performed the Moby-Dick anecdote for an audience that I hoped to impress with my precociousness, I implicitly asserted that I knew and was entirely comfortable with the difference between the pornographic and the literary. I allowed Mr. R———'s question ("What's his name?") to create a position of knowingness for myself so that I could be the teacher in a story about someone else's humiliation and ignorance. And so that I could tell a story about sex without, however, being the object of the story.

I produced myself as "knowing" culture, against the background of my "unsophisticated" sister, with the black dick of an unnamed porn star as the prop at once invoked and disavowed *(fort-da)* in a story negotiating the desire to claim some kind of agency over my own body. (As I make this confession, as I track my own contortions around this moment, I in fact dig the hole deeper—indulgently producing more knowledge against a racialized background of sex, white privilege allowing a confessional stream [a hand-wringing somehow typical of white feminism] that can be about me, and not about me, insofar as the abjecting forces that animate the anecdote are ultimately organized against the spectacle of a silent black male body.)

Looking back, I can say that on some level that photograph of a black man as Moby-Dick documented my fear—a fear of the process of othering that could reduce a man to a dick, in a violent reduction of person to sex that must have spoken volumes to my own anxieties as an adolescent girl—in which my body, in public, seemed to occasion other people's pleasure and my humiliation; in which my status as person (which already hinged on external recognition of my intellect) was perpetually trumped by my potential to be a thing (a "cunt").

That my primary experiences of sexual humiliation were specific to my experience of going to school lent additional weight to an already overdetermined lower-middle-class investment in education. It taught me something important—that the feeling of being stripped down to a sex object is very much a dressing-down in culture. That dressing-down in culture is in turn racially marked. Writing about another photograph of a black man's dick, Kobena Mercer has critiqued Robert Mapplethorpe's "Man in a Polyester Suit," a portrait of a black man in a cheap suit, with his penis hanging out and his face cropped out of the image. Mercer observes that "the racism it presupposed or complies with is effaced and whitewashed by the jokey irony of the contrast between the black man's private parts and his public attire in the cheap and tacky polyester suit. . . . Sex is confirmed as the *nature* of black male identity, as the polyester suit confirms the black man's failure to gain access to *culture*."[4]

The humor of the Moby-Dick anecdote was held together by the assumption that a naked black man captioned with the title of a literary masterpiece made a great joke.[5] And as long as I either assumed or reinforced the distinction between the obscene and the literary and attempted to contain the processes of abjection embedded in my relationship to the photograph, in no small part by disavowing the racialization of that relationship, the storytelling was more defensive than radicalizing. At that moment, at least in conversation, I played the part of the good critic—the critic who can sort through an archive of words and images to produce a hierarchy of taste.

My first encounter with Melville's novel had been a clandestine exercise in sorting out the difference between art and pornography. Looking back, one could say that this encounter with that novel, or at least with the mythology that surrounds it, provided the primary scene for my formation as a critic. Reading *Moby-Dick* years after I had spun a tale about my precocity as a reader out of a photograph of a black man's dick and an L.L.Bean sweater, I found myself the inhabitant of a place that looked an awful lot like the position of unknowing I had constructed for my sister: nearly every node in the anecdote is already embedded in Melville's text—from Melville's broad function as a vehicle for queer recognition (by which one Melville fan recognizes a shared set of homoerotic interests with another reader, adding depth to Mr. R——'s question, "What's his name? Moby-Dick?"), to the novel's determined projection of whiteness through blackness,[6] and the novel's often outrageously sexualized vocabulary, which is, at times, so over the top that you can't but allow yourself, as reader, to make a pornographic turn and revel in *all* the possibilities of reading.

Reading *Moby-Dick* as an adult, I thought it would be a great thing to talk about *that*, about art that tells us how sex *matters*.

Kusama's Boat

MOBY-DICK'S LONG LIFE as a pornographic moniker suggests that the idea that art and pornography are mutually exclusive opposites is more convenient than it is true. More nearly, they are overlapping representational modes, in which one is a possibility always contained within the category of the other. Moby-Dick's pornographic career turns common sense about art and pornography on its ear. Angela Carter describes this received wisdom as the "liberal theory that art disinfects eroticism of its latent subversiveness, and pornography that is also art loses its shock and its magnetism, becomes 'safe.' The truth of it," Carter continues, "is that once pornography is labeled 'art' or 'literature' it is stamped with the approval of an elitist culture and many ordinary people avoid it on principle, out of a fear of being bored."[1] In the case of the full-frontal photograph of a naked black man posing as Moby-Dick, we have a reversal of the usual routine (of a liberal claim of artistic value for a pornographic text). Here we see the attachment of the label "porn" to a text already in place as boring but important "Literature." A pornographic "Moby-Dick" is a campy exception to the fantasy that stages pornography and art as wrestling against, rather than *with*, one another.

When I tried, as a teenager, to demonstrate my command over the difference between art and porn, I had never read *Moby-Dick* (let alone theories of pornography). I was not yet capable of the interpretive leaps that might see close cousins in Melville's novel and a hypersexualized portrait of a black man, or a satire on the notion that aesthetic pleasure might displace and transcend sexual arousal. In fact, I wasn't even sophisticated enough to recognize that my first contact with visual pornography was with a catalog advertising videotapes to gay male consumers. But now, as a critic, these intersections between art and desire are exactly what I want to explore.

At the same time I started writing about the erotics of reading *Moby-Dick*, I went to see a 1999 exhibition of the work of Yayoi Kusama at the Museum of Modern Art in New York (Love Forever: Yayoi Kusama, 1958–1968).[2] There I stumbled on a visual articulation of the tension between sexual interest and boredom that I had been trying to describe (now the subject of chapter 1, "*Moby-Dick*'s Boring Parts").

Aggregation—Rowboat (1962–65) is a rowboat, every surface of which (including the oars' blades) is covered with phallic extrusions of various sizes and shapes. It belongs to a series of household items covered with stuffed *phalli* produced by Kusama in the mid-1960s: an ironing board, shoes, chairs, baking tins, a couch, a purse, a raincoat, a baby carriage. This object in particular is also part of an installation that places the rowboat in a room wallpapered with posters depicting that rowboat. Kusama's objects literalize the unruliness of

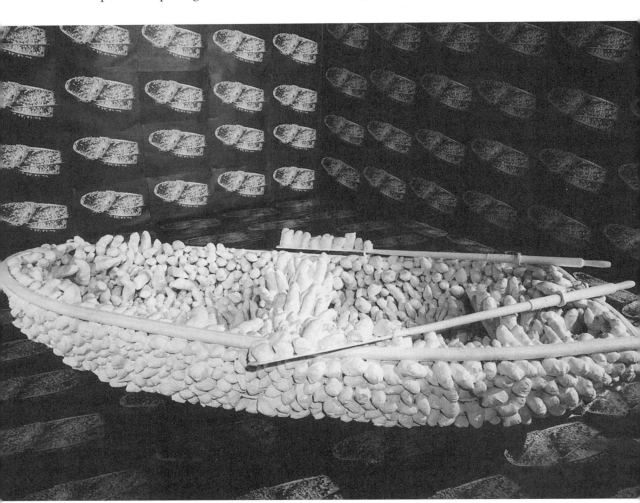

Figure 1. Yayoi Kusama, *Aggregation—Rowboat,* 1962–65. Courtesy of Stedelijk Museum, Amsterdam.

sexual desire, its ability to cover everything, to spread. When confronted with her works, you can't help but feel that they vibrate with desire. The rowboat is so overrun with phallic objects, described by Claes Oldenburg as "a small thing that covers," that there is no room for anything (or anyone) else.[3] Desire, they declare, works like this. Elizabeth Grosz invokes this aspect of sexuality's unruliness when she writes, "As a concept, sexuality is incapable of ready containment: it refuses to stay within its own predesignated regions, for it seeps across boundaries into areas that are not apparently its own. As drive, it infests all sorts of other areas in the structure of desire. It renders even the desire not to desire . . . as sexual. . . . As a set of activities and practices, it refuses to accept the containment of the bedroom or to restrict itself only to those activities which prepare for orgasmic pleasure. It is excessive, redundant, and superfluous in its languid and fervent overachieving."[4] Kusama's accumulations certainly hypostatize this action of desire. But they also express the proximity of sexual intensity with obsessive repetition and boredom. They overwhelm us with the hours of monotonous (and distinctly feminine) labor that the production of these objects require (cutting, sewing, stuffing) and with the maniacal impulse to subsume everything around us under the singular blanket of the sexual. This, I thought when confronted with the strange, small excesses of Kusama's objects, is how Ishmael, the narrator of *Moby-Dick,* thinks.

The present book is written from the sense that in thinking critically about art and sex it is useful to step back from debates about pornography and censorship, and from narratives of repression and recovery, to think both more creatively and more carefully about how and where "sex" happens in art. Kusama's work reminded me that sex, as a subject of art and literature, is often not the Big Secret we make it out to be. It is more like "a small thing that covers." In his critique of the repressive hypothesis (of the notion that we have lived—at least since the Victorian era—under a blanket prohibition against speaking about sex, from which we can be liberated by bringing sex "into the light"), Michel Foucault famously warned critics against the seduction of unveiling sexuality as the ultimate truth of a story. The repressive hypothesis, in its promise to get at truth through the liberation of the sexual subject, he writes, promises to describe the mechanisms of "not only an economy of pleasure but an ordered system of knowledge." Under its regime, "sex gradually [becomes] an object of great suspicion; the general and disquieting meaning that pervades our conduct and our existence . . . the point of weakness where evil portends to reach us."[5] The idea that sex might be the great secret of modern life *is* a tempting hypothesis. Sex as the Big Secret and the Ultimate Truth, as the thing that explains everything, makes for a great story—its narrative pull is irresistible.

Moreover, sexist and homophobic institutions *have* had a profound impact on art and literary history: they have indisputably "hidden" sex stories from view—actively suppressing, for example, the fact of artists' homosexuality, censoring openly homoerotic art or ignoring homoerotic content in favor

of "formal" analysis, or cordoning off women artists and feminist art as superfluous subcategories.[6] The facts of homophobia and misogyny make the telling of stories of exclusion and censorship a matter of not only interest but urgency.[7] Critics who think and write about sexuality and gender can thus sometimes feel cornered by the desire to fight phobic institutions and the narratives they generate, by the power of the repressive hypothesis (which continues to order much identity-based criticism by setting up sexuality as the suppressed truth of works of art by women and gay men especially), and, finally, by the knowledge that there is much more to criticism about sexuality than the revelation, "Look! It's all about sex!"

If I had to define the experience of writing this book in terms of one revelation, it would be the discovery of how very easy it is to write yourself into these kinds of corners, and how unsatisfying—because what we mean by "sex" in those sorts of declarations, and how it matters, is rarely transparent. Do we mean, for example, the "sex" of sexual identity? Of gender? The body? "Sex" as a discursive field, as something deployed? (What would that look like?) As something that happens to us? Or as something that we initiate and seek out? (How is art about *that*?) To assert that a book, or a painting, or a film, is about sex—or to assert that something is pornographic—is to say surprisingly little. To point out that Kusama's rowboat is all about sex is to state the obvious, to reveal no more than the work itself: her boat is so overrun with sex objects that there is room for nothing else. And this is, in a way, Kusama's point.[8]

And so while the following chapters may be described as about "sex in art," to say so would not reveal much. Each of the subjects of these chapters has taught me just how inadequate such descriptions can be. Thomas Eakins's paintings are differently about sex than Melville's novel. Tracey Emin's squiggly drawings of naked women are differently about sex than Andy Warhol's portraits of Marilyn Monroe. Warhol's *Marilyn* portraits are differently about sex than his filmic portraits of Factory superstars. And Vaginal Davis's performances as Vanessa Beecroft are differently about sex than Beecroft's performances themselves. The complexity of these representations of sex is perhaps why many of the artists and writers I discuss (at least the less contemporary and more well-known ones like Melville, Eakins, and Warhol) are major figures in sexuality studies. In their unruliness, their unpredictability, their heterogeneity, they remind us that we should be suspicious of critical projects that promise to tell us all, once and for all, the story about sex.

They offer us a portrait of eroticism in art radically different, furthermore, from the visual tradition mapped by Carol Duncan in her essay "Modern Erotic Art." In her feminist overview of representations of the female nude, Duncan identifies an "equation of female sexual experience with surrender and victimization . . . so familiar in what our culture designates as erotic art, and so sanctioned by both popular and high cultural traditions, that one hardly stops to think it odd."[9] Those works of art (Duncan invokes, by way of examples, Eugène Delacroix's painting *The Woman in White Stockings* [c. 1832] and

Hiram Powers's 1843 sculpture *The Greek Slave*) imagine the sexual body as a passive, feminine vehicle for the beautiful and the sublime. The texts at the heart of this project, on the other hand, rarely present sex as sublime or even beautiful—rather, they explore the everydayness of sexual subjectivity: the wanderings of desire, the importance of boredom, desire's haptic dimension, the stubborn and delicate nature of our attachments to each other, the seductive power of misunderstanding, and the inevitability of sexual failure and humiliation. And so, although the following chapters unfold chronologically, the dramatic arc of their movement from a reading of Melville's *Moby-Dick* in the first chapter to a reading of contemporary performance art by the Los Angeles–based artist Vaginal Davis in the last is not one of historical progression. The chapters are best understood as interlaced explorations of the relationship between what Roland Barthes called the "dialectics of desire"—the fluid and unpredictable life of pleasure—and its political and historical contingencies. The book offers a multifaceted study in how the pleasures we take from art are shaped and determined both by specific conflicts within our understanding of what art is, where it comes from, what and who it is *for,* and by specific conflicts about what sexuality is, about gender difference, about the body, and about the nature of desire itself.[10]

Gender Troubles and Sex Objects

This book begins with two chapters on nineteenth-century texts: Melville's *Moby-Dick* and Eakins's painting *The Gross Clinic*. Melville and Eakins are similarly compelling figures within sexuality studies, insofar as both are strongly identified with homoeroticism and gay studies, but neither, biographically, sits perfectly within the category "homosexual." Attempts to decipher both artists' representations of relationships between men, and between men and women, struggle with the particularly vexing questions pertaining to the history of sexuality in general, and in the United States in particular. For many of the most interestingly queer male figures of the period (Melville, Eakins, Walt Whitman), the diacritical axis gay/straight was neither persuasive nor reliable for describing their communities, their emotional and libidinal affiliations, their aesthetic practices. No amount of scrutiny of their art or personal correspondence, for example, satisfyingly reveals their texts as symptomatic expressions of a single repressed sexual identity (one can certainly argue, however, that all are deeply preoccupied with this epistemological puzzle).[11] And so, I take a different kind of approach and shift the focus of my inquiry from the relationship between the art object (be it a novel or a painting) and the artist's sexuality, to the kinds of relationships to art itself those objects foster. Rather than ask, for example, how *Moby-Dick* might read as a novel written by a repressed homosexual, or how it might have read as "queer" to nineteenth-century readers, I explore how we might connect the erotics of Melville's novel and its appeal to queer readers today to the intensity with which the novel eroticizes the scene of reading itself.

In other words, my approach to the novel is grounded in the following kinds of questions: What forms of connection and affection does this novel conjure into being? What does reading this novel feel like? How does the novel seem to recognize, and in fact, to be about this? This is not to dismiss the historical question of Melville's gay readers or Melville's sexuality, but to use the text itself to address the novel's queer presence to readers today—and, perhaps, to speculate on why some of us love this novel *so much*.

Similarly, rather than deploy the gender ambiguity of the central figure in Eakins's painting *The Gross Clinic* (1876) behind an attempt to "out" Eakins as a homosexual painter, I ask how we might take that painting as always already about the pleasures and anxieties that animate the drive to "know" the sex of the body, and argue for Eakins's importance as an artist deeply invested in representing the complexity of the relationship between sex and art. Eakins is, in fact, a near-perfect case study for how messy the sex politics of art history (for example) can get: because of the overt and tender homoeroticism of much of his work, he is a tremendously important figure in gay studies in art history. Because of the homophobia of that discipline, the homoerotics of his work was almost completely ignored until the past decade—in which we have seen the publication of several articles and a book-length study on homoeroticism, masculinity, and gender in his work.[12] As recently as 2002, however, the Philadelphia Museum of Art excluded any discussion of new work on Eakins and sexuality from the catalog accompanying its major exhibition of the artist's oeuvre. And so it is imperative to gay studies in art history that we forward interpretations of the homoerotic current that animates Eakins's representations of men and that we acknowledge the romantic intimacy of his relationships to the men in his circle. In the face of the willful institutional erasure of these facts (as well as of scholarship grounded in them), it is important to say that Eakins's work is homoerotic, that his work and his life are queer, and to insist on this fact as central to a full understanding of his importance as an American artist.[13]

Things get even more interesting when we turn to the Eakins archive. His letters are filled with defenses against accusations of sodomy and incest and effusive celebrations of the male physique—offering just what one might think one would find when reading the papers of a closeted homosexual. That said, the same archive tells us that he had lifelong relationships with women, including a marriage to Susan MacDowell (an interesting artist in her own right and a frequent subject in Eakins's portraiture), and that Eakins was pursued by sodomitical scandal generated not by his romantic attachments to men but by the bohemianism of his relationships with the women in his circle.

The disciplinary protocols of identity-based discourses sometimes make the full discussion of subjects like the sexual politics of Eakins's work and career feel almost impossible without stepping outside the boundaries of those fields, as they are traditionally conceived. Unspoken codes of critical conduct shape identity-based criticism (such as: feminist critics write about female artists and representations of women; gay critics write about male artists and representa-

tions of men). So where does Eakins fit in? How can we talk about the place of women in his life and work without furthering the homophobic erasure of his relationships with men, and the eroticism of his photographs and paintings of them? How can we talk about the latter without shutting down analysis of the former? To answer these questions we need to find more-flexible models for describing the connections between an artist, his audience, and his aesthetic practices. Chapter 2 offers such a model by using the association of bohemianism with sodomy in the rumors that dogged Eakins throughout his career to unpack the relationship between Eakins's attempt to reimagine how we make art (e.g., by focusing on the material presence of the body, by treating men and women the same) and the ambiguous articulation of gender difference in his work.

The intensity of the relationship between discourse on art and discourse on sex is perhaps nowhere more apparent than in the reception history of Andy Warhol's work, the subject of chapter 3. Critical narratives about the relationship of Warhol's work to its audience have long been shaped by a sexualized and feminizing vocabulary that is often at once homophobic and misogynistic (in part because the former is often so dependent on the latter). Some aspects of this subject have been explored by Cécile Whiting in her innovative portrait of the gendering of Pop Art's investment in popular culture (by both its critics and its practitioners). She writes, "An implicit dismissal of the woman's domain can be detected in many of the adjectives critics selected to characterize the motifs represented in Pop Art: banal, commonplace, vulgar. Even the efforts to defend Pop Art as 'art' reveal a certain anxiety, a certain desire to step around its subject matter, filled as it was with objects considered of minor importance and value owing to their strong association with women."[14] Whiting excavates the gendering of the reception of Pop as a movement, as well as Pop's "appropriation of those aspects of consumer culture associated with women—feminine spaces, feminine motifs . . . feminine viewing practices." In chapter 3, I pursue the relationship between the gendering of Pop, phobic responses (in criticism) to Warhol's sexuality, and the place of sexuality in Warhol's work itself.

These diverse subjects are brought together by the use of figures of prostitution in criticism as emblems for Warhol's relationship to his work, and also by Warhol's own fascination with the harmonies between sex work and the "work" of being a sexed subject. I place the recurrence of figures of prostitution in and around Warhol's work within a larger rhetorical tradition that I call a "rhetoric of prostitution."[15] That rhetoric imagines the relation of the artist to the market as, in essence, like that of a woman forced to attach a price to that which should never be sold (sex). In the rhetoric of prostitution, the critic routes anxiety about the category of art (and especially about the art market) through discourse about women and sex, using the pejorative energies of moral panic to reinstate the virtue of aesthetic experience (as, for example, not licentious). On the particular symbolic force associated with figures of prostitution, Herbert Marcuse writes that "the full force of civilized morality [is] mobilized against the use of the body as mere object, means, instrument of pleasure; such reification . . .

remain[s] the ill-reputed privileges of whores, degenerates, and perverts."[16] The prostitute draws to our attention the ideological knot of the culture that would enact such prohibitions against the instrumental use of the body in the bedroom while requiring that instrumentality in the marketplace. The use of figures of prostitution as allegories for the artist's relationship to the market taps into the anxiety provoked by the idea of using the body as a "means," in order to manage the paradoxical nature of the work of art (in the conflict, for instance, between the notion of the autonomy of art and its commodification). The emphasis on sex within this rhetoric may be thought of as an effect of the repressive hypothesis insofar as it ascribes to sexuality the value of foundational, revelatory truth. The rhetoric of prostitution in criticism is an extension of this overdetermination of sex into how we understand art as a category because, as we see in reading Warhol's critics (and as was anticipated by Eakins's detractors), it inevitably suggests sexual deviancy as the generative source of "bad" art.

The relative undertheorization of women in Warhol's films (in which they figure prominently) and of the relationship of Warhol's work to feminism or feminist theories of visual culture is a dramatic example of how developments in gay studies and feminist criticism have produced blind spots around exactly those moments when the interests of both ought to produce collaboration. Somehow, such a project (the subject of chapter 4) would seem to forward neither the most programmatic aims of gay studies (by focusing on women) nor feminism (by focusing on the art of a gay man). With a few notable exceptions, to date the discussion of this topic has generally been limited to appreciations of Edie Sedgwick; gay fandom and the iconicity of celebrities like Marilyn Monroe and Liz Taylor; and meditations on the fact that Valerie Solanas nearly killed the artist.[17] Or, the strangeness of the place of women in gay underground cinema is recognized by acknowledgments of the misogyny implied by the "rape" scenes of Warhol's *Lonesome Cowboys* or Jack Smith's *Flaming Creatures.*[18]

That camp performances of sexual violence should have such a frequent, even casual, place in gay underground filmmaking of the 1960s, the very years that produced feminist critical perspectives on heterosexuality as an institutionalization of rape, should suggest radical feminism as an object of queer fascination and interest. Warhol's films, furthermore, are clearly played out against the backdrop of the sexual revolution and its aggressive revision of women's roles in the household, and against their relationships to their own bodies and to sexual pleasure. In the case of Warhol scholarship, however, the fact that he was violently attacked by Solanas, a woman identified with late-1960s radicalism, only makes feminist readings of the gay male artist or of the camp staging of sexual violence and abjection in his films feel unlikely, even inappropriate.

Warhol's work has been an extremely generative sight for recovering, celebrating, animating erotic expressions between men: for exploring the performative aspect of sexuality, as does Gavin Butt in his analysis of gossip and Warhol's negotiation of a public queer life; for exploring how an artist anticipates homophobic systems in his work, embedding both defensive and subversive positions

within his visual practices, as does Richard Meyer; for examining, as does Douglas Crimp, how art-historical discourses clamp down on historical and political readings of Warhol at exactly (and only) the moment the conversation turns toward his homosexuality. This work is tremendously useful to thinking about the production and consumption of gay and queer identities. With few exceptions, the question of feminism—of how the films that feature women might read to women spectators, for example, or how they might formally be read as *feminist*—has largely remained outside the scope of these projects.[19]

In part because this topic marks an intersection in feminist and queer modes of critical inquiry, the problem of women in Warhol scholarship is similar to that which the film scholar Pamela Robertson describes in her work on feminism and camp: "Most people who have written about camp assume that the exchange between gay men's and women's cultures has been wholly one-sided; in other words, that gay men appropriate a feminine aesthetic and certain female stars but that women, lesbian or heterosexual, do not similarly appropriate aspects of gay male culture. This suggests that women are camp but do not knowingly produce themselves as camp, and, furthermore, do not even have access to a camp sensibility." Within scholarship about camp, Robertson concludes, women are trafficked: "Women are objects of camp and subject to it but are not camp subjects."[20] Thus, within the critical discourse on gay underground cinema, the operatic gang rape around which much of Smith's *Flaming Creatures* is staged becomes legible as *only* not-feminist, an ugly detail—and the fact that this offers us a woman's camp performance as sexual victim to a circle (and audience) of gay men, transsexuals, drag queens, and queer women is, in a sense, invisible. While on the surface these kinds of moments in camp/gay cinema may seem to betray feminism, to mark off the distance between a gay-affirmative cinema and an antipatriarchal one, and to firm up the commonsense suspicion of gay culture as secretly misogynist, these farcical performances of the disasters of heterosexual culture may also be read, in fact, as quite profoundly feminist—as, in fact, perhaps *best* read through the urtexts of feminist criticism.[21]

On some level, my readings of women in Warhol's films, my impulse to think about the relevance of Warhol's work to feminism, and my investment in artists like Melville and Eakins extend my commitment to the forms of intimacy that take shape between women (straight and gay) and gay men. As often as relationships between women and gay men are played out for our amusement in pop culture (e.g., the television series *Will & Grace*), they are subject at other moments to a level of vitriol unique to the sense of betrayal provoked by these cross-gender and often cross-sexuality friendships (e.g., the phobic axiom "fruit flies don't live very long"). One might say the failure to be smart about fag hags signals the same kind of limit to collaborations between feminist and queer theory that has obscured the presence of women in gay bohemian environments. "Generally," Hilton Als writes in his ambivalent (one might even say

poisonous) rendition of these relationships, "the fag hag comes into being in an attempt to escape her body by identifying with a difference not her own." This identification, he writes, is mirrored by her gay friend's attachment to her: "What gay men see in the fag hag is someone who plays out their narrative of disenfranchisement."[22] Als, writing of Dorothy Dean (one of New York's most luminous and complex fag hags), reproduces the most debilitating characterizations of such women: "She becomes a star attraction among men who have limited, if any, sexual response to her (a fact she eventually and inevitably resents). The fag hag prizes self-control even as she performs outrageous acts. She harbors anger towards her audience for accepting, laughingly, what she does not speak: her fear of romantic intimacy—which she identifies as a potential violence against herself, given the (assumed) proclivities of heterosexual men, their desire and ability to control *her*."[23] Common sense (that reservoir of wisdom!) about these relationships suggests they are immature and compensatory retreats from intimacy. Common sense casts the fact that many of these men and women do not "settle down" into heterosexual coupledom or gay normalcy as sexual failure. Within these narratives, the occasional animation of these relationships between gay men and women with sexual desire or romantic investment is always represented as a misrecognition, or a pathological fantasy. Unthinkable within this pathologizing narrative is the possibility that these mutually sustaining relationships are organized around the nurturing of queer possibility and a shared refusal to be "normal." Within Als's narrative, the difficulty of acknowledging the importance of nonsexual (but sometimes erotic), antidomestic intimacies renders invisible, for example, the fact that one of Dean's "fags," Joe Campbell (who described Dean as "the love of my life"), was at her bedside when she died.[24] Was their friendship any less meaningful for not having been sexual? Are friendships worth less because they are not articulated as marriages?

The filmmaker and theorist Laura Marks offers a more nuanced and generous portrait of how and why some women are drawn to gay men and gay culture. In a remarkable essay on women spectators and gay pornography, she eloquently describes her attachment, as a "fag hag," to not only homosexual environments (like clubs) but erotic representations of gay sex. She writes, "A straight woman who likes to go to gay men's nightclubs knows the peculiar pleasure of seeing men on full erotic display yet remaining herself practically invisible." She associates this, "the fag hag's pleasure," with the freedom of enjoyment she feels as a spectator of gay porn: "When I look at images of gay men, made for gay men, I can look all I want. . . . I can do whatever I want to this image with my eyes. . . . Looking at gay porn, I borrow a gay man's look at other men, drop in on a man's desiring gaze at another man."[25] Counterintuitively, Marks argues, some people may intensely enjoy haunting spaces in which they are invisible (or are at least differently visible), and consuming images not only not intended for them but not interested in representing them and their desires.[26] The insertion of herself into a queer homoerotic environment is

not a retreat from the sexual. For this woman, finding herself in a queer space can be sexually empowering—it may be the *only* space in which her sexuality is acknowledged in all its unruliness; or, it may be a space in which she feels like a sexual subject precisely because she is not a sex object.

This book's title refers perhaps most directly to Tracey Emin's work, the subject of chapter 5. Drawings of naked women on their hands and knees, captioned with acidic notes-to-self like "I used to have such a good imagination," speak directly to the ordinary, exhilarating, and humiliating aspects of living in a sexual body. Her work is animated by the sense that power dynamics outside the bedroom structure what happens inside the bedroom (and vice versa). Emin has generally been read in terms of her biography. This is not only because she takes her life as the content of her work but because she often presents her art objects as personal effects (e.g., letters, drawings scrawled on hotel stationery, her bed surrounded by the detritus of a messy sex life, a tent appliquéd with the names of everyone she has slept with). In my chapter on Emin, I explore the place of intimacy and banality in her work. In doing so, I hope to shift critical discourse on her work away from the analysis of its confessional component to the intensity of its effect on the spectator. Continuing a discussion I raise in my writing on Eakins, I argue that in focusing on the autobiographical aspect of Emin's work, writing about Emin has reproduced the confusion of cause and effect most commonly associated with realism—in which we take a painting, for example, as a literal record of an actual (but now lost) scene. I approach the intimacy of Emin's work—its materialization of physical and emotional availability, its metonymic relation to the artist and her body, its invitation to melodramatic identification—as an effect, as an aesthetic strategy not unlike the effect of realism described by the art historian Michael Fried in his work on nineteenth-century painting. Rather than think of Emin's work as a portrait of the artist's narcissism, I explore its appeal to the narcissism of the spectator.

Reports of Emin's exhibitions often describe young women weeping to her video narratives of abortion and sexual humiliation, and suggest that the emotional immediacy of Emin's work may be its most powerful element. On the other end of the affective spectrum we find Vanessa Beecroft, an art world celebrity (profiled in *Vogue* and the *New Yorker*) famous for her "installations" of "live models" (naked women) in galleries. These women, who are styled to look alike (hair dyed the same color, covered in white body paint or dressed in identical Gucci bikinis), are instructed to look expressionless and avoid any communication with the spectators gathered to watch their performance. These installations appear to literalize sexual objectification. "Sex" is deployed very differently by these two high-profile, even notorious, contemporary artists. Emin's work is aggressively expressive—her paintings, drawings, and monoprints especially feel as though they were produced in the haze of sexual intensity and in the wake of messy breakups. Beecroft's work pivots instead on a highly

controlled form of sexual display. Photographs of her installations are glossy, highly "produced," and oddly impersonal. We cannot help but notice Beecroft's managerial presence. In fact, one might say that if Beecroft's work has an erotic component, it is in the control she exerts over the bodies of her performers.

In 2001 and 2002, the Los Angeles–based underground artist Vaginal Davis staged a series of camp parodies of Beecroft's performances. In chapter 6 I contrast the reification of sex in Beecroft's work with the possibilities for sexual contact that Davis fosters in her performances. This chapter extends my work on the deployment of discourse on sex in the art world in chapter 3 in order to consider the difference between these two artists. I use Davis's performances to gain critical leverage on the circulation of sex in contemporary art as an empty gesture toward avant-gardism—as an instance of what Theodor Adorno once called the "de-sexualization" of sex. Implicit in this chapter is an opposition between a reactionary deployment of sex in contemporary art as an allegory for art's compromised relation to its audience, and the way sex "happens" in underground queer performances like Davis's, which are overtly "pornographic" but whose importance does not rest on the exposure of sex as Art's big dirty secret. Davis's work is organized by a completely different set of aims: in her milieu, art is an ethos, a way of life designed to make sexual community feel at least momentarily possible.

The Anatomies of Boredom

My reading of Davis's work orbits a series of failures in her performance—the presence of boredom, the spectacle of sexual failure, and the failure of the audience to recognize Davis's drag as a parody of an actual art-world celebrity. Many of the artists I discuss—Melville, Warhol, Emin, Davis—testify to the quotidian cycles of desire, in antiheroic portraits of anxiety, pleasure, rage, and boredom. By approaching their work from these angles, I return to the questions about boredom, sex, and desire raised by Kusama's boat. In an extension of this book's concern with the affective space around artworks, I turn frequently to boredom as a paradoxically generative form of inattention. Boredom is often treated in criticism as a failure or as a pathological symptom. The bored spectator or reader usually poses the same problem for the critic that the bored child does for adults: the analyst and essayist Adam Phillips writes that boredom is heard by adults "as a demand, sometimes as an accusation or failure or disappointment, [but] it is rarely agreed to, or simply acknowledged. How often, in fact, the child's boredom is met by that most perplexing form of disapproval, the adult's wish to distract him—as though the adults have decided that the child's life must be, or be seen to be, endlessly interesting."[27] The risk one takes in writing about boredom is the reproduction of the scene of this demand—that the text be endlessly interesting, that the reader be endlessly interested, that we critics, at the very least, produce the effect of interest. To cite Phillips again: "Boredom . . . protects the individual, makes tolerable for him the impossible

experience of waiting for something without knowing what it could be. . . . So the paradox of the waiting that goes on in boredom is that the individual does not know what he is waiting for until he finds it, and that often he does not know that he is waiting (at all)."[28] Boredom flowers only in the absence of a sense of purpose. When we encounter it while reading a novel, or watching a film or a performance, we sometimes feel let down by the text (which fails to attract our attention) or by ourselves (by our inability to "get" something from Art). Phillips suggests, however, another way of thinking about these "failures"—as necessary to poetics, as the negative space of interest. The ephemeral character of boredom distinguishes it from other affects. It is not unlike "surprise," which Sylvan Tomkins describes as a "resetting" affect. A resetting affect has no life outside the moment of resetting; it is, by definition, a moving affect, more a route than a destination—a route, furthermore, that takes you not from one point to another on the same grid (from "a" to "b") but from one grid to another (from "a" to "2").[29]

In this book, I think of boredom strategically, as an affective state that helps us get from one place to another. Phillips approaches the affect with an eye on its place in therapy. Extending his description of boredom's space-clearing relation to desire to the work of the psychoanalyst, Phillips suggests that "one could, in this sense, speak of the 'analytic attitude' as an attentive boredom." The good analyst will not perform interest for the sake of his client so much as he will allow himself to be bored by her (and what, really, is more pleasurable than a therapist who seems to relax under the blanket of your prattle?). With a little tinkering, we might use this understanding of boredom as a model for an embodied form of aesthetic enjoyment.[30] Toward this end, in his essay "Idle Talk: Scarcity and Excess of Language in Narrative," Alexander Gelley explores boredom as "a purely formal attention" and as "what is minimally required in the act of reading."[31] Along with the suspension of disbelief we might thus add another precondition to the pleasure of representation: an openness to boredom that would allow us to replace the "detached observer" with a body both less committal (always ready to walk away) and more promiscuous (or go straight to bed).

But this distracted form of reading, listening, or watching has its risks. In *A Lover's Discourse,* for example, Barthes writes, "Like a bad concert hall, affective space contains dead spots where the sound fails to circulate. —The perfect interlocutor, the friend, is he not the one who constructs around you the greatest possible resonance? Cannot friendship be defined as a space with total sonority?" In contrast with the resonant space of friendship, Barthes gives us the sonic void of love gone awry, in which the anxious lover finds himself confronted by a wall of indifference, the silence of the uninterested partner who tolerates the other's prattle. He writes, "This distracted kind of listening generates an anxiety of decisions: should I continue, go on talking 'in the void'? This would require precisely the assurance which amorous sensibility does not permit. Should I stop, give up? This would seem to show anger, accusation of the

other, producing a 'scene.' The trap all over again."[32] The therapeutic benefits of Phillips's "attentive boredom" is possible only as long as the speaker trusts the attachment between himself and his audience. Nibbling on the edges of the experience of boredom, and the experience of being boring, is both the possibility of the discovery of desire and the threat of total failure. The art in this book not only plays with boredom's possibilities, it tends also to explore the specifics of boredom—raising questions about exactly who is bored by what and why; how it feels to be boring; what it is like to know that you have failed to hold the other's interest.

Our Objects

To approach the subject of sexuality and art from these perspectives is to re-imagine the subject/object relation that structures much scholarship in this area. It is to place special emphasis on the character of the relationship between ourselves and our objects, our books, photographs, paintings, and films—to ask what it is that we get out of our love for art. The following chapters therefore model an approach to the representation of sexuality that draws from, but is not bounded by, the analysis of the prohibition and production of sexual identities.

This is another way of saying that these chapters were written in the wake of a particular kind of queer theory—the queer theory that addresses the limitations of dominant (largely binary) models of sexual identity for describing our sexual lives or for understanding representations of sexual difference and sexual desire. In "Getting the Warhol We Deserve," Douglas Crimp makes this kind of claim for the complexity of representations of sexuality and for the importance of certain artists to thinking through that complexity. He writes, "That is one reason why an art such as [Jack] Smith's—and Warhol's—matters, why I want to make of it the art I need and the art I deserve—not because it reflects or refers to a historical gay identity and thus serves to confirm my own now, but because it disdains and defies the coherence and stability of all sexual identity. That to me is the meaning of *queer,* and it is a meaning we need now, in all its historical richness, to counter both the normalization of sexuality and the historical reification of avant-garde genealogy."[33] Crimp reasserts in this essay a principal theme of queer criticism—its investment not in the articulation and production of concrete categories of sexuality and gender but in the very real ways that queer art (be it a novel, a photograph, a film, a performance) can cut across and dismantle the attempt to produce sexual subjects as inevitable members of a "type" and, at the same time, call into question the disciplinary narratives that have formed around the queer art that has been absorbed into the canonical record (such as work by Melville, Eakins, or Warhol) or that stubbornly remains "underground" (such as work by Jack Smith or Vaginal Davis). In paying attention to these artists, we discover that their "queerness" resides not only in the domain of the sexual but in how they make art, in the kinds of relationships between people and art they foster. Eve Kosofsky Sedgwick's 1993 essay "Queer

and Now," like Crimp's, represents the queer critical project as both deeply personal and political, and, furthermore, as relational. Among the important definitional work performed by that essay, we find the following assertion of the importance of our particular investments in certain objects:

> I think that for many of us in childhood the ability to attach intently to a few cultural objects, objects of high culture or popular culture or both, objects whose meaning seemed mysterious, excessive, or oblique in relation to the codes most readily available to us, became a prime resource for survival. We needed for there to be sites where the meanings didn't line up tidily with each other, and we learned to invest those sites with fascination and love. This can't help coloring the adult relation to cultural texts and objects; in fact, it's almost hard for me to imagine another way of coming to care enough about literature to give a lifetime to it. The demands on both the text and the reader from so intent an attachment can be multiple, even paradoxical. For me, a kind of formalism, a visceral near-identification with the writing I cared for, at the level of sentence structure, metrical pattern, rhyme, was one way of trying to appropriate what seemed the numinous and resistant power of the chosen objects.[34]

We feel recognized in those sites where meanings do not "line up tidily with each other," in part because they mirror our struggles with those moments when, Sedgwick writes, "all institutions are speaking with one voice," when "religion, state, capital, ideology, domesticity, the discourses of power and legitimacy" unite as a monolith around one word, such as "family" or "nation."[35] For those of us (which is probably most of us) who find ourselves living at odd angles with these monolithic structures, art is not a luxury but a necessity—queer readings of books, novels, films, paintings, and performances give us our maps, our user's manuals for finding pleasure in a world more often than not organized around that pleasure's annihilation.

As I hope these chapters make clear, my intention is not to deflate the importance of identity-based models of criticism but rather to suggest the directions of critical thought about representations of sexuality and desire that those models have enabled. This book, taken as a whole, asks those of us working in gay and lesbian studies and in women's studies to reconsider how we draw up the boundaries of our work. It is written against other disciplinary grains, too: drawing from the nineteenth century and from the present (without, however, constructing a historical narrative that rationalizes my choices), and from literature, art, performance, and film (without, however, absorbing them into a linear narrative or representing them as members of the same genre). My aim has been to use these texts as leverage, to approach the subject of sex and art from diverse angles to create a picture of how sex happens in art, and why it matters.

Moby-Dick's Boring Parts
Pornography's Allegorical Hothouse

Reading the Dictionary

[The pale Usher—threadbare in coat, heart, body, and brain; I see him now. He was ever dusting his old lexicons and grammars with a queer handkerchief, mockingly embellished with all the gay flags of all the known nations of the world. He loved to dust his old grammars; it somehow mildly reminded him of his mortality.]

"While you take in hand to school others, and to teach them by what name a whale-fish is to be called in our tongue, leaving out, through ignorance, the letter H, which alone maketh up the signification of the word, you deliver that which is not true."
 Hackluyt.

"WHALE.***Sw. and Dan. *hval.* This animal is named from roundness or rolling; for in Dan. *hvalt* is arched or vaulted."
 Webster's Dictionary.

"WHALE.***it is more immediately from the Dut. and Ger. *Wallen*; A.S. *Walw-ian*, to roll, to wallow."
 Richardson's Dictionary.

—The actual opening of *Moby-Dick*

As much as we tend to think otherwise, *Moby-Dick* does not begin with Ishmael's invitation to call him Ishmael. The book opens instead under the heading "Etymology" with a parenthetical description of "a late consumptive usher to a grammar school" handling his books: a queer reader with a perverse affection for his books bracketed off, even within the preface, as optional

text—legible only to the careful reader with a similarly angled and intense relationship to his library.

From here, Melville offers us a glimpse of this man's collection of notes on the origins of the word *whale*. These odd sentences are followed by another introductory section, "Extracts," a scrapbook of whale lore "supplied by a sub-sub librarian." The two prefaces are the first of what we might call *Moby-Dick*'s boring parts, and they instruct the reader early in the book's queerness (and its sense of humor). The most substantial of *Moby-Dick*'s boring parts are the "cetology chapters," widely acknowledged as the chapters that "story lovers love to skip."[1] Chapter titles like "Monstrous Pictures of Whales," "Less Erroneous Pictures of Whales," "Of Whales in Paint, in Teeth, &c.," "The Sperm Whale's Head," "The Right Whale's Head," "Jonah Historically Regarded," and "Measurement of the Whale's Skeleton" discourage many from wading all the way through Melville's tome. Much of the aggressively embodied writing about men and whales and the obviously campy and sexual addresses to the reader are nested in chapters like these, which are often completely detached from the narrative trajectory of the book.[2] That the words "queer" *and* "gay" are in the novel's forgotten opening paragraph seems to shore up the function of these parts as a home for things that, for one reason or another (structural, phobic, historical), don't have a place in *Moby-Dick*'s story.[3]

Moby-Dick has a memorable plot. Captain Ahab, who lost his leg to a large white sperm whale named Moby-Dick, is obsessed with the whale and tracks him across the globe, pushing the men on his ship to their limits and, ultimately, to their deaths. The story's rough outlines can be conjured by very many more people than have actually read, or finished, the book. Those who have read or have tried to read *Moby-Dick* know that nearly half of the novel's bulk is taken up by chapters in which the "main" plot is at a standstill. The cetology chapters far outweigh those driven by plot—not necessarily in number but in the calm density of the encyclopedic catalog of whale detail. They do nothing to further Ahab's hunt for Moby-Dick except as the ship implicitly sails along underneath the narrator's ramblings on all things cetological. For many of us, reading the chapters in which things *happen* is the least characteristic experience of reading *Moby-Dick*.

At first glance, the characters' relationships to boredom parallel the relationship between boredom and the reader. The Pequod's men sign on to stave off boredom; the reader, presumably, picks up the book with a similar plan.[4] This much is suggested in the sentences that follow Ishmael's cruisey self-introduction. "Call me Ishmael," he tells us as he launches into a chatty recitation of the lethargy that drives him to the sea:

> Some years ago—never mind how long ago precisely—having little or no money in my purse, and nothing particular to interest me on shore, I thought I would sail about a little and see the watery part of the world. It is a way I have of driving off the spleen, and regulating the circulation. Whenever I find myself involuntarily pausing before the coffin warehouses, and bringing up the rear of every

funeral procession I meet; and especially whenever my hypos get such an upper hand of me, that it requires a strong moral principle to prevent me from deliberately stepping into the street, and methodically knocking people's hats off—then, I account it high time to get to sea as soon as I can. [5]

In other words, Ishmael's seafaring is an attempt to ward off a morose boredom. This is not a promising indicator of the story's interest to us (although novels often do represent themselves as originating in boredom).[6] We could call Ishmael melancholic if the term did not seem saturated with a level of seriousness that belies the bitchy, misanthropic spirit of a man who cannot decide whether he should kill himself or simply knock the hats off of his fellow pedestrians, or the giddy antipathy of a book that eventually becomes utterly disinterested in whether the reader finishes it. Once Ishmael is at sea, the boredom equation inverts. From the narrator's perspective, as soon as land recedes from view, so does boredom. But for the reader, the more interested Ishmael is in the world around him, the less interesting he becomes to us (at least in terms of the story's narrative drive). *Moby-Dick*'s formula for interest gradually turns itself inside out, and the reader embarks on a gymnastic routine in which boredom precipitates arousal, the dull becomes obscene, and the flat-footed bubbles into camp hysterics. In other words, to read *Moby-Dick* you have to read against the grain or, at least, against the plot.

Melville's narrators often associate anecdotal diversion with perversion and offer apologies like *Billy Budd*'s: "In this matter of writing, resolve as one may to keep to the main road, some bypaths have an encitement not readily withstood. . . . If the reader will keep me company I shall be glad. At the least we can promise ourselves that pleasure which is wickedly said to be in sinning, for a literary sin the divergence will be."[7] In *Moby-Dick* the divergence is so great that the Great Question becomes less "What does the Whale symbolize?" and more "Where is this book going?" Our own attachment to the book can become visible as a problem: this, as it happens, mirrors one of the great crises in the novel's story. Deep into the book, barrels of sperm oil so far collected on the Pequod spring substantial leaks—but Ahab refuses to take the ship off of Moby-Dick's trail to repair them. Starbuck, Ahab's chief officer, gets the sense that the whaling venture is only a pretext for Ahab's personal mission to avenge his lost leg and kill the whale. Ahab eventually relents—but not because his lust for revenge has been diminished. Rather, he simply appeases Starbuck to keep him "on board"—in accordance with "the prudent policy which, under the circumstance, imperiously forbade the slightest symptom of open disaffection, however transient, in the important chief officer of his ship" (364). An irony is built into the structure of the book: as the crew begins to despair of ever returning home—so lost is Ahab in his obsession (GET MOBY DICK)—we despair of ever getting to the end of the novel, so lost is Ishmael in the details of the voyage. The confrontation with the white whale is, of course, what we, as readers, signed on for (unlike Ahab's crew). Thus one of the most interesting

allegorical functions of Moby-Dick (the whale): an elaborate and inverted stand-in for *Moby-Dick* (the book) and the act of reading.

Reading the Parts and the Whole

Moby-Dick's relevance to gender studies extends beyond its importance as a portrait of men and their attachments to each other. It is just as powerful an example of how deeply erotic play can be embedded into the scene of writing and reading itself. As Robert K. Martin remarks, echoing in tone and content a major theme in writing on *Moby-Dick,* "No other work is so sustained by the recognition that language does not express content so much as embody it."[8] Melville's book circles endlessly around questions like "What kind of writing makes itself known as a body?" "What sort of reading does it take to recognize that body?" "What sort of reader practices that kind of reading?" "What kind of a thing is *Moby-Dick*?" "What is the nature of our attachment to it?" Ishmael appears to acknowledge this when he speaks to the different currents that pull the reader out of the novel and suck the reader back in. In the chapter "Fast Fish and Loose Fish," after a lengthy discourse on the difference between the two (the loose fish swims free in the ocean, available to anyone who can catch it; the fast fish has been caught, fastened to the boat, belonging to whoever holds it), Ishmael addresses the reader with the rhetorical question: "What are you dear reader but a Loose Fish and a Fast Fish too?" We, in essence, are "loose fish" as long as Moby-Dick is a "loose fish."[9] We are loose fish as long as our attention is up for grabs, but we are fast fish, too, as long as we hold the book in our hands. Often, the allegorical presence of the book itself is less acrobatic—in the chapter "Cetology," for instance, each whale that Ishmael describes is represented as a book—as, according to the size of the whale, a "folio whale," an "octavo whale," or a "duodecimo whale." Details like these push the function of the literal to such an extreme that, as you read on, you find yourself absorbed by the problem of being absorbed by what is self-evident (which raises the question: does not absorption in this kind of writing make *you* dull?).

And so, as *Moby-Dick* unwinds itself, the novel jerks the reader from one unrelated whaling encounter to another. It offers, as interlude, long, obsessive descriptions of whales and their bodies. The chapter "A Squeeze of the Hand," for instance, famously describes the procedure by which whalemen "process" the whale's sperm oil—stripping it from the carcass, placing it in a "large Constantine's bath," and sitting around the tub, to "squeeze these lumps back into fluid." As Ishmael describes the process he is carried further and further away by a passion that creeps up his hands and takes over his body:

> Squeeze! squeeze! squeeze! all the morning long; I squeezed that sperm till I myself almost melted in it; I squeezed that sperm till a strange sort of insanity came over me; and I found myself unwittingly squeezing my colaborers' hands in it,

mistaking their hands for the gentle globules. Such an abounding, affectionate, friendly, loving feeling did this avocation beget; that at last I was continually squeezing their hands, and looking up into their eyes sentimentally; as much as to say,—Oh! my dear fellow beings, why should we longer cherish any social acerbities, or know the slightest ill-humor or envy! Come; let us squeeze hands all around; nay, let us all squeeze ourselves into each other; let us squeeze ourselves universally into the very milk and sperm of kindness.

Would that I could keep squeezing that sperm for ever! For now, since by many prolonged, repeated experiences, I have perceived that in all cases man must eventually lower, or at least shift, his conceit of attainable felicity; not placing it anywhere in the intellect or the fancy; but in the wife, the bed, the table, the saddle, the fire-side, the country; now that I have perceived all this, I am ready to squeeze eternally. In thoughts of the visions of the night, I saw long rows of angels in paradise, each with his hands in a jar of spermaceti. (348–49)

If you skipped the boring parts, you would miss Ishmael's celebration of manly love and sperm oil and the bittersweet note on the inevitability of being asked to "lower" and "shift" his affections (from ship to hearth, from men to women). You might miss, too, the squeezing of this "loving feeling" through his finger-tips and hands into his heart and head—a model of communication that is, also, a fantasy about the physical pleasures of reading, of the movement of an imaginary current from the book to the hand, and from the hand to head and heart.[10] Melville knits his most elaborately erotic writing into the novel's most encyclopedic passages. "A Squeeze of the Hand," along with its neighbor, "The Castaway" (which relates the near loss of Pip at sea), follows a long procession of expository chapters on heads and tails of fish, on who owns the fish in the sea, on schools of fish, and on "Ambergris"—a meditation on whale odor and the contents of whales' bowels. "A Squeeze of the Hand" itself moves without transition from the above ecstatic homotopic play to the presentation of a long list of parts of blubber. ("Now, while discoursing of sperm," Ishmael explains, "it behooves me to speak of other things akin to it" [349].)

Even Melville's defenders, as F. O. Matthiessen explains in his apology for Melville's genius, cede the author's tendency to ramble. Matthiessen writes: "At the time of Melville's death, Richard Henry Stoddard, one of [Melville's] few professed defenders, felt obliged to state that 'his vocabulary was large, fluent, eloquent, but it was excessive, inaccurate, and unliterary.'"[11] Matthiessen goes on to explain Melville's way with words as a careful negotiation of standards of propriety. When he was unable to use the *best* word, for fear of leaning too much into obscenity, Melville used a wordy substitute instead—as in the following tap dance around the word *sodomy* (which Matthiessen cannot quite bring himself to name either, except by citing Melville's wordy evasion): "The sins for which the cities of the plain were overthrown still linger in some of these wood-walled Gomorrahs of the deep."[12] Perhaps the most athletic writing around a word in *Moby-Dick* is the chapter "The Cassock," which follows "A Squeeze of the Hand" and is devoted exclusively to the whale's penis (note

the sequence of chapters—from bowel, to hand, to dick).[13] The whale dick is referred to only as "a very strange, enigmatical object," "not the wondrous cistern of the whale's huge head; not the prodigy of his unhinged jaw; not the miracle of his symmetrical tail; none of these would so surprise you, as half a glimpse of that unaccountable cone,—longer than a Kentukian is tall, nigh a foot in diameter at the base, and jet-black as Yojo, the ebony idol of Queequeg" (350–51). We have met Yojo, the phallic fetish, before. In the opening chapters, Ishmael watches with fascination as Queequeg makes offerings to "his Congo idol . . . exactly the color of a three days' old Congo baby"(30). This reference to Queequeg's idol halts the list of things the "enigmatical object" is like and *not* like, effectively anchoring the enigma of the object in Queequeg himself or, more precisely, in his Africanized ebony appendage (Queequeg is Polynesian). The ship's "mincer," Ishmael goes on to explain, makes off with the unnamed "grandisimuss, as the mariners call it, and with bowed shoulders, staggers off with it as if . . . carrying a dead comrade from the field." He skins the giant penis "as an African hunter the pelt of a boa," stretches the skin, dries it, and then, in a minstrel consummation of the novel's fantasy of contact, assimilation, and identification, the mincer lops off the tip, cuts two holes in the sides for his arms, and "lengthwise slips himself bodily into it," wearing the black whale dick's skin as an "archbishoprick" would a cassock (or Marlene Dietrich an ape costume). Soberly "arrayed in decent black," Melville visually pairs black dick and book as the mincer-cum-priest (now the color of "Yojo") shaves the blubber into "sheets" as fine as "bible leaves"[14] (351).

The outrageous subject of "The Cassock" raises what must be one of the most popular questions asked of the book: does the "dick" in *Moby-Dick* mean *"dick"*? Not that it matters much now, but, among other things, in the nineteenth-century "dick" worked as an abbreviation for "dictionary" ("dic" still works this way in French) and as slang for a person's excessive use of "fine language, long words." A man was "said to have 'swallowed the dick'" if he used "fine words without much judgment."[15] This happy accident of etymology underscores the book's ontological troubles: Is *Moby-Dick* a book or a body? Is there a difference between the two? Is a body something we read? Or is it something we eat, as would Queequeg, "the cannibal," who will eat anything? As the ship's mincer slips into the whale's black foreskin and shaves off paper-thin sheets of blubber, Melville renders the theatrics surrounding white lust for blackness as a metonymic thrust into the book's pages. He renders that scene (white appropriation of the black body) as a textual wormhole, tying book to body and back again. If anyone has "swallowed the dick," it's Ishmael. In the long delay between actual encounters with whales (most of which are not the long-promised Moby-Dick), he schools the reader in the history and lore of the animal at the heart of his and Captain Ahab's obsessions. Nearly every attempt at capturing the whale in prose is prefaced by a meditation on the impossibility of adequately representing the whale's glory. In his lengthy treatise on "Fossil Whales," for instance, Ishmael stretches the limit of his vocabulary:

> Having already described him out in most of his present habitory and anatomi-
> cal peculiarities, it now remains to magnify him in an archeological, fossilifer-
> ous, and antediluvian point of view. Applied to any other creature than the
> Leviathan—to an ant or a flea—such portly terms might justly be deemed un-
> warrantably grandiloquent. But when Leviathan is the text, the case is altered.
> Fain am I to stagger to this enterprise under the weightiest words of the diction-
> ary. And here it be said, that whenever it has been convenient to consult one in
> the course of these dissertations, I have invariably used a huge quarto edition of
> Johnson, expressly purchased for that purpose; because that famous lexicogra-
> pher's uncommon personal bulk more fitted him to compile a lexicon to be used
> by a whale author like me. (379)

The very funny confusion of the size of the sperm whale with the size of
Johnson's dictionary, and the size of Dr. Johnson himself, typifies the mad
knots in Ishmael's frenzied prattle about whales, bodies, and books. Ishmael
tells us at every turn that we cannot comprehend the whale's body and that he
cannot bring the reader into direct contact with the whale ("any way you may
look at it, you must needs conclude that the great Leviathan is that one creature
in the world which must remain unpainted to the last"). He presumes that to
write of the whale one must, in essence, be like the whale—a cetological iden-
tification carried out in the phrase "a whale author like me." Does he mean a
man who writes about whales? Or a man like whales who writes?

The substitution of man for whale continues as Ishmael describes the magni-
tude of his affection for his subject with a terrific passion:

> One often hears of writers that rise and swell with their subject, though it may
> seem an ordinary one. How then with me, writing of this Leviathan? . . . Give
> me a condor's quill! Give me Vesuvius's crater for an inkstand! Friends, hold my
> arms! For in the mere act of penning my thoughts of this Leviathan, they weary
> me, and make me faint with their outreaching comprehensiveness of sweep, as
> if to include the whole circle of sciences, and all the generations of whales, and
> men, and mastodons, past, present, and to come. . . . Such, and so magnifying,
> is the virtue of a large and liberal theme! We expand to its bulk. To produce a
> mighty book, you must choose a mighty theme. (379)

This passage is typical. When one weighs the size of *Moby-Dick* (the book)
against statements like "the virtue of a large and liberal theme" is that "we
expand to its bulk," and "to produce a mighty book, you must choose a mighty
theme," it seems as if Ishmael or, rather, Melville takes this literally: to write a
big book you must choose a big subject. If you choose a big subject you must
write a big book. The very idea of this correspondence between body and book
gets Ishmael excited: "Hold my arms," he cries as if he might leap into the
whale's body to possess it himself (something that actually does happen, in a
sense, as Tashtego, one of the Pequod shipmates, falls into a whale's head and
reemerges like a newborn from the oily mass). And at this moment of height-
ened, swollen excitement, Ishmael dives into the dull. Without segue, he offers
us proof of his qualifications as a geologist:

> Ere entering upon the subject of Fossil Whales, I present my credentials as a ge-
> ologist, by stating that in my miscellaneous time I have been a stone-mason, and
> also a great digger of ditches, canals and wells, wine-vaults. Likewise, by way
> of preliminary [not that there is anything *preliminary* to a sentence that occurs
> in chapter 104!] I desire to remind the reader, that while in the earlier geologi-
> cal strata there are found the fossils of monsters now almost completely extinct;
> the subsequent relics discovered in what are called the Tertiary formations seem
> connecting, or at any rate intercepted links, between the antechronica creatures,
> and those whose remote posterity are said to have entered the Ark; all the Fossil
> Whales hitherto discovered belong to the Tertiary period, which is the last pre-
> ceding the superficial formations. (379)

Ishmael goes on. He plunges into a relentless explanation of whale fossils and then, in the next chapter, he tackles the pressing question: have whales over the millennia diminished in size or are they getting bigger? In fits of ecstasy Ishmael picks apart whales with the excitement of the man who forgets that one person's passion may instigate another person's boredom. This is what talking to a person with an obsession is sometimes like—as their excitement grows, our interest in the conversation dwindles.

This is, in essence, an excessive take on the attention to detail that marks the realist impulse of much nineteenth-century literature. Although grounded in Ishmael's attempts to visually conjure the whale, this digressive impulse takes on a life of its own and threatens to undo the novel's unity.[16] The danger of the detail, Naomi Schor writes, resides in its power to upend "the delicate balance of the autonomy of the part and the unity of the whole" and reveal the artificiality of the model of the novel as an organic unit, complete in itself. The scandalousness of Roland Barthes's arguments on behalf of the superfluous detail (in his essay "The Reality Effect") therefore lies, Schor writes, in Barthes's direct challenge to "the legitimacy of the organic model of literary interpretation, according to which all details—no matter how aberrant their initial appearance—can, indeed must be integrated into the whole, since the work of art is itself organically constituted."[17] This is formally mirrored in Melville's novel by the alignment of Ishmael's catalog of whale detail with the action of pulling the whale apart. Chapters like "Cistern and Buckets," "The Whale as a Dish," "Pitchpoling," "The Tail," "The Crotch," "The Spirit Spout" work in an encyclopedic direction and with a surgical intensity. The detail of Ishmael's frenzied assessments of the whale are therefore more evocative of the Marquis de Sade than, say, Henry James or Gustave Flaubert. Which is to say that they require a different sort of attention. Sade's "stories," Georges Bataille writes, "are full of measurements; often the length of the penis is given, in inches and twelfths; sometimes a partner will measure it during the orgy. The characters' speeches are . . . paradoxical. . . . Their violence lacks a certain authenticity, but at the cost of their slow ponderousness de Sade manages at last to bring to violence an awareness that permits him to talk about his own delirium as if it

were an external object."[18] *Moby-Dick* is Sadeian in its coupling of the excitement with the excess of detail, *and* the boredom of such recitations.[19]

Here, in the collapse of description and desire, the novel approximates the representational knots of pornography. Attempts to define pornography, for example, are uniquely destined to fail by becoming an example of the very thing defined.[20] There is no catalog of pornography, no legislation of pornography that is not pornographic in and of itself. The predicament of those who attempt to define pornography as a discrete category, argues Susan Stewart, is the "impossibility of describing desire without generating desire; the impossibility of separating form from content within the process of sublimation; and, most importantly, the impossibility of constructing a meta-discourse of pornography once we recognize the interested nature of all discursive practices."[21] To recast this last point of Stewart's as a hypothesis: it is not only impossible to describe desire without generating desire, it is perhaps impossible to *describe* without generating desire. The act of taking interest in any object undermines the subject's difference from that object.[22] This "representational collapse," as Frances Ferguson describes it, is the event-horizon of writing about pornography.[23] Catharine MacKinnon argues, therefore, that pornography is not *about* sex: "It is used as sex. It therefore *is* sex."[24] (In other words, in thinking about sex, we always seem to end up in Kusama's boat.)

Despite the yards of shelf space devoted to its theorization, pornography is not often explored in terms of form. The feminist film theorist Linda Williams, in her book *Hard Core: Power, Pleasure, and the "Frenzy of the Visible,"* entertains the idea that pornography might have formal signatures and describes the kind of narrative disintegration around detail we find in *Moby-Dick*. Writing of hard-core stag films, she observes that "the rule seems to be this: a narrative . . . that [is] already rudimentary [becomes] primitive during [its] hard-core sequences."[25] Williams goes on to explain hard core's filmic primitivism as the formal refusal to absorb its characteristic close-up into a cause-effect narrative. "It is as if, having mastered the limit degree of narrative technique necessary to bring the hard-core genital action into focus for the spectator, the stag film was then content to offer up these details as so many discontinuous spectacles, each shot being, we are to infer, a good enough show in itself."[26] A distinguishing feature of hard-core films, and of pornography more broadly, is that it enacts a violence against the whole: to appreciate hard core as such, you must enjoy its bits and pieces as bits and pieces. There is, in this sense, a harmony between the violence some imagine porn as acting on the body and the violence of pornographic consumption to the status of the text as a work of art. Among pornography's offenses we find the independence of its potential to be sexually exciting (in parts, as parts), from its value as a whole. In a novel like Melville's, the literary version of hard core's close-up is not only loosened from narrative's grip, it is also free of pornography's genital imperative. Ishmael's passion for detail, for little facts and odd anecdotes, has its own momentum.

The Erotics of Reading (Our Books, Our Bodies, Our Selves)

The question remains as to why an overidentification of the book with the body (be it the whale's, Ishmael's, or our own) would coincide with the pornographic turn, and why, furthermore, we also encounter boredom at this intersection. Sharon Cameron takes up the literal identification of man with whale in her explanation of the social construction of the body in *Moby-Dick*.[27] She delineates the most pressing questions asked in Melville's book: "Why am I not identical to the world?" and "why am I not identical to myself?" Melville, she writes, "poses questions of identity in emphatically physical terms, asking: can things be taken literally? Can they be taken bodily? What would it mean so to take them? Differently put, then, the novel's tension is between the spirit and the letter, one exegetical in its focus, the other affixed to the bodily thing itself. The novel dramatizes a return to the letter, to the literalization that kills."[28] For Cameron, *Moby-Dick* is preoccupied with the problem of having a body, a problem expressed, in the novel, in the circuit of identifications between Ahab, Ishmael, the other shipmates, the ship, and the whale. This problem is both expressed and resolved by Ahab's death (he ends up bound to the whale). The outcome of the novel, in other words, structures Cameron's association of literalization, of hermeneutical collapse, with death. But that association of literalization, thingness, with death works best if we allow the end of the book to determine how we understand the entire novel.[29]

What happens, however, when we pull this circuit apart to allow a place for the reader, or the book as a thing in itself? Does becoming a thing like a book always mean death?

Angela Carter's exploration of the poetics and politics of the Marquis de Sade's writings (in *The Sadeian Woman and the Ideology of Pornography*) suggests other possibilities. When reading successfully for porn, the book feels like a body for all the ways it acts on your body. In the exchange between text and porn consumer the material of the work (paint, canvas, ink, paper) seems to disappear, calling out as hypocrisy the fantasy of the pleasures of aesthetic experience as independent of the pleasures of the body in the world at large. In pornographic writing, Carter argues, the author must "suppress the metaphor as much as he can and leave us with a handful of empty words."[30] The point is not to render words transparent but to render their thingness, to make them palpable as objects of desire, and, in doing so, the pornographer brings writing closer to *being*—the pornographer, in getting so close to content, becomes a formalist. "Pornographic writing," Carter continues, "retains this in common with all literature—that it turns flesh into word. This is the real transformation the text performs upon libidinous fantasy."[31] Because *Moby-Dick,* as a book, is fascinated by the idea of "turning flesh into word," by the range of ways we might imagine that happening—literalization, objectification, appropriation, identification—it works up a heightened awareness of what we might call "the pornographic turn" as a latent possibility in all acts of reading.

To complicate matters further, Melville often stages this turn—the turning of body into book, book into body—around the encounter with the racialized other. Looking back (in terms of this narrative), we might think of the porno-graphic photograph advertising Moby Dick, the porn star, as a lubricious echo of Ishmael's studious interest in the skin of the other: the novel's narrator stares endlessly at the skin of his Polynesian roommate while inventorying the embod-ied details of his darker-complexioned tattooed companion.

> This tattooing had been the work of a departed prophet and seer of his island, who, by those hieroglyphic marks, had written out on his body a complete theory of the heavens and the earth, and a mystical treatise on the art of attain-ing truth; so that Queequeg in his own proper person was a riddle to unfold; a wondrous work in one volume; but whose mysteries not even himself could read, though his own live heart beat against them; and these mysteries were therefore destined in the end to moulder away with the living parchment whereon they were inscribed, and so be unsolved to the last.[32] (399)

Under the cover of studying this "wondrous work in one volume" (a book-in-flesh that, in the end, turns out to be impossible to understand) Ishmael cuddles up close to the object of his interest. Maybe the producers of *Moby Dick* (the dirty movie) wanted to pornographically rewrite the erotic tensions of the novel, in which disinterested appreciation takes on the aspects of the porno-graphic gaze that looks on the body as though it were a slab of meat whose measure needs taking. In which, under cover of anthropological fascination, the white subject takes visual possession of the black body.[33]

The often-cited "marriage" between Queequeg and Ishmael is preceded by a sketch of just this sort of scene, in which the thingness of a book conducts an erotic tenderness, creating a space for cross-racial contact and intimacy. Their "wedding" takes place after Ishmael finds Queequeg, the "clean, comely looking cannibal" "counting the pages" of "a large book . . . with deliberate regulari-ty; at every fiftieth page . . . stopping a moment, looking vacantly around him, and giving utterance to a long-drawn gurgling whistle of astonishment" (31). Queequeg is excited by the book as an object. As Ishmael watches his room-mate scan the book's pages and marvel at its size and heft (at exactly the things that normally disappear when we read), Ishmael similarly "scans" Queequeg, exploring his partner's visual aspect and attempting to read, in essence, his body: "Through all his unearthly tattooings, I thought I saw traces of a simple honest heart; and in his large, deep eyes, fiery black and bold, there seemed to-kens of a spirit that would dare a thousand devils. . . . Whether it was, too, that his head being shaved, his forehead was drawn out in freer and brighter relief, and looked more expansive than it otherwise would, this I will not venture to decide; but certain it was his head was phrenologically an excellent one." As he reads Queequeg reading and imagines how Queequeg's head might feel under his fingertips, Ishmael is thoroughly seduced by the picture of the "cannibal" "counting the pages" of "a large book" (52). This romantic triangle (white

man, book, black man) delineates an erotics of racialized literary seduction—the fungibility of Queequeg's body, its capacity to pass into narrative without entirely disappearing, draws Ishmael in. Frantz Fanon recalls, "in any group of young men in the Antilles, the one who expresses himself well, who has mastered the language, is inordinately feared; keep an eye on that one, he is almost white. In France one says, 'He talks like a book.' In Martinique, 'He talks like a white man.'"[34] In this instance, however, we have the racialized subject not talking like a book but becoming a book. The encounter with racial otherness is aligned with inscrutability and with the provocation of the desire to read.

Unlike Queequeg, whose wonder at the book is rooted in its placid silence, Ishmael, as a reader, wants to interpret rather than look at and feel his text. Or, at least, Ishmael's drive to read is his pretext for intimacy with the other. He scrutinizes Queequeg's body from the moment they first meet, spying on his roommate when he first enters their room: "What a sight! Such a face! It was of a dark, purplish, yellow color, here and there stuck over with large, blackish looking squares. . . . he's been in a fight, got dreadfully cut. . . . But at that moment . . . I plainly saw . . . those black squares on his cheeks. They were stains of some sort" (28). He gets stuck on Queequeg's skin color: "But what to make of his unearthly complexion, that part of it, I mean, lying round about, and completely independent of the tattooing. To be sure, it might be nothing but a good coat of tropical tattooing, but I never heard of a hot sun's tanning a white man into a purplish one" (29). "I now screwed my eyes hard towards the half-hidden image" (30). With his eyes Ishmael traces Queequeg's tattoos and ruminates on the mystery of his Polynesian pal, imagining that he can see *through* the tattoos, to Queequeg's heart and soul. It is a dramatically different perspective on what Henry Louis Gates Jr. described as the "trope of the Talking Book," a primary scene in African American literature in which the black subject watches the white reader reading and acquires, from his attempt to inhabit the same position before the book, a consciousness of the link between literacy, privilege, and whiteness. Gates cites the following passage from an eighteenth-century slave narrative: "When I first saw him read, I was never so surprised in my life, as when I saw the book talk to my master, for I thought it did, as I observed him to look upon it, and move his lips."[35] Attempting to inhabit the reader's position, the black narrator approaches the book: "I followed him to the place where he put the book, being mightily delighted with it, and when nobody saw me, I opened it, and put my ear close down to it, in great hopes that it would say something to me; but I was very sorry, and greatly disappointed, when I found that it would not speak. This thought immediately presented itself to me, that every body and every thing despised me because I was black." The book, Gates writes, is here figured as "a silent primary text . . . in which the black man found no echo of his own voice." The difference between the text's loquacity and its silence appears to the narrator as "the very blackness of silence," a demoralizing collapse that Gates reads as a substitution of "the oral and the visual—the book refused to speak to me because my face was black."[36]

And, given the violence with which black literacy is policed, this misrecognition of forms is, really, a terrifying recognition of a social and historical truth.

Melville (who never shied away from the most overdetermined sites within the racist American imaginary) reconfigures this scene, placing Ishmael in the position of the white spectator to the scene of the colonial other holding a book in his hands (we might also take this as a queer reproduction of the representational geometry of the scene of black reading in American literature, often staged for the benefit of a circumspect, but thrilled, Anglo audience).[37] In a metonymic slip, Queequeg's body becomes the "talking book," albeit one that refuses to talk to Ishmael.

Queequeg, crucially, puts an end to Ishmael's tension with a touch. Ishmael draws up a bench and explains the "purpose of the printing." They share a pipe. Then, Ishmael explains, Queequeg "pressed his forehead against mine, clasped me around the waist, and said thenceforth we were married" (53). The "purpose of the printing" in this scene is not to narrate but to offer the occasion for touch. The particular form of touching described here, the pressing of foreheads, is, as Michael Lynch so elegantly reminded us, the quintessential expression of the nineteenth-century category of affection known as "adhesiveness"—a loving, erotic coupling between male friends.[38] This touch initiates Ishmael into a more intimate partnership with his bedmate, and so, like "Man and wife," they lay "open the very bottom of their souls to each other" like some "old couples [who] often lie and chat over old times till nearly morning. Thus, then, in our heart's honeymoon, lay I and Queequeg—a cosy, loving pair" (54). Perhaps a more appropriate (although anachronistic) point of reference for this representation of the limits and possibilities of the racialized erotics of reading is Frank O'Hara's practice of "personism," a movement "founded by me," he explains in his manifesto, "after lunch with LeRoi Jones on August 27, 1959, a day in which I was in love with someone (not Roi, by the way, a blond). I went back to work and wrote a poem for this person. While I was writing it I was realizing that if I wanted to I could use the telephone instead of writing the poem, and so Personism was born. It's a very exciting movement which will undoubtedly have lots of adherents. It puts the poem squarely between the poet and the person, Lucky Pierre style, and the poem is correspondingly gratified."[39] In imagining his poem in between himself and his reader, in imagining this as an act of love, and in imagining the poem as itself a body that might be doubly gratified by this position, O'Hara describes what is, in essence, a pornographic turn: the hallmarks (and perceived hazard) of porn are, on the one hand, its ability to dissolve its textuality into a sex act (as if, following MacKinnon, getting off to porn is the same thing is getting off in the space of the sex act imagined in porn) and, on the other, its ability to make a representational artifact (a book, a magazine) into a workable substitute for a body. On the first point, Michael Moon observes that "we are accustomed to thinking of . . . the kind of writing that negates itself in the process of producing some kind of sexual connection between the reader and author and/or

between the reader and text as pornography."[40] The urge to maintain the difference between books and bodies is a main ingredient in anxious discourse on pornography and representation—and this is the second set of problems posed by the pornographic. A defining aspect of the modern (legal) distinction between obscenity and art lies in the perception of the pornographic text as having no value—no textual density, no instructive purpose—other than a sexual one. *That* value is in turn negated because porn substitutes a text for "the real thing"—a penetrative, and reproductive, encounter between two live, white, and differently sexed bodies. Where in conservative discourse pornography is opposed to "real" sex, as a fraudulent (mediated) version of "the real thing," Moon finds that "what the works of . . . aggressively 'queer' writers suggest is that all sexuality resides 'in touch,' that all sexuality is mediated and textual, that there is no such thing as unmediated exchange between persons, including unmediated sexual exchange."[41] Thus the ease of the transfer of readerly attention in Melville from the book to the body and back again, and the slide from reading lesson to pillow talk.

Moby-Dick asks us to take the book off of its representational hinges, to touch it as Queequeg touches his book, and as Ishmael touches Queequeg. Does it also ask us, though, to use Queequeg's body as the conduit for an attachment to writing, in the same way that LeRoi Jones's black body bears witness to the birth of O'Hara's Personism, only to be banished as "not blond," as the route but not quite the destiny of O'Hara's desire? (Of course, we might read O'Hara's manifesto as a defense against—and testimony to—Jones's mythic charm, which had much of New York, gay and straight, at his feet.)

Melville and O'Hara's writings share, at the very least, not a desire for unmediated connection but the excitement of mediation as the very domain in which desire unfolds. This is, perhaps, one of the environmental conditions that makes porn an especially friendly space for boundary-crossing fantasies—for queer sex, for imagined (and actual) cross-class and cross-racial sexual contact.[42] The pornographic is an allegorical hothouse. And what burns in American writing hotter than cross-racial desire? What body most embodies the pleasures and dangers of becoming an object?

Sex, Sodomy, and Scandal Art and Undress in the Work of Thomas Eakins

THOMAS EAKINS spent the better part of his career embroiled in scandal. His paintings sparked controversy and his relationship to the art establishment was embattled, to say the least. His teaching practices were unconventional, even revolutionary, for the time. He was a magnet for sex scandals. This chapter explores the conflicts around art and desire that shape at least two aspects of these scandals: his interest in the nude and his pedagogic strategy, and his work itself, specifically the painting *The Gross Clinic*.

When Eakins submitted *The Gross Clinic* to the 1876 Centennial Exposition in Philadelphia, it was rejected: it was too gruesome, critics argued, to be accepted as a work of art.[1] About ten years later a colleague, Edward Coates, commissioned a work from Eakins. The artist's offering, *The Swimming Hole,* was declined on the argument that it was too aggressive in its display of naked men, easily recognizable as Eakins and his students at the Pennsylvania Academy of the Fine Arts where he taught and where the painting was to be exhibited. On the heels of that incident, amid complaints about his practice of teaching life drawing to women using naked models as well as rumors about his sex life, Eakins was forced to resign from the Academy. Nearly ten years after his resignation, in the 1890s, he was again associated with scandal. This time he was blamed for the suicide of his niece Ella, who had studied with him. Her parents accused Eakins of fostering the promiscuous atmosphere in his classroom and in his home that may have led to her insanity; her sister told people that Eakins drove Ella mad by introducing her to "sexual excitements in the manner of Oscar Wilde."[2]

The complaints against the founder of realism in American painting included

objections to his insistence on using naked models of both sexes in life-drawing classes (even with women students), disapproval of the sexual politics of his circle (which favored treating men and women the same), and less formal, less coherent but certainly powerful accusations of sodomy and incest. Critical and institutional rejection of his work framed the complaints about his pedagogy and his character.

Today, Eakins is often thought of as a maverick underappreciated by his ill-informed contemporaries. In much writing on him, we get the impression that the troubles he encountered with the public and his colleagues were the

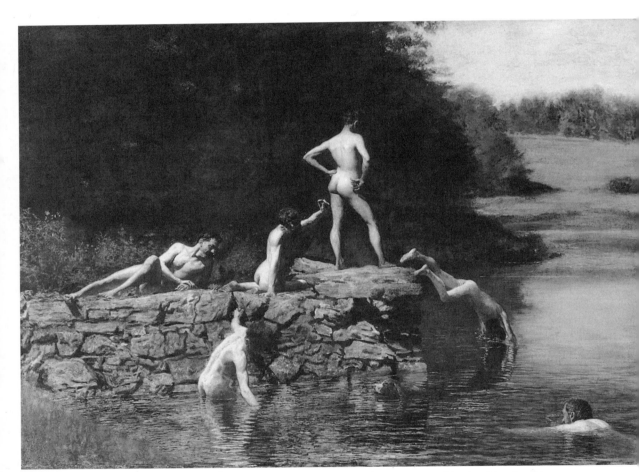

Figure 2. Thomas Eakins, *Swimming (The Swimming Hole),* 1885. Purchased by the Friends of Art, Fort Worth Art Association, 1925; acquired by the Amon Carter Museum, 1990, from the Modern Art Museum of Fort Worth through grants and donations from the Amon G. Carter Foundation, the Sid W. Richardson Foundation, the Anne Burnett and Charles Tandy Foundation, Capital Cities/ABC Foundation, Fort Worth Star-Telegram, the R. D. and Joan Dale Hubbard Foundation, and the people of Fort Worth.

result of their prudery. We like to think that we are more enlightened than his Victorian colleagues and that we would be more accepting of his methods: where they saw sexual corruption, we see, as one critic put it, "Eros. Not sex."[3] How many of us, though, would really be comfortable hanging, in our offices, a painting like *The Swimming Hole,* executed by a colleague who appeared in the painting along with a number of his and our own students, all naked, of the same sex, and suggestively posed?[4]

With the cultural anxieties that swirl around sex and the workplace, never mind homosexuality and pederasty, not many would be inclined to openly and unambivalently support a project that involved, as did *The Swimming Hole,* a teacher spending an afternoon taking photographs of himself naked with students. Furthermore, how many of us can honestly say that we are sure enough of the boundary that protects student-teacher relationships to spend an afternoon naked with our students—and take pictures, and show them to our colleagues— and believe that we would keep our posts?

The Case of "The Gross Clinic"

The Gross Clinic has long anchored the art-historical portrait of Eakins as the great observer himself unmoved by emotion, even as he confronted his audience with violent spectacles (like a surgery) or with close attention to the naked body. An homage to the surgeon Dr. Samuel Gross, the painting depicts a surgery in process. The path of least resistance has been to see Eakins's portrait of Dr. Gross as a symbolic assertion of his own powers as an artist. Just as Gross helped convert surgery from a disreputable practice associated with the sawing off of diseased limbs into an enlightened, noble, and healing profession, so Eakins brought a faith in empirical observation and an aura of professionalism to the practice of painting.

This painting was the first and perhaps most paradigmatic challenge Eakins offered to the spectator's comfort zone in the name of realism. *The Gross Clinic* appears to literalize the association of realism with gore. The canvas is cluttered, bloody, and melodramatic. In the words of one of its early reviewers, it is "decidedly unpleasant and sickeningly real in all its gory detail."[5] The ostensible subject of the painting is Dr. Gross, but it is the body under the knife that draws our eyes. It is the heart of the canvas, and almost everyone in the painting looks at this body that is, however, largely hidden from our view. The only part of it that we see clearly is the bloody surgical wound. The patient's body is cut open and bleeds from a vagina-like gash on the thigh. Assistants lean in and stretch the wound wide, poking and prodding to give their eyes full access to what lies inside. Our perspective, however, is less intimate. The patient's feet are foregrounded. From there we can trace the calves, thigh, backside, hips. The rest of the body, however, is cut off from our view. Because of this, *The Gross Clinic* is often described as a "puzzle," requiring a guide to explain that

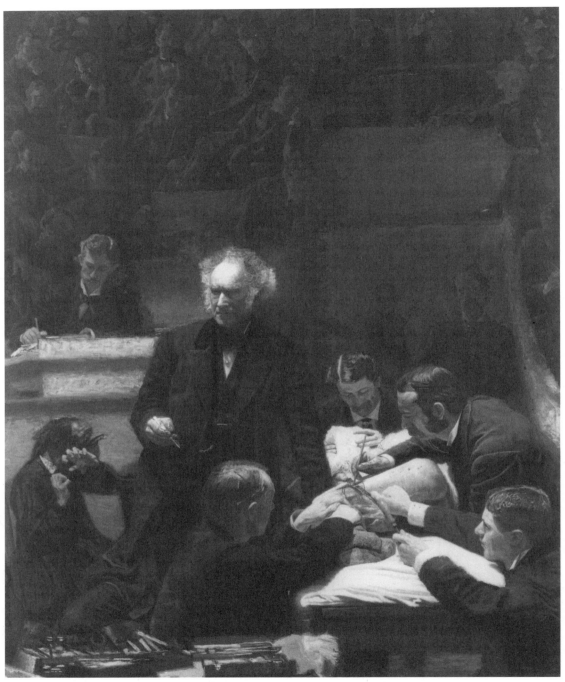

Figure 3. Thomas Eakins, *The Gross Clinic*, 1873. Courtesy of Jefferson Medical College of Thomas Jefferson University, Philadelphia.

the wound is on a thigh and that the body is in a sense both backward and upside down.

Until recently, it was the habit of Eakins scholars to cite accuracy in defense of the painting's confusing composition and the aggressive presentation of the bloody instruments of surgery and the surgical wound. The assumption had been that the people who were made uneasy by the painting were naive or ill-informed. The difficulty of *The Gross Clinic* was attributed to Eakins's unflinching gaze that required that he paint what he saw as he saw it. This, however, does not help us make sense of the painting's tremendous affective power. Why pin an assertion of realism to confusion, dismay, or shock? Michael Fried offered the most economical correction to the evaluation of *The Gross Clinic*'s realism in terms of its verisimilitude. In general, he writes, reception of the painting privileged an original scene that Eakins transcribed; its "realism," in this view, "represents with something approaching total fidelity the painter's perception of an original, actual situation, from which the further conclusion is drawn that any features of the painting that are at all unusual have their rationale in the specifics of that situation and in the emphases and limitations inherent in the painter's point of view."[6] The painting appears crowded because the surgical theater *was* crowded. We cannot see much of the patient because Eakins could not. We see blood because Eakins saw blood. This approach, Fried argues, is built around a metalepsis—the confusion of "effect with cause—the only evidence we have of that original situation and determining point of view is the painting itself which therefore can't be taken to establish the priority of either."[7] Those who assess the painting in terms of its veracity are, in essence, so thoroughly seduced by the painting's fantasies of origin that they are unable to step outside its internal aesthetic ideology, which imagines the artist as unmoved by the spectacular scene that he transcribes with a near-mechanical accuracy. The sense that the painting is a record of an original scene, now lost, and the desire to reconstruct that lost point of reference are realism's definitive effects. In developing this redefinition of realism, Fried changes the question we ask of *The Gross Clinic* from "What are the sources for the painting?" to "What kind of effect does the painting create in the spectator?"

Each time I look at *The Gross Clinic* I am struck by the juxtaposition of the serene postures of the men working on the patient, the hysterical posture of the woman, and the inscrutability of the patient. Naked and exposed, the patient's body is extremely vulnerable, but, because it is presented to us from behind, the body is also not entirely available to the spectator's inquiring gaze. Few have explored this most interesting element of the tableau in depth: despite its aggressive presentation, the patient's body remains not only anonymous but androgynous as well. The gender ambiguity of the patient sets *The Gross Clinic* apart from Eakins's other works and even makes it fairly unique within art history. We often debate *how* an artist establishes the gender of a figure, but rarely *if* the artist has done so. At the center of *The Gross Clinic*, a painting whose

difficulty, whose confusion and clutter have been taken to be the hallmarks of its realism, is a body so strangely positioned that it is without a discernible gender.[8] Of the patient's "bony posterior," Fried writes, for example, that it "raises but conspicuously fails to answer the question of the body's gender."[9] That ambiguity is a crucial starting point for thinking critically about the sex politics of Eakins's art, art-making practices, and his place within art history.

As I started writing about Eakins, I was surprised, given the amount of scholarship on this painting, that the patient's gender had not really been recognized as a major problem.[10] On closer examination, one finds that the gender ambiguity is only one of a series of conundrums Eakins poses to contemporary sexuality studies. A critical tradition and an accompanying set of assumptions about Eakins and *The Gross Clinic* have facilitated the elision of the patient's ambiguous sex in treatments of this painting. The patient is usually read as male because there is evidence that Eakins attended a similar surgery performed on a young man.[11] This is, however, not the only reason the body's gender has been treated as a given. Also compelling as an explanation for why this assumption has worked for so long is the status of the painting in Eakins's oeuvre as an allegorical assertion of his powers as an artist, a status that has, in turn, been pinned to discourse about Eakins's masculinity. *The Gross Clinic* is the first in a group of celebrations of the seriousness of the artist's work. *The Agnew Clinic* (1889), for example, similarly draws an equation between the artist's work and the surgeon's. The two versions of *William Rush Carving His Allegorical Figure of the Schuylkill River* (1877, 1908) explore different approaches to the artist's respectability. The first imagines Rush as a noble craftsman and pictures him as absorbed by the demanding and meticulous work of sculpting. The second recasts the artist as a working man, drawing on American celebrations of the nobility of labor to, perhaps, inoculate the artist against the perception that the enterprise of art making was a feminizing one. Together with the portraits of Agnew and Rush, *The Gross Clinic* established Eakins as an artist who linked, in the words of Leo Steinberg, "art with Work, and with work conceived as its own reward." These paintings, Steinberg writes, represent "a manful attempt to silence the American objection to art and undress by assimilating both to an ethic of work."[12] In so celebrating Eakins's work as "manful," Steinberg in fact recycles the dominant perspective on Eakins's importance as an American artist. His work has been explicitly valued as masculine as early as the turn of the century.[13] There are (at least) two elements of Eakins's work, however, that complicate this portrait of him as the quintessential "manful" American painter. The first is that the discourse that supports the appropriation of Eakins as the father of American realism and as a paragon of creative masculinity has a conflicted relationship to the homoeroticism of Eakins's work, the sexual politics of his community, and the importance of Eakins's work to gay and lesbian studies in art history.[14] The second, which I will hold in reserve for the moment, is that none of the above-mentioned paint-

ings (and especially *The Gross Clinic*) offer an easy, or even coherent, perspective on the subject of gender difference.

Scholars interested in the homoeroticism of Eakins's work have faced a number of problems. For a long time there was a lack of critical discussion of the place of homoeroticism in his (or, for that matter, any artist's) work. In combating this kind of silence, the temptation has been to decode his oeuvre using psychoanalytic tools, to discuss sexuality as if it were the hidden subject of his paintings and photography—to discover in *The Swimming Hole* the structure of a homosexual fantasy (as Whitney Davis argues) or, in the case of *The Gross Clinic*, the hysterical fantasy of a repressed homosexual (as Fried suggests). Because critics interested in Eakins's work have largely processed sexuality through the gay/straight opposition, they have avoided drawing attention to the sex scandals that dogged him for most of his career. As most of the scandals centered on his relationships with women, they appear on the surface to be at best only marginally related to the topics of homoeroticism and masculinity. In any case, making the homoerotics of his art the subject of critical attention is risky and difficult enough without engaging the scandals that clung to Eakins's relationships with his students. The acknowledgment of the homoeroticism of his work *and* the unsettling stories about his relationships with women, for instance, immediately raise problems such as the prevailing view that a participant in a homoerotic community must necessarily be, on some level, a homosexual or, at least, have homosexual desires—which, when buttressed by rumors of abusive relationships with female students, can set into motion the phobic assumption that any difficulties in this person's relationships with women can be explained by his latent sexual preference for men.

Attempts to decipher Eakins's representations of relationships between men, and between men and women, must struggle with the particularly vexing questions pertaining to the history of sexuality in general, and in the United States in particular. For many of the most interestingly queer figures of the period (Eakins, Melville, and Walt Whitman, for starters), the diacritical axis homo/hetero was neither a compelling nor a reliable means for describing their community or their emotional and libidinal affiliations.[15] It is unlikely that the scrutiny of Eakins's life, work, and personal correspondence will ever satisfyingly and permanently establish any single work of art as the concrete expression of a repressed homosexual identity. (Even if it did, we would still be left with the complex question of his relationships with women, as not only students but as painterly and photographic subjects.) Critics sensitive to the history of sexuality in the United States often find themselves with little or no available vocabulary for analyzing the gender dynamics of work by a figure like Eakins.[16] Elizabeth Johns, for instance, recently wrestled with the apparent incompatibility of modern paradigms of sexuality with nineteenth-century culture in making the observation that "*The Swimming Hole* is most richly interpreted as not preference-specific (that is, as not explicitly homosexual)."[17]

On one level (largely biographical and historical) this makes sense—Eakins's life is not easily legible as a gay one by today's definition. Johns is right to argue that it is more accurate to approach this painting from a different perspective. It is here, however, that we encounter a problem. The kind of caution Johns displays can be taken up in other settings in the service of homophobic impulses to argue that the painting is about "Eros, not sex," as one art critic put it, and that those of us who would like to recover the painting's homoeroticism are, in essence, reading too aggressively in the service of an academic "special interest." In other words, the risk with arguing that it is an anachronism to say Eakins was gay is that we will support desexualizing and degaying his work in every context. Eakins's work, however, in every sense of the word, is infused with the sexual. Even if his oeuvre is not legible as the expression of the sexuality of a gay man (and that is a pretty big "if"), it is shot through with a queerness immediately relevant to gay audiences. It is entirely possible to place Eakins and *The Swimming Hole,* for instance, near the beginning of a homoerotic (and even homosexual) visual tradition in American art. For instance, we could easily link Eakins and his work to an artist like Robert Mapplethorpe and his meticulous portraits of naked black men, or Andy Warhol and his habit of taking Polaroids of the genitals of visitors to his studio, and Warhol films like *Lonesome Cowboys* or *My Hustler* whose spirit of play suggests they are direct descendants of the photographs Eakins took of his students horsing around in the woods. In other words, do we really need to know anything about Eakins's sexuality to assert the homoerotics, and even the gay component, of these works and their relevance to a gay audience? The answer to that question is both no and yes. No, because it is, in fact, insulting to the spectator to say that a photographic study of nude men together has *no* homoerotic element to it. We should be able to assert this aspect of an image regardless of the artist's gender or sexuality. And yes, because politically, the erasure of the *fact* of homoeroticism and homosexuality from the archive is part of a wider homophobic system that would prefer to imagine a world in which homosexuality and homosexuals did not exist—as if the censorship of the historical homosexual will somehow stamp out the homosexual *present.*

That said, instead of/in addition to worrying about the gayness of Eakins's work and what that tells us about his sexual identity—out of a need to anchor queer readings in a historical record of homosexual identity—we might consider how Eakins's work is shaped by, or is in dialogue with, the changing landscape of sexual politics of not only his day but ours. Given that Eakins lived during exactly those years in which a new kind of scrutiny was being applied to the body, it may be the case that his work is very much involved with sorting out the link between sex, gender, and things like art and work. It is the way that Eakins's work and career engaged the particular consequences of having a body at the end of the nineteenth century that makes him an exciting subject for gender criticism. To begin to apply questions about the relationship between

desire, gender, sex, and art to Eakins's textual practices as a painter, however, we need a vocabulary for sexuality based on something besides identity positions like homosexual/heterosexual.

We find an alternative model in a surprising source: the rhetoric used by Eakins's contemporaries to denounce his practices as a teacher and Eakins's own struggle to fend off their attacks on his character. The terms of his ostracization speak directly to the particular character of late-nineteenth-century sexual politics, as they wove together terms like art, virtue, sexual interest, and sodomy. They were not, in other words, overtly defined by a gay/straight distinction.

It is interesting that *The Gross Clinic,* Eakins's first major painting, the painting in his oeuvre perhaps most firmly ensconced in the canon of American art, and the painting perhaps least obviously legible in terms of gender politics, should *most* predict the weird blend of utopianism, homoerotics, proto-feminism, and misogyny of Eakins and his circle. This is only surprising until we remember the near-absolute reliability of the inchoate text to act out the ideological struggles of its moment *as* struggle, as incoherence, as, even, illegibility. The centrality of gender ambiguity to the painting most often looked to as confirmation of Eakins's daring, together with the fact that the complaints made against him were underwritten by a rhetoric of sodomy, as I demonstrate below, suggests that the dynamics of gender and sexuality in Eakins's realism is much more interesting than a triumph of "masculine power" over sentimentalism and the "American objection to art and undress."

Gender Troubles at the Academy

Thomas Eakins studied and touched bodies. He taught drawing and anatomy classes, and required his "professional" students to study anatomy through dissection. But the artist memorialized as cerebral, scientific, and serious in his approach to art was more famous in his day as one who *failed* to resist the slip from neutral observer to impassioned actor. At that moment, studying from living naked models was controversial in the United States (more acceptable was working from plaster casts of classical sculpture). The scientific study of the body through the dissection of cadavers was seen as absolutely antithetical to the aesthetic purposes of high art. Eakins's aggression against these and other codes of conduct for art instruction offered fertile ground for the rumors that ultimately led to his forced resignation from the Pennsylvania Academy in 1886. Publicly, the reason given for his departure was "abuse of authority." This "abuse" included his insistence on using naked models when teaching women students, the use of naked male and female models together, and his students' modeling in the nude for each other. Any of these practices would have been reason enough to dismiss him. From what access we have to the letters and affidavits surrounding his resignation from the Academy, however, it

is clear that his personal morality was as much at issue as his pedagogic strate-
gies. Or, more nearly, the two were so intertwined that once the integrity of one
was at issue, it was inevitable that the other would also come into question.

As touched on above, the most hurtful campaign was led by his brother-in-
law George Stephens (married to Eakins's youngest sister, Caroline). Stephens
spread the stories that upset people enough to require Eakins's expulsion, link-
ing as they did his pedagogic practices with the suggestion of a more deeply
rooted depravity. These rumors were vague (on at least one occasion, Stephens
refused to provide a written account of the charges against Eakins). They
ranged from descriptions of generally immodest behavior (such as walking
around the house in "shirt tails" in front of his nieces and telling indecent
jokes to female students) to incestuous, even "bestial" relations with his niece
Maggie (with whom Eakins had been very close, and who died years before
rumors of this type surfaced).[18]

Almost ten years after his resignation, the stories took on a more sinister
tone with the suggestion that he was responsible for Ella Crowell's insanity and
suicide.[19] In an 1896 letter to Ella's mother, Frances (Eakins's sister), Eakins's
wife, Susan, complained that Ella's sister (Maggie) was facilitating his public
condemnation. Maggie, apparently, was spreading stories of Eakins's abuse of
Ella around the Academy and was in the habit of punctuating these tales with
allusions to the sexual practices of Oscar Wilde, whose 1895 sodomy trial was
still very much alive in the American public imagination: "Maggie is freely
talking at the Academy against her Uncle Tom. The stories are that her sister
Ella's insanity was brought on by the wearing effect of unnatural sexual ex-
citements practiced upon her in the manner of Oscar Wilde. Such stories and
behavior will injure her own reputation as well as Ella's."[20] In this letter the
phrase "sexual excitements . . . in the manner of Oscar Wilde" does not ap-
pear to give the author any pause. That she is not concerned that Fanny will
not "get" the drift of the rumors, and that the stories Maggie spread hinged on
inference, demonstrates a shared understanding of sodomy as a thing not to be
named but as a thing everyone is presumed to understand. Trying to get a han-
dle on the scandals, which were stubbornly inexplicit, would nearly prove to be
Eakins's undoing. "I . . . have upon me," he would write, "more than I might
ever hope to contradict."[21]

As far as I can tell, the term *sodomy* is not used in the correspondence
surrounding the "troubles" (as Eakins and his wife called them). Rather, it
is referenced through allusion and innuendo, as in the reference to bestiality
and Wilde. The latter reference, as Cheryl Leibold points out, invoked sexual
perversion but also, and perhaps equally, "bohemianism." Leibold writes,
"However different in personal style, [Eakins and Wilde] occupied the far
'artistic' fringes of their communities. . . . Relative to local audiences, they
both represented every dangerous, ungodly, immoral, sexually liberal tenet of
aestheticism."[22] The lack of specific charges, and the constant confusion of ar-
tistic, professional, and sexual interests and behaviors, suggests that sodomy,

as that "utterly confused category," may be the most useful term available to us today for making sense of the web of inference in which Eakins was caught. Historically, *sodomy* has been used to describe sex acts that constitute, as Jonathan Goldberg has put it, "violations of social order."[23] It is known to us as "the infamous crime against nature"—the phrase is Blackstone's, but its status as a "crime against nature" was used as a reason for upholding Georgia's antisodomy statute in *Bowers v. Hardwick* (reversed in *Lawrence v. Texas* in 2003). Generally, the term describes nonprocreative sex (oral, anal) with members of either gender, and bestiality (which at times refers to the performance of sex acts with animals, but also, however, as is the case with the term's use in reference to Eakins, it is a stand-in for nonprocreative or illicit sex, such as incest).[24] As Goldberg described it in an overview of current thinking on the term, sodomy is defined not by the sexuality or gender of the participants but by "the diacritical axis of procreative/nonprocreative sex, with its ramifying connections to sociopolitical arrangements" such as the family, the nation-state, and the male bonds and privileges associated with homosocial spaces.[25] It is not reducible "to either a simple or a singular sex crime." More nearly (but much more vaguely), the term is "mobilized in the face of threats to the social order," though it is wielded with terrific discrimination against gay men—in no small part for the way that the possibility of same-sex desire haunts a wide range of social relations between men (fraternal, military, athletic, pedagogic).[26] In these cases, the accusation of sodomy is directed at men who seem to draw attention to an otherwise disavowed eroticism in, or sexual component to, the ties that bind men together. Potentially, the term can also be directed at those who would highlight the political and sexual oppression of women that often lubricates homosocial networks. The sodomite is a scapegoat whose public abjection performs the fetishistic ritual of reassuring an audience of the sanctity, and stability, of a dominant ordering of sex and gender.

As a term used to manage threats to the dominant arrangement in gender relations, sodomy derives some of its force from its flexibility. It was used in the nineteenth century, for instance, to describe the heretical assertion of the primacy of sexual pleasure over the imperative to reproduce (and still resonates today with this most fundamental sin). The suggestion that Eakins engaged in sodomitical relations with the women around him was related to (if not inspired by) his promotion of these women's interests in the body (and in their own bodies) as something other than a mechanism for reproducing the species within the family. His offenses can all be described as challenges to the dominant structure of power relations between men, and between men and women at the Academy. He posited that a woman's nudity was no source of shame; therefore, any woman, even his own students, might model in the nude without putting her integrity at risk (at least in his artistic community). He asserted that a woman had the same visual capacities as a man. Women, Eakins suggested, could handle looking at and studying naked men, even dissecting cadavers, without any jeopardy to either their virtue or their mental stability. This was

not an acceptable hypothesis at the time: it was incomprehensible that a woman could exhibit that kind of control over her emotions—to ask her to conquer her feelings, furthermore, amounted to the demand she overcome femininity itself.

With his own family members offering evidence like Maggie's stories in support of rumors of a personal depravity, Eakins's detractors had little trouble discerning evidence of sexual perversity in his insistence on working from naked models, in his interest in his students (and their interest in him), and in his relationship to painting. The condemnation of Eakins's work as a teacher and as an artist was inextricable from the condemnation of his relationship to sex and from the perception that he failed to maintain the distinction between the professional and the sexual.[27]

Take, for example, one set of complaints made against Eakins in an anonymous letter sent to the Academy by, presumably, a concerned mother. The point of entry into her diatribe is simple enough: the association of respectable women with women who would take off their clothes for money. "Would you be willing to take a young daughter of your own into the Academy Life Class," she asks, "to the study of the *nude figure* of a woman, whom you would shudder to have sit and converse with your daughter?" The problem here is as much the exposure of her daughter to a particular sort of woman as to that woman's nudity. She goes on to reference Eakins's habit of speaking frankly about the models' bodies and the risk that acclimatizing young women to the spectacle of the naked body posed to their virtue:

> Would you be willing to . . . know [your daughter] was sitting there with a dozen others, *studying* a nude figure, while the professor walked around criticizing that nudity, as to her *roundness in this part,* and swell of the muscles in another? That daughter at home had been shielded from every thought that might lead her young mind from the most rigid chastity. . . . yet at the age of eighteen . . . for the culture of *high Art,* she had entered a class where both *male* and female figures stood before her in their horrid nakedness. . . . I know at this time two young ladies of culture, refined families, enthusiastic students of painting, whose parents after . . . assurances that Art could *only be studied* successfully BY ENTERING such a class, consented. . . . They entered, and from their own lips I heard the statements of the terrible shock to their feelings *at first,* how they trembled when the professor came, one stating that she thought she would faint. Her fellow students . . . assured her that she would soon *get over that,* and not mind at all! She persevered, and now "don't mind seeing a naked man or woman in the least." She has learned to consider it the only road to *high Art,* and has become so interested she never sees a fine looking person without thinking what a fine *nude study* they would make! What has become of her *womanly* refinement and delicacy? . . . There is no use in saying that she must look upon the study as she would that of a wooden figure! . . . Living, moving flesh and blood, is not, cannot, be studied thus. The stifling heat of the room, adds to the excitement, and what might be a cool unimpassioned study in a room at 35 degrees, at 85 degrees or even higher is dreadful.[28]

It is noteworthy that one of the few descriptions of what Eakins's classroom *felt* like should come from a protest against it. The sensuous details she offers—the gradual seduction of the students as their modesty breaks down, the depiction of Eakins's interest in the body as a form of connoisseurship, the "stifling heat" of the studio, and the model's naked presence felt as "moving flesh and blood"—remind us that diatribes against sensationalism and obscenity almost always have a prurient value in and of themselves. Although her position is predicated on an extremely conservative view about women's capacities as observers, in which the preservation of their virtue required them to avoid indelicate sights, the author of this letter does describe the basic disavowals of the connection between aesthetic and sexual interest that underwrite "high Art." She names constitutive art-world hypocrisies that Rosalind Krauss formulated as "the denial and self-deception under which the thrill of libidinal possession (is) carried on in the name of disinterested pleasure and ideal beauty."[29] Eakins did stand much closer to the "denial and self-deception" Krauss describes than his accusers: all agreed that the prurient and the aesthetic were antithetical, but his detractors steadfastly refused to accept the possibility that one could look at naked men and women, and discuss the "roundness" of this part or that, without experiencing some sort of sexual excitement.

From his expressed attitude toward the subject of the female nude in painting, and the rarity and caution with which he approached the genre, it is clear that his involvement in and awareness of the contradictions of the artist's studio and art-world culture made it difficult to take the nude as a subject in his own art at all. The image of a naked woman, Eakins wrote, is tightly bound to convention—teasing the woman's sexual presence out from the traditional nude struck him as next to impossible, as seen in his most well-known statement on the subject:

> When a man paints a naked woman he gives her less than poor Nature did. I can conceive of few circumstances wherein I would paint a woman naked, but if I did I would not mutilate her for double the money. She is the most beautiful thing there is—except a naked man, but I never yet saw a study of one exhibited. It would be a godsend to see a fine man painted in a studio with bare walls, alongside the smiling, smirking goddesses of many complexions, amidst the delicious arsenic-green trees and gentle wax flowers and purling streams a-running up and down hills, especially up. I hate affectation.[30]

This conflicted statement is typical of Eakins's feelings about the female body in art—it seemed impossible to him to bring the form of a naked woman into a painting without invoking the cultural baggage of the Nude that goes with it: the representation of the female body as an impenetrable whole, covering up the fact of her sexual difference as if it were shameful; or the collective enjoyment of the spectacle of her nudity without any acknowledgment of the specificity of the female body. The most effective antidote Eakins can imagine is the image of a naked man: "It would be a godsend to see a fine man painted

in a studio with bare walls." If Eakins could have had his way with the exhibitions of the late nineteenth century, frank portraits of male nudity not unlike his photography would have upstaged the sentimentalized and romantic female nudes that populated parlor walls. His photographs of nude men and women are stark and to the point—studies of the body standing, prone, and moving. Eakins complains that when the artist is presented with the female body, too often he turns away from its particularities. The artist instead excises the signs of her sex (genitals, pubic hair, etc.) and paints the "Nude"—a gentle, purified, and, in Eakins's view, sexless version of the naked woman. Eakins suggests that when the artist "gives [the nude] less than poor Nature did" he performs a kind of "mutilation." Though reluctant to take the naked woman as a subject at all, Eakins asserts that if he were to "paint a woman naked" he would not censor her sex—"I would not mutilate her for double the money." In what I am tempted to rescue as a protofeminist critique of representations of women, Eakins in effect argues that the artist castrates Woman when he censors her sex.

Perhaps in part because he wanted to get around the problems raised by the spectacle of the female body, in his own paintings Eakins favored other subjects. In the few instances in which he included a naked woman in the canvas, her role is heavily circumscribed, and full-frontal nudity is almost entirely avoided. This is the case with *Arcadia* (c. 1883), an idyllic portrait of three nude figures outdoors—a woman with two young boys (one of whom plays a flute). She lies on her side with her back toward the viewer. Martin Berger writes, "What announced the woman's sex is the small bun in which her hair is tied at the nape of her neck rather than any uniquely female bodily features. Although all the models are naked, what alerts us to the woman's sex is a cultural construction of 'femaleness' . . . rather than the picturing of any biological differences."[31] The nude woman in the Rush paintings is carefully positioned as a model (and therefore not as a classical nude), and her back is again positioned toward the spectator.

Aside from *Arcadia* and the two versions of Rush's studio (and related studies), the only major work incorporating an image of an unclothed woman is *The Agnew Clinic*. Eakins "would not mutilate her for double the money," and yet *The Agnew Clinic* places the naked female subject on her back under the surgeon's knife, suggesting the female body as something to be controlled with the knife. In that painting, a surgeon bathed in a glowing light stands as the enlightened subject at a critical distance from the body of the ailing woman—whose illness he cures with a scalpel. A case might be made from this painting that Eakins's relationship to the female body was characterized precisely by the will to mutilate or castrate, a symptom of a culture that regularly mutilated women's reproductive systems in attempts to cure them of various female maladies such as neurasthenia. If *The Agnew Clinic* aligns the artist's work with the surgeon's, it does so less through an equation of scientific progress with artistic innovation than through the equation of the painter's brush with the surgeon's

scalpel—it illustrates not only the subjugation of the female body by modern medicine but the now-cliché practice of demonstrating artistic genius by conquering, even mutilating, the image of a woman—as if the female body were the most logical stand-in for the unruliness of representation. The spectators to this surgery are far more visible than in the portrait of Samuel Gross—bathed in a powdery light they lounge, they relax, they keep company with each other. They hardly seem transfixed by the doctor's brilliance. The brutality of the painting, in fact, is amplified by the casualness with which they bear witness to violence. Today, we might thus read the painting as offering a cynical critique of the violence the tradition of the Nude perpetuates on the image of the female body (whether Eakins set out to paint it as such or not).[32]

To return to the place of women in Eakins's studio, Eakins took a progressive stand against every practice of hiding the fact of the body's sex from women students, who were presumed to be too delicate to handle such display. In a move a bit ahead of its time, he sought to teach them the ways of the "big painters." If a woman expected to make a living from her work, he argued, then she must be a man about it and look without squirming at the human body. And she must be allowed to do so as a professional—without fear of accusation of impropriety. In his words: "She must assume professional privileges. She must be the guardian of her own virtue. She must take on the right to examine naked men and women. . . . a certificate of prudery would not in this age help sell a figure piece by a young lady."[33] With just a quick glance at these issues—the insistence on nudity, the admission of women to his classroom, his criticism of bourgeois codes of conduct—we see that Eakins's career can be understood as a perpetual testing of the sexual codes of conduct that are embedded within professional codes of conduct.

The realism for which Eakins is known developed not only from an investment in truthfulness in painting (as his ideological bent is commonly represented) but also from his ideas about the primary importance, in learning how to paint, of having direct contact with the body. His classes were remembered by his students as bringing a different experience of the body to bear upon the canvas, one in which a student could not get close enough: "Mr. Eakins teaches that the great masses of the body are the first thing that should be put on the canvas, in preference to the outline, which is, to a certain extent, an accident, rather than the essential; and the students build up their figures from the inside, rather than fill them up after having lined in the outside."[34] Or, in his own words, "Get life into the middle line. If you get life into that the rest will be easy to put on."[35] Eakins conceived of his "inside" as a corrective to representational practices associated with romanticism and sentimentalism that he felt were so saturated with social etiquette that they could only limn their subjects. In other words, the sort of body he wanted to bring into paint is one defined not only by the appearance of texture but by a texture that implies the mass contained within (which perhaps explains his extraordinary skill rendering the texture of clothing in his

paintings). "Feel the model," he advised his students, "a sculptor when he is finishing has his hands almost continually on the model."[36]

Eakins's encouragement of a direct knowledge of the body, however, had some dramatic consequences. Biographies offer a wealth of unsettling anecdotes about Eakins touching his sitters to get a feel for their bodies. As one sitter tells it, Eakins dug his fingers into her chest as she posed, and when she called out, "Tom, for heaven's sake, what are you doing?" he answered, "I'm feeling for bones."[37] A number of women recall Eakins as quite aggressive, even predatory, in asking them to pose naked for him. One remembers him as evangelical in his commitment to nudity, as Eakins gave her, as a gift, a photograph of himself (naked) carrying a naked woman in his arms (probably Figure 4); yet another student (this one, male) complained that "the nude was rather rammed down our throats."[38] Some of the more unnerving accounts of Eakins's habits (furnished here by his own letters) suggest a tendency toward exhibitionism. On at least one occasion he used his own body as a model when explaining the finer points of human anatomy to his students:

> Once in the dissection room (Emily Van Buren) asked me the explanation of a movement of the pelvis in relation to the axis of movement of the whole body, so I told her to come round with me to my own studio where I was shortly going. There stripping myself, I gave her the explanation of a movement as I could not have done by words only. There was not the slightest embarrassment or cause for embarrassment on her part or mine.[39]

With the bravado of the maverick that must have been his ego ideal, Eakins argued that this act of self-display was more respectful than the customary practice of paying complete strangers to take their clothes off for an artist unwilling to do so himself: "I think indeed (Van Buren) might have been embarrassed, if I had picked up a man on the street and endeavored to persuade him to undress before the lady for a quarter."[40] Eakins's willingness to exhibit his own body expressed, in part, his vision of an artistic community in which all members are potential subjects. It was also, however, part of his attempt to "class up" the classroom and distance himself from practices that might look like prostitution—which was by the late nineteenth century a major (if not *the* major) subject of sex panics in Britain and the United States.

Prostitutes were by that point widely associated with contagious disease and moral decrepitude. Surely his own body, Eakins argued, offered a better anatomical example than what he might pick up off the streets. Along these lines, he suggested that the Academy move away from hiring women working in brothels because, in his view, they were "coarse, flabby, ill formed & unfit in every way for the requirements of the school."[41] He asked that he be allowed to advertise for respectable ladies, "among whom will be found beautiful ones with forms fit to be studied" who might be "accompanied by their mothers or

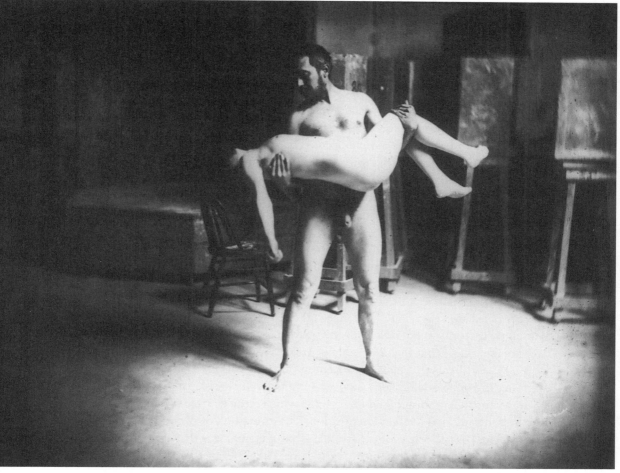

Figure 4. Thomas Eakins, *Thomas Eakins nude, holding nude female in his arms, looking down,* c. 1885. Courtesy of the Pennsylvania Academy of the Fine Arts, Philadelphia. Charles Bregler's Thomas Eakins Collection. Purchased with the partial support of the Pew Memorial Trust.

other female relatives. Terms $1 per hour."[42] If such an ad was placed, it appears that there was no response to it—again, no doubt, because it placed the well-heeled woman too close to prostitution. The solution to the conflict between wanting models "of respectability" and the disreputability of modeling itself was to encourage students to pose for each other (which was, in any case, cheaper). After all, who could be more "fit to be studied" than the sons and daughters of the Philadelphia elite who studied with him?

Eakins thought he was correcting one of the art world's more disgraceful practices. But in seeking to expel prostitutes from the artist's studio, he asked his colleagues to allow their wives and daughters to disrobe for him and his

students. Instead of making modeling more respectable, Eakins only made it more noticeable. No one paid modeling much mind as long it was prostitutes or servants dropping their clothes for the sake of art. Ask your respectable middle-class sister, though, and you render all the more visible what Griselda Pollock has termed the "prostitutionalization" of the arts—the intermingling and disavowal of sex, erotic interest, and money in the art world (the subject of the following chapter).[43] The unintended consequence of Eakins's revision of studio culture was that he helped expose the economic and sexual relationships that long underpinned studio culture. This point has largely been lost in celebrations of Eakins's battles with Victorian propriety. Naked women had long occupied the artist's studio, but these women were of a class for whom access to money was frequently tied to sexual service.

In attempting to reimagine the role of women in studio culture, Eakins was responding to the great crisis in art of his century: the erosion of the systems of patronage that underwrote the production of art and literature and their replacement with a literary and artistic marketplace. This set one system of value (aesthetic) against another (economic). It quickly became a commonplace for writers and painters to assert that they must prostitute themselves. That is, as artists felt that they could no longer survive on the support of patrons but had to sell their works to the new bourgeoisie, there was not only resentment but widespread anxiety that the only value of art was its ability to attract a willing buyer.

When Elizabeth MacDowell Kenton (his wife's sister) wrote to Eakins, "Your mingling of personal and business relations I still consider to have been most unfortunate and originated the trouble which ensued,"[44] she spoke directly to the contradiction of Eakins's position. The "mingling of personal and business relations" *is* the origin of the trouble—but it is not clear that Eakins could have separated the two in any meaningful way. The difference between the artist's business and personal relations is unclear. No artist at the time would have relished thinking about his painting as "business," nor would he have been comfortable with thinking of his art as entirely "personal." Many artists and writers of the period used the figure of the prostitute to dramatize anxieties about the struggle to reconcile the need for an audience and for money with an aesthetic standard of value that measures artistic worth in terms of its distance from the pecuniary. Some French artists especially (like Manet and Baudelaire) exploited her allegorical possibility as a living commodity, converting the melancholic bile produced by submission to the market into a distinctly modernist expression of ambivalence.

Eakins pursued a different tack. Instead of appropriating the abjection of the prostitute in a defensive response to the presence of the market, he acted as if it were possible to liberate the artist's studio of abjection and libidinal energy. He looked at the model and thought it possible to replace her with himself. It was as if, in sensing that as an artist he was expected to sell himself, he saw an equation between his work and the model's and thought he could cleanse the studio of all signs of the "sex-cash nexus" (the phrase is Pollock's) by literaliz-

ing the equivalence between artist and model, effectively eliminating the structural support of the difference between them. He would make a better model than anyone he could pick up off the streets, and if his students expected to be "professional" artists, they ought to also be willing to disrobe for the sake of art, too.

The part of his pedagogic mission that insisted that women participate in studio culture as equal partners attacked the male privilege that long underwrote such art-world contradictions as the idealization of the female nude as the supreme embodiment of aesthetic beauty and the exclusion of women themselves as artists from studio culture. Inviting bourgeois women to participate in the art and sex-cash nexus as subjects rather than objects did not have the effect Eakins may have wished for. At the same time that he introduced the idea of female students modeling nude for each other, he tried to give his women students exactly the same access to the body that a male artist could take for granted. This is an odd conjunction of projects: he asked that the women in his circle be seen as objects of aesthetic interest, *and* he asked that they, in essence, as student-painters, be treated like men (as capable of disinterested appreciation of the human form, as potential artists). In essence, he restructured the terms of the equation "male is to subject of the gaze as female is to object of it," so that male and female were interchangeable.

The presence of women threw the display of the naked model (female or male) into relief and made the disavowal of the libidinal energies that circulate in the studio around the display of a person's body to the fully clothed artist untenable. In an interview with Lloyd Goodrich, for example, one of the male students at the Academy complained that while he was posing nude for the artist Samuel Murray, Eakins brought a female Academy student to pose in the nude alongside him. Goodrich writes, "Ziegler didn't mind posing in the school, but this was different—a girl who might work alongside of him in the class." To Goodrich, the difference between Ziegler modeling in the nude for an artist and modeling alongside a female colleague from the Academy "seems minimal."[45] But in fact, that difference meant everything. Ziegler was being asked to accept the display of nudity from a woman of his own social circle, and he was expected to be able to see her, even after seeing her naked, as a colleague (which, at the time, was new enough an idea in and of itself). It also, furthermore, made the latent prurience of his own display visible—reminding him that his position as a model was one that could be associated with a woman, or even worse: a whore.

Each attempt to argue that the artist rises above the heat of the studio crumbles under the least bit of scrutiny. The definition of the artist's work was (and is) so intensely defined against the possibility of seduction contained in every level of art production and latent in every scene of exchange, that the proximity of sexuality and art, and art and money, came to structure all attempts to figure out what the artist's work is. When Eakins is celebrated for linking "art with work and with work conceived of as its own reward," it

is in opposition to the specter of the person who makes her living from sell-
ing pleasure. And so we end up with the assertion of the "manful[ness]" of
Eakins's practices, reminding us that the position of art producer is a masculine
one—in defense of the nagging certainty that, as long as art production is in-
scribed within an economic relation, as long as the artist is expected to sell, the
position is a feminizing one. The failure of Eakins to sell his work has always,
in art-historical narratives of his greatness, been the proof of his success.[46]

If he attempted to assimilate art making and nakedness to an ethic of work
(as Steinberg remarked), it was to a particular idea of professionalism as a space
immune from anything but the most pure, selfless, and rational interest. Eakins
looked for a model of artistic production in figures whose work seemed to rise
above the market and whose work was embedded in a system that protected it
from the appearance of libidinal and pecuniary interest. In letters and on can-
vas, Eakins turned to medicine for relief, imagining himself and his students
as misunderstood doctors and surgeons. For him, the practice of medicine was
like painting because it required an intimate knowledge of the body. Unlike the
painter, however, the doctor had successfully carved out for himself a privileged
relationship to the body, one that gave him total access to it and freed him from
the suspicion of being motivated by prurience. This was the professional privilege
Eakins wished to win for the painter. In an 1886 letter to Coates, he writes:

> If for instance, I should be in a railroad accident, and escaping myself unhurt,
> should on looking around me, perceive a lady bleeding most dangerously from
> the lower extremity; then and there I should try to find the artery and compress
> it, perhaps tie it . . . and for this I might well receive both her gratitude and that
> of her folks.
>
> Now if years later, some evil person would run busily about and whisper that
> I had lifted up a lady's clothes in a public place, that on account of it, there was
> a great scandal at the time (when there was none) . . . I should have upon me at
> once more than I might ever hope to contradict, except to a very few friends, and
> of my few friends, some would sympathize with me, but would wish I wouldn't
> do unconventional things, and some would tell me that it is always bad to have
> dealings with strange women anyhow, and others with much worldly wisdom
> that no motives can ever be understood by the public except lechery and money
> making, and as there was no money in the affair I should not have meddled, as if
> my chief care should be the applause of the vulgar.[47]

Eakins rails against the social codes of behavior that would chastise a man for
saving a woman's life if it meant raising her skirt above her ankles. The fable is
a condensed version of Eakins's career—the man with no patience for conven-
tion who unintentionally exposes the hypocrisy of the audiences that, on the
one hand, demanded he cover up his models and remove offending genitalia
from cadavers used in anatomy classes and, on the other, salivated over stories
of his depravity.

Nevertheless, this does not seem to be quite the approach to his self-defense.
The unavoidable gap between the story he tells about helping an injured woman

in a train wreck and the path of his own career is that no one's *life* depended on Eakins's artistic practices. Try as he might to lend his project a sense of urgency, he was not a surgeon. The story's point (that like a doctor, he must get close to the body to do his work) is overshadowed by the fact that in response to the allegations against him, the *best* illustration Eakins can come up with is one in which it would be necessary for him to lift "up a lady's clothes in a public place," in a manner that would be confusing to the nearby spectator. The story lurches toward the inappropriate, both because of the delusion of grandeur it implies (that his work is lifesaving) and because the choice of the woman's injury is exceedingly provocative—not a broken bone but a bleeding wound, almost as if he imagines treating her for "the curse" of being a woman. Eakins's fantasy of himself as an injured woman's savior makes us wonder what the difference is between imagining himself as this woman's healer and the fantasy of the injury that must precede it.

The medical doctor works with a sense of urgency that the painter cannot marshal on his behalf. The analogy works only insofar as it describes the gap between what Eakins was (an artist dogged by scandal) and the position of privilege he longed for. The analogy, in other words, is more compelling than convincing—perhaps because it is much better suited as a description of Eakins's practices as a painter, of our relationship to his canvas, than a description of the importance of nudity to art instruction. Eakins's habit of touching his models seems to inhabit a space in between the surgeon's and the seducer's treatment of the body as an object. The adoption of the position of disavowal—a blend of the "denial and self-deception" of aesthetic disinterest and the technical language of a "scientia sexualis"—allows the artist to penetrate deeper into the subject, without, however, addressing him or her *as* a subject. And so Eakins could, with a straight face and in all sincerity, hand a photograph of himself naked to a colleague and ask her to study it closely for the fine example of the nude, or invite a friend into his studio to meet a new model, opening the door to reveal a completely naked woman, or pass a weekend frolicking in the woods with his students, again naked, all in the service of high art. But in taking this posture to a kind of logical extreme (by proclaiming the *absence* of any libidinal interest in the naked body so loudly and so publicly, and by asserting that in the absence of libidinal interests he might engage in these practices with *women,* too), he made the disavowal of the presence of sexual interest and desire in the art world much harder, if not impossible, to plausibly carry off.

This brings us to the affinity between the train wreck scenario and *The Gross Clinic*: "Bleeding most dangerously from a lower extremity," the injury conjures up the surgical wound visible on the patient's thigh in Eakins's work (painted nearly a decade earlier). The story speaks neatly to the painting's scandalized audiences and the sensationalism of their condemnation of the painting. Even more compelling is how the story places the management of sexual difference and sexual excitement at the heart of Eakins's struggle. All of the troubles Eakins encountered can be tied to this finger puzzle: the attempt to name and

define the difference between aesthetic and prurient interest only, it seems, increases the strengths of the tie between them.

Realism's Touch: The Gross Clinic

From this detour through the scandals and the discourse of sodomy that surrounded them, through Eakins's interest in the nude and the trouble that caused him, we return to Dr. Gross's theater. Mapping out the nature of Eakins's "troubles" helps us confirm the suspicion that gender troubles are deeply woven into his work. Almost no critic has seriously entertained the possibility that the patient could be a girl or a woman, which leaves me as curious about the critical habit of gendering the patient male as I am about the consequences of reading the patient's gender as indeterminate.[48] The similarity between the scenario of Eakins's fantasy train wreck surgery and the tableau of *The Gross Clinic*, as well as the gender of the patient in the painting's most obvious analog, *The Agnew Clinic*, is enough to suggest that we at least entertain the possibility that the body could be female. This immediately raises questions: How can we tell the difference? Would a woman wear socks like that? Would her legs appear so sinewy? Are the buttocks fleshy enough to belong to a woman? The body seems so small in comparison with the figures crowded around it that we also have to wonder if it belongs to an adult, or a child, or an adolescent—in which case, the secondary signs of gender become even less legible. That we are reduced to scrutinizing the body so aggressively for signs of its gender makes my point: *The Gross Clinic* draws a visual equation between the rigor of a certain kind of professional attention and the attempt to detect gender—an attempt, though, that the painting refuses to see through to a conclusion. The patient's body is not legible as male or female. It simply is not legible except as an object of our interest.

Perhaps it is the aggressive feminist in me who loves putting women in places where they don't belong or, at least, noticing the women who lurk on the margins. But I do have to wonder at my own drive to explore the patient's gender position. Maybe critics of *The Gross Clinic* tend to assume that the patient is a man because it is more comforting than entertaining the possibility that it is a woman. The very idea that Eakins could have so positioned a woman on the canvas is, like the rumors of his having engaged in "bestial" relations with his sister, almost too scandalous to consider. The "unnaturalness" of the offense of sodomy is its insult to the procreative imperative and the behavioral commands that follow from the recognition of gender difference. Turning a woman's back to us and offering us, in substitution for her sex, a bleeding wound would have been a disturbing affront to the same audiences that fetishized women's sexual difference—insisting on its centrality but demanding that it be hidden.

Early attempts to explain the painting's horrifying effect pivoted on the character of the patient's nudity. In the words of one reviewer, "This violent and bloody scene shows that at the time it was painted, if not now, the art-

ist had no conception of where to stop, or what the limits are between the beauty of the nude and the indecency of the naked. Power it has, but very little art."[49] The traditional female nude, as Abigail Solomon-Godeau put it, "must deny or allay the fear [of sexual difference] that the real female body always risks producing—hence such conventions as the suppression of the vagina and the elimination of body hair as well as a prescribed repertory of acceptable poses."[50] The "smiling, smirking goddesses" who so irritated Eakins faced the spectator in a placid, reassuring display of a feminine beauty stripped of any strong indication of a sexual presence. *The Gross Clinic*'s spectator has access to the patient's body, but not the comfortable spectator position offered to the person gazing gently on the female nude. *The Gross Clinic* does not stage its intervention around a display of the naked female body. The most violent insult to the Nude in this painting is the substitution of a graphic wound for sexual difference itself. The laceration on the thigh appears to take on the haunting sign of sexual difference, but the sign of sexual difference severed from a gendered body—as if the patient embodied exactly and *only* the thing that aesthetic tradition requires the Nude to transcend. The painting, in other words, literalizes the moment in the oedipal narrative when the sexual difference of a woman is interpreted as the absence of genitalia, a loss that the child denies by demanding a fetish to stand in for the lost sex. It is a visualization of the scene of castration. The painting, however, must also be read as saying more: Eakins's version of the scene of castration is unresolved.

The most powerful attempt to explore the gender dynamics of the painting is offered by Michael Fried, in support of his analysis of Eakins's realism. Turning to psychoanalytic insights to unpack *The Gross Clinic*'s fascination with oedipal violence, Fried reads the painting as a dramatization of Eakins's anxiety of influence—as an allegorical representation of struggles for power over his teachers and his father (who was himself also a teacher). Fried points out that we might take any number of positions, including that of the patient, as allegorical positions for Eakins himself as he experienced and negotiated the threat of castration. Fried's analysis of the textual, performative aspects of the painting's realism is indispensable. It is surprising, given his argument for the primacy of the painting itself, given the caution he issues against grounding readings of the painting in imagined points of origin, and his acknowledgment of the painting's refusal to gender the patient's body, that Fried ultimately grounds the body within the oedipalizing (and masculine) castration narrative. He is, however, in this instance, working off of a critical tradition that has universally assumed that the patient is male because there is archival evidence that Eakins attended a similar type of surgery performed by Dr. Gross on a young man. Fried takes the *a tergo* position, which excludes the patient's genitals and head from our view, together with the contrast between the gaping wound and the controlling paternal aspect of Dr. Gross as he wields the bloody scalpel, as symbolically mapping out the dramatic positions of a castration narrative, as well as the paranoid fantasy of a repressed homosexual. The latter

interpretation emerges from Fried's perception of a harmony between the painting's association of the threat of castration with anal intercourse and the fantasy of one of Freud's case studies, Dr. Schreber, who imagined that his body would be transformed "into a female body, and surrendered to the person in question, with a view to sexual abuse."[51] The painting, indeed, offers multiple figures for castration. We might, for example, read the woman in the painting as a surrogate mother figure participating in a scene of castration, a stand-in who sets off the patient as a male about to experience castration. Fried writes, "Looked at anew . . . the mother's empty and contorted left hand emerges as a figure for castration, or . . . both for the castration (by virtue of its clawlikeness and more broadly its offensiveness to vision) and for castratedness as such (by virtue of its emptiness and more broadly as a marker of femininity)."[52] Cringing in the corner of the tableau, the woman throws the serene triumph of Gross and his assistants into relief. She is the spectator succumbed to the spectacle, so overcome that she has raised her hand as if to ward off a blow. The effect of *The Gross Clinic*'s realism is generated in no small part by her hands as they ward off the spectacle too painful to look at with a histrionic gesture that only amplifies the demand that we look. She is an extremely reluctant object of attention, but she is nevertheless a perfect surrogate for the uneasy viewer of the painting because, as Fried has argued, she hypostatizes the difficulty of *looking*. "The definitive realist painting," he imagines, "would be one that the viewer literally could not bear to look at." Or, more precisely, Fried muses, a work like *The Gross Clinic* suspends the viewer between an image too horrible to look at and an image "all but impossible, hence painful, *to look away from* (so keen is our craving for precisely that confirmation of our own bodily reality)."[53] In his attraction to the experience of his own revulsion, the spectator encounters his corporeality as an effect of looking at the painting—it is here that he encounters the "real"—a confrontation that, given the exclusion of genitals from the painting, the bloody wound on the thigh, and the (albeit fleeting) identification with the woman, suggests an encounter with the scene of castration.

Fried describes the network of power relations in *The Gross Clinic* as a management of the economy of pain and pleasure in which the artist and the spectator of the painting are caught—at once wincing in discomfort and squinting to see more. The castration narrative that emerges from the contrast between Dr. Gross's serene countenance, the horrific task suggested by the bloody scalpel, and the woman's posture invokes "the paradoxical logic" of the sublime that requires both the spectator's fear of injury and his or her protection from harm. According to this reading of the (negative) sublime, first the viewer feels anxious at the possibility of being overwhelmed by the experience, an anxiety homologous with castration anxiety. The viewer overcomes this anxiety by identifying with the "'paternal' power that was the immediate or . . . ostensible cause of the terror." This spectator, then, incorporates or internalizes the "image of superior power" to gain distance on his or her spectatorial posi-

tion. He or she thus recognizes this fear (of castration) and banishes it by iden-
tifying with the power behind the threat.

From a feminist perspective, the understanding of the sublime (as a man-
agement of castration anxiety) that structures Fried's discussion of *The Gross
Clinic* has serious limits. There is no accounting for a feminine subject-position
within the castration narrative—the narrative passes through rather than settles
on her. The drama of the painting, understood as a game of *fort-da* in which
the phallus is alternately promised and withdrawn, circulates around the pro-
duction of the male subject—be it Dr. Gross, Thomas Eakins, or the enlight-
ened critic. (And even that reading masks—or at least avoids naming—the
homoerotic current that animates these lines of identification.)[54] The indetermi-
nacy of the patient's gender is here subsumed by a narrative about the produc-
tion of the male subject.[55] Fried's reading does not explain the painting's refusal
to bestow a sex on the body so much as it fills in the gap with a projection of
his own gender position (and, in many ways, the gender position of art history
itself). He resolves the patient's gender via a diagnosis (of Eakins's oedipality,
or Eakins as having repressed homosexual desires) that presumes the body's
sex as male (a substitute for the artist himself) and minimizes the disorienting
powers of the body presented from behind. To read the painting as a set piece
of Eakins's oedipal anxieties is to step around the aspects of the painting that
exceed or frustrate the attempt to narrate the production of gender difference.
Ultimately, this approach assimilates the painting's sexual politics to a psycho-
logical narrative about Eakins (which is, nevertheless, interesting) and leaves
the relationship between the spectator and the painting, and the place of sex
and gender in that exchange, unexplained.

Given Fried's skepticism about the projection of narratives behind the
painting, it is surprising that Fried turns to psychoanalysis for insight into the
painting's gender dynamics, as psychoanalysis is itself so deeply organized
around the quest for points of origin. Overripe with the promise of discover-
ing a hidden or repressed sexual content, *The Gross Clinic* is less answered by
explanation of its anal-erotics as the work of a repressed or protohomosexual
than it is already *about* the urge to produce such an explanation. The ques-
tion, as Fried argues in other moments of his essay on Eakins, is not what *The
Gross Clinic* purports to represent and how well it represents that subject, but
how it generates an effect of the real through its solicitation of a particular
kind of epistemological attention from the viewer. The desire to sex this body
is as much an effect of the painting's realism as our need to see its clutter and
violence as transcriptions of an event prior to the painting. The confusion pro-
voked by the body presented to us from behind is where the painting invites
us into its frame—it invites us to construct a gender for the patient, and to do
that we must project a narrative behind it. We might therefore think of *The
Gross Clinic* as distinguished by its overproduction of what Lee Edelman has
cleverly called "(be)hindsight"—a term he uses to capture the overdetermined

relation between the defining interpretive moves of psychoanalysis and the mis-recognitions (of backs and fronts, cause and effect, sex and text) associated with sodomy. The spectacle of sodomy and the confusions it generates (about gender and sex acts) invokes "the sodomitical implications of psychoanalysis itself" as a practice that "approaches experience from behind through the ana-lyst's efforts to replicate the distinctive logic of the unconscious" and in which there is a permanent undecidability as to the exact nature of the narrative pro-duced in analysis.[56] Edelman consequently theorizes that "the scene of sodomy comes to figure . . . both a spatial disturbance in the logic of positions (i.e., a confusion of front and back) and a temporal disturbance in the logic essential to narrative development."[57] The story told in analysis, in other words, has an effect similar to realism: it produces a grand metalepsis as the analyst must pro-ject backward from the analysand's words an original trauma, from which a narrative is forwardly projected. It seems possible to think of *The Gross Clinic*'s spectator as implicated in the scene of sodomy as witness (of the painting and the patient's position) and participant (confusing before and after, front and back by projecting a gender for the patient into the painting).

As if to confirm the priority of *The Gross Clinic,* the painting, to the fantasies projected behind it, we have a photograph of the scene of the painting taken by Eakins himself and his students—not a study of Dr. Samuel Gross's clinic but a parody of the painting that reappropriates its most "realist" and oedipal ges-tures to a comic, even camp effect.

It is a direct subversion of the painting and restages the operation with the smut of a burlesque performance. Eakins and his students selectively reverse points of *The Gross Clinic*—flipping the patient over and then blocking his lower body from our view, placing a man in the woman's chair, now looking away from the table but toward us—now foregrounded instead of receding into the background. It is *almost* as if the photograph produces what the painting cannot—an "inside view" into Dr. Samuel Gross's theater—a fantasy vantage point internal to the painting. From this perspective "Dr. Gross" wields an ax, and his demeanor is more ferocious than enlightened. A mock-anesthetist stands on a chair and holds what looks like a sack over the patient's head as if to smother him. At the foot of the table another man squats while he holds the patient's feet down—suggesting a recent or immanent struggle between the now compliant patient and his captors. As if in anticipation of the tendency to read paintbrushes and pencils in Eakins's work as phallic expressions of his au-thorial powers, the instruments of surgery in the photograph take on a different life as phallic fantasy—not as instruments of castration but as prosthetic toys. The probing assistant, also standing on a chair, pushes into the table with one leg and leans into a harpoonlike pole that might just as well be shooting from the patient and out of the frame of the photograph as diving into him, ending at a point somewhere below the patient's waist.

I would like to assert that it is Eakins who poses in the place of the womanly,

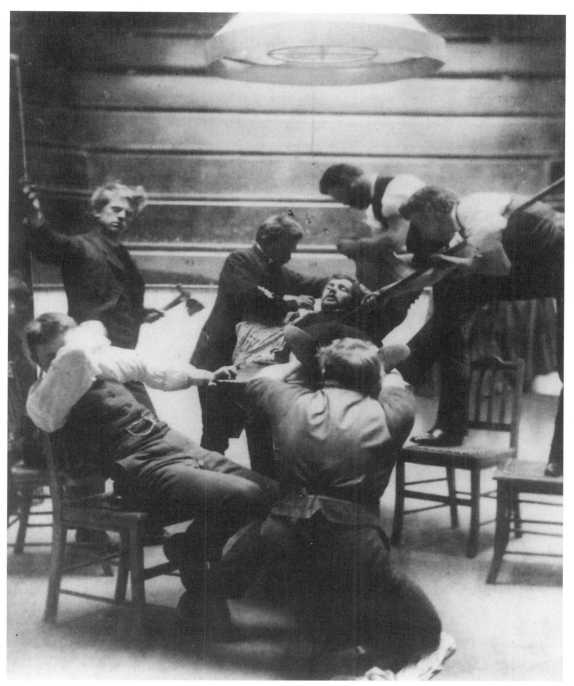

Figure 5. Circle of Thomas Eakins, *Parody of "The Gross Clinic,"* 1875–76. Courtesy of the Philadelphia Museum of Art; gift of George Barker, 1977.

melodramatic spectator, though I cannot say for certain that it is he. The two figures offer a provocative point of intersection between the photograph and the painting. In the photograph, it is only through his posture that we guess that Eakins is playing the part of the woman. He holds his knees together as he grips the table with one hand to push himself away. He throws the other hand across his eyes and buries his head in the crook of his arm to avoid the once sublime but now ridiculous tableau—perhaps hiding his face as much to cover laughter as to simulate a woman's horror. Returning to the painting, I notice for the first time that the woman in *The Gross Clinic* is almost as hard to read as the patient. She is buried in clothes and gesture, and we have no more access to her skin than we do to the patient's identity: it is only through her posture and costume that we guess she plays the part of a woman. In this way, she is an inverted figure for the patient. *Her* gender position is immediately legible, but only as it is signified by costume and gesture, only as it signifies as performance.

Interestingly, some of the painting's first critics linked the painting's gore to the theatricality of her gesture: "The ugly, naked, unreal thigh, the pincers and lancet, the spurting blood, and the blood on the hands of the Professor and his assistants *are bad enough,* but Mr. Eakins has introduced, quite unnecessarily, *an additional element of horror in the shape of a woman* . . . who covers her face and by the motion of her hands expresses a scream of horror."[58] The syntax of the phrase "horror in the shape of a woman" supports the desire to read the woman as performing the dual functions of spectator surrogate and a figure for castration, an allegory for the spectator's affective response to *The Gross Clinic* and the thing we can't stand to see. She upset critics because she brought a gratuitous and generically disruptive presence to the painting. She cannot be assimilated into the painting's seriousness, to its presentation of male heroism.

> Is it usual for the relative of a patient who is undergoing a serious operation to be admitted to the room? And, whether it be or not, *is it not unnecessary to introduce a melodramatic element—wholly hostile to the right purpose of art*—into the scene, to show us this old woman writhing her body and twisting her hands as the professor details the doings of the scalpel in the house of life of someone dear to her? Here we have a horrible story—horrible to the layman, at least—*told in all its details for the mere sake of telling it and telling it to those who have no need of hearing it.*[59]

The abuse of the patient's body was "bad enough," but it was ultimately admissible as "what the artist saw." The woman's presence and her demeanor, however, looked like an unnecessary and even obscene insertion of the artist's presence into a scene that would otherwise appear natural. If the nude body stands in for what the artist saw, she stands in for what the spectator feels. The sentiment she holds in her posture is out of place in this scene of concentration and seriousness, just as she herself is out of place in what would otherwise be (putting aside the patient's ambiguous sex) an exclusively male tableau.

In late-nineteenth-century conversations about American art, realism was

often articulated as a corrective to melodrama and the sentimental (as in Eakins's own statement against idealized versions of the Nude). The sentimental continues to work as a pejorative for particular kinds of relationships to texts whose definitive characteristic is, as Eve Kosofsky Sedgwick has argued (speaking of sentimentalism), the enabling of "the tacitness and consequent nonaccountability of the identification between sufferer and sentimental spectator."[60] The complaint against the sentimental or melodramatic spectacle is that it produces an excess of emotion in response to vicarious experience, to a representation instead of a real event. All of the disgraced genres—the sentimental novel, melodrama, pornography—may have this in common: they are suspected of being too seductive, of encouraging too lubricious an interaction between a representation and its consumer, of diverting the affections of the audience from people, from the world, from the purported *subject* of representations, and directing it toward representation itself. Melodrama's excessive displays of suffering and ecstasy bring the text too close to the consumer's body, moving her to horror, shame, or titillation—without, however, there being any "right" or enlightening "purpose" to this production of bodily affect.

This is what is surprising about the photograph: it suggests that one could have a playful relationship to this serious and earnest painting. If we look at the painting and the photograph as a pair, we find that the confusion of gender difference, sex, and the misuse of texts comes together in *The Gross Clinic* to charge its realism with an unexpected salaciousness. It is as if behind *The Gross Clinic*'s realism is something altogether different from what we thought we were looking for. In not matching our expectations, the photograph reminds us that we have expectations—in the same way that the cringing woman reminds us of our expectation that the surgical theater is for men only, and in the same way that the absence of a gender for the patient's body reminds us that we fully expect the body to have one. Only by pointing up that wish for a point of origin does it offer us one in our own desire. Here the painting and the spectator's desire interpenetrate—and the painting offers up as an allegory for this relation an image of cutting into a body but also, at the same time but not quite the same place in the painting, a sodomitical scene—an overdetermined mapping of the forgetting of the self that allows us to step inside the work of art, to feel it working on our own body, onto the spectacle of the body presented from behind, the spectacle of a nonprocreative sex.

The sexual play of the photograph lends oedipal readings of *The Gross Clinic* a comic air—the photo reproduces the oedipal family drama for us, but minus the tragic and serious tone of the painting (minus women, but with much more affection for the feminine position than the painting allows). Oedipal tragedy is here transformed into comedy, realism is recast as parody, and not the parody of Dr. Gross's clinic but the parody of the painting. The difference between the idea of realism as a precise copy of an original scene and camp as a submission to the mimetic pleasures of parody is revealed to be little more than a matter of affect.

The photograph is a portrait of what *The Gross Clinic* excludes, of all that is memorialized in horrific fashion by the painting's loose ends: the woman's gesture and the open wound. The excess of her pose threatens to contaminate the reserved seriousness of the men around her and reveal that they are no *less* posed, no *less* contrived, than she is. The contrast between the painting and the photograph suggests, furthermore, that conquering feeling has something to do with the production of the homosocial. That is, the reining in of affect in the name of realism (the work *The Gross Clinic* describes) *requires* the presence of a woman: the heroic performance of masculine power is acted out around, and against, the backdrop of her abjection. Of the figures on the canvas, the woman most explicitly and aggressively displays her gender position, and the naked body on the table has no discernible gender whatsoever, which suggests, in addition, that sexual difference, as it is produced within this setting, does not, as Walt Whitman once wrote, "stand alone." The trimmings (character, personality, gesture, costume, position) are everything.

The painting's failure to gender the patient allows us to place the management of the production of sexual difference at the core of not only the medical discourses the painting celebrates but the sociology of art that it allegorizes. The photograph, too, speaks to the sodomitical possibilities inscribed within the scene of producing and consuming art, as activities that allowed men and women a physical intimacy defined by something other than the imperative to reproduce, as a scene in which the pleasures of representing sex outstrip the epistemological drive to figure sex out.

Tricks of the Trade Pop Art and the Rhetoric of Prostitution

The Price of Art

If Thomas Eakins sits at one end of the struggle to make a life and a career for himself as an artist, Andy Warhol is at the other. Eakins struggled to make a living and insisted on the purity of his intentions. Warhol never hesitated to market his work and himself, and *insisted* on the prurience of his intentions. If we take him at his word, Andy Warhol was pretty certain that love had a price, that it was a business much like art was a business, that sex was work, and that these could be good things. He thought that "making money is art and working is art and good business is the best art." And he recommended that in love affairs we follow at least one rule: "I'll pay you if you'll pay me."[1] But where Warhol's fans might be galvanized by his aphorisms on the business of art, love, and sex, and where a jilted superstar might find solace in his idea of advice ("Don't worry, you're going to be very famous someday and you'll be able to buy him"[2]), readers are probably more familiar with the endless citation of Warholian axioms by grumpy pundits who read them as the cynical expressions of the whore who embraces the very system that exploits her.

If figures of sex work had never appeared in our vocabulary, Warhol's critics would have had no small problem on their hands. Whores, hustlers, madams, and drag queens are particularly frequent visitors in the reception history of this artist. In the service of the most conservative impulses in criticism they work rhetorically as a shorthand for Pop's perversions—for how Pop flaunts the business of art, how Warhol was not really an artist because he pandered to a popular audience, and how the dubious pleasures of Pop art are extracted from the very act of "selling out." More broadly, they appear as embodiments of the artist's dilemma, in which selling your art risks selling your place in an

avant-garde that imagines itself, in the words of Andreas Huyssen, as "resis-
tance to the seductive lure of mass culture, [and] abstention from the pleasure
of trying to please a larger audience."[3]

In the critical reception of Warhol's work, a rhetoric of prostitution links sex
and work to give the critic leverage to distinguish Warhol's work from the kind
of work other people do and to make the judgment that his art fails to provide
a meaningful social critique. Moreover, in figuring Warhol's relationship to his
work as a form of prostitution, critics frequently discredit his relationship to art
by suggesting he also has a perverse, unnatural, or destructive relationship to
sex. The use of a rhetoric of prostitution and its stigma of outlaw sex to name
the artistic practices of a famous (and famously) gay man more often than not
functions to signal (but only through inference) Warhol's homosexuality while
also displacing the discussion of sexuality in Warhol's work onto a feminized,
particularly public, and abject figure.

Critics have thus hinted at Warhol's sexuality as relevant to his work (by,
for example, invoking Oscar Wilde as a figure with a similar understanding of
celebrity)[4] and have suggested, in effect, that Warhol's work is all about sex,
without making these links explicit (even when confronted with the sexually
explicit nature of much of Warhol's oeuvre). The result is a kind of critical shell
game that cloaks not only the libidinal investments *of* Pop but the critic's in-
vestment *in* Pop, declaring on the one hand that Pop is not about art but about
sex (that it is ultimately prurient) and on the other hand that this sex is not
about love but about money (and is, therefore, perverse).

The condensation and dismissal of issues key to Warhol's work under the
rubric of prostitution is the starting point for my own approach to Warhol.
I begin by sketching out what these highly volatile and conflicted rhetorical
gestures in Warhol criticism look like and then place them in a larger histori-
cal context—the critical habit of using the sexually compromised woman as
an allegory for the position of the artist in relation to the market. I follow this
narrative about Warhol's reception and its context with a reading of Warhol's
career-long effort to exploit the incoherencies and contradictions in and around
definitions of "work" to challenge available models of authorship, art, and sex.

Madam Warhol

Representations of Warhol as a whore and Pop as prostitution are often con-
cerned with the question of whether the way Warhol and other Pop artists
produced art counts as a legitimate form of art making. For example, in his
essay on Warhol, Thierry de Duve writes that "Warhol managed the factory
not like a boss, but like a madam, if he managed it at all."[5] His remark exem-
plifies the way such rhetoric can both signal and circle Warhol's problematic
relation to categories of art and work. It also echoes a more widespread, un-
examined deployment of ideologies of sex and sexual difference in critiques
of mass culture.[6] In casting Warhol as a madam, de Duve responds not just to

how Warhol made his art or to how he made his art a business. Although these aspects of Warhol's art are interesting to de Duve, what distinguishes Warhol from other artists is how his work manipulated and manufactured desire. For de Duve, Warhol was like a madam because he was "content to base his art on the universal law of exchange" and to make "himself the go-between for the least avowable desires of his contemporaries. Each with his or her own 'look,' quirks, neurosis, sexual specificity, and idiom." De Duve continues by describing Warhol's "lifestyle" as "beautiful only in its coherence," as a way of life "that wasn't a life, and was in no way the life of the species-being." He then diagnoses Warhol's work as embodying "the cynicism of capital interiorized by even those it causes to suffer . . . the pleasure of the prostitute." While I would not argue with de Duve on the cynicism of Warhol's work (his essay is, in fact, one of the more provocative Marxist readings of Pop), I would like to explore the rhetorical equations that underpin writing like this and a phrase like "the pleasure of the prostitute."

A wide variety of critics (from the theoretically complex de Duve to the reactionary Robert Hughes) use prostitution and other figures of sexual deviance (e.g., drag) as metaphors for Warhol's production of art as though the logic of that comparison were transparent. In a 1980 editorial for *Art in America,* for example, Suzi Gablik casually figures the Pop artist as a streetwalker when she criticizes Warhol for generating an atmosphere that makes "the practice of art . . . like any other career" whereby artists "lose their identities as artists" and will do anything to "make it . . . even if it means hanging from the lamp posts."[7] In his 1963 *ARTnews* editorial, Thomas Hess invokes both drag and prostitution as metaphors for "phony" cultural production in worrying that Pop encouraged artists to "fake it" for profit. Pop was "phony" because it was motivated by money and not by the "real crisis" expressed in modern painting (e.g., abstract expressionism), "which can kill or forge a man's identity." Real art is when real men produce what produces real men. According to his argument, "phony" modes of artistic production threaten that masculinity. He thus warns readers against allowing themselves to be seduced by Pop's production of the "phony crisis which kills (mostly with kindness)." "How long," he wonders, "will even the most talented be able to resist the equivalents of cloche hats, beaded skirts, and the shimmy?" Pop, for Hess, as the art of "phony crisis," is the dangerously seductive art of faked orgasm—an on-demand performance that "avoids the real crisis by painting it over with a trademark or a sentimentality."[8] It is the doubly fraudulent spectacle of a drag imitation of the already impugned ecstasy of the feminine. According to this story, in the same way that a woman is compromised by prostitution or a man by drag, Warhol and his audiences are compromised by his success. The logic of the story is that a woman who takes money for sex or a man who dresses as a woman are degraded versions of the real thing.

When critics cast Warhol (or any artist) as a madam, a hustler, or a whore, they draw the pejorative energy of their rhetoric from the pathologization of

prostitution to negotiate, among other things, the question of what art is and is not, and what it ought to do.[9] In doing so, they partake in a discourse on prostitution that, on the one hand, localizes prostitution to a "certain type of girl" belonging to a "certain part of town" and that, on the other, figures nearly every relation of imaginable social relation of exchange as a kind of prostitution—from marriage to labor, consumption, and art making.[10] These minoritizing and universalizing impulses tend to operate in tandem. At times the latter borrows from the criminalization and stigmatization of sex work as a venal practice to point up a crisis in all social relations; in turn, a minoritizing discourse converts the exigency of this crisis into the fervent policing of prostitutes to reassure us that we *do* know a whore when we see one and that we *can* tell the difference between prostitution and, say, the institution of marriage. In other words, this discourse both articulates and manages the possibility, the thought, that all of us are whores in how we address others sexually, in how we dress, in our professional lives, and in what we do for money, for love, for pleasure. Any relationship involving an exchange (of looks, of money, of favors) can look like prostitution.

Insofar as it points out the absence of a solid apparatus for making distinctions between high art and mass culture or between the art object and the commodity, Warhol's work is a magnet for this rhetorical deployment of sex. When art critics mobilize this discourse to evaluate an artist's work, they map the anxieties of prostitution onto the vicissitudes of the category of art itself. The end product is a profoundly tautological rhetoric that backs up the assertion "I know art when I see it" with the accusation "I know a whore when I see one."[11]

So when Warhol the artist is outed as a fraud, it is by referencing a language of fraudulent, phony, imitation, or failed sex. In his response to Warhol, Hughes consistently reads Warhol's work as a kind of pornography, as the mediated and false representation of the "real thing." In this spirit he describes *Marilyn Monroe's Lips* (1962) as a cynical representation of "the administration of fantasy by the media, and not the enjoyment of fantasy by lovers," and characterizes Warhol as a "diligent and frigid" celebrity who surrounded himself with an entourage of characters with "unfulfilled desires and undesirable ambitions."[12] The presumption is that Warhol's work, as a kind of pornography, mistakes mediated sex for the "real thing" and that people who make or enjoy such representations of sex and pleasure are "frigid," "unfulfilled, and "undesirable."

The thematization of erection or orgasm as what Pop either cannot do or as what Pop fakes (e.g., the "phony crisis") begins early with Peter Selz's "Pop Goes the Artist." Amazingly retitled as "The Flaccid Art," this essay is unembarrassed in its complaints about the failure of the Pop artist to produce himself as a phallic hero, describing him as "slick, effete, and chic" and Pop as "limp art" generated by an "extraordinary relaxation of effort, which implies . . . a profound cowardice."[13] This rhetoric of complicity was itself inspired by Aline Saarinen's 1963 survey of Pop artists in which she attributes the weakness of Warhol's work to a lack of "the penetrating gaze" necessary

to the production of so-called real art and speculates on Warhol's incapacity for feeling: "I suspect he feels not love, but complacency and that he sees, not with pleasure or disgust, but with acquiescence. These are weak ways of seeing and feeling."[14] More recent critics reference Warhol's sex life as they evaluate, for example, the merits of the Warhol Museum in Pittsburgh. Writing for the *Wall Street Journal,* Deborah Solomon takes the following swipe: "The Warhol Museum is like a chic YMCA, turning the artist's dissolute ways and pursuit of celebrity into so much moral uplift for the community."[15] Dissolute, effete, frigid, indifferent, complacent, acquiescent—these words all phobicly hint at Warhol's homosexuality—and, in particular, his effeminacy—in making judgments about his art.[16]

Whether a whore or a hustler, the prostitute has been defined by legal and social apparatuses as a venal body, as a perversion of femininity, and as a person who has a passive relation to sex—either in the act of selecting a partner or in the performance of sex acts, or both.[17] Often it is the paradoxical willfulness of that passivity that is the crux of anxious writing about prostitution—the paradox of someone whose "preferment of indolent ease to labor" and eagerness to turn a profit combine to make a job of sex. In her writing on sex work, Anne McClintock has argued (using a term developed by Mark Seltzer) that the figure of the prostitute embodies a "pathology of agency" as well as sex. While the prostitute is understood as having no agency in selecting partners and as being a pure commodity, she is also represented as "having an excess of agency, as irresponsibly trafficking in male fantasies and commodification."[18] This particular logic shapes discussion of intentionality in Warhol's work: when critics ascribe intention to Warhol, it is the intention to submit (or, more nearly, the intention to not resist). Thus Pop, according to one critic, wants us "to believe that it is in fact adopting a critical posture towards that to which it has actually surrendered."[19] To this effect, Dore Ashton, in a key 1963 symposium on Pop, remarked, "Far from being an art of social protest, [Pop art] is an art of capitulation."[20] For Jean Baudrillard, one of Pop's more nuanced critics, its sense of humor is "not the smile of critical distance, but the smile of *collusion*."[21]

As often as these critics animate their writing with hustlers, whores, and drag queens, they avoid speaking directly about the place of sex, gender, and sexual practices in Warhol's art. Criticism animated by sex but which evacuates sex from Warhol's work makes up a substantial amount of the writing in not only philosophical essays but also reviews, feature stories, and obituaries on Warhol in art journals and mass media outlets like the *New York Times, Time,* and *Esquire*. In glossing the language of criticism on Warhol, I am suggesting that we not take the queer figures that populate it for granted. They draw out some of Pop's most interesting attitudes—its curious configuration of agency that looks at once passive and active, its investment in art and sex as sites of exchange, its use of the queerness of these sites to resist monolithic narratives about what sex and art are. They also have an extensive history.

The Rhetoric of Prostitution

The use of figures of prostitution in the critical narration of Warhol's relationship to art and to his audience is by no means unique. Figures of prostitution, sexual abjection, and illicit forms of economic exchange dominate paintings, novels, and poems associated with the advent of the modern. The prostitute has been a powerful allegory for modernity, and for the alienating aspects of modern life, since at least the mid-nineteenth century. In the attempt to adequately capture the upheavals of the Haussmanization of Paris, the industrialization of England, or the development of a mass culture in the United States, writers and artists as diverse as Elizabeth Gaskell, Edouard Manet, Henri de Toulouse-Lautrec, Theodore Dreiser, Charles Baudelaire, and Émile Zola were drawn to the fallen woman and, as John Berger puts it, "the realism of the prostitute."[22] Where we do not find prostitutes, we find overlapping figures for sexual abjection and economic perversion in, for example, the recurrence of the actress (another kind of "painted woman"), the celebrity (a living commodity), or the sodomite (who engages in nonreproductive sex). We have a myriad of brothel scenes in French art (by Manet, Degas, and Toulouse-Lautrec, for instance), Zola's infamous (and influential) novel *Nana,* and the spectacularly magnetic title character of Dreiser's *Sister Carrie.* The latter's rise to theatrical celebrity is explicitly figured as a descent in character and is initiated by her acceptance of money from a suitor:

> He pressed her hand gently and she tried to withdraw it. At first he held it fast, and she no longer protested. Then he slipped the greenbacks he had into her palm, and when she began to protest, he whispered: "I'll loan it to you—that's all right. I'll loan it to you."
>
> He made her take it. She felt bound to him by a strange tie of affection now. . . . Carrie left him, feeling as though a great arm had slipped out before her to draw off trouble. The money she had accepted was two soft, green, handsome ten-dollar bills.[23]

As she fingers the bills, feeling how soft they have become from having passed through so many hands, Carrie trembles not with fear but with an almost sexual excitement. Once she puts the money in her pocket, there is no going back. The change that comes over her is as permanent as it is mysterious. Every step she takes away from domesticity and honest work seems both inexplicable and inevitable.

Characters like Carrie bridge the sexual and the economic and allegorize a modernization of both realms. Berger's use of the phrase "the realism of the prostitute" refers to the way that the figure of the prostitute appears in modern art as a stand-in for "the real." A few feminists have noted the strength of this theme: Griselda Pollock touches on it when she asks, "Why [is modernism so frequently] installed upon the territory of a commodified female body?"[24] In her study of realism in painting, Linda Nochlin also observes that figures of prostitution were a privileged subject. She speculates that "the overwhelming

attention accorded by both writers and artists to a social category [that of the prostitute or demimondaine] previously neglected or treated with less than seriousness" was not only "consistent with the Realist concern to get at the truth" but may have been realism's defining preoccupation.[25] In criticism, the observation of the link between the prostitute and modernity is almost de rigueur.[26] As is the case with Berger, Pollock, and Nochlin, the prostitute is invoked in an attempt to identify the specific concerns of modernism and realism, but without direct reflection on what this association between prostitution and art means, where it comes from, or what its legacy might be.[27]

The prostitute, in the context of criticism about the arts, represents not the sociality of sex but the sociality of art.[28] We can say that as artists and authors came to depend more and more on the market for their livelihoods, the work of art was increasingly seen as at risk of becoming a kind of sex work. The autonomy of art (the idea that aesthetic value is independent of economics, of politics, of the body) emerges against the negative example of prostitution. Where figures of prostitution (figures that represent an extremely alienated relationship to their work, to their own bodies) operate for some writers and artists (Walter Benjamin, Zola, Manet) as productive if sometimes melancholic allegories for the work of the artist, for many critics of the period, figures of prostitution rise up like demons—fallen angels who warn the would-be artist by negative example.

I have developed the phrase "rhetoric of prostitution" to describe the ways that the artist, art object, and reader/spectator are represented in (especially) criticism as participating in an illicit sexual exchange.[29] In the rhetoric of prostitution, money and sex move along a Möbius strip. We have the impression that they exist on separate planes, but as we chase these terms we find that these separate planes are one and the same. The whore or the act of prostitution appears in criticism not only as a condensation of art's relation to the market but as a mixture of money's stigma of the abject, as well as the aura of the sexual that clings to scenes of exchange. Georg Simmel describes the circulation of these qualities around both money and the prostitute in *The Philosophy of Money*: "We experience in the nature of money itself something of the essence of prostitution. The indifference as to its use, the lack of attachment to any individual because it is unrelated to any of them, the objectivity inherent in money as a mere means which excludes any emotional relationship—all this produces an ominous analogy between money and prostitution."[30] When Simmel writes that we find "the essence of prostitution" in "the nature of money itself," it is, really, another way of saying that "money itself" has no essence, no ontological ground. He uses a set of assumptions about prostitution (as devoid of love or feeling, as nonprocreative, the prostitute imagined as both diseased and sterile) to describe the devastating effects of money on the individual's understanding of his or her own value.

The rhetoric of prostitution manages the same problem in the work of art— the anxiety that it has no inherent value, no value outside relations of exchange.

It works rhetorically to contain the fear that this lack is contagious, routing the lack at the heart of the art object through discourses that would appear to be external to aesthetics. In reaching for some standard according to which he can judge the text at hand, the critic borrows from a language of sex and desire to represent its value to the reader, or from a language of money and investment. Or he uses these same words and images to prove the artist's corruption and the art's worthlessness. The moment the critic tries to discern a stable, internal origin of aesthetic value, it is indeed hard *not* to use discourse on money, or sex, in the movement toward judgment.

When a critic describes an artist as engaging in a form of prostitution and asserts this in a lament about the decline of culture, he draws the pejorative energy of his rhetoric from a pathology of prostitution to negotiate the question of what art is and is not, and of what art ought to do.[31]

By the late nineteenth century it was commonplace for writers and artists to describe themselves using these terms. Thus when the French naturalist writers, the Goncourt brothers, for instance, deride popular novels as "spicy little works, memoirs of street-walkers, bedroom confessions, erotic smuttiness, scandals that hitch up their skirts in pictures in bookshop windows," they not only align the writing of the sensation novel with prostitution, they confuse the sensation novel itself with a prostitute—as if to pick up such a book is to answer to a whore's solicitous display of her body.[32] Such confusions of figures of speech—in which a book becomes a picture, which becomes a woman's body—indicate how overdetermined the figure of the prostitute is. Without missing a beat, she can be symptom and then disease, agent and then victim. The French painter William-Adolphe Bouguereau complained, for instance, that the market forced painters to "prostitute themselves" and that the intrusion of the market into the art world forces artists to abandon their "dedication to the 'high' goals of art" in favor of their "professional survival."[33] The American novelist Frank Norris similarly asserts that the authors of popular fiction are "copyists . . . fakirs—They are not novelists at all, though they write novels that sell by the hundreds of thousands." He continues, "If they are content to prostitute the good name of American literature for a sliding scale of royalties—let's have done with them."[34] The perceived erosion of an aristocratic system of patronage that underwrote the production of art and literature and its replacement with a marketplace, whose rules are determined more by popular taste than by an ethical imperative (always already underwritten by class interest), set one system of value (aesthetic) against the other (economic). Or, to rephrase the problem somewhat differently, the development of an art market—in substitution for a system of explicit patronage—set into motion a nostalgic longing for a time when the artist's relationship to his work was (or at least appeared to be) less mediated.

The prostitute's appearance in complaints about the state of the arts exploits her significance as a living commodity. She dramatizes anxieties about the struggle to reconcile the need for an audience and for money with an aesthetic

standard of value that measures artistic worth in terms of its distance from the pecuniary. In short, artists and authors felt that, like a prostitute, they were being forced to attach a price to something that is not supposed to have a price at all: art in the case of the artist, sex in the case of the prostitute. We therefore find that prostitution, the practice of mixing things that are supposed to be kept separate (sex and money), emerges as the negative ground against which critics might assert the autonomy of art, the independence of aesthetic value from the economic, the political, or the sexual.

I would like to make clear, however, that the rhetoric of prostitution is not simply criticism that explicitly represents the artist as a prostitute or as a sexual degenerate. I use the phrase to mark a shift in discourse on art, in which the *most* important aspect in determining an artwork's aesthetic worth is the attitude it appears to take toward the act of being sold.

The prostitute plays a crucial function in critical writing about the state of the arts, even when she is only a shadowy presence: even—or especially—when she is unnamed, standing on the periphery, she serves as a powerful negative example. In another passage from his essay, Norris offers the following advice to the would-be writer: "The man must be above the work or the work is worthless, and the man better off at some other work than producing fiction. The eyes never once should wander to the gallery, but be always and with single purpose turned *inward* upon the work, testing and retesting it that it rings true."[35] This is the kind of prescription that I am most interested in—this is the pose that Warhol inverts. Norris imagines the writer as an actor on the stage and also, implicitly, as a body up for sale. He argues, however, that the "true novelist" will maintain for his audience (and presumably for himself) a suspension of the knowledge that his "work" is a paid performance. Here, Norris advocates for a literary version of what Michael Fried described as "the primacy of absorption."[36] To produce "good" fiction, the writer must visibly perform the disavowal of the audience's presence. His words resonate as well with a general prescription for the proper attitude toward the work of art in general—for the good critic, the disciplined spectator, the careful reader, to keep his eyes "upon the work" and away from "the gallery."

Within the logic of a rhetoric of prostitution, the artwork's aesthetic value is therefore often denounced for having the "wrong" relationship to the market. For Norris, the difference between a popular novelist (whom he hardly considers a novelist at all) and a good novelist is that the former appears to play to the audience's desires. The former's self-presentation is openly solicitous. The latter appears absorbed in the world of his own work and ignorant of the gallery of eyes watching him. He works for the same crowd as the "fakir," but, like Bouguereau's traditional female nude, at once demure and utterly content in her nudity, Norris's writer wears his modesty as a shield.

In his 1908 essay "The Man of Letters as a Man of Business," William Dean Howells (editor of the *Atlantic Monthly* and a primary arbiter of literary tastes at the turn of the century) reveals a similar understanding of the artist's

dilemma: "I do not think any man ought to live by an art. . . . There is an in-stinctive sense of this, even in the midst of the grotesque confusion of our eco-nomic being; people feel there is something profane, something impious, in tak-ing money for a picture, or a poem, or a statue. Most of all, the artist himself feels this. He puts on a bold front with the world, to be sure, and brazens it out as a business; but he knows very well that there is something false and vulgar in it; and that the *work* which cannot be truly priced in money cannot be truly paid in money. . . . The artist can say that . . . unless he sells his art he cannot live . . . and . . . this is bitterly true. . . . All the same, the sin and shame remain, and the averted eye sees them still, with its inward vision."[37] The artist finds himself longing to convert aesthetic value into a pecuniary form to ensure not only his own survival but the survival of the work, as a precious object, into the future. But once the artist turns his time as an artist into money, the artwork becomes "false," "vulgar," and "profane." Note the recurrence of the posture Norris prescribes (eyes "always and with single purpose turned *inward* upon the work") in Howells's words: the "averted eye" that sees "the sin and shame" of his situation "with its inward vision." Howells acknowledges that the scene of art production is so saturated with the market that there is no sanctuary: the artist's turn "*inward* upon the work," to ensure that "it rings true," is ultimate-ly, for Howells, an act of bad faith. "The sin and the shame remain" no matter how deep into the work of art the artist attempts to retreat. The only decent position available to him—and this is the posture that Howells suggests the art-ist adopt—is as a reluctant participant in the marketplace.

Like other writers of his generation, Howells imagines the artist as caught in the same double bind as women—in which their worth is ultimately derived from an equation that requires them to sacrifice their integrity. He writes: "It does not change the nature of the case to say that Tennyson and Longfellow and Emerson sold the poems in which they couched the most mystical messages their genius was charged to bear mankind. They submitted to the conditions that none could escape; but that does not justify the conditions, which are none the less the conditions of hucksters because they are imposed upon poets."[38] Throughout his criticism, Howells struggles with the implications of his posi-tion: to imagine the artist in this relationship to the market is to imagine his work as deeply feminized. For example, he worried that the writer's dependence on a market would inevitably lead to the feminization of American literature, not only because the act of selling one's art amounts to a kind of prostitution but because the primary consumers for literature are women: "The man of let-ters must make up his mind that in the United States the fate of a book is in the hands of women. It is the women with us who have the most leisure, and they read the most books. . . . If they do not always know what is good, they do know what pleases them, and it is useless to quarrel with their decisions, for there is no appeal from them."[39] His concern, furthermore, is not only that it is women who read but that women read differently. Women engage in the vora-cious, addictive reading of popular novels and sentimental fiction, a kind of

reading practice Howells sees as "the emptiest dissipation, hardly more related to thought or the wholesome exercise of the mental faculties than opium eating."[40] Howells famously reproduced this debate about popular literature and women's reading habits in his novel *The Rise of Silas Lapham,* in which dinner party guests discuss a popular novel called *Tears, Idle Tears*—the title alone stands as an implicit critique of the sentimental novel.[41]

Against something like *Tears, Idle Tears,* Howells recommends a fiction "of real usefulness" to combat the denigration of writing by its association with women and money. His description of useful or productive literature is deeply structured by a reactionary need to reassert the artist's masculinity, because at every turn the artist's work begins to look like women's work. Howells offers, as an antidote, a masculinized version of writing, in which it is imagined as a form of production and positioned as far from the world of consumption as possible. He writes: "A man's art should be his privilege, when he has proven his fitness to exercise it, and has otherwise earned his daily bread." He recommends manual labor to the artist, as necessary to building his strength and self-reliance.[42] This kind of work experience steels the writer against the luscious exchange between author and audience. With manual labor the artist will develop a worker's calluses—this thickening of his skin will, Howells imagines, work as a buffer against the overwhelming sensuality of market culture—a marvelous confusion, as if the one thing (the toughness one develops in response to regular encounters with physical difficulty) ever necessarily translates into the other (an indifference to the sensuousness of advertisement, of popular culture, of celebrity, fame, and wealth). For Howells (as it was for Eakins and other artists of the period), aesthetic integrity is synonymous with physical vigor—it is the product of the well-conditioned body.[43]

While casting the artist's work in terms of manual labor, Howells carefully explains that he does not mean the sort of work that women do. The "the art of fiction" is not related to "the rudest crafts that feed and house and clothe." This is a striking contradiction: Howells borrows from ideas of privilege, fitness, and natural right to secure the value of cultural production as a kind of labor, as a kind of work, but nevertheless defines art against domestic labor. The association of women with the work of reproduction is strong enough for Howells to avoid placing his artist in relation to it, and to force Howells to look for a haven in the factory and in the working-class masculinity that would later be a template for Jackson Pollock's rise to celebrity (for example).[44]

One might say that recommending the labor of the worker over the labor of the wife as a more suitable model for the artist goes against all that Howells has argued. The laborer sells the product of his hands just as the artist does. How could such an experience function as a refuge from the pressures of the market, from the experience of money as the thing that gives your work value? And whence the disdain for the "rudest crafts" of the home, if not from a deeply anchored disdain for the work of women: after all, what sort of work eludes the market more effectively than the continually unpaid labor of the wife?

Howells's acrobatic negotiation of the interface of art and work brings the following problem to our attention: underneath narratives about "good" and "bad" relations to the market are deeply gendered narratives about the value of women's work.

Implicit in Howells's concern with the seduction of the artist by the romance of money is the equation of an artist's integrity with a woman's virtue.[45] The rhetoric of prostitution holds out the possibility of a pure, innocent relation to art as an ideal that one must work toward. The commodification of the art object is represented as, at best, a regrettable process, a necessary evil that the artist must somehow transcend. The rhetoric of prostitution is a postlapsarian lament—restoring authenticity to aesthetic experience by decrying its loss. As such, it is a distinctly modern (and bourgeois) jeremiad. The value of a work of art is, within this model, supposed to be intrinsic—it is supposed to transcend popular taste into a realm of classic, timeless, universal value.[46] A balance of formal harmony and ethical purpose is supposed to be the source for an aesthetic value that precedes any price one might attach to a work of art. The prostitute offers herself as the embodiment of all of the things drained from the work of art—sexual interest, money, and the public's demand that its desires be met at any cost to the people whose time and labor are invested in the objects the public consumes.

These kinds of assumptions about the whore's sexuality frame Simmel's discussion of prostitution in *The Philosophy of Money*. He offers the following insight into the modern public's discomfort with prostitution: in selling sex, the prostitute interferes with the social negotiation of the difference between "personal value," or the degree to which each person is seen as a unique individual, and monetary value, which erases all difference by rendering all things fungible. The bourgeoisie, in Simmel's argument, is disturbed by prostitution because of the sex industry's reversion to a precapitalist, premodern economy that did not place a premium on the individual at all and could therefore, for instance, practice slavery. Prostitution exposes the worst elements of a money economy because in prostitution both parties disregard the enlightenment imperative "never to use human beings as a mere means." The "mutual degradation" of the sex-for-cash exchange grows, for Simmel, not only from the debasement of the sex act (in the dissociation of sex from the expression of love or the reproduction of the family) but from the shameful insight it brings to all relations of exchange—the whore exposes as an empty promise the prohibition against treating people as things. The prostitute "degrades" both the sanctity of a woman's sex and the value of each individual subject by asserting that a woman's virtue is worth less than the money she might earn by selling it.

We might take this to mean that the figure of the prostitute is useful for launching a critique of the hypocrisy of the enlightenment imperative not to "use human beings as a mere means." But, for Simmel and other social theorists of this era (like, for instance, Thorstein Veblen), the ability for the figure of the prostitute to throw the difference between personal and economic value

into such extreme relief is grounded in problematic assumptions about women's relationships to sex. Simmel extracts a moral imperative against prostitution—as the practice that is the *most* exploitative (more exploitative than, for instance, child labor)—from naturalized assumptions about the difference between men and women. He writes: "The purely sexual act that is at issue in prostitution employs only a minimum of the man's ego but a maximum of the woman's." Simmel's discussion of prostitution is in fact deeply informed by an understanding of the woman who traffics in sex as an always already corrupted subject. He writes that the "prostitute has to endure a terrible void and lack of satisfaction in her relations with men," hence "the frequently reported cases of lesbianism among prostitutes."[47] The whore's problem, in Simmel's view, is that she has abandoned all will—she no longer chooses whom she sleeps with because, on some level, she no longer cares (and therefore, he writes—echoing Freud—she becomes a lesbian not by desire but by default).

My point here is that the rhetoric of prostitution in criticism rests on a misogynist discourse about women. Not only is this rhetoric misogynist, it is also tautological. The critic needs to check the loss of an epistemological ground for determining the art object's aesthetic value—a loss set into motion by the assignation of a monetary value to it. He shores up the category of art with the prostitute—a figure *against* which he can define the work of the artist. When a critic uses the rhetoric of prostitution, he applies the moral outrage that the public might be expected to have about the corruption of a woman, of womanhood itself, to something the public might not be very concerned with at all (the commodification of the art object). In reviewing the case of Andy Warhol, we find that much post-Pop art has been pushed to this limit: the annunciation of art as always already compromised becomes the very thing that makes it interesting to the art market (as in the case of Vanessa Beecroft).

The depiction of the artist as in danger of being romanced by the promise of wealth and fame can be thought of as an extension of the seduction narratives that structured novels of the eighteenth and early nineteenth century. "The female was the figure, above all else," Nancy Armstrong observes, "on whom depended the outcome of the struggle among competing ideologies. For no other reason than this could Samuel Richardson's novel *Pamela* represent a landowner's assault upon the chastity of an otherwise undistinguished servant girl as a major threat to our world as well as hers."[48] In those romances, a woman's survival appears to hinge on the surrender of her virtue/virginity, which she manages to preserve by proving her self (if not her body) impervious to the base demands of her seducer. Her struggle, contrived as it is, manifests itself as an elastic coupling and uncoupling of self and body. The heroine at some point dissociates her "true worth" from the condition of her body, and in doing so discovers a power over herself that no master can claim.[49] The honor at risk here in the rhetoric of prostitution belongs not to a woman but an artist, to the painter or writer who would prefer to keep his honor but cannot.

Norris's and Howells's rhetoric taps popular sentiment of the turn of the

century. Both of their essays resonate with the moral outrage circulating at that moment around urban prostitution and sensational reports of sex trafficking or, as it was then known, "white slavery." During the decades in the nineteenth century when the use of the prostitute as an allegorical stand-in for the modern artist was gaining momentum, American and British reading publics were perpetually whipped into frenzies over the social disease of urban prostitution—which American journalists and public health officials represented (only a few decades after the end of the Civil War, and at the height of the antilynching campaign) as "the greatest crime" in world history.

Until the mid-nineteenth century, the sex industry was understood as a necessary evil not unlike sewers, and the only answer to the question of why women engaged in prostitution was that these women who sold themselves did so in expression of an inherited depravity. In fact, the first serious chronicler of the modern urban sex industry, the French health official Alexandre Parent-Duchâtelet, was himself an expert on the link between sewage treatment and urban hygiene. His 1836 encyclopedic study of prostitution (the first modern analysis of the subject) is an extension of his work on the treatment of waste. Prostitutes, Parent-Duchâtelet argues, are an inevitable product of the city. Their activities must be scrutinized at every level because they pose "the most dangerous [public health threat] in society," more dangerous than open sewers and improper disposal of offal.[50] Commensurate with this view on prostitution was the enforcement of, for example, in England, the Contagious Disease Acts—which generated lists of suspected prostitutes whom the state could track, and supported the forced examination of these women identified as prostitutes as a way to curb the spread of venereal diseases (the end result, given the absence of sterile equipment, however, was the opposite).

Toward the end of the nineteenth century, the figure of the inherently diseased, internally corrupt prostitute was reinvented by the British journalist W. T. Stead, when he rewrote the subject of urban prostitution as a form of "white slavery." In 1885 the London newspaper *Pall Mall Gazette* published Stead's infamous series, "The Maiden Tribute of Modern Babylon." The product of a "secret commission" (Stead's own undercover reporting), these stories describe in lurid detail the traffic in women—especially young white women and girls sold into prostitution by dissolute and abusive working-class families. "The Maiden Tribute" sold countless copies in England and created a huge sensation in the United States as well.[51]

"The Maiden Tribute" is not about corrupt women who turn to prostitution from a congenital flaw. For Stead and his contemporaries, "the characteristic which distinguishes the white slave traffic from immorality in general [meaning from women who engage in prostitution out of their own dissolution or lassitude] is that the women who are the victims of the traffic are *forced unwillingly* to live an immoral life."[52] The women in these stories are "innocent victims." They are "snared, trapped, [and] outraged, either when under the influence of

drugs or after a prolonged struggle in a locked room," then sold or seduced without an understanding of the nature of the exchange. These reports sparked major reform movements in England and in the United States—which, interestingly, resulted in the eventual repeal of the Contagious Disease Acts and the passing of age of consent laws, as well as the articulation of late-nineteenth-century feminism. These reports were, furthermore, so sensational that they themselves were targeted by an outraged public that found them so inflammatory in their descriptions of the sexual violation of girls as to be obscene.

To return to Howells's essay, by the time the editor of the *Atlantic* writes "The Man of Letters as a Man of Business" (in 1898) the congenitally diseased whore who had so preoccupied early- and mid-nineteenth-century city health officials and sexologists had been upstaged in the public imagination by the "white slave"—the woman abused by circumstance. This revision of the character of the prostitute makes it possible, even desirable, to look to her condition as analogous to that of the writer or painter who must make a living. Like the woman "drafted" by the white slave market, the artist whom Howells describes is a reluctant whore. Howells in particular takes the moral outrage at the subject of "white slavery" as an unquestioned assumption and uses it to fuel the rhetorical strategy by which he announces the intrusion of money into the mise-en-scène of the artist's or writer's studio as a problem.

The rhetoric of prostitution is a permanent shadow of the ideology that imagines the aesthetic as removed from the concerns of the everyday, the personal, the libidinous, and the political. It works in the neighborhood of the high modernist slogan, "art for art's sake," in the attempt to ward off its antithesis ("art for profit").[53] The rhetoric of prostitution plays out a crisis in the determination of the value of art as a crisis in economic and sexual relations between people. The exchange of money for art is allegorized by a woman who takes money for sexual favors, and soon enough we find the collapse of two different kinds of seduction in discourse about the corruption of art by things feminine, by mass culture, by the seductive appeal to a mass audience's basest desires. Figures of prostitution embody the always already overdetermined association of women and money with negativity, lack, and nothingness. The image of the prostitute, furthermore, holds together the contradictions inherent to the art market. The whore is, Walter Benjamin writes, "commodity and seller in one."[54] In the prostitute, "both moments [of production and consumption] remain visible" in contrast with the display of the object for sale, in which "every trace of [the] wage labor who produced the commodity is extinguished."[55]

For Howells—or, more fairly, for the traditions of aesthetic judgment in American criticism that I take him to represent—aesthetic value is derived from the transcendence of processes of objectification. The category of "art" is, however, only visible against the negative ground of the market, personified as the sexually debased woman. The fantasy of the art object that exists independently from economic relations is itself a product of that market.

Pop Art/Pop Sex

Warhol "loved porno" and "bought lots of the stuff all the time—the really dirty, exciting stuff."[56] He took explicit photographs of male genitalia throughout his career and produced several silk-screen prints from photographs of gay sex (one of which hangs in MJ's, the local gay bar in my neighborhood). Responding in his diary to a complaint he missed a luncheon appointment because he was "just down at Chris's [Makos] to make male porno photographs," Warhol explains that of course he was, "but it was for *work*! I mean, I'm just trying to work and make some money. . . . I mean, the porno pictures are for a *show*. They're *work*."[57] Throughout his career as an artist, Warhol was asked to defend his work against the charge of pornography. Thus he does not balk when in an interview for *Vogue* Leticia Kent outed him as a pornographer:

> KENT: *Blue Movie* has recently been declared "hard-core pornography."
>
> WARHOL: It's soft-core pornography. We used misty color. What's pornography anyway? The muscle magazines are pornography, but they're really not. They teach you to have good bodies. They're the fashion magazines of Forty-Second Street—that more people read. I think movies *should* appeal to prurient interests. I mean the way things are going now—people are alienated from one another. Movies should-uh-arouse you. . . . I really do think movies *should* arouse you, get you excited about people, should be prurient.[58]

Blithely ignoring the line between art and porn, Warhol offers a case for the "social" uses of porn, contradicting the rhetoric of his critics at the very moment he agrees with them. Yes, his work is pornographic. But art "should appeal to prurient interests" because "people are alienated from one another" and porn gets you "excited about people." When asked if this approach to art as a mechanism for "arousing" people contradicts his famous declaration of wanting to be a machine, Warhol retorts: "Prurience is part of the machine. It keeps you happy. It keeps you running."[59] At nearly every level of his work, Warhol challenges and parodies the fantasy of artistic production as original, unmediated expression.

Mechanization and mediation are not obstacles to being "excited about people" but the very mechanisms by which that arousal happens. These answers to the charge of pornography look to his critics like hopeless cynicism. But from a different angle his refusal of the fantasy of unmediated exchange looks like an incredible optimism about what art, as mediated exchange, can do.[60]

The relationships between sex, work, and art are as important to Pop as they are problematic. Nothing in the film *Flesh* (Warhol and Paul Morrissey, 1968–69), for example, lines up "straight." The equations by which heterosexuality, marriage, love, and reproduction are derived from one another are irrelevant to *Flesh*'s hustler Joe (played by Joe Dallesandro) and his family. Joe

supports his wife by having sex with men; Joe's wife has a lesbian girlfriend, who is pregnant but is not having the baby—Joe is paying for the (illegal) abortion. The network articulated around the hustler redefines and confounds any received ideas about what a family looks like, what work is, and what sex means.

Sex, art, and money are all part of the same economy in *Flesh*. This film—like many of Warhol's more narrative works—acts out the capriciousness of the categories of art and work around the figure of the hustler. As it scripts artistic exchange as the setting for erotic, sexual exchange and frames both as kinds of economic activities, *Flesh* dramatizes some of what Warhol may have meant when he said that art "should appeal to prurient interests." The hustler's relationship to work unravels the category itself.

Take, for example, one scene in which an older john (Maurice Bradell) cruises Joe, and initiates the following exchange:

> JOHN: Do you know anything about art?
> JOE: A little. I did a little modeling.
> JOHN: Now, isn't that strange. That's exactly what I had in mind when I saw you. [Pause.] How much do you think you're worth?
> JOE: One hundred dollars.
> JOHN: One hundred dollars? For that you'll have to take your clothes off.

Here the query "Do you know anything about art?" is the perfect solicitation because of the expansiveness and ambiguity of "art" as a category. In this exchange, "art" becomes a euphemism for sex and, specifically, for sex that you pay for. Once they have negotiated the terms of their econo-erotic exchange, Joe goes to the john's apartment where, scantily clad, he models classical poses for his customer, who bores him with lengthy but enthusiastic musings on how "body worship is the whole thing behind all art, all music, and all love." In a double-reverse take on artistic production, the artist is positioned as a john/consumer, who then proceeds to do most of the work—if what we mean by "work" is activity—as he philosophizes, sketches, and directs the hustler, who, in turn, poses and looks bored.

Dallesandro's affect of boredom and disinterest (an affect often attributed to Warhol himself) is what, on the street, translates into the look of unavailability that makes him a good hustler. This element of his look prompted Stephen Koch to theorize that "the hustler, identifying himself as the sexuality of his flesh and nothing more, proposes himself as a wholly passive and will-less being, subject exclusively to the will of others."[61] The hustler, furthermore, turns the opposition passive/active inside out. Often it appears as if most of the energy expended in the film goes into consuming Dallesandro. Yet even when it looks as if he does nothing or as if his customers are doing all the work—painting, talking, or giving him a blow job—he is the one getting

paid for it. David James foregrounds the hustler's demeanor as a kind of "self-presentation" so as to draw out how that very appearance of "extreme passivity" itself constitutes a kind of performance.[62] Gayatri Spivak's neologism "actively passive" (which she uses to convey the work that goes into the performance of a faked orgasm) gives us some traction on the slippery slope of agency within these scenes of posing and on the complicated place of agency in Warhol's own relationship to his work.[63] In thinking of the hustler as "actively passive," we can read his affect not as a mask that hides or denies a true self but as a strategic gesture, a pose that clears the space for his work, a pose that, indeed, is his work.

The hustler's pose, framed by an economic exchange, enables the disavowals (the hustler's "I'm not queer, I do it for the money," or the john's "I'm not queer, just ask my wife") that anchor the positions of both participants.[64] That the hustler is getting paid makes what he does "work." And because he does what he does for money means that it is not "real" sex, at least not sex that might make him "queer." These disavowals are equally important to the john—because he pays for sex, it similarly doesn't "count" except as something he bought (as if this means it wasn't what he wanted).

Hustling and prostitution are practices that insist on sex not as an expression of congenital identity but as "trade." Anything that produces money is work, and thus whatever you do for money you can disavow as just work. The presence of money in any exchange renders that exchange a kind of prostitution, because each time you accept money for something that you do, you, in a sense, sell yourself. Warhol reverses the truism that all kinds of paid labor are forms of prostitution to suggest that there is *no* sex that is *not* work and, by extension, that sex work is not some kind of exception (and therefore sex that does not "count") but is, instead, paradigmatic. Thus the hustler's second axiom on sex work and the work of sex: "Nobody's straight—you just do whatever you have to do." Here, Warhol's art, as it luxuriates in this exchange and its slippage, is not attacking the "heterosexual dollar" (as one early reviewer, citing Allen Ginsberg, put it) so much as it suggests that the dollar itself is a queering thing.[65]

Warhol's "Crazy Golden Slippers" (as *Life* called his early shoe drawings) also luxuriates in the overlapping and excessive meanings of sex, work, and art. Whether Cinderella's pumps revised for Zsa Zsa Gabor and Truman Capote or Dorothy's ruby slippers worked as *Diamond Dust Shoes* (1986), his shoe portraits wrap a rendition of the incoherencies and complexity of authorship in a visually indulgent celebration of one of femininity's most necessary accessories. By-products of his illustrations for I. Miller & Sons Shoes, the shoe drawings were Warhol's work, his "bread and butter."[66] Their painstaking detail imitates the work of the sewing machine—a mimetic relation he emphasized by visually likening his line drawings to the stitches produced by

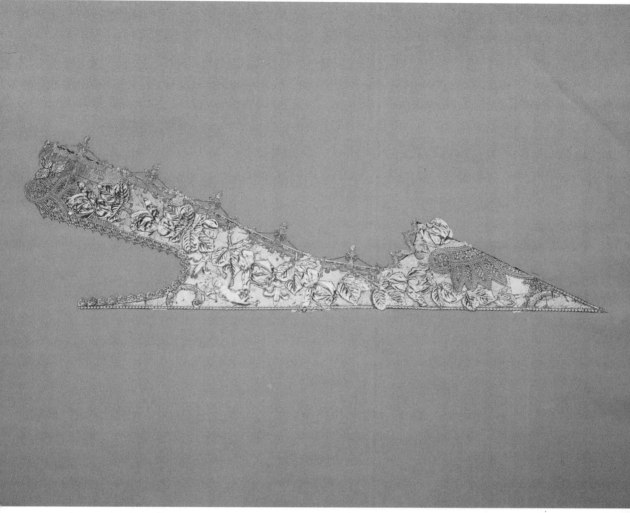

Figure 6. Andy Warhol, *Large Woman's Shoe,* 1950s. Founding Collection, Andy Warhol Museum, Pittsburgh. Copyright 2004 Andy Warhol Foundation for the Visual Arts/ARS, New York.

a sewing machine. They accomplish what Tina Fredericks, as the art director of *Glamour,* asked of them: "They have to look neat, have to 'sell'; you have to see every stitch, you have to really want to wear them, or be able to tell what they're like."[67] The dainty and precious details of these drawings reference machine-made fingerwork and set into motion a confusion of hands and machines.

It also metonymically signals another kind of enterprise, the involved work of wearing these kinds of shoes. Walking in a pair of heels is an acquired skill. The work embodied by the fantastic heels of *A la Recherche du Shoe Perdu* lies in walking in them. On the runway, the well-trained supermodel walks

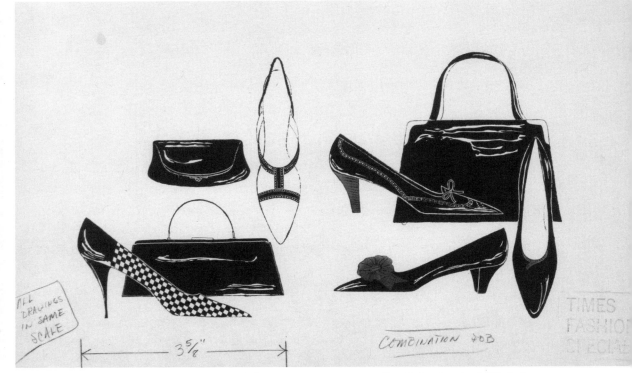

Figure 7. Andy Warhol, *Five Shoes and Three Purses,* 1950s. Founding Collection, Andy Warhol Museum, Pittsburgh. Copyright 2004 Andy Warhol Foundation for the Visual Arts/ARS, New York.

toe to heel, an awkward step, but one that makes you swat your hips and lift your knees in a runway sashay that constitutes the performance of high-fashion femininity.

Remarking on the amount of energy required by this kind of performance (specifically, the work of drag), Warhol once said, "Being sexed is hard work." Part of the appeal of Warhol's use of the term *work* is that it can accommodate a range of activities that are generally thought of in opposition to work—even pleasure is a production, when we, like Warhol, consider that "having sex is hard work." "Being sexed" is "so much work at something you don't always want to do."

Behind the syntax of statements like "having sex is hard work" and "being sexed is hard work" is a complex assertion about the strangeness of "sex." The actively passive syntax of these maxims reproduces the difficulty of sorting out who we are from what we do by clouding the difference between subject and object, between noun and verb. How a subject performs being sexed and having a body is a question that orients a major tradition in theoretical work on gender identity, from Joan Riviere's assertion that "womanliness" is

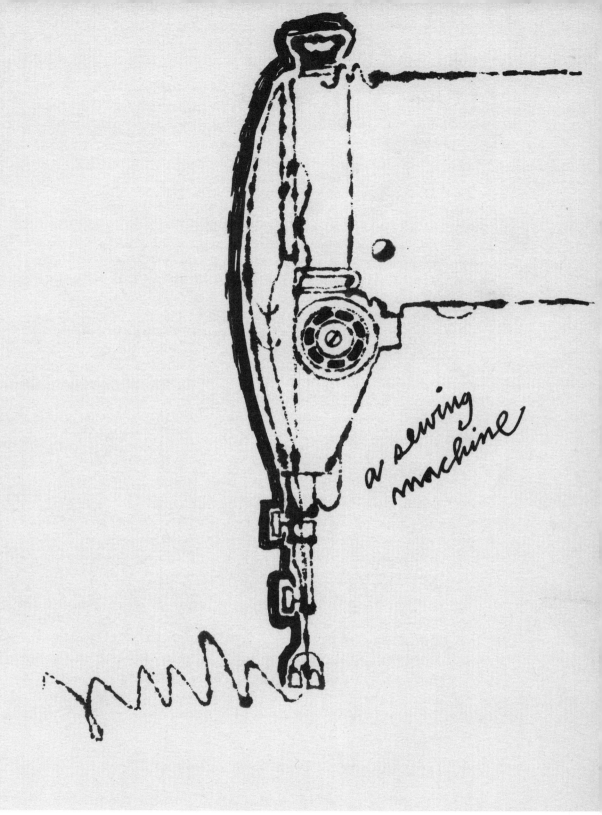

a sewing machine

Figure 8. Andy Warhol, *Sewing Machine Detail,* c. 1952. Founding Collection, Andy Warhol Museum, Pittsburgh. Copyright 2004 Andy Warhol Foundation for the Visual Arts/ARS, New York.

"masquerade" to Simone de Beauvoir's more widely referenced "women are not born, they are made" and to Judith Butler's often-cited arguments: "There is no gender identity behind expressions of gender; that identity is performatively constituted by the very 'expressions' that are said to be its results," and "Gender is always a doing, though not by a subject who might be said to preexist the deed."[68] All these theorists problematize the relationship between agency and the constitution of gender identity. Butler's work, as it advises us to be wary of formulations of identity in terms of presence or absence of will, seems especially salient for reading Warhol, given the ambiguous place of agency in his work and the frequency with which his relationship to will, desire, gender, and sexuality has been pathologized by his critics. Like Warhol's superstars, who in *Esquire*'s words "are neither born nor made," who "just happen," the Pop subject "happens" within and through its queer grammars.[69]

The ambiguity of Warhol's syntax is by no means limited to his aphorisms. The very way he made his work reconfigured agency so as to make saying how Warhol actually created or authored his art not only difficult but also in many ways irrelevant. He deliberately tinkered with melodramas of authorship and boasted that his art-making process was so routinized that, ideally, no matter who followed the routine, the result was the production of a Warhol. "I want to be a machine" announces what James identifies as Warhol's "most characteristic authorial gesture," the "erasure of authorship."[70] Or, as James himself argues when he suggests we think of Warhol as a kind of producer, Warhol's most characteristic authorial gesture was to insist on authorship as itself an effect.

Many have argued that it is unproductive to read even the accidental marks on the canvas of a *Marilyn Monroe*, for instance, as the return of a repressed authorial presence.[71] Its overlapping and disjointed layers of color and image draw attention not to the movements of the artist's hand but to the accidents of the layered mechanical reproduction definitive of Warhol's style (photography and silk screening). Warhol's painted but paradoxically not painted face replaces a fantasy of unmediated self-expression with the manufacturing of a "painted woman." Making a joke of a long tradition in painting of acting out struggles with self-expression and quests for encounters with the "real" or the authentic in representations of the sexualized, often prostituted, female figure,[72] *Marilyn Monroe* enacts a parody of the fantasy of authorship, a parody of gender identity, and, furthermore, a satire on the heteromasculine tradition of using images of compromised women as object to the heroic subject of art (Manet's *Olympia*, Picasso's *Les Demoiselles d'Avignon*, Willem de Kooning's *Woman* series).

Like Warhol's shoes that mimic the work of wearing high heels in their highly wrought detail, the celebrity portrait maximizes the slippage of the mechanical production of the work of art to underscore the degree to which being sexed is a kind of work, is something that is itself produced. The "painted woman," to borrow Butler's words, is not an artificial version of the real thing

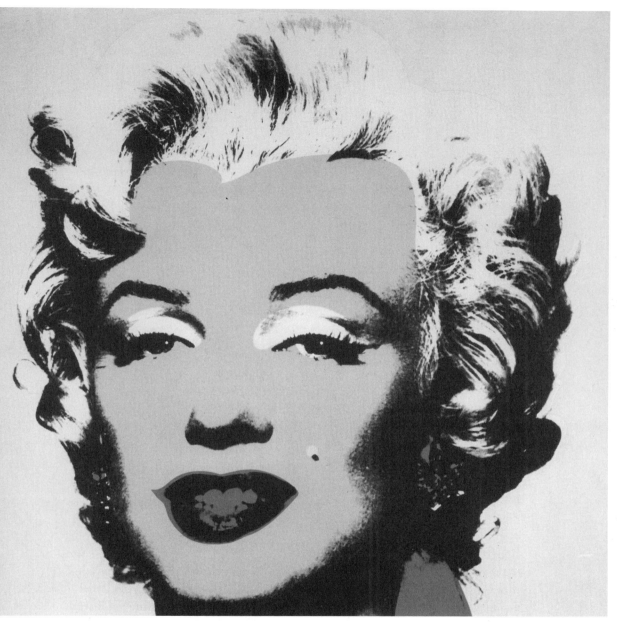

Figure 9. Andy Warhol, *Marilyn,* 1967. Andy Warhol Museum, Pittsburgh. Copyright 2004 Andy Warhol Foundation for the Visual Arts/ARS, New York.

but a parody of "the very notion of an original. . . . It is a production which, in effect—that is, in its effect—postures as an imitation." *Marilyn Monroe* is so overdetermined as "produced" (rather than authored) as to suggest what Butler has formulated as "the imitative structure of gender itself."[73] The "painted woman" amplifies, in its effects, the authorship of art and the authorship of gender *as* effects.

Warhol explicitly ties the discursiveness of authorship and of gender in *Forged Images: Centerfold by Andy Warhol,* a special project Warhol designed for *Artforum.* In the center of the magazine on opposing pages are a dollar sign (borrowed from the 1981 *Dollar Sign* series) and Christopher Makos's photograph of Warhol in drag (in citation of Duchamp). This arrangement of drag and the dollar toys with the format of the centerfold. The spread is not an unveiling of Warhol that establishes a real, original, identity underneath the drag. Unfolding the page yields three panels from the *Dollar Sign* series for a total of three dollar signs. In short, *Forged Images* juxtaposes what Trevor Fairbrother noted as "the things about [Warhol] that most bothered most people"—his commercialism and his fagginess.[74]

His drag queerly adopts a range of gender affiliations at the same time— femininity (the wig and makeup), mannishness (the jeans, the shirt, the tie), and girlishness (the pose). The mundane "look" of Warhol's drag in Makos's photograph and the refusal to disavow the dragness of his drag dramatize what Butler, drawing on the work of Esther Newton, has described as the principal property of drag, that is, "not the putting on of a gender that belongs properly to some other group, i.e. an act of *ex*propriation or *ap*propriation that assumes gender is the rightful property of sex, that 'masculine' belongs to 'male' and 'feminine' belongs to 'female.' . . . Drag constitutes the mundane way in which genders are appropriated, theatricalized, worn, and done; it implies that all gendering is a kind of impersonation and approximation."[75] Butler's words underscore the banality of Warhol's drag and the curiously flat-footed title of the centerfold, *Forged Images.* As if confirming her argument, the spread unveils no "doer behind the deed" but instead offers us dollar signs—an abstraction, furthermore, the symbol for U.S. exchange itself—as what is behind or inside Warhol's drag.[76] The rhetorical force of the juxtaposition of drag and the dollar is to make even more visible the status of gender as "produced" by framing it as both "drag" and "work." In doing so, Warhol suggests an interesting homology between drag and his self-representation as an artist.

The conjunction of drag and the dollar in an art magazine likens both being sexed (the work of drag) and selling sex (what a centerfold does) to art. Thus Warhol divulges the open secret of art, that it is something also done for money. *Forged Images* formally recalls a porn centerfold, playing on all the promises a centerfold offers its consumers: the promise of seeing someone undressed, something "dirty."

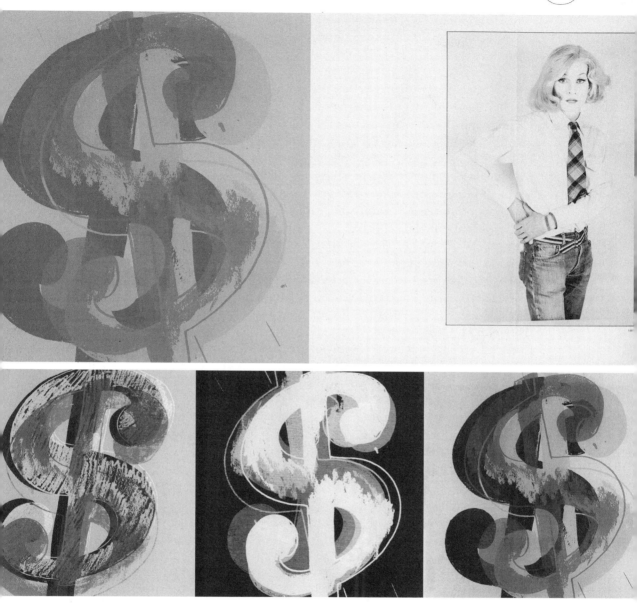

Figure 10. Andy Warhol, *Forged Images,* special project designed for *ArtForum,* 1982. Copyright 2004 Andy Warhol Foundation for the Visual Arts/ARS, New York. Portrait of Andy Warhol by Christopher Makos.

In offering dollar signs as the art world denuded, Warhol's centerfold enacts a version of one of his most-often recalled fantasies about art: "I like money on the wall. Say you were going to buy a $200,000 painting. I think you should take that money, tie it up, and hang it on the wall."[77] The irony, of course, is that he did not hang a bag of money on the wall. That would be

beside the point. The *Dollar Sign* series makes visible how even when Warhol manufactures "painted" money, it has value on the market only insofar as it is "painted," insofar as it is, in a sense, a forgery. The forgery, or paintedness of the *Dollar Sign* series, allows for the disavowal of its status as a commodity, even as the dollar sign makes that disavowal visible.

Like the drag image (or the "painted woman") that maximizes the incongruities of a "look" to expose not the imitative structure of drag but of gender, the painted dollar signs make visible the refusal of art to acknowledge its status as a commodity. Thus the homology between pornography and art—where porn makes an industry out of selling representations of something that is not supposed to have a market (but clearly does), what we might call Warhol's money shots obscenely undress the extent to which the art world (and, often, art criticism) is invested in the disavowal of its relationship to an art market. The "trick," then, is to carry off the double action of the disclaimer—to sell the pose. In this sense the pose the john solicits from the hustler—the pose that disavows the homoerotic nature of the sexual exchange by asserting its nature as a *monetary* one—is a mirrored version of what is solicited from the artist: a pose that, in disavowing a relationship to the art market, allows the artist entry into its economy, into the pages of an art critic's magazine like *Artforum*.

Pornography, in the oldest sense of the word, is writing about or representations of prostitution (*pornográphos*: writing about harlots). In more contemporary usage, the word *pornography* signals something that appeals to prurient interests and that has no value as "art."[78] *Forged Images* works both of these aspects of the word—speaking (like a child who does not know better) of how sex sells art and art sells sex, of how art sells itself and of how all of these things are the invisible supports for the system by which art is identified as such. Warhol's suggestion that pornographic magazines are the "fashion magazines of Forty-Second Street" turns itself inside out to recast *Artforum* as the "porno" of SoHo.

Warhol's conjunction of a portrait of himself as the artist in drag with a three-dollar triptych offers us a clever pictograph: art making can make an artist as queer as a three-dollar bill.

Chapter 4

"I Must Be Boring Someone"
Women in Warhol's Films

Viragos, Fag Hags, and Superstars

Well into Warhol's film *Bike Boy* (1967–68), Ingrid Superstar interrupts her own especially pointless monologue about food, delivered to no one in particular, and sighs—almost hopefully—"I must be boring someone," as if this were her principal aim. If you *are* bored by her, it's very likely you'll miss this statement, buried as it is under a prodigious amount of empty talk. It's a statement not entirely unlike the parenthetical opening of Melville's novel. Delivered by a woman sharing the screen with Bike Boy, the hunky trade title character in whom we are all supposed to be interested, it underscores her peculiar position as *not really* the film's subject.

Women have a strange and powerful presence in Warhol's work. They linger on the edges of writing about the artist, but, as the marginal are wont to do, they haunt the entire field. They are irrelevant, and absolutely central. Fag hags and icons. Gal Fridays like Pat Hackett (who edited *The Diary of Andy Warhol*); superstars like Edie Sedgwick, Viva, and Ultra Violet; best buddies like Brigid Berlin (whom he copied in his obsessive use of Polaroid cameras and tape recorders); celebrities like Liz Taylor or Shirley Temple, whom he idolized as a child.[1] And then, of course, there is his mother, Julia Warhola, with whom he lived until her death. How we ought to think about women and Warhol is not obvious, in part because it is never clear how we ought to think about the presence of women in gay male spaces and in part because women never played only one or even two particular roles consistently in Warhol's world.

I want to take up this issue in my own experiment on thinking about Warhol's films as feminist. Toward this aim, I wish to excavate the overtly queer feminist aspect of two films, *Bike Boy* and *I, a Man* (1967–68), and ask, furthermore,

what happens if we take some of feminist criticism's central questions about representations of sex and sexual difference, about form, ideology, and visual pleasure, and apply them to representations of women in the Factory films. This is to shift discussion of sexuality in Warhol's films momentarily away from Warhol's historical audience to the films themselves and to participate in a return to formal analysis (once used to erase from criticism any reference to the films' gay subject matter) in order to recover the intensity with which these films challenge straight culture and its representations of sexuality and sexual difference.[2] The questions I raise below, and the interpretive strategies I use, may be applied to a large number of Warhol's films.[3] The tension and over-lap between what we might provisionally call the gay and the queer feminist aspects of Warhol's films are, I think, particularly acute in *Bike Boy* and *I, a Man*.[4] The former is sharply divided into homoerotic and "straight" halves as it tracks the movements of the title character through a series of encounters with gay men and then with women; the latter places its title character, an os-tensibly straight liberated man, in a series of seduction scenarios with women (at least one of whom is a lesbian).

I want to claim a queer feminist potential for Warhol's filmic work as an in-tervention in the representational codes that shape mainstream representations of women and female sexuality, but also as documents that trace the relation-ship of the unconventional, sexually aggressive, virago[5] to gay underground culture. While one could say that there is no place for feminism in Warhol's films because their dominant erotic economy is gay (authored by gay men, aimed at largely gay male audiences), one might also say that many of these films cre-ate an alternative cinematic space for women exactly insofar as the films read as "gay." Because she is framed by a gay male context, she gets to be something other than the straight sex object.

That alternative context, however, is not one in which we see "happy" repre-sentations of women—meaning, for example, positive representations of women, women free from violence and oppression, at ease with their femininity, and valued by their on-screen counterparts as full human subjects. *Bike Boy* and *I, a Man* flesh out the utopian highs *and* catastrophic lows of queer communi-ties formed, as Michael Warner writes, around a shared refusal to transcend "the indignities of sex."[6] As often as they assert a liberated, antipatriarchal position, women also find themselves subject to hostility and abjection and are not often able to convert that negativity into something glamorous. In fact, many of the performances in Warhol's films can be painful to watch (for this reason, for some, the films are distinctly *un*feminist). In this sense, they an-ticipate the work of an artist like Tracey Emin. They represent an important, if complex, legacy to queer feminism—not entirely unlike the importance of Thomas Eakins, for instance, to gay studies. What makes these films remark-able (to me, as a feminist critic moved by complexity) is their canny portrait of not only empowered female desire but also the ambivalence, abjection, and rage that comes with that package.

She Shot Andy Warhol

The June 1968 afternoon Valerie Solanas shot up Andy Warhol's studio has been taken as the defining moment in the relationship between feminism and Pop art.[7] Until that day, Solanas had been a minor but recognizable figure in the Greenwich Village scene, known chiefly for selling her infamous *SCUM Manifesto* (SCUM stands for the Society for Cutting Up Men) on the streets.[8] By the time her movements in New York took her to Warhol's Factory, she had already achieved cult status as the protofeminist author of this scabrous tract (having been interviewed by the *Village Voice*). In the 1970s, after she served her three years for the attempt on the artist's life, she was again a part of the neighborhood and could be found on St. Mark's Place, hanging out in the street, managing the rumpled bags of a woman who had nowhere else to go.[9] Warhol closed his studio doors after the shooting and erected walls between himself and many of the methamphetamine-fueled Factory characters who had peopled his films. This was in part because Solanas was still around and had, on several occasions, phoned the Factory looking for him.

In the months leading up to the shooting, Solanas had given Warhol a copy of her play *Up Your Ass* and was promised twenty dollars for her appearance in *I, a Man*. *Up Your Ass* was so obscene that Warhol—whose films in those years were frequently shut down by the police for obscenity—thought it might have been some sort of police trap. The script was misplaced. Solanas kept asking for it back and had been turned out of the Factory hours before she returned hiding a gun and a sanitary napkin in a wrinkled paper bag. Famously, when she turned herself in, by way of explanation she said, simply, "He had too much control over my life." Hailed as "a heroine of the revitalized feminist movement" by Ti-Grace Atkinson and Florynce Kennedy, she became, for the moment, a reluctant poster girl for radical feminism.

Like Eakins's scandalous relationships with his female students and relatives, Solanas's attack on Warhol is too easily absorbed into an already existing narrative about women and gay men, in which both are positioned as each other's worst nightmare. In his biography of Warhol, Wayne Koestenbaum facilitates this narrative condensation when he argues that "those who see a feminist, oedipal, or revolutionary meaning in Valerie's homicidal act . . . forget the reality of Warhol's wounds, the worth of his body, and the final damage done to it."[10] Koestenbaum's statement raises several questions. What does he mean by seeing a feminist meaning in the act?[11] To whom is he referring? (He does not cite any specific scholarship on this point.) And since when does seeing the historical or political context of an act like Solanas's attack on Warhol necessarily imply indifference to the pain on the other side of the gun? Can we at least entertain the possibility of reading Solanas's act in relation to radicalism (as does the scholar James Harding),[12] for the sake of argument, without mistaking that thought experiment as an endorsement of violence? And why would anyone want to shut down an analysis of the attack? Why not, given Warhol's own relentless fascination with other people's pain, with death, open it up?

Koestenbaum equates a feminist reading of Solanas with an attack on the artist and calls into question the attachment to Warhol of anyone who would venture a feminist analysis of, for instance, the conditions of possibility for Solanas's attack. (Solanas was a lesbian, an unusually smart person with paranoid tendencies born into an era when there was, as she said herself, "nothing relevant for women".)[13] Within the logic of Koestenbaum's statement, to think historically about the attack is to abandon Warhol to its trauma.

Also embedded in Koestenbaum's statement is a complex and important assumption about feminist criticism: to think seriously about this moment, to think seriously about a "madwoman" like Solanas, is almost by definition to think as a feminist. He unfortunately also implies, however, that to think as a feminist is to not think at all but to emotionally and uncritically identify with whatever female counterpart the scene offers. On this point filmmaker Mary Harron said of her own hesitation to make her film about Solanas (I Shot Andy Warhol), "People will think I'm crazy. They'll think I'm like Valerie."[14] This is an unfortunate but not uncommon characterization of feminism—a facile dismissal of feminist intellectual work on women like Solanas as "merely" an extension of hysterical identification. At the risk of giving more weight to Koestenbaum's remark than it probably merits, it also forecloses the possibility of critical thought unfolding around *exactly* the possibility of identifying with the woman in the story. Which, I should say, I do. If, in a flight of fantasy, I sometimes like to imagine I'd have made a great hag to Warhol's fag, in moments of realism I know I'd have been far too awkward and serious to pull it off—I am much more like Valerie Solanas than like Edie Sedgwick or Brigid Berlin. I relate more to Solanas's hapless descent into paranoid madness than to the speed-enhanced scary charm of Warhol's prep-school heiresses (Solanas called them "stupidstars"). "On some nights," writes Avitell Ronell in a recent essay published with a new edition of The SCUM Manifesto, "Valerie's weariness washes over me. I hear her typing out in the apartment above mine: 'The shit you have to go through in this world just to survive.'"[15]

At the very least, Koestenbaum's remark betrays the fact that Solanas's attack provokes strong feelings from Warhol scholars. Most of us are also Warhol fans. But, as the questions generated by his remark reveal, the ethical problems raised by the fact of Warhol having been shot by a woman who appeared in one of his films are not resolved by cordoning off the event from critical analysis—quite the opposite. We might take Koestenbaum's dismay at what critical attention has been given to Solanas as symptomatic of the anxieties raised by the specter of women (lesbian or not, crazy or not) in gay places—as if turning our gaze toward them (and toward the problems they often raise, and embody) somehow requires a betrayal of our commitment to supporting, celebrating, thinking, and writing about the lives, work, and sexual politics of gay male artists. As if turning our attention toward women requires a turn away from a commitment to homosexuality itself (a problem that, in queer theory, often leaves lesbians in the dark). As if Solanas represents something inevitably

true about what happens when women participate in queer communities. As if thinking about how a homophobic world might make gay men vulnerable means we can't also think about how a patriarchal world (in which gay men sometimes participate) might make women crazy.

This last point is perhaps why many of the most significant gay male artists of the twentieth century frequently put women in their work, not only as iconic placeholders for an idealized, deconstructed, or camp version of femininity but as crucial allies in the attempt to make a livable life out of a world organized against the minority sexual subject. Watch Pier Paolo Pasolini's *Teorema*, Rainer Werner Fassbinder's *The Bitter Tears of Petra von Kant*, Jack Smith's *Flaming Creatures*, and Warhol's *Beauty #2* (not to mention more recent films like Gus Van Sant's *To Die For* or Todd Haynes's *Safe*), and it becomes hard to think of these films as *not* also about women—their portraits of the sexual lives of women are, at the very least, radically different from mainstream representations of femininity. Of course gay audiences know this, and there is work that explores the relationship of gay male audiences to these kinds of representations of femininity.[16] The joy of watching many of these films comes from how they allow gay audiences to identify with these women and, furthermore, to enjoy how these films are also about the women—the viragos, the dykes, the fag hags, the overbearing mothers—in their lives. An examination of the formal and narrative dynamics of Warhol's films that include women reveals that the sexual radicalism of Warhol's work is very much pinned to their troubling presence.

If there was ever an unlikely candidate for making visible the flexibility of women's relationships to Warhol's cinematic practice, it is the overdetermined, utterly humorless mythical cult figure of Solanas, the angry radical lesbian feminist wielding *The SCUM Manifesto* in one hand and a gun in the other. But nevertheless, there she is, about an hour into *I, a Man*, climbing a New York apartment building staircase with the roguishly handsome Tom Baker, in one of the funniest scenes in the Factory film archive.

I, a Man, like *Bike Boy*, is one of Warhol's later films—meaning it is more narrative, and much more "talky," than works like *Empire, Blow Job*, or *Sleep*. The two films center on men who are relative outsiders to Warhol's scene. *Bike Boy* tracks Joe Spencer, a motorcycle enthusiast from Boston, through a series of Warholian encounters with men and then with women; *I, a Man*, was loosely inspired by the Swedish sexploitation movie *I, a Woman* (1965), and follows the adventures of a man played by an actual actor (Baker, friend of Jim Morrison, who was originally supposed to star). Both men are placed in seduction scenes with some of the women most strongly identified with the Factory—Brigid Berlin, Ultra Violet, Nico, Viva, Ingrid Superstar, and Valerie Solanas.

By the time we meet Solanas in the stairwell we've already sat through an hourlong series of seductions between Baker and various women, and we more or less know what's coming. He's going to try to pick her up, and it will be awkward.

Figure 11. Andy Warhol, *I, a Man,* 1967–68, frame enlargement. 16-mm film, color, sound, 95 minutes. Pictured, left to right: Valerie Solanas, Tom Baker. Copyright 2005 The Andy Warhol Museum, Pittsburgh. All rights reserved.

The basic premise is that Solanas has grabbed his ass in an elevator, and now he assumes he is going to go home with her. They are on their way up to her girlfriend's apartment. The stairwell is poorly lit. When combined with our hindsight about the outcome of Solanas's contact with Warhol, the dark lighting lends the scene an unusually ominous tone for a Factory film. Baker is visibly uncomfortable in his negotiations with Solanas. As he follows her up the stairs, she wonders out loud what she is doing with him. She stops, speaking in the staccato of a strong New York accent, and asks, "What am I doing up here with a finko like you? I can't figure it out because you're a fink. Please explain it to me—what's my motivation?" Baker looks perplexed. Solanas continues: "Oh, I remember. I grabbed your ass. You have a squishy ass. How come your ass is so squishy? It's the squishiest man's ass. How did it get so squishy?" They go on about the squishiness of his ass, and as they stand in the stairwell, the momentum for the seduction stalls. She wavers and decides that she grabbed his ass in a moment of weakness. "I'm a sucker for squishy ass," she says, explaining herself to herself. But now she is not sure this is enough of a reason for bringing this man up to the apartment. "But what else have you got?" she asks him. He resists answering the question and suggests they get to know each other better: "Let's explore each other," he says, adopting his preferred mode of address, that of the liberated sixties bohemian man.

Solanas interrupts: "Look, I got the upper hand, let's not forget that."

Baker laughs, and jokes: "I haven't forgotten it for a moment."

They go back and forth in the stairwell. Eventually, she seems to reach a decision. She says her girlfriend is in, and so she doesn't want to take him inside the apartment. In an attempt to dismiss him, she says, "You go sniffin' along after every girl who squeezes your ass. I'll be a good guy and squish once more." She grabs his ass again and says, "There ya go, there ya go," and tells him to "shove off."

At this point we get the strobe cuts characteristic of Warhol's films, in-camera edits in which we glimpse the actors in between flashes of white. At the other end of this cut, we find that Baker has not left but is in fact following Solanas up the stairs. They both arrive on the landing, and he pushes himself at her. He takes off his shirt, and she half-heartedly complains that he is attacking her. She yells, "What's this shit!" jokingly accuses him of rape, and then she tells him her roommate might get mad because, she says, "She'll be jealous. She's very possessive." There are more strobe cuts, and the tone shifts. Now Solanas stands on the stairs to the next floor, above him, in the center of the screen, blocking his way. As the scene unfolds, he is reduced to begging and pleading as she asserts more and more control over their dialogue and the scene. He asks her to look at his shirtless body.

SOLANAS: I just told you, I don't like your tits.
BAKER: I don't care—I'll keep my shirt on, you know—
SOLANAS: I still don't like your tits.

BAKER: Do you dig men? You dig men?

SOLANAS: We're not talking about men, we're talking about tits.

BAKER: D'you dig men's tits?

SOLANAS [turning the tables]: Do *you* dig men's tits?

BAKER: No—I dig *my* tits—

SOLANAS: What's so special about your tits?

BAKER: Because they're mine, they're the only pair I got—they're men's tits. [growing frustrated, raising his voice] I don't want to discuss them! I want to talk about why we're not, can't go—

SOLANAS: No, I wanna discuss them, you brought the subject up—

BAKER: No, you said you didn't like them—

SOLANAS: You brought the subject of men's tits up, now, let's pursue the subject.

They go on in this vein. Both dig in their heels, and together they produce a rapid-fire (if fairly one-sided) exchange of wits. As Solanas and Baker debate his interest in his own tits, the scene is again interrupted by a strobe cut, in which we catch a startling glimpse of Solanas.

In the intercut, we see her wave off the camera and shake her head. A blink, a wink at the camera, and as she turns her head she is lit up, in a flash, and smiles directly (even flirtatiously) at the camera. Given the overdetermined place of Solanas as she-who-shot-Andy-Warhol, as the poster girl for uptight feminism gone haywire, this shot of Solanas flirting with the camera, cooperating fully with the campy humor of this scene, is something of a shock. Not entirely unlike the photographic parody of *The Gross Clinic,* which unravels that painting's seriousness, Solanas's glance at Warhol's camera asks us to reconsider the historical narrative of their intersection.

Before we can think about this, we are dropped back into the scene, and the dialogue continues.

BAKER [mumbling]: What is it, some philosophy of life that you don't, that you don't, uh—

SOLANAS: Let me ask you: Do *you* dig men?

BAKER: Sure as friends. Some, friends, all my best friends are men.

SOLANAS: Really? You dig 'em romantically? Sexually?

BAKER: Sure. I mean, I have friends that are men, friends that I love . . .

SOLANAS: You dig men sexually?

BAKER: You mean have I balled men? Naah, uh, not since I was young—

SOLANAS: Why not?

BAKER: It's not my instinct.

SOLANAS: Why?

BAKER: I have to follow my instincts . . .

SOLANAS: Why?

Figure 12. Andy Warhol, *I, a Man,* 1967–68, frame enlargement. Pictured, left to right: Tom Baker, Valerie Solanas. Copyright 2005 The Andy Warhol Museum, Pittsburgh. All rights reserved.

BAKER: Why? My instincts tell me what to do.

SOLANAS: My instincts tell *me* what to do.

BAKER: What do your instincts tell you to do now?

SOLANAS: Same thing your instincts tell you to do.

BAKER: My instincts tell me to, er, let's go upstairs and get together—

SOLANAS: Your instincts tell you to chase chicks, right?

BAKER: Right!

SOLANAS: My instincts tell me to do the same thing.

BAKER: Oh. [Pause, getting it at last.] Wow.

SOLANAS: Why should my standards be lower than yours?

> BAKER: Well, then. Your instincts tell you to chase chicks.
> SOLANAS: Yeah. My instincts are your instincts.
> BAKER: Well, let's go upstairs and do your roommate, then.
> SOLANAS: No, my roommate wouldn't like you.
> BAKER: Wow baby. You're missin' out on a lot of things.

Having clearly lost the battle, he loses steam. She pushes past him, saying, "I don't live here, I wanna go home, I wanna beat my meat."

Unusual for this kind of Warhol film (in which the end of the reel determines the end of the scene, often cutting performers off midsentence), this scene actually comes to a firm conclusion as Solanas walks past Baker and then down the stairs and off the screen (an edit actually moves the camera to follow her, as she says—to whoever is behind the camera—"All the way down?"). The film cuts back to Baker, smoking, alone in the hallway.

If this improvised battle of the sexes can be said to cite Hollywood, it is via the conversational prowess of a star like Katherine Hepburn, whose quick tongue could turn Spencer Tracy or Cary Grant inside out, bringing him to the limit of frustration and desire. Here, however, we have an out lesbian and none of Hollywood's glamour. Solanas's performance is that of a sexual predator ("a sucker for a squishy ass") and sexual pedagogue who leads the ostensibly already liberated Baker through a dialogue on sex and identity toward insight ("Oh. . . . Wow."). That insight is, for Baker, into the nature of their difference (ironically articulated by Solanas as a shared instinct). For us, however, their difference is more a matter of self-understanding. Baker performs the stubborn ignorance (and optimism) of masculine privilege. Solanas collaborates with the camera to unhinge that performance while also presenting herself as the subject with a command over the discursive system that sets them at odds with each other. In this sense, we might approach their encounter as an enactment of, and a resistance to, the privileges of unknowing that mark heterosexist thought: as Baker flips from not-getting-it to dismissing Solanas as "missin' out on a lot of things," we watch how "the powerful mechanism of the open secret," as Eve Kosofsky Sedgwick has argued of straight thinking, is "made perfectly congruent with the smooth, dismissive knowingness of the urbane and the pseudo-urbane."[17] Solanas's performance in *I, a Man* makes clear that women in Warhol's films actively destabilize heterosexuality and its institutions. This is in part because, as women, they channel heterosexual possibility—they are able to literalize, halt, and sabotage the heterosexual imperative more aggressively than nearly any other character type served up to us by the Factory. But embedded in a strobe cut—a smile, a wave of the hand, a coy gesture made with a cigarette—we also discover the distance between the story we have about the Solanas who shot Warhol and the Solanas who was shot *by* Warhol. The contrast between Solanas's brilliantly comic performance, between her fleeting glance colluding with Warhol's camera and her violent

descent into paranoia, tragically marks off the distance between the romantic hopes we might have about queer coalitions, about queer utopias, and the material forces of oppression that can make such coalitions uneven, ephemeral, and occasionally disastrous.[18]

The Twenty-Ninth Bather: Seeing Women

Because their presence in the historical record can be so tenuous, so marginal, so problematic, it is hard to keep these women in our focus. I would like to think of women in the Factory as not entirely unlike the twenty-ninth bather in Walt Whitman's *Leaves of Grass*. She appears in "Song of Myself" in a segment that has become a touchstone in gay literary studies, in part because it contains some of the most explicitly homoerotic writing in Whitman's poetry.[19] It has also become something of a Gordian knot in Whitman studies, as the speaker of the poem observes and identifies with a woman who spies on twenty-eight young men bathing by the shore. What to do, the critic wonders, with this conjunction of homosexual expression and feminine presence? This is, of course, the question raised by the fantastic, unpredictable, rich contributions of a host of women—Brigid Berlin, Viva, Ultra Violet, Nico, Valerie Solanas, Edie Sedgwick, Ingrid Superstar—to Warhol's films.

"The twenty-ninth bather" section has been invoked in a range of contexts as a signpost for Whitman's insight into nineteenth-century arrangements of gender and for his utopian vision of a space in which people might experience comradeship and intimacy across difference.[20] In it the poet expresses the longing for a world in which men, and women, might have access to a continuum of expressions of tenderness, empathy, and community. The narrative perspective approaches the men's glistening bodies, following the woman's line of sight as she "hides" in her home.

> Twenty-eight young men bathe by the shore,
> Twenty-eight young men and all so friendly;
> Twenty-eight years of womanly life and all so lonesome.
>
> She owns the fine house by the rise of the bank,
> She hides handsome and richly drest aft the blinds of the window.
>
> Which of the young men does she like the best?
> Ah the homeliest of them is beautiful to her.
>
> Where are you off to, lady? For I see you,
> You splash in the water there, yet stay stock still in your room.
>
> Dancing and laughing along the beach came the twenty-ninth bather,
> The rest did not see her, but she saw them and loved them.
>
> The beards of the young men glisten'd with wet, it ran from their long hair,
> Little streams pass'd all over their bodies.

An unseen hand also pass'd over their bodies,
It descended tremblingly from their temples and ribs.

The young men float on their backs, their white bellies bulge
to the sun, they do not ask who seizes fast to them,
They do not know who puffs and declines with pendant and bending arch,
They do not think whom they souse with spray.[21]

The lonely female figure facilitates an erotic encounter between Whitman, the narrator, and the male body. She has therefore been read (by, for example, Robert K. Martin) as a conduit for homosexual expression and desire.[22] Whitman's use of a woman as a point of identification with the narrator creates a bridge between looking at, and touching, the male body.

Where one is tempted to read the shift in perspective as a kind of cross-dressing in which Whitman inhabits and appropriates the woman's body and her desire, Michael Moon rightly argues that "it would be more appropriate, in view of the significant role the female figure occupies in the first half of this section, to interpret her as being incorporated into the passage at its crucial midpoint and for the rest of the section . . . as a figure of femininity and not merely as a transvestite 'cover' or mask for the male bathers [s]he 'spies' through the window." Moon wants to retain the poem's fluidity, in which we might imagine a masculine identification with a feminine perspective. This feminine perspective furthermore "escapes traditional circuits of authority and desire which render the biblical bathers [Bathsheba, Susanna] victimized women and their observers guilty evildoers," Moon writes, "in order to enter and occupy a utopian space in which a figure representative of feminine desire and identity can effectively be incorporated into a scene of male jouissance." He continues, "That this key scene of male 'fluidity,' one of the most determinately and specifically erotic of all such scenes in *Leaves of Grass,* is inflected as it is with feminine erotic desire argues against the assumption that Whitman's privileging of male-homoeroticism in itself precludes his also representing feminine sexuality and feminine agency in his text."[23] In the latter half of this section of "Song of Myself" the woman secretly joins the bathers, and the reader draws close, alongside her, to the bodies she has been enjoying from a distance. As Moon suggests, the speaker's identification with her point of view does not require an appropriation and elision of it. It can be read instead as a kind of collaboration in which the speaker disperses, *along* with this feminine presence, this intensely sexual body across the scene to touch the sexualized bodies (glistening, wet) of the bathers. It furthermore allows for the retention of the feminine subject-position as an endpoint to identification, rather than a rest stop. This poem might then describe what Whitman and this woman share—and, provocatively, as what a woman reader might share with the poet besides a romantic investment in one another. That point of intersection may be the bathers through whom they are triangulated, and it may also be a shared relationship to poetry, to the scene of reading.

That said, one can understand Martin's reading of the female body as disappearing under Whitman's gaze. He writes, for example, "At this point the woman disappears completely from the poem, since she is not present in the men's consciousness (nor, one suspects, the poet's)."[24] To insist on her presence is to risk "degaying" the scene, setting into motion a reading in which she becomes an alibi guaranteeing the innocence, or at least the heterosexuality, of the homosocial (something Moon is careful not to do). It is a problem that the presence of women in homoerotic settings cannot help but initiate. In his reading of the sexual politics of Larry Clark's photographs, José Muñoz observes, for example, that teenage girls in Clark's images seem to chaperone the boys, acting as a check on the homosexual potential of the voyeurism of Clark's camera. He writes, "Women, in Clark's photographs, are made to stand in for 'institutional relations, family, profession and obligatory camaraderie.' . . . They maintain heterosexuality while queerness continues to hum in the background. It is . . . distressing to consider the ways in which women, who as a class are routinely subjugated within hetero-normative culture, are made to stand in for these toxic forces."[25] At the heart of "the twenty-ninth bather" is an ambivalent portrait of the symbolic overdetermination by which a woman's mere presence becomes the guarantor of institutionalized heterosexuality, in essence, an embodiment for heterosexuality itself.

So the woman remains invisible at least to the other bathers in part because her visibility would be the first push in the synecdotal rush away from homosexual play. She is the unwilling specter of Ishmael's complaint that "in all cases man must eventually lower, or at least shift, his conceit of attainable felicity; not placing it anywhere in the intellect or the fancy; but in the wife, the bed, the table, the saddle, the fire-side, the country."[26] Ishmael, given the choice, would "squeeze eternally" the oily hands of his comrades and dream of rows of angels, with their hands in jars of spermaceti. For Melville, the "lowering" of this felicity is inevitable, and the wife is always already one entry in an inventory of obstacles to happiness. Whitman's portrait of the domestic feminine subject-position is more complex. The house is in *her* way, too. He imagines what it might feel like to be in her position—the speaker of the poem, in fact, identifies with her position. She is a restless ghost, forced to inhabit a structure, a mode of being, in which she is not at home.

Whitman grounds the visual geometry of the scene in the body of woman whose scopophilic drive is so intense that it projects her out of her body, out of her house, and into the water. The poet and scholar John Vincent writes: Whitman "uses his ability to rotate the optics of the poem in order to offer the young widow a space in the young men's company, although it is a space carved out by negatives. The reader, taken by reverie, and the gentleness with which the river scene is drawn, is taken down to the river in the words of the poem and has his shoulders turned back up toward the house by Whitman's sympathetic hands."[27] The poem folds together several subjective positions—the woman moves from the position of the spectator into the space she sees, and

as she does so, the reader goes with her and the poem seems to literally open itself up, inviting us to imagine that to hold Whitman's book in your hands is to caress the bodies of the bathers and to allow their bodies to act on you. The reader's projection into the poem is mirrored by the woman's projection out of her house—allegorically linking reading the poem to a resistance to domestic constraint.

As Moon argues, Whitman revises the patriarchal staging of women's bodies as the unwitting objects of male voyeurism. Grounded in an active, desiring position of the female spectator—and complicating as it does the distance between the spectator and the spectacle—the poem anticipates the central thematics of feminist approaches to visual culture and suggests that the active critique of patriarchal modes of organizing gender difference is of foundational importance to not only feminist and antihomophobic projects but some homoerotic ones as well.

Among the definitive subjects of feminist writing about the visual is the position of the female spectator within masculinist visual narratives, in which, in the words of Laura Mulvey, a woman's "on-screen analogue is (passive) raw material for the (active) gaze of man," in which the cinematic apparatus works at controlling the contradictions unleashed by her visual presence (she, for example, appears as castrated and therefore is at once object of visual pleasure and the embodiment of the threat of castration). The pleasure men might take from watching her image on-screen seems, Samuel Delany writes, to "depend entirely on the absence of 'the woman'—or at least depend on flattening 'the woman' till she is only an image on a screen, whether of light or memory, reduced to 'pure' 'sexuality,' till, a magical essence, a mystical energy, she pervades, even grounds, even fuels the entire process, from which she is corporeally, intellectually, emotionally, and politically absent."[28] Given the rigidity of mainstream cinematic codes, women spectators, in Mulvey's words, are thus often "restless in transvestite clothes,"[29] experts at cross-identification, because visual pleasure would be almost impossible were she to identify herself with the woman placed before her on-screen—instead, to imagine herself as a participant in narrative cinema, she (like the gay spectator or the black spectator) must regularly project herself into spaces and positions to which she does not belong. Toward this understanding of "the contradictions and convolutions of female spectatorship," Mary Anne Doane argues that the female spectator must "look, as if she were a man with the phallic power of the gaze, at a woman who would attract that gaze, in order to be that woman." The female spectator therefore moves back and forth between male and female subject-positions—her identity as a female spectator is bound up in an a priori identification with the masculine.[30] Patricia White intervenes in this formula, however, to point out that these kinds of theorizations of female spectatorship elide the possibility of female homosexual desire and identification. Within these readings of female spectatorship as always already a cross-gendered identification, lesbian desire and identification becomes unthinkable. "Female subjectivity," White

argues of Doane's work, "is analogous to female homosexuality which *is* sexuality only insofar as it is analogous to male sexuality. The chain of comparisons ultimately slides into actual delusion: 'a woman who thinks she is a man.' In what seems to me a profoundly disempowering proposition, the very possibility of female desire as well as spectatorship is relinquished in the retreat from the ghost of lesbian desire."[31] At stake in theorizations of female spectatorship, in other words, is the recognition not only of active female desire but of homosexuality itself.[32] This is true of both mainstream Hollywood cinema and gay underground cinema—the insertion of a woman into the audience seems, in the case of the former, to raise lesbian desire as a threatening possibility that must be refused and, in the case of the latter, to shut down homosexual possibility by introducing heterosexuality's ultimate alibi (a woman).

Solanas's duet with Baker plays with exactly this difficulty of recognizing lesbian presence. Solanas's sexual unavailability (to him) is the last thing to cross Baker's mind, and even when he seems to grasp the futility of his attempt to seduce her, he soldiers on with the resilience of masculine privilege ("Well, let's go upstairs and do your roommate, then") and, when she finally puts the heterosexual seduction plot to rest, he mutters, "Wow, baby. You're missin' out on a lot of things," without seeming to get that even though, technically, *I, a Man* is a series of straight encounters, it is not a straight film. Yet Warhol's films are not simply inversions of patriarchal and heteronormative ways of looking at the male body—even a film like *Blow Job* does more than put a man's body in the place of a woman's.[33] *I, a Man* simultaneously unravels the heterosexual imperative (setting up straight masculinity as only a moderately successful defense against the threat of failure and irrelevance) and builds Baker up as the film's straight man and the audience's sex object.

Similarly, it is not quite right to say that Whitman's poem offers a simple inversion of patriarchal dynamics of spectatorship. The poem instead literalizes some of the complexity of the woman's position within those dynamics. The poem asks us to inhabit the woman spectator's subject-position, as it is constructed by those ideological systems—in which she is both "flattened" and dispersed across the scene as "pure sexuality." It importantly offers her perspective as the major axis of identification in the poem—the narrator identifies with her vision, with her erotic drive. The poet asks us to be carried along by her line of sight, by the sexual drive of this woman who steals a glance. Whitman gives her, as her object of sight, not simply a male body but the spectacle of unselfconscious homoerotic contact between men—a mise-en-scène for not only sexual contact but sexual community. That communal bond is, however, as Vincent argues, felt most keenly not between the bathers (who are represented as unknowing, unseeing) but between the narrator/poet and the invisible woman. This arrangement is very different from the Girardian triangle that channels homoerotic possibility through male rivalry for a passive female prize—the primary relationship here is between the poet and the woman as they bond over their shared interest in the bathers. However, the utopian

possibilities of this connection are undercut by the prerequisite that she remain, to the others at least, invisible.

Whitman draws out the contradictions of the woman's position, in which intimacy with these twenty-eight young men is grounded on a collective agreement to not see her (in which their intimacy with each other happens despite her presence, rather than because of it). Although the operational invisibility of the twenty-ninth bather has underwritten the reading of her presence as a cover or an alibi (and as either irrelevant or antifeminist), we might approach it on another level as a fantasy about an escape from the regimes of visibility that bear down with particular force on women and other sexually overdetermined figures (e.g., the black man, the Asian woman, the effeminate homosexual, the butch lesbian) who are positioned in dominant culture as nodes of transference rather than identification. The arc of her movement through the poem is, crucially, out of the house, into an alternative space in which she might enjoy the privileged subject's freedom of movement.

What I find particularly moving about this poem is Whitman's emphasis on the collaborative side of this process. Even her secret participation in this spectacle of sexual community requires conspirators—a fellow willing to cover for her when she makes her escape. Whitman suggests that we cannot tap the utopian possibilities embedded in homoerotic community unless we fight alongside this invisible woman—unless we can figure out how to nourish both homoerotic and feminist forms of intimacy and expression. Unless we first figure out how to both see her and not see her.

The centrality of the woman's presence to the utopian moment of that poem, and the intertwining of an antipatriarchal vision with a homoerotic one, gives us a literary model for thinking about the ferocious and complex presence of women in queer spaces like Warhol's Factory. Ultimately, however, we must remain ambivalent about the principal condition for the twenty-ninth bather's presence (that it be imperceptible from certain perspectives). The poem seems on some level to forecast the erasure of (especially) queer women from art-historical account. Women participated, for example, in Thomas Eakins's circle—as the earlier chapter demonstrates, Eakins's career was profoundly affected by his attempts to fold women into his version of bohemia. But *their* careers are too inchoate, too frustrated to make an easy story. Art history has furthermore rendered their vanishing as inevitable—the difficulty, in Warhol scholarship, of integrating our understanding of the artist as "producer" into the protocols of criticism (which still, nevertheless, seem to require an "author") has meant that the performances of women in Warhol's films are still read almost exclusively as manifestations of Warhol's intentions.[34]

She's All Talk

Using Whitman to think about Warhol is a perverse move: where Whitman's poetic vision is nearly utopic, a bittersweet meditation on erotic (im)possibility,

Warhol's films map very different kinds of encounters between men and women—filled with ambivalence, awkward haggling, unsuccessful negotiations, and sometimes open hostility. His films are very interested in the parts of women with which normative culture is most uncomfortable—sexually aggressive and demanding, bitchy, defensive and predatory, creepily maternal and sexual.

If *I, a Man* places the title character in a series of ostensibly heterosexual encounters, *Bike Boy* has a more complex structure in that it explicitly contrasts male homoerotic and heterosexual encounters and leaves us with a distinctly uneasy portrait of the latter. As a whole, the film moves Bike Boy away from camp homosexual play and toward what José Muñoz has described as "a minstrel performance of heterosexuality."[35] Where camp seems to open up erotic possibility in the homoerotic half of the film, its effects are far more ambiguous in the scenes between men and women. The film opens with a long segment of Bike Boy (Joe Spencer) naked in the shower, then drying himself off and getting dressed. This is followed by a few minutes in which he stares into the camera, and a longer scene in which unnamed men try on clothes (e.g., tiny bathing suits) while two queeny shop clerks prattle on about their customers. Bike Boy enters this scene and tries on outfits under their tutelage (as he slips on a leather jacket: "It makes you look like Peter Fonda"). At one point a clerk gently whips him with a belt; at another, they measure his inseam ("Is it right up there George?" "Yes it is." "Is it in the right place?" "Yes, it is." "Oh!"); later they spray him with perfume ("This one has a fruity smell and I think you might like that"). From here we move to Bike Boy in a flower shop with Ed Hood, with whom he talks largely about fucking sheep. Throughout the film's first hour, Bike Boy is explicitly offered up as a spectacle for our enjoyment, and our position as spectators is more or less lined up with the queens in the film enjoying his presence and who are often, like us, off-camera. Our position as voyeuristic spectators and his as object of our enjoyment is relatively stable.

The rest of the film places Bike Boy on-screen with Factory women in a series of heterosexual seductions gone awry: in a kitchen with Ingrid Superstar as she talks and he says nothing; with Anne Wehrer haggling over who is going to pay for gas and beer as they try to plan a date; with Brigid Berlin, drinking beer while she snorts speed, him calling her a fat dyke, her calling him a leather queen and a faggot; naked on a couch, talking and flirting with Viva, but wandering further and further from intimacy.

In the film's first segment, Bike Boy is part of an overtly campy and homoerotic mis-en-scène. Talk happens around and about him. In the latter segment (more than half of the film), he is placed on-screen in a series of confrontational encounters in which the "talk" between men and women is laced with aggression and hostility. In this hour of Bike Boy wrangling with the complicated presences of these women, women outtalk men. Callie Angell, the director of the Andy Warhol Film Project, observes: "'Bike Boy' is more about failure of communication than sexual connection: however sexy he may look, Joe is

painfully inadequate to the conversational demands of his costars, and is repeatedly reduced to being vulgar, awkward, or simply bewildered in response to the verbal onslaughts of [his on-screen counterparts]."[36] That failure of communication is, however, specific to Bike Boy's interaction with women. Provocatively, the collapse of conversation is presented in Warhol's films as the very stuff of normative heterosexuality.

This is partly because when Bike Boy is visually positioned as the object of homosexual desire, he does not have to do anything to hold onto this position—he doesn't speak, or at least, doesn't say much, and isn't expected to. Furthermore, these scenes are not staged as seductive duets. The sexual play of the film's first section lies more in how he is framed by the camera (as beefcake). He doesn't appear to be interested in anyone else, and this hardly matters. As he showers endlessly in the opening sequence, for example, the spectacle of his performance of male narcissism is enough to hold our attention. Naked, slightly self-conscious as he tentatively looks at the camera every now and again for direction, he appears almost vulnerable, which adds to his allure. Even in the long shopping sequence, no one literally tries to pick up the customers. The queeny shop clerks leave Bike Boy just enough room to play dumb as he tries on outfits and samples perfume. Later, however, as he spars with Brigid Berlin and Viva, his cluelessness and vulnerability take on a different and less appealing shape. Faced with their sexual aggression, he becomes defensive—retreating again and again into a macho posture that becomes less credible with each repetition. "Bikie," as he calls himself, alternates between bragging about his cunnilingual expertise and letting loose a stream of misogynist and gynophobic remarks. He refers compulsively to women's sex parts as "the hole down there," threatens Berlin with a knife, calls her a "horse," says she has "the horny face of a dyke," and calls Viva a "cold little bitch." The more Bike Boy talks, the straighter (and more repulsive) he becomes.[37] Bike Boy's conversation with Berlin is the most hostile. Berlin reclines on a daybed, fending off an extended verbal attack from Bike Boy. At one point, fed up with his insults, Berlin asks that the filming stop (it does not). She begins to gay-bait him in response to his frequent coupling of misogyny, come-on, and homophobic insult, calling him a "leather queen." As they spar, his working-class macho posture is thrown into relief by the heft of Berlin's imperiousness (her father ran the Hearst empire) as she mocks his Boston accent. Watching their exchange is exhausting.

By the time Bike Boy winds up on the couch at the film's conclusion with the ethereally white, cosmopolitan, and cool Viva, who complains that he "comes on like a bulldozer," you believe that he is, as she tells him, a bad kisser, that he cannot get it up for her, that he is legitimately scared, because she is genuinely scary. When the film ends, they are naked on the couch, and she is laughing at him—"Well, I'm not laughing at you," she explains, "I am just laughing because you're funny." "Funny? I ain't funny," he says, and, not even midway through this statement the film goes to black, cutting him out of the picture in a formal enactment of his impotence. And, of course, the joke is on him—

because by this point his performance of heterosexual masculinity has been completely unraveled by the virago's bottomless reservoir of talk and verbal manipulations. If *Bike Boy* begins with one portrait of the biker's nakedness, in which his body is ours to enjoy, it ends with another kind of stripping down, in which his defense of straight masculinity against not only active female desire but a relentless cosmopolitanism breaks down into a performance of class abjection almost too painful to watch. No one, in this setup, gets what they want.

Sandwiched in between the happy homoerotics of the first half, and the disastrous heterodynamics of the second, is a scene that presents another cinematic possibility for female participation in this environment—a kind of parenthetical, it interrupts the film's movement away from camp play. Bike Boy's encounter

Figure 13. Andy Warhol, *Bike Boy,* 1967–68, frame enlargement. 16-mm film, color, sound, 95 minutes. Pictured, left to right: Joe Spencer, Ingrid Superstar. Copyright 2005 The Andy Warhol Museum, Pittsburgh. All rights reserved.

with Ingrid Superstar is the first of the (failed) heterosexual seduction scenes and is, formally and politically, the most provocative. He leans against the wall of a small New York kitchen, as Superstar paces in and out of the frame aggressing him, trying to get him to talk to her. The kitchen feels small, cramped, and too bright. Ingrid's makeup is caked on—her blue eye shadow so thick and opaque it evokes Warhol's most garish portraits.

A sometimes maligned superstar, Ingrid Superstar was, according to Factory lore, brought in from New Jersey as a "low-class" substitute for Edie Sedgwick. As the scene starts, she calls Bike Boy out on his arrogance, as one of those "bikies" who "just think they are so hot and can get any girl they want," a sexual tourist who has come from "California to New York just to see what it's like and to ball a New York chick and to see how New York operates"—as if the woman and the city were the same thing. We can read a lot into this association—a tradition as old as the city itself, in which its offerings are imagined in terms of sexual possibility and sexual damage, an inventory of streetwalkers, runaways, hustlers, society mavens, queens, old maids, *bohemiennes*. It is Walter Benjamin's city, Diane di Prima's, Samuel Delany's, Warhol's. Perhaps our Bike Boy, she speculates, channeling the film's picaresque plot, is looking for this sort of thrill? But Superstar doesn't stay with this train of thought for long. Confronted with a wall of silence, she changes her tack and sails off in another direction. As she does so, Bike Boy smokes, he strokes his arms, he shifts from one foot to another. Despite her appeals to him throughout the scene, he never acknowledges her presence. He appears, in fact, quite serene—a quiet Marlon Brando, off in his own space.

"What do I have to do to get your attention?" Superstar whines, halfheartedly: "What are you, are you a faggot or something?" (Which comes off as a great joke, in which she plays the dumb broad set up by the campy scenes that lead to this encounter.) Again, he does not acknowledge that she is speaking to him. Rather than become nonplussed, Superstar surprisingly settles into her irrelevance. Combing her hair, she prattles on, modifying the rules for this improvised encounter. (One can imagine the instructions—"Ingrid: You talk. Like you want to get his attention. Joe: You lean against the wall. Ignore her and say nothing.") She stops trying to get anyone's attention and fills the duration of the scene with verbal diarrhea.

When she takes the measure of her situation, when she realizes he will never respond to her, she seems relieved by the fact that she no longer needs to be interesting. She hoists herself onto the kitchen countertop, and from this perch she settles into a topic of sorts—food. *She* does not even seem to pay attention to what she is saying (some of her recipes do not make sense), and as she talks, she slips off her bra and takes an arm out of her sleeveless dress, leaving one breast exposed. This has no effect on Bike Boy. Indifferent to his indifference, Ingrid prattles on and on about how to cook what. For example, after explaining at length how to make a salad, roast a chicken, and the various ways one might serve shrimp, she launches into the following recitation on soup:

And then there's always the soup. Now, the soup of the meal is, uh, very very important because soup is very very easy to digest and it doesn't really fill you up that much, unless you're sick. Now, there's all different kinds of soups. Different kinds of soups. Soup—it's just so much fun, and, like, so easy to make. Say you wanna make a vegetable soup. All you do is take a big pot and fill it up with some water or some broth and start chopping potatoes and onions and carrots and peas and lettuce and celery and cucumbers and everything, uh, and noodles and meat and fish and lobsters and shrimp and just mix it all together in a big garbage soup [here, she lowers the other strap of her dress] and, really, it tastes so delicious and you season it with salt and pepper and garlic salt, you drop a couple of fried eggs in it, make sure they don't get runny, and, uhm, and then if the leaves get curly you take an iron and ya iron the leaves out. And, uh, I mean, soup is just so divine, my dear. It really is. And then the second, the uh third course of course would be the salad, which I've already discussed. Now for the fifth course, I would like to make you some roast beef.

At which point she asks Bike Boy (but without really engaging him), "Do you like roast beef?" She cocks her head to the side, leaving room for a reply without, however, appearing to expect one. After a beat, she continues: "Well I don't care if you like roast beef, because *I* like roast beef and that's all that matters: What *I* like, not what you like. So, uh. Roast beef. Well you just stick the roast in the oven for a couple hours . . ." As her soliloquy picks up a rhythm, she relaxes into her position as *not* Bike Boy's object of interest. In fact, it becomes increasingly obvious as the camera stays on them that he does not even seem to be bored by her—he seems, rather, to participate in a different economy of interest altogether (that of the trade hustler, leaning against a bar, waiting for someone else). It is not clear that he is even listening to her.

So Superstar kills time, emptying out her speech until the viewer can hardly stand it because the dynamics of interest in the scene have become so perverse. As a boring performance, it both shares much with and differs significantly from Ishmael's narrative excesses. The motor of his desire drives him to obsessively record every detail of the object of his desire—and while we might waver in our commitment to the subject, we never doubt the strength of Ishmael's attachment to it. Superstar, on the other hand, is simply filling up the time and space of the scene. Her passive resistance to the demand that she interest Bike Boy becomes fascinating as a performance of the desire to be boring, of, even, the production of boredom as a critical mode. Toward this effect, she interrupts her strange culinary excursus and sighs wistfully, "I must be boring someone," as if this were her hope.

As she says this, she outlines the difficulty of her position on the screen. What she lacks (to quote the feminist critic Naomi Schor, writing about Emma Bovary) "is not a lover, but a receiver."[38] She is talking to herself—and, worse, she is talking to herself not because she is alone but because her on-screen partner is not listening to her. Carla Kaplan writes that "no form of talk is as self-effacing, humiliating, or damaging to social standing as is talking to ourselves."[39] The disempowered subject "longs" for talk, longs for a listener

who might engage her talk and turn it into conversation.[40] Superstar, however, seems very comfortable in her chatter—we might, in fact, compare her performance with that of *le bavard*, the title character of a 1946 experimental novel that charts the aimless, nonstop chatter of its narrator. Eleanor Kaufman, in an essay on chatter and philosophical friendship, suggests that this experimental transcription of meaningless talk renders speech into a play of forms—in which form stands "slightly apart from content," to "far surpass . . . anything that the content might disclose."[41] Toward this end, Maurice Blanchot writes of *le bavard* that "chatter is the shame of language. To chatter is not to speak. The stuff of speech destroys silence while at the same time impeding speech. When one chatters, nothing true is said, even if nothing false is said, because one is not truly speaking."[42] It is speech, Kaufman writes (drawing on Blanchot's words), and not chatter, that "risks shutting language down," insofar as it is in chatter that we play with language—with happy accidents and strange conjunctions.[43] She wonders, then, if "saying exactly nothing is really saying nothing. . . . in laying bare the nothingness of a text, in making that nothingness excessive, perhaps something extraordinary is being iterated."[44] Superstar offers us a cinematic version of *le bavard*'s excessive nothingness. She seems to luxuriate in the meaningless of her talk and in her own boredom, displacing any discomfort with her situation onto the audience and leaving us to wonder at the point of it all. Her performance—which conjoins seduction, nudity, and domestic mundanity—furthermore draws to the surface the association of this kind of pointless talk with the housewife.

Her performance in this scene thus parodies the wreckage of heterosexual coupling that Vogler describes in "Sex and Talk," the kind of breakdown in communication that is the subject of endless talk shows about marriage, and of pop psychology books on the differences between the sexes. In those situations, the man longs for intimacy through sex, and the woman for the same, through talk. Both are after (in Vogler's words) "depersonalizing forms of intimacy" in which they might be relieved of the burden of producing the contours of the self for the other—but fail to understand the nature of their differences and what ought to be done about it. Drawing from Deborah Tannen's work, Vogler writes that women

> voice fleeting thoughts, impressions, doubts, and feelings and mix discussion of minor events in intricate sensory detail with talk of bigger things. This is one of *the* most common ways exemplary U.S. women engage each other verbally and exemplary U.S. men *can't stand it*. As one man put it in an interview [with Tannen], "I do not value my fleeting thoughts, and I do not value the fleeting thoughts of others," having had to engage with a woman's troubles talk for the sake of finding a new partner after his divorce left him "dizzy from having been bounced around like a yo-yo tied to the string of her self-consciousness."[45]

Superstar acts out for us the humiliation of the woman's position in this domestic drama insofar as it mirrors her place in the world-at-large that ignores

her or talks over her as if she were not talking at all. To borrow again from Kaplan's discussion of the ethics and erotics of talk, Superstar's performance satirizes "the disjunction between the implied promise of dialogue and narrative exchange and the actual social, discursive, and material conditions faced by disadvantaged speakers, the conditions in which any dialogic exchange must actually take place."[46] Her performance is a rather acidic comment on what heterosexuality wants from women (empty speech)—a hysterical bookend to Pedro Almodóvar's "Talk to Her" (which suggests that what heterosexuality "wants" from women is to put them in a coma). Here, the heterosexual woman is literalized as the weak interlocutor—satirized as the woman who won't shut up, exactly because she knows no one is listening to her. And also because, let's not forget, the man she's talking to isn't interested in women—the awkwardness of her presence seems mainly to underscore the film's queerness. The queer frame of their encounter is perhaps the only thing that keeps the scene on the funnier side of the tragic. Her performance is enabled by Bike Boy's, the perfect "trade" object of homosexual desire; his presence unmoors hers from the seduction narrative and allows our attention to wander. As she says "I must be boring someone," we bear witness both to her desire for an audience and to her familiarity with talking to an empty house.

Radical Boredoms

Siegfried Kracauer argues for boredom as crucial to the resistance to bourgeois culture—a willingness to be boring as a kind of luxury that resists capitalist modes of production and the demand to be always productive. He writes, "People whose duties occasionally make them yawn may be less boring than those who do their business by inclination," and argues against the constant stream of information, images, and sound that "effaces every trace of private existence."[47] Reading Ingrid Superstar's performance against that of Brigid Berlin, in this context the "low-rent Edie Sedgwick" is more provocative than Berlin, who constantly pushes the boundaries of her conversation with Bike Boy and tries to keep things interesting (calling him a leather queen, etc.). Superstar proves that boredom can "provide . . . a kind of guarantee that one is, so to speak, still in control of one's existence." Hers is a dialectical reversal of the demand to be interesting, in which the refusal to interest opens up the possibility of something actually happening.

This is the point at which the postmodern readings of Warhol's films—in terms of the death of the author, the erasure of the traces of the author's subjective presence—converge with their potential as feminist texts. Boredom interests Kracauer as a mute negation of the capitalist mandate to production, and Warhol's blank affect, his performance of cosmopolitan boredom, has been taken as definitive of Pop's postmodern turn—its refusal of modernism's weighty self-importance, its negation (emptying out) of the sign.

David Joselit's "Yippie Pop: Abbie Hoffman, Andy Warhol, and Sixties

Media Politics" is one of the most interesting essays on this side of Warhol's aesthetic. In his exploration of the harmony between Warhol's aesthetic and Abbie Hoffman's politics, Joselit maps their shared interest in the dissolution of the difference between figure and ground. In particular, Joselit writes, the Exploding Plastic Inevitable (multimedia events produced by Warhol around Velvet Underground performances) bred "a circuit of media feedback . . . in which the line between performing oneself and becoming an image was perpetually crossed and re-crossed."[48] As the audience found itself lit up by the flicker of a strobe light, for example, they seemed to experience themselves as though they were literally on film. His characterization of Warhol's multimedia events is surprisingly evocative of Laura Mulvey's call for the destruction of traditional forms of cinematic pleasure:

> The first blow against the monolithic accumulation of traditional film conventions (already undertaken by radical film-makers) is to free the look of the camera into its materiality in time and space and the look of the audience into dialectics and passionate detachment. There is no doubt that this destroys the satisfaction, pleasure, and privilege of the "invisible guest," and highlights the way film has depended on voyeuristic active/passive mechanisms. Women, whose image has continually been stolen and used for this end, cannot view the decline of traditional film form with anything much more than sentimental regret.[49]

We can thus read the radicalism of Ingrid Superstar's performance from two angles: the production of boredom as a refusal of traditional forms of cinematic pleasure and as a formal resistance in its confounding of the relationship between figure and ground. As she talks on and on about food, she becomes not only just something to look at (like Bike Boy) but also, in essence, a fixture of the kitchen (anticipating Chantal Akerman).

Mulvey famously denounces narrative cinema's organization of women as objects of interest, as mysteries to be figured out, reined in, re-presented as pure spectacle. As Superstar prattles on about food and inexplicably peels herself out of the top of her dress, she replicates and inverts one of Hollywood cinema's most conservative presentations of the spectacle of feminine sexual difference. Her performance of depersonalized talk (which, in terms of what it says, reveals nothing) calls to mind the musical numbers in suspense films, around which all action would grind to a halt so that the femme fatale might offer herself up as a spectacle. Explaining why suspense films so often arrested the development of plot to offer the spectator apparently pointless musical numbers, Mulvey writes:

> The woman displayed has functioned on two levels: as an erotic object for the characters within the screen's story, and as an erotic object for the spectator within the auditorium, with the shifting tension between the looks on either side of the screen. . . . the device of the showgirl allows the two looks to be united technically without any apparent break in the diagesis. A woman performs with-

Figure 14. Andy Warhol, *Bike Boy,* 1967–68, frame enlargement. Pictured, left to right: Joe Spencer, Ingrid Superstar. Copyright 2005 The Andy Warhol Museum, Pittsburgh. All rights reserved.

in the narrative; the gaze of the spectator and that of the male characters in the film are neatly combined without breaking narrative similitude. For a moment the sexual impact of the performing woman takes the film into a no man's land outside its own time and space.[50]

The juxtaposition of Superstar's nudity with her pointless speech traces out the ludicrousness of the woman's position on film—that she hold our interest, without, however, becoming narrative's agent.

Ironically, Kracauer argues, "If one were never to be bored, one would presumably not really be present at all"; one would never encounter one's self "and would thus be merely one more object of boredom," becoming of a piece with the closed-circuit broadcast that prevents even people waiting in line from

finding "the peace and quiet necessary to be as thoroughly bored with the world as it ultimately deserves."[51] We might imagine Superstar as suspended within this mandate to always keep the audience interested (and distracted). Superstar's refusal of the imperative to be interesting, her invitation to find her boring (enabled by her own willingness to be bored), allows us to inhabit the scene alongside her—to find her boring, to find him boring, to be bored, and to find oneself boring—which, for Kracauer, Phillips, Benjamin (for all the philosophers of boredom), is the first step to taking an interest in the world. The moment Superstar relaxes into her position as not-interesting, we are released from a spell—for at this point, she stops competing with Bike Boy for our attention, and, counterintuitively, we find ourselves finally able to really see her.

We might place her at one point on a spectrum of feminist takes on boredom (alongside, for example, Akerman), with Valerie Solanas at its extreme. For the heroine of *I, a Man* opens *The SCUM Manifesto* with a frontal attack on patriarchal normalcy that, while in its forthrightness is perhaps the exact opposite of Ishmael's circumlocutory style, is, like *Moby-Dick,* presented as a response to boredom:

> Life in this society being, at best, an utter bore and no aspect of society being at all relevant to women, there remains to civic-minded, responsible, thrill seeking females only to overthrow the government, eliminate the money system, institute complete automation and destroy the male sex.[52]

These diverse voices are the calls of the twenty-ninth bather, the visible invisible woman who encounters her self only by finding herself in a place she does not belong, on one level surrounded by an audience of people who take no notice of her presence, and confronted on another by the singular spectator who, too bored to follow the plot, discovers that there is more to the story than the story.

The Effect of Intimacy
Tracey Emin's Bad Sex Aesthetics

Bad Sex: An Academic Exercise

In a funny expression of the academy's ability to assimilate anything into criti-cal discourse (especially things that seem to echo the structure-of-feeling of the academy itself), several years ago I was asked by some feminist colleagues to participate in a "think tank" about bad sex. The conversations we had that weekend never went anywhere—the collective intellectual project has since been abandoned. Nevertheless, some of the terms we kicked around in our discussions pointed toward a vocabulary for representing what I take to be one of the most interesting aspects of Tracey Emin's work: its participation in what one might call a "bad sex aesthetic."

Tracey Emin is, next to Damien Hirst, the most famous of the YBA's, a generation of young British artists whose work was aggressively collected and exhibited by Charles Saatchi in the 1990s (most notoriously through the *Sensation* show, exhibited in the United States at the Brooklyn Museum of Art). Emin remains a regular in British tabloids, as well as in more main-stream newspapers (like the *Guardian*) in which she appears as a sort of wise female Keith Richards haloed by a mythology of debauchery, creative genius, and stamina. She has, more than any other artist from her circle, become a celebrity. In an essay on the relationship between Emin's celebrity persona and her video work, Lorna Healy writes, "Emin has fans who seemingly want to possess her sexually or romantically, or be like her." Girls have lined up at art openings to get her autograph, shouting "I love you, Tracey!" Healy continues, "People cry 'I love you, Madonna' maybe, or express similar emotions to other pop stars and celebrities, but nobody, at gallery openings, shouts to [artists] Auerbach or Craig-Martin 'I love you, Frank,' 'I love you, Michael.'"[1] Emin's

work, in other words, solicits an emotional response from her audience more akin to pop culture than high art. Her work is almost always overtly confessional, and personal. It incorporates ordinary objects, mementos, detritus from her everyday life—and, most frequently, moving portraits of the affective life of a sexually provocative woman, of a woman intimately familiar with the experience of being fueled and ruled by desire. If ever there was an artist who has thought seriously about the negative side of sex, it is Tracey Emin.

Her work came to mind during that academic conversation about bad sex not because it offers a cautionary tale to its audience—quite the opposite. As many members of her fan base would tell you, Emin's work is, in fact, inspiring. The question it posed to us was the following: why would anyone find a work like *Inspired* (1998) inspiring?

As feminists, our hope that weekend was to use the term *bad sex* to drive a wedge into discourse on women and sexual history in which negative, dis-

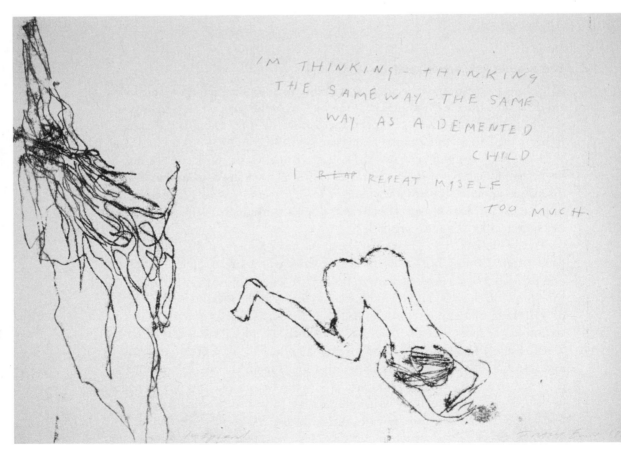

Figure 15. Tracey Emin, *Inspired,* 1998. Monoprint, 11¾ x 16½ inches (30 x 42 cm). Photograph by Stephen White. Reproduced with permission of the artist.

abling, unpleasurable, humiliating, abjecting sexual experiences might be projected into a space defined by something more complex than a contractual, consent/nonconsent model of sexual encounters. That model offers women (and perhaps especially American women, who must wrangle with a cultural imperative to psychosexual health) a choice between only two kinds of sex—good/happy/fulfilling (sex you want and ask for) or assaultive (sex you do not want and have not consented to).[2] It seemed to us that we could use more room to acknowledge the importance of experiences of boring or nonorgasmic sex, of humiliation, and experiences that are painful and traumatic (but entirely consensual). These encounters are sometimes potentially formative, foundational, at the very least as experiences of what we do *not* want—*again,* or anymore, or in that way. These experiences sometimes reemerge—modified or reenacted with fetishistic perfection—as the basis for the scripts of the sex encounters we pursue. In our group discussion we wanted to claim this kind of sex as something that happens without enacting around ourselves a therapeutic discourse of victimization, confession, and recovery. We wanted, furthermore, to distinguish our interest in "bad sex" from sex policing (and its history within feminism) and from a redemptive project advocating one kind of encounter or another as "good/healthy sex," as egalitarian in form, and, therefore, as "good for you." States like self-abandonment, submission, objectification—the experience of being made the object of another's pleasure—are not only exciting and fun, we all agreed, but important, even necessary, to experiences of sexual pleasure.

Our concerns thus revisited Leo Bersani's polemic against the "pastoralization" of sex within feminist and antihomophobic writing. In his essay "Is the Rectum a Grave?" Bersani describes sex as structurally pivoting on a will to self-disintegration. Ideally it is not, as liberals like Catharine MacKinnon and Andrea Dworkin would have it, an expression of "tenderness and love" but, again, *structurally* "anticommunal, antiegalitarian, antinurturing, antiloving"—unequal in its essence.[3] Bersani advocates a vision of "the sexual as . . . moving between a hyperbolic sense of self and a loss of all consciousness of self." Bersani continues, "It is primarily *the degeneration of the sexual into a relationship that condemns sexuality to becoming a struggle for power.* As soon as persons are posited, the war begins."[4] What one proposes to *do* about this "war" marks the difference between Bersani (who writes of the power dynamics in sex as "our primary hygienic practice of nonviolence," as valuable *for* its disruption of the social, the communal) and MacKinnon (who, for nearly the same reasons, would reorganize the practice of sex to bring about women's social empowerment).

The philosopher Candace Vogler (a participant in the bad sex weekend retreat) neatly summarizes the attraction and the difficulty of Bersani's writing in her essay "Sex and Talk": "If one hasn't the boundless self-assurance . . . required to find the pastoral vision of sex anything but decidedly un-sexy, alien, and faintly revolting," she writes, "then one almost cannot not love [Bersani's]

account of the sexual as sublime. The story is a delicious antidote to the wide-spread impulse to harness sexuality firmly to carts carrying happy selves to-wards egalitarian camaraderie. Nevertheless, it's worth resisting the impulse to sublime sex if only because . . . it's worth resisting the impulse to sublime anything."[5] Vogler argues that Bersani's "account of the seesaw of me-not-me in sex . . . treats sexual excitement, *not* as a culturally imbricated destination for *men* with overly rigid senses of masculine self-hood seeking depersonalizing intimacy, but rather as the sublime footprint of human evolution."[6] In doing so, he risks underrepresenting the degree to which the possibility of taking pleasure from being relieved of personhood is deeply contingent and political, and naturalizing the designation of sex as *the* place in which this happens (and as an intersubjective space less social, less ideological than any other). One's access to the desire for this experience of self-dissolution may be a symptom of privilege—a white man, for instance, might crave that experience more intensely for all the ways that he experiences his personhood as burden. The articulation, furthermore, of social privilege around feminized, racialized, classed spectacles of sexual abjection is a definitive operation in the social practice of white bourgeois heterosexual masculinity.[7] People subjected to these dynamics outside the bedroom may yearn for the reiteration of those dynamics in the bedroom *differently* (more or less intensely, more or less modified).[8] This is not to say that this social inequity is not in and of itself useful as an erotic script to minority subjects male and female—merely that the ecstatic rehearsal of these scripts is, sometimes, all the more delicate for your real-world resemblance to (or difference from) the part you play in the bedroom.

Bersani's polemic presumes, furthermore, that "self-shattering and solipsistic jouissance" always "drives [lovers] apart."[9] What if it doesn't? What if, in fact, when everything goes well, sexual contact facilitates connection *exactly* insofar as it facilitates a relief from the epistemic pressures of selfhood? Toward this effect, Vogler writes that "the fact that some intimacies are *not* affairs of the self is what makes people want them" and, furthermore, want them with other people.[10] What if, returning to the subject of bad sex, bad sex grows out of the failures of the mechanism that allows us to take pleasure in letting the body become a thing, a body "subjected" to another's desires—the play with one's own thingness being one condition of possibility for the ecstasy of being relieved, for a moment, of one's personhood. What if, following Vogler's model, bad sex is what happens when the architecture that supports "depersonalized intimacy" falls apart?

Vogler and Sharon Willis (another member of the bad sex collective) described this unhappy experience of oneself as a "subject" in sex as a "failure in objectification." This failure might happen when, in sex, you see yourself—when the phone rings, for example, or when someone knocks on the door. You catch an accidental glimpse of your own banality (à la Sartre), and the wind is sucked out of your sails. Or, worse, you discover that you've misread the moment, misread your desires, or theirs, and don't trust that you can "go there"

and come back intact. You might not be in the mood, you could be feeling too fragile to let your body go that way, or perhaps you misrecognized the context and find yourself giving your body over in a way you don't enjoy and to a person you don't trust. Maybe bad sex is sex you deeply regret, a continual source of shame—not because it was assaultive but precisely because, out of curiosity, out of a desire to please, out of a fear of appearing prudish, you did ask for it. Bad sex, in this sense, may also happen around the production of one person's *social* privilege as the other's *sexual* abjection—and one's proximity to social, political abjection (via sex, sexuality, race, ethnicity, nationality, class) may make the process of self-abandonment more emotionally tricky and more risky. Becoming object may not be sexy if objectness is always already thrust upon you. Or, for becoming object to be desirable, it may require feeling safe from the penalties that accrue in everyday settings to being the already objectified person.

As we talked about bad sex, I found myself increasingly preoccupied with certain kinds of objects—art objects by mostly women artists that tickle the line between the pretty and the abject, that invoke the body, but not exactly the subject: Yayoi Kusama's obsessive sculptures—ordinary furniture covered with penile extrusions (*Accumulation No. 1*, 1962), for example—or the organic minimalism of Eva Hesse's flesh-textured tubes and sagging sacks, Helen Chadwick's piss flowers, or Louise Bourgeois's biomorphic sculptures. The terms of our conversation—objectification, ambivalence, desire, abjection—offered a conceptual framework for thinking about art that explores the more difficult contours of sexual life by invoking the uncanny body, the humiliated body, the body obsessed by desire and constantly undone by that obsession. The objects that came into view seemed to get at another aspect of the conversation: sexual experiences "stick" to your body.

The phrase "failure of objectification," and its sexual context, struck me as immediately useful for thinking about these contemporary artists who work through the difference between the abject and the beautiful, enacting a violent seduction and rejection, fucking with our interest in art. These objects might repel the spectator—but that repulsion is precipitated by an aggressive interest in, or attraction to, the object's prettiness from a distance. Your attraction to it turns that object into something grotesque—this is, as it happens, how Chris Ofili's controversial "Virgin Mary" works: his painterly multimedia collages are, above all else, colorful and gorgeous. It is only as you draw close—solicited by its prettiness and, perhaps, by the curiosity, as one nineteenth-century writer put it, of a colonial hoping "to discover some new race of Hottentot"[11]—that you notice she is surrounded by butterfly collages of pornographic "beaver shots" and clumps of elephant shit.[12] This sort of work produces affective states deeply inappropriate to (and yet already embedded in) the museum space—sexual interest, disgust, boredom, or tears. It can also express how desire turns the body into a frightening thing, a shameful thing, an abject thing. It seems to concretize the unevenness of sexual disasters—in which one person seems to end up with more than her fair share of the shame.

If These Walls Could Talk

If my vaginal ego could talk, it would definitely disobey the two-word limit Eve Ensler put on the participants in her project *The Vagina Monologues*. It would prattle on, it would repeat itself, it would forget itself, embarrass itself, embarrass its audience—offering up instead a stinking, maudlin stream of thought not altogether unlike the following:

> I know when the fighting starts—I know that I have lost—every hole in my body is bleeding—my nose my cunt—my eyes are red raw from all the tears—I'm clutching my stomach, holding onto myself—trying to stop my SHIT from spilling onto the floor—I'm all wrapped up in my own pathetic loneliness—desperate to feel loved again I can't eat—I can't sleep—my mind jumps from a grinding numbness—to some crazy fucked up out of control DOG like hell. That's how it is to live without LOVE.

These words are Tracey Emin's. And I conjure them up as an elliptical response to one of Warhol's early forays into Pop: a 1965 combination of advertising elements that captions a torso with the question, "Where is your rupture?" Warhol's uncomfortable blend of a sexing question with a sexless body presumes that we all have ruptures and that we love to talk about them. The body in this image, however, has none, merely arrows suggesting that if it did, we might find it somewhere between the heart and the crotch. In place of the kind of splitting one might imagine in response to the question posed by the painting, Warhol offers us a neat tuck, a hospital-corner fold, a drag queen's crotch: sex as everywhere but *there*.

The torso is blank. The vaguely medical, therapeutic caption implies a narrative that might sex the body, might locate the body in sex. The question "Where is your rupture?" hopes to produce the breach it assumes. We could take this work as a somewhat flat-footed illustration of one principle of queer performativity—that the body, as we know it, is produced through narrative, that sexual difference is less discovered than produced by the question, "Boy or Girl?" Sexual difference as imagined in art, furthermore, is no more a record of the Real or the natural than the painting that depicts it or the spectator's demand for it. "Where is your rupture?" may be the first question you ask of an image of a sexless torso—forgetting Magritte's lesson, "Ceci n'est pas une pipe" (This is not a pipe).

My interest in this work is not as noble, however, as an academic's commitment to allegorical valuation: I like it because I think it is talking to *me*, I take it as *about* me. It indulges my narcissism: "Here! Here! My rupture is right here!" Being the Warhol fan that I am, I imagine the artist himself asking me to tell him all about it (over the phone, each in our own bed, downing Valium and vitamins, gossiping, talking about sexual triumph, romantic abjection, abortions, and colostomies). A fag hag's fantasy of being a favored hag to the ultimate fag. (A fantasy always already undermined by my affection for Solanas.)

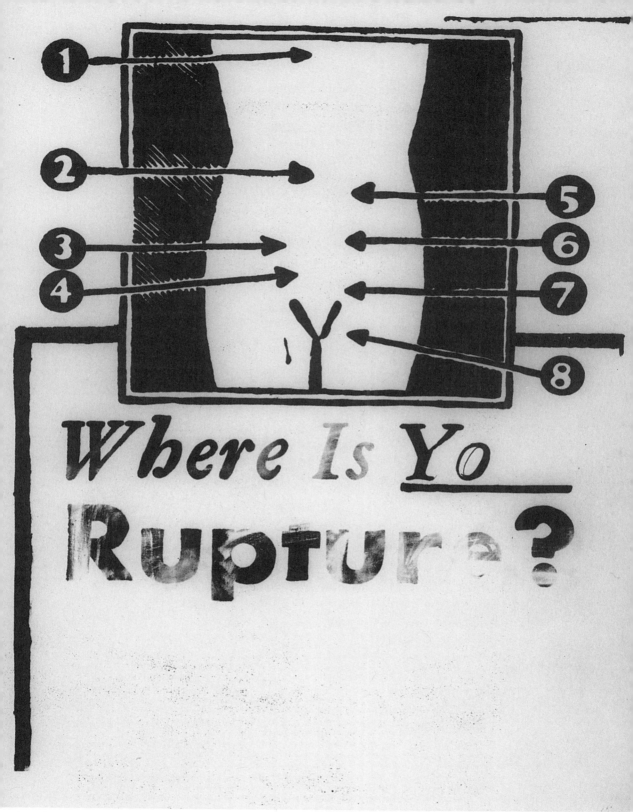

Figure 16. Andy Warhol, *Where Is Yo——Rupture?* 1960. Copyright 2004 Andy Warhol Foundation for the Visual Arts/ARS, New York.

Where Is Yo—— Rupture? conjoins formula and sincerity—it invokes a story that is simultaneously completely scripted and absolutely personal.[13] It implies that you can produce the most generic story about your "rupture" with the utmost sincerity and eagerness of affect. If you are a person who has these kinds of ruptures, you tell your story again and again, forgetting (or, more nearly, not caring) whom you've told what.

One could place Emin's monoprint, *I Used to Have Such a Good Imagination* (1997) alongside Warhol's painting, as one response to his question. It is a rough impression of a crudely drawn woman, legs splayed open on a couch, fingering herself, a strange object hovering in space behind her—a rifle? a broom? (Either way, it signals an impending punishment: a shot to the head, or housework.)

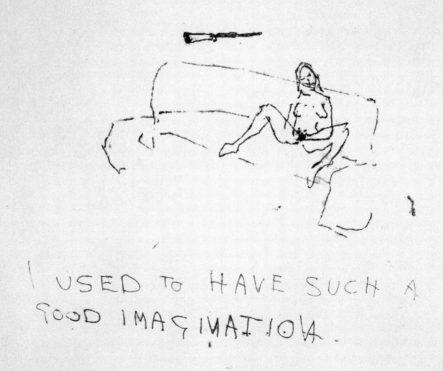

Figure 17. Tracey Emin, *I Used to Have Such a Good Imagination*, 1997. Monoprint, 23¼ x 28¾ inches (59 x 73 cm). Photograph by Stephen White. Reproduced with permission of the artist.

This work equates a failure of imagination with masturbation, with the excesses of everyday desire. The woman in the picture seems like she might be bored. The picture seems drawn out of boredom—carelessly executed by a person without much of an attention span, tossed off. The light touch of Emin's line (partly an effect of the monoprint, which places the touch of the artist's hand at a slight remove from the page) makes the work feel quick, executed without much of a plan, with a minimum of intention.

The sex recorded in Emin's work is aggressive, delirious, irritating, and joyful, loaded with fear, anxiety, humiliation, and anger. The romantic moments she describes are hopelessly melodramatic (take, for instance, *Love Poem* [1996], a blanket embroidered with the following: "Every part of my body is / screaming I'm lost / about to be smashed / into a thousand million / pieces each part for /ever belonging to you").

Her drawings, monoprints, and paintings in particular delineate a life ruled and often undermined by sexual desire—a will to fuck no matter the cost. "If I have to be honest, I'd rather not be painting" captions a painting of a man and woman fucking; *No Clear Thoughts* (1998) repeats the ambivalent equation of sexual aggression with the failure of intellect in *I Used to Have Such a Good Imagination*. Emin frames naked women on hands and knees with "I'm thinking the same way—the same way as a demented child I repeat myself too much" *(Inspired)* and a pathetic plea—"Don't just leave me here" (1997).[14] These works are acidic when compared with the folksy charm of a tent appliquéd with the names of everyone she has ever slept with (siblings, best friends, lovers, parents), or the defiantly happy stance of "Mad Tracey from Margate" expressed in her literalized crazy quilts—gin-soaked observations stitched into colorful blankets ("LEAVE HIM TRACE," "FUCK OFF BACK TO YOUR WEEK WORLD THAT YOU CAME FROM," "I LOVE ALL MY FRIENDS"). Taken as a whole, the work testifies to the ordinariness of pathos. The drawings and blankets produce extraordinary affect through an almost quotidian recital of romantic triumph and disaster—like *Where Is Your Rupture?* they turn the travesties of a sexual life into everyday banalities.

The overwhelming consensus on Emin's art is that it is confessional, that it is personal and tautological ("she opens her heart and mind without seeking sympathy or forgiveness"; "Emin's subject matter is herself")—she is her art and her art is she.[15] Adoring and circumspect critics alike worry (defensively or critically) that she will run out of things to say and write about her antics with the failure of subtlety particular to discourse on former lovers and ex-wives. Neal Brown opens his catalog essay with "Tracey Emin has big tits" before launching into an effusive explanation of why he loves her work. Matthew Collings begins his essay "Just How Big Are They?" with "Tracey Emin is very striking. Jay Jopling once said she was all woman." David Bowie, in his interview with her for *Modern Painters* (excerpted and reprinted in *Harper's Bazaar*), remarks, "She shimmied like a disco-queen. If she wanted, she could travel the length and

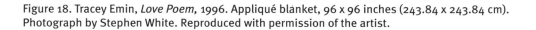

Figure 18. Tracey Emin, *Love Poem*, 1996. Appliqué blanket, 96 x 96 inches (243.84 x 243.84 cm). Photograph by Stephen White. Reproduced with permission of the artist.

breadth of the land with me and my band. Everyone from stagehands to musicians would immediately fall in love with her."[16] Emin's reception is littered with come-ons and effusive praise for her attractiveness to others. Everyone is trying to "pick up" Emin—as if her use of props from her everyday life (like her bed) and personal experiences (like a pregnancy and abortion) constitutes an invitation to think about Emin the artist as an always already available sexual object, as if these objects worked as metonyms for Emin the (injured) woman more powerfully than they do as metonyms for Emin the artist.

As irritating as the (un)critical obsession with Emin's body can be, I am not interested in contesting this aspect of her reception history. The blurring of the boundary between Emin's person, her work, and her public persona is an important effect of the work itself, and not simply because the work is so explicitly autobiographical. I am not convinced, in other words, that what makes Emin controversial or interesting is the deep narcissism described by her oeuvre, or an autobiographical practice unchecked by a sense of decency or shame.[17] One could ascribe those same qualities to artists with extremely different styles—Mary Kelly, Jeff Koons, Robert Mapplethorpe. At first glance, it seems that Emin's work fits squarely within the major paradigms of feminist art making: grounded in personal experience; explicitly critical, even accusatory in tone; her body offering itself up as a site of spectacular ambivalence; the citation of domesticity—a bed here and there, a grandmother's chair, homemade blankets. (These objects, like the quilts, often invoke a longing for domesticity, indicating the failure of a working-class house to fully acquire the aspects of a "proper home.") One might invoke a range of feminist art-historical contexts for Emin—artists like Carolee Schneemann, Cindy Sherman, or Hannah Wilke, who explore "the paradox of being both artist and object at once";[18] Faith Wilding's recuperation of feminine modes of production (like quilting); Ann Magnuson's and Annie Sprinkle's uses of their own bodies in the performance of sexual scripts. Karen Finley is the closest in affect: at once confrontational and personal—full of pleasure and rage. Finley's performances and writings are an important point of reference, for few artists produce work that is as maudlin and provokes such a particular, peculiarly sentimental, response from spectators.[19] Emin's work seems to offer itself up as an "unedited" incorporation of the remains of a messy sex life, as a fantasy of a (nearly) unmediated encounter with the artist herself—again, less precisely as an "artist" than as a woman. In doing so, however, it sets the stage for a fantasy encounter between the artist, spectator, and critic.

What makes Emin interesting is not only the sensationalism of her self-presentation and the way that her work seems to encourage suspicion, doubts about the originality of the gesture—as if the force of narratives of abuse, unwanted pregnancy, sexual conquest, and humiliation were pinned entirely to their novelty or even their veracity.[20] The work is, on top of all these other

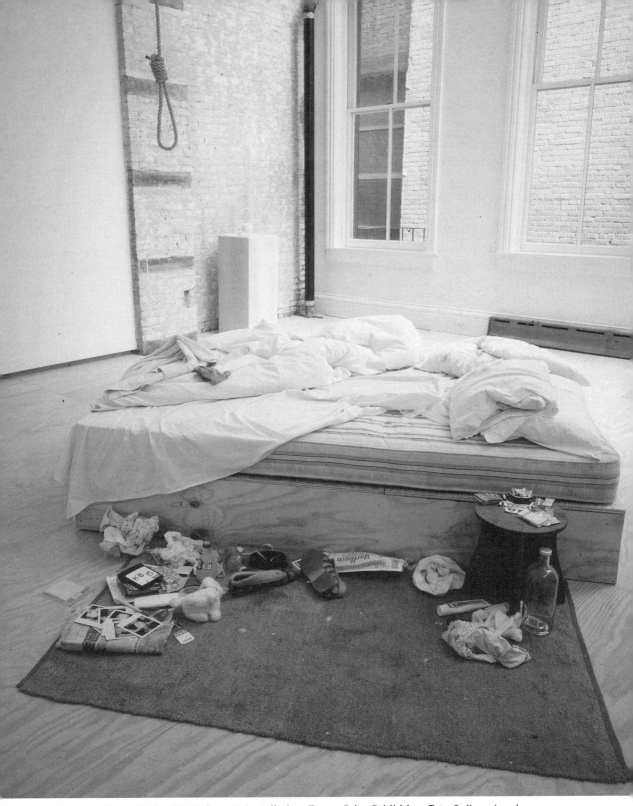

Figure 19. Tracey Emin, *My Bed,* 1998. Installation, Turner Prize Exhibition, Tate Gallery, London, 2000, and installation "Every Part of Me's Bleeding," Lehmann Maupin Gallery, New York, 1999. Mattress, linens, pillows, rope, various memorabilia, 31 x 83 x 92 inches (79 x 211 x 234 cm). Photograph by Stephen White. Reproduced with permission of the artist.

things, melodramatic—and this trait is fundamentally intersubjective. Reviews almost invariably describe weeping young women who identify with Emin's narratives of abuse, humiliation, rebellion. These spectators are so moved because they feel the work is not so much about "Trace" as it is about *them*.

Emin's work asks us to take it personally. I first saw *My Bed*, the monoprints, and videotapes at the Lehmann Maupin Gallery in New York (*Every Part of Me Is Bleeding*, 1999) and, as jaded an art consumer as I am, works like *No Clear Thoughts* and *Terribly Wrong* (1997) glued me to the floor. The body in the latter leans so far back her head disappears—her legs are open and her body expels an abortive, squiggly pile of blood, shit, or semen. It is a gynophobic poster—a record of sexual damage. The body ego limned by this drawing was familiar. I found myself interpolated by the work, as a spectator, in a manner that was both uncomfortable and exhilarating—I couldn't help

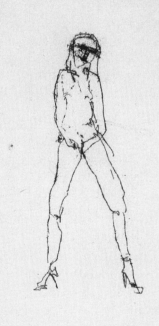

Figure 20. Tracey Emin, *No Clear Thoughts*, 1998. Monoprint, 9 x 31⅞ inches (23 x 81 cm). Photograph by Stephen White. Reproduced with permission of the artist.

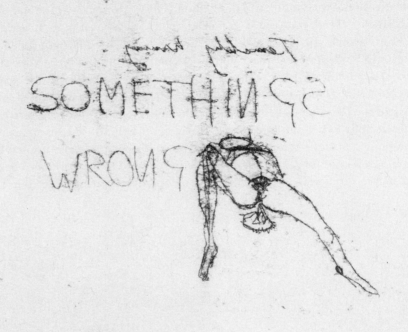

Figure 21. Tracey Emin, *Terribly Wrong*, 1997. Monoprint, 23 x 32 inches (58 x 81 cm). Reproduced with permission of the artist.

but think "Isn't this how Judy Chicago and Georgia O'Keeffe are supposed to make me feel (but don't)?"

The invitation to a mimetic identification with the affect of this work is not unlike the spectatorial dynamics of a film like *Stella Dallas* (1937, King Vidor). *Stella Dallas* tracks a "low-class" single mother's attempts to give her daughter the "proper" life she has always wanted for herself. Her efforts to move herself and her daughter up the social ladder are, however, continually undermined, as Linda Williams puts it, by "the excessive presence of Stella's body and dress," which can't help but give away Stella's lack of social position.[21] Once she comes to understand this (in an excruciatingly painful scene in which she overhears her daughter's friends making fun of her mother), Stella (Barbara Stanwyck) evacuates herself from the picture (by pretending she doesn't want her daughter

around anymore) so that her daughter can be absorbed into the happy bourgeois home of her (remarried) father. In this proper home, her daughter might meet and marry a suitable future husband—the kind of man who would be horrified by the brassy and low-class Stella. This supreme maternal sacrifice is emblematized in the film's last scene by the image of Stella standing outside her ex-husband's brownstone mansion, watching through a bay window as her daughter marries the man of her dreams, surrounded by the glowing, white, perfectly dressed and mannered members of her new family. Stella, in contrast, watches the wedding in the rain, crying, chewing on her handkerchief as she witnesses her daughter's entry into the bourgeois space that she could never reproduce around her *own* body. A policeman appears and tells her to move along—this scene of happy heterosexuality is not even hers to watch. Watching this, the sentimental spectator (who in critical accounts is invariably female) mirrors Stella's tears—she not only identifies with the woman on the screen; when she cries in sympathy, she reproduces Stella's position.

Emin similarly offers herself to us as a spectacle of feminine abjection. The unavoidably personal character of responses to Emin is always already a problem in criticism: she draws us too close, her work lacks emotional discipline. We reveal too much about ourselves in laying claim to this response (a risk that does not adhere—at least not in the same way—to identification with O'Keeffe's or Chicago's soft, slightly abstracted vaginal portraits). That the work feels as if it is addressing "me" does not feel like a critical response at all. Rather, it feels like a failure of intellect to rise above emotion. Add to that the popularity of Emin's work (her celebrity, the work's accessibility), and we find that the critic who writes about Emin faces the same kinds of suspicion that feminist critics have faced when they have taken up popular forms like melodramatic film or sentimental novels—"body genres" denigrated for their appeal to the spectator's/reader's body, for their manipulation of their audiences, and for their commercialism.

The difficulty of evacuating the personal, the intimate, from the discussion of Emin's work makes it hard to defend the work's value within traditional art historical frameworks. It is hard to speak of the encounter with Emin's work strictly in terms of aesthetic experience or formal importance unless we do so negatively, insofar as it is grounded firmly in those things (semen, tears) against which high art is traditionally defined. Even the work's insistence on the desiring body is framed around negative emotions like rage and embarrassment. Take Emin's *Room Service*, for example. A pen-and-ink drawing on hotel stationery, its form is transitory. It looks carelessly, or at least spontaneously, drawn. The image is of a woman on her back, grabbing her crotch, her knees bent, legs spread apart. Her head is scratched out, and helicopters (the kind you would imagine a boy might draw while bored at school) fly over her. Dotted lines trace the imagined trajectory of their bullets: her cunt. "WISH YOU WERE HERE" is written above her, "COME ON" and an "X" below. This piece is accompanied by a note scrawled on the same Soho Grand hotel stationery:

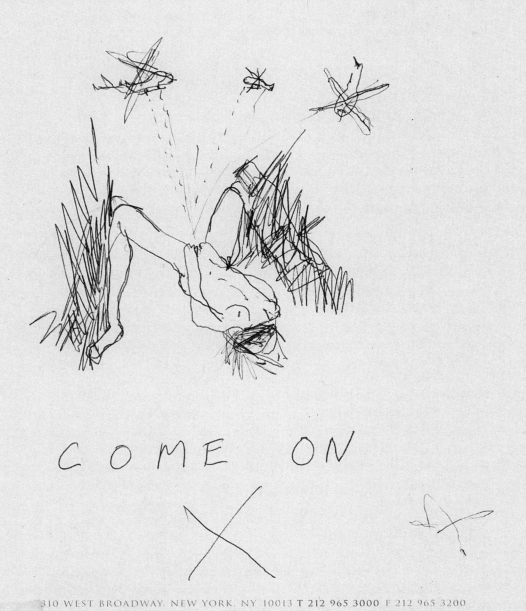

Figure 22. Tracey Emin, *Room Service,* n.d. Drawing. Reproduced with permission of the artist.

SOHOGRANDHOTEL

I Fucking LOVE you.
laying in bed watching MTV.
Thinking about The weekend.
PURE Spunk + Vodka.
And a bit of medetranian
Sky Throw in -
my kind of dream
Yea really beautiful
Kiss me now, And I'd
be SURE to Cum

X

P.S. probley in Your face.

I Fucking Love you.
Laying in bed watching MTV.
Thinking about the weekend.
Pure spunk + vodka.
And a bit of medetranian
sky throw in.
my kind of dream.
Yea really beautiful
Kiss me now, And I'd
be sure to cum
X
P.S. probley in your face

These doubly graphic works (drawn by hand, and also sexually explicit) render sentiments into things—turning a feeling into a note. Other drawings captioned by ironic self-statements (like "I used to have such a good imagination") similarly link the artist's ambivalence toward her body to an ambivalence about making art. They furthermore flicker between an accusatory and a sexually aggressive tone that positions the spectator as somehow complicit in her loneliness (as if these records of sexual glory and damage were made for our eyes).

Maybe we can read *I Fucking Love You* as a love letter. As such, it anticipates her fan's cry ("I love you, Tracey") and perhaps here we stumble onto what is genuinely "obscene" about Emin's art. In *A Lover's Discourse* Roland Barthes speculates that "it is no longer the sexual which is indecent, it is the sentimental."[22] He writes, "The moral tax levied by society on all transgressions affects passion still more than sex today. Everyone will understand that X has 'huge problems' with his sexuality; not one will be interested in those Y may have with his sentimentality: love is obscene precisely in that it puts the sentimental in place of the sexual."[23] Emin's works are not about sex-in-itself (whatever that might be) as much as they are about having a sentimental *and* a sexual life, about having feelings *and* a body.

Bad Sex Objects

In bringing the sentimental, the sexual, and art into such tight proximity with each other, Emin's drawings bring to the surface some of the tensions that shape critical thought on processes of objectification, and the politics of representation. Think, for instance, of Michael Fried's famously anxious (and influential) essay on (and against) minimalism, "Art and Objecthood." Fried's polemic has been thoroughly critiqued from inside and outside art history for its contradictory and moralizing attitudes toward minimalist sculpture.[24] In that article, he narrates his suspicion of the seductive powers of the art object that seems to anticipate the physical, sensual presence of the beholder, that appears to depend upon the desires of an audience (and therefore leans into theatricality, inducing, in his argument, a miscegenation of genre). This kind of work, Fried writes,

insists on its own "objecthood." This, in his argument, risks a dangerous anthropomorphism. Faced with this aspect of the object, "The beholder knows himself to stand in an indeterminate, open-ended—and unexacting—relation *as subject* to the impassive object. . . . In fact, being distanced by such objects is not, I suggest, entirely unlike being distanced, or crowded, by the silent presence of another person."[25] This kind of work is fundamentally antimodernist (and therefore bad) within Fried's model because it does not stand on its own. Fried's position is haunted by a deep suspicion of the subject/object relation. It is also shaped by an unease with the feminine, excessive quality of art that solicits, that waits for an audience (it shares much, in this sense, with the spirit of a rhetoric of prostitution). Amelia Jones, in her incisive reading of his arguments against theatricality, identifies within Fried's writing an unease with theatricality's femininity: the sort of object Fried opposes as "non-art" "lacks," in his view, Jones writes, "precisely in its theatricality: in its acknowledgement that it does not contain its own inherent significance and value, in its overt dependence on, even embrace of, spectatorial desire as a condition of meaning and value, and, in Peggy Phelan's terms, in its 'feminine' openness and solicitation of spectatorial relations of waiting, . . . rehearsal and masquerade."[26] Without venturing too deeply into the well-traveled territory of Fried's arguments against objecthood (and critiques of it), I would like to point out that his wariness, his ambivalence about the place of embodiment and feeling in contemporary art, interestingly (and paradoxically) rhymes with a feminist (or antihomophobic, or antiracist) sense of the hazards of having a body. The structure of Fried's ambivalence about objects is similar, for example, to Laura Mulvey's critique of the dependence of the pleasures of narrative cinema on the visual subjection (objectification) of women in representation, or even with a Foucauldian suspicion of the liberatory possibilities of making sex visible, as an object of study. Feminists are not necessarily, in other words, any less uneasy than the average art historian with the appeal that art makes to the senses—for all the ways that this seems to flirt with disaster, with the fleshiness of "objecthood."

The difference between a critic like Fried and a critic like Jones is that the latter, as a feminist, sees the fantasy of transcending the body as deeply problematic—as, indeed, the fantasy of the critical subject whose body is itself experienced as unmarked. She writes: "The psychic dimension of aesthetic judgment as a strategic mode of *othering* (of producing boundaries to define white, upper-middle class, masculine culture as superior in relation to a debased—non-white or 'primitive,' lower-class, feminine—alternative) is relatively clear." Traditionally, the critic sets himself or herself up as an authority on the object of his or her critique and writes as though the boundaries between this self and the object of critical thought are solid, impenetrable. "It is crucial, then," Jones argues, "for [this kind of critic] to claim 'pure pleasure,' to avoid acknowledging his investments in the determination of meaning: 'the loss of the subject in the object' [in which the reader or spectator identifies with

the object of representation—is turned on, repulsed, moved to tears or to anger] threatens not only the interpreter's claim to authority, but his very coherence as a subject (who is implicitly masculine, white, heterosexual, upper middle class, etc.)."[27] Within that critical paradigm, tears, sexual arousal, boredom, anger (the states, especially, of women, adolescents, political activists, people of color, and homosexuals) lie beyond the affective range prescribed to the good critic, under the assumption that the precondition for critical thought is emotional distance.[28] Fried's advocacy for the transcendental position is a mask for his sense of his own entitlement. His is a model of criticism that displaces the questions that most shape our work as critics (questions about pleasure and the body, for example) of all the organic materials that make those problems interesting (the material and political role of sex, gender, race, or money in aesthetics). "We are embodied, particular in our identifications," Jones writes, "we are flesh and part of the flesh of the world. As such, we *change* the things we encounter."[29] Jones asks us to consider the particular stories behind our sense of being "distanced," "crowded," or displaced, to avow the nature of our attachments to works of art.

Emin's work preempts the critical erasure of the subject from the object—this is why it came to mind in response to the hypothesis that bad sex results from a "failure of objectification." *My Bed,* an installation of Emin's empty bed and the detritus of the personal life staged in and around it (dirty linens, empty liquor bottle, a tube of KY Jelly, an overflowing ashtray), recasts the removal of the artist's presence from the gallery as an empty bed. And even that eviction is not complete. The rumpled sheets, the overflowing ashtray, and the work's title all suggest, as Jones has pointed out, "a synecdotal extension" of Emin herself, as well as an invitation to the spectator to imagine a place for his or her body in Emin's world.[30] Mandy Merck writes, "Hence the journalists' replies to *My Bed* [headlines like, "Would you show your bed to the public?"]: What about *his* bed? *Her* bed? What about *my* bed? Or, to move from the metaphor to the implicit meaning, what about my subjectivity? My body? My art? My suffering?"[31] Emin's work theatricalizes personal space—drawing the beholder into bed, kicking him out of it.

Intimacy and Melodrama

With a little revision, we can use other theoretical work by Fried to describe the affective charge, the emotional proximity of Emin's art. Fried's extensive writing on painterly realism leaves much more room for thinking about the body's presence to works of art.[32] Emin's generation of an effect of intimacy between the artist, the art object, and the beholder may be read as analogous to his description of how the "effect of realism" works in painting. In his writing about realism Fried powerfully displaces the critical treatment of painterly realism as "the painter painting what he saw as he saw it" in order that we might consider the ways that a painting sometimes leaves us with the sense that it records an

image that was, once, actually *there*. Rather than ask what *was* there, he asks how the painting generates this desire, in us, to ask that question in the first place. In more recent work on Gustave Courbet and Adolf Menzel, Fried explores how the effects of realist painting can be also thought of as a prolongation of the beholder's (and the artist's) physical presence to the work of art—as enacting an "effect of exchange or transfer," even an economy of empathy, between the artwork and the spectator's body (a body that, however, in Fried's work, is never marked as having a gender, race, etc.).[33]

What if we approach the intimacy of Emin's work—its materialization of physical and emotional availability, its metonymic relation to the artist and her body, its invitation to melodramatic identification—as an effect, as an aesthetic strategy, not unlike the effect of realism? This is to take intimacy and availability itself as the subjects of her work. In this sense, Emin's work resonates with other contemporary art that, as Liz Kotz argues, "allows viewers to project themselves and their own pasts into the image while also insisting on its specificity as a document of [the artist's] life, not ours." Kotz continues: "Part of the pleasure this work offers is to allow the *viewer* to feel like an 'insider,' an intimate, partaking in an experience that is neither public nor official."[34] The artists who most interest Kotz attempt to resist the institutionalization of art and art consumption through an aesthetics of "private disclosure" that is self-conscious in its mobilization of the personal as an aesthetic strategy. This work, she argues, has a complex relationship to the institutional spaces of art and a suspicion of the programmatic side of popular culture (which Kotz shares): "If we all feel the same sentimental rush before the same image," Kotz writes, "it ceases to be poignant, and instead becomes trite, coded, formulaic: an index of bland liberal humanism rather than acute social difference. And few things are more repellent than a programmed sense of 'intimacy' or a regulated experience of 'accident.'"[35] In her exploration of an aesthetics of intimacy, Kotz contrasts the deployment of intimacy in photography by Nan Goldin and Jack Pierson. Where Goldin's work deploys intimacy as a form of visual tourism that uses the artist's insider status (as a participant-observer) to legitimize the spectator's voyeuristic impulses and desire for the exoticism of the "underground," Pierson, Kotz argues, treats "the legitimizing values of subcultural documentary—'immediacy,' 'honesty,' 'intimacy' and the like . . . as effects of photographic codes, rather than as spontaneous intersubjective performances communicated neutrally via the photograph."[36] Pierson's aesthetic is overtly stylized—"he clearly understands photographs as fully semioticized, fully coded."[37] In making this contrast Kotz suggests the different ways an artist might use an aesthetics of intimacy to either reinforce liberal humanist models of authorship (as in Goldin's almost anthropological attempt to get at the "truth") or invert and rework them (Pierson's figuration of "truth" as a pose).[38]

Emin's work falls in between these poles, deconstructing the opposition of naive-deployment-of-formula and theoretically-savvy-self-referentiality. Her aesthetics of intimacy (e.g., the casualness of her line or the use of hotel stationery)

gives her audience a melodramatic contact high. It toys with the proximity of intimacy-effects to melodrama and the battery of suspicion directed toward popular cultural forms that are, like melodrama, gendered feminine (as excessively emotional, uncritical, etc.). It therefore resists the oppositional structure for the aesthetics of intimacy that Kotz describes on two points: if that category finally insists on the privacy of the artist's experience, on the work of art as a document of her experience, and "not ours," Emin's work inhabits instead the formulaic, programmed forms of intimacy associated with popular culture (soap opera, tabloid confessionals). It insists, in other words, on the most public forms of self-disclosure. Emin's audience recognizes, and feels recognized by, the ordinariness of her stories of sexual abuse, sexual trauma, sexual boredom, class humiliation, painful longing, romantic rejection, unfulfilled desire. This complex relationship between identification, affect, and formula is, again, characteristic—even definitive—of popular "feminine" genres. Of the sentimental novel, the literary historian Nancy Glazener argues, for example, that "the formula, the convention, and the exaggerated gesture that were supposed to characterize sentimentalism all call attention to the textuality of communication."[39] Linda Williams similarly argues on behalf of the sophistication of the spectator of filmic melodrama, who can at once be moved by the story's pathos and, at the same time, recognize it as deeply stylized. In her essay on *Stella Dallas*, Williams writes:

> In this final scene, Stella is no different than the naïve spectator. . . . In order to justify her sacrifice, she must *believe* in the reality of the cinematic illusion she sees: bride and groom kneeling before the priest, proud father looking on. We, however, *know* the artifice and suffering behind it [because we have seen the price Stella herself has paid for it]. So when we look at Stella looking at the glamorous and artificial "movie" of her daughter's life, we cannot, like Stella, naively believe in the reality of the happy ending.[40]

Williams, Glazener, and other feminists writing about women's consumption of popular culture (e.g., Tania Modleski, Janice Radway) offer us useful models for thinking about how people respond to and interact with work like Emin's—they allow us to imagine a spectator who can think and cry at the same time, and an artist whose work might be saturated with both sincerity and cynicism.

This is to say that the impulse to take my own response to Emin's work as its *content* is no less scripted, no less banal than the stories and states that Emin depicts. I am compelled, somewhat counterintuitively, by Emin's work insofar as it enacts a series of immediately recognizable, powerfully scripted performances of feminine sexual abjection. I recognize myself in the overdetermined banality of those scenes. And, worse, I find myself caught in the cliché of a woman's response to a woman's work—in which I identify with it, in which I refuse emotional distance and linger in affective proximity. One might argue that women who weep over Emin's work are fans, not critics, and are, in essence, not much different from women who weep at the end of *Stella Dallas*. To this one might

counter that these weeping women (Emin's audience, as well as *Stella Dallas*'s) feel and know the scriptedness of this kind of encounter. We are moved by exactly this tension between the sentiment provoked by the spectacle of sexual abjection and the banality of the entire mise-en-scène.

Furthermore, because Emin's work is centered on her working-class origins, on the traumas that attend to not only that experience but an ambivalent movement up the social hierarchy, she inverts the dynamics of intimacy that shapes work like Goldin's (as Kotz theorizes it). Rather than making the spectator feel special by virtue of a privileged access to the artist's private underground universe, Emin insists on her own "outsiderness" and invites the spectator to identify with *that*. "Entitlement," Dorothy Allison once observed, "is a matter of feeling like we rather than they."[41] People who have grown up as members of an underclass experience this on many levels: not only because "they" broadly are "othered" against the "we" of the middle class but also because the privacy implied by the kind of "we" or "me" that Allison describes is itself a class privilege.

Here, we might return to the image of Stella Dallas, standing in the rain, watching the scene of bourgeois family bliss in which she can never participate (which is, in fact, predicated on her exile—and which is, furthermore, presented in the film more as spectacle than reality) as a kind of emblem for Emin's own performance of celebrity. In placing herself on the outside in this particular way (as both an outsider in relation to the privileged culture of the art world and a public figure, a celebrity), Emin turns the gallery space inside out. Emin's "we" identifies with the woman who cannot, and will not, mimic the emotionally disciplined performance of bourgeois femininity. The intimacy of her work can only be experienced as unruly, loud, brassy, aggressive, vulgar. It is the public disclosure of an artist who has not always had much access to (or a desire, need, or use for) certain forms of privacy.

In conjoining these sets of problems (feminine abjection; ambivalent objecthood; the impossibility for some subjects to become fully abstracted, for some bodies to "rise above" their particularity; the scriptedness of not only sentimental and melodramatic narratives but femininity itself), Emin's work draws to the surface the particular burdens of authorship that women artists must shoulder whether they want to or not. Rather than draw this out through a resistance to the pressure that will always reduce her to her body (in which her capacity to be an artist will always be trumped by her capacity to be a thing, an object—a "cunt"), Emin gives in to it totally: the extremity of her commitment to herself produces her life as the "same old story." If, as Gayatri Spivak writes, "the discourse of man is the metaphor of woman," the allegorical force of Emin's self-portrait, before she sets pen to paper, has always already been enlisted in the service of someone else.[42] Emin's work describes the ambivalence about objecthood shared by diverse writers (Bersani, Fried, Mulvey), albeit for different reasons. The visibility of public investment in Emin, as erotic object, *should* reveal the homosociality of art criticism that is all the time working

itself up over the bravura and wounded masculinity of characters like Jackson Pollock, Julian Schnabel, or Damien Hirst without avowing the econo-erotic investments in them. It renders visible, instead, the odd place of women in art—walking wounded, vagina dentata, emptied-out sexpots, valuable only insofar as they are fungible, only insofar as their bodies are always already containers for someone else's story.

Thus the necessity of what Jones termed "the embodiment of the interpretive act" to reading Emin's work.[43] Emin leaves us with no room to stand back and consider it from a distance—it takes too personal a turn. Emin offers us studies in failures of objectification, injecting too much "subject" into her objects, making the disinterested appropriation of it as "art object" impossible without flirting with the very conservative models of artistic genius and expression that Emin lampoons. Instead, we are left with the disavowed affective and emotional universe that lies beyond the usual business of art history.

As you wander through Emin's gallery, you discover that there are too many people in the room, reciting too many scripts. And you are moved not by the originality of her story but by its familiarity.

White Sex Vaginal Davis
Does Vanessa Beecroft

Vaginal Davis's Anticulture Industry

Once, in the midst of a morning phone conversation about art and Los Angeles audiences, Vaginal Davis asserted to me: "I am not interested in entertainment." She wrapped herself in the sentence several times, turning up the volume with each repetition and imperiously emphasizing a different word: I am not interested in ENTERTAINMENT. I am not INTERESTED in ENTERTAINMENT!" With each repetition, she became more operatic, hilarious, and entertaining.

Davis is a black drag queen/performance artist from Los Angeles—a "black-tress," as she puts it. A central figure in *Disidentifications*, José Muñoz's portrait of contemporary performance art by queer artists of color, Davis is unrepresented by any gallery and has little to no institutional presence within the disciplinary borders of art history, but is nevertheless one of the defining presences in contemporary art in the United States at least as it is experienced outside museums and galleries. Davis's oeuvre includes video art (e.g., *The Three Faces of Women* [1994], *The White to Be Angry* [1999]), live solo and group performance, curation (with Ron Athey, for the performance art festivals "Platinum Oasis" [2001, 2002 in Los Angeles] and "Visions of Excess" [2003 for the Fierce Festival in Birmingham, England]), music (PME, Black Fag, Cholita), and prose (journalism, erotica, casual philosophy). Locally in Los Angeles, Davis is known largely for hosting club nights in queer bars, often taking the stage herself in a range of her drag personas.[1]

Her presence, her voice, her charisma are all larger than life, amplified by an Amazonian physique. Well over six feet tall, she towers above her entourage. She is incredible to watch, partly because she welds a hard and intricate version of femininity to a super-sized black body: she could be Edith Piaf's mulatta gay

brother, magnified. As Davis lamented the limitations of her audience in Los Angeles (a city *very* interested in entertainment), I had to hold the phone away from my ears—I could have heard her campy assertion of avant-garde pretension from across the room.

In our phone conversation, Davis and I reviewed the successes, failures, and scandals of her performance art boutique, GIMP, run out of a queer bar in Los Angeles, in partnership with her friend and collaborator, the performance artist Ron Athey. The previous night's event had been thematically organized by the slogan "Don't Ask, Don't Tell, Don't Care," and Davis had worked it as Vanessa Beecroft, an art-world star and actual person, represented by the Gagosian Gallery, invited to participate in that year's Whitney Biennial, and most known for her "installations" of scantily clad female fashion models and fully uniformed U.S. Navy SEALs. Dressed and coiffed just like Beecroft—who is a petite, beautiful Italian woman—Davis boasted, again and again, about having been invited to participate in the Whitney Biennial. Working the room in the elegant haute couture and pumps of a well-bred bitch and in a near-perfect imitation of Beecroft's particular brand of feminine naïveté, Davis-as-Beecroft crowed about her achievement as she introduced each new act.

Beecroft's installations are deliberately provocative—clusters of naked and nearly naked skeletal women stare vacantly into space and mime the posture of haute couture, citing the conceptual runway antics of the season's hottest designers; Navy SEALs stand in formation as ready-made national monuments. Beecroft performances are gala publicity events: people crowd into the galleries to see the "live" version of the girls pictured in the photographs used in her publicity kits and sold by her galleries. Her work (often supported by corporate sponsorship) finalizes the marriage of art and fashion, and renders visible the libidinal dynamics of art consumption: gorgeous bodies served up to paying customers under the guise of aesthetic contemplation and enjoyment.[2]

Taking up the complexity of Davis's citation of Beecroft, I want to explore the difference between the two artists. I want to position Davis in a critical, dialectical relation to the institutions of the art world as they are expressed in Beecroft's work, primarily through a discussion of the place of sex in the work of both artists. My aim here is not only to make explicit Davis's location in U.S. contemporary art as consciously anti-institutional but to use Davis's performance as Beecroft to track the deployment of sex, as a discursive field, inside the official, institutional production of art. My reading of the two artist rests on the opposition of their relationships to the art market. Following my work on the rhetoric of prostitution in art criticism, however, I am more interested in how sex "works" differently in Beecroft's and Davis's installations than in setting up one as necessarily "better" than the other. That said, I suggest that Beecroft's installations work within the rhetoric of prostitution insofar as they literalize (rather than challenge) its logics.

Figure 23. Vanessa Beecroft, *VB42,* 2000. Intrepid Sea Air Space Museum, New York. *vb42.110.ali.* Photograph by Armin Linke. Copyright 2000 Vanessa Beecroft. Reproduced with permission of the artist.

When guilt and shame register in contemporary art, it is frequently around spectacles of femininity, homosexuality, and blackness. The institutional consequences of material difference become differently visible in Davis's and Beecroft's performances *as* sexual and racial difference. We see in Beecroft's installations of nude women—and, implicitly, in much contemporary art that looks as if it is about sex—the reproduction of the repressive hypothesis (as defined by Foucault in *The History of Sexuality*), insofar as the installations' shock value rests on the exposure of our supposedly disavowed libidinal investment in art. Davis's performances as Beecroft not only satirize this aspect of contemporary art, they in fact model an alternative means for making sex the subject of art—one *not* invested in uncovering sex as the ultimate truth of art but in using sex to make the social regulation of "art" visible. Art, as understood by Davis in her citation of Beecroft, is a form of class warfare.

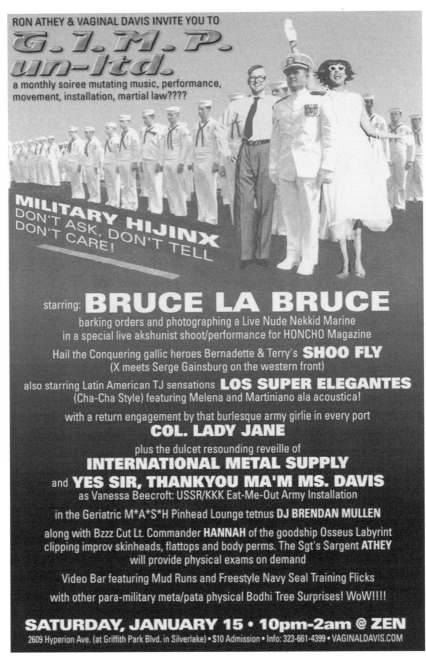

Figure 24. Poster advertising GIMP in January 2000, featuring Vaginal Davis as Vanessa Beecroft. Reproduced with permission.

The Trouble with Men

Davis's performance in "Don't Ask, Don't Tell, Don't Care" (January 2001) cited Beecroft's work with the U.S. Navy, in which neatly uniformed military men lined up in galleries or on the deck of a navy ship to reiterate nationalism's creepy glamour. Where Beecroft's work with women has, over time, moved toward the presentation of an idealized high-fashion femininity, "U.S. NAVY," writes Ron Athey, "used the military's ultimate marine warriors, the SEALs, to stand in for the male."[3] Men handpicked by navy representatives marched into the gallery space and stood at attention for about twenty minutes, shifted their posture in unison, and then marched out and marched in again, repeating the performance. By all accounts the most interesting part of this event was the visible difficulty the men had maintaining a straight face.

As Beecroft, Davis hosted "Don't Ask, Don't Tell, Don't Care," orchestrating an evening of queer burlesque—singers, strippers, body artists shared their quirky projects with a mostly drunk, cruisey, and queer audience. The evening's headline performance was Davis's own. Reading from a dog-eared handbook of military conduct for marines, Davis/Beecroft called a small crowd of carefully chosen young men onto the performance area (the event was staged in the back of a bar). Unlike the state-approved pressed and manicured men of Beecroft's "U.S. Navy," Davis's boys were soft, skinny, rumpled, floppy-haired aspiring bohemians. Some seemed just barely on the legal side of eighteen; others, more weathered. While they filed into place, Davis kept time in her lilting and booming voice and elaborated on passages in the handbook that struck her as particularly erotic. Her boys paraded in uniform from the waist-up only: dressed in Russian sailor shirts, jockey shorts, and socks. Once all were arranged in rows, a "real live marine" in full military regalia marched ceremoniously to the foot of the performance area, stripped, and played with himself while gay art-pornographer Bruce La Bruce, in a crouch, camera in hand, circled, documenting.

The porn star/marine failed to work up an erection. One of Davis's navy boys stepped forward and dropped to his knees ("ever-ready," Davis sang out, "to serve his country!"). This was an unexpected turn of events. As he knelt at the feet of the naked marine, the sailor appeared to be drunk, but very enthusiastic. The performance dissolved around this moment. As an audience we watched the "marine" massage his penis and then receive a rather vigorous blow job. We were suspended in a state of anticipation—and then an almost excruciating boredom. The chorus member's fellatio made little impact on the problem. We found ourselves leaning forward, scrutinizing the performance. A question yawned before us. Whose failure was this? The marine's? Or was he the recipient of a bad blow job? Were we the problem? Did we make the marine nervous?

I could say that a cloud of anxieties gathered over the room: the spectacle of phallic failure produced the possibility that the shame circulating throughout

the room might come to rest on the audience. But this is not exactly what the performance felt like. Even before the navy boy stepped up to go down, it was clear to most of us that the marine was never going to get a full erection, never mind ejaculate. I, at least, stopped waiting for this and found myself growing bored with the spectacle. We had started out knowing what we were waiting for (something dirty)—and as long as we were waiting for this we were held in a state of anticipation. Once, however, the performance's trajectory veered off the script of phallic display and into the domain of phallic failure the most pressing issue became our presence—what were we waiting for, if it wasn't sex?

According to the original plan, the "real live marine" was supposed to ejaculate into the audience. Instead, he reminded us that the penis is rarely the Phallus we want it to be. His failure to perform exposed our investment in the discovery of military culture as pornographic fantasy. The truth of the piece was far more interesting than that of the pornographic spectacle: military culture was here revealed as a compensation for the vicissitudes, the unpredictability of the masculine body. The official space cited by Beecroft and Davis was exposed by the latter as the last place where one might find an economy of pleasure that could assign value to the man who cannot get it up. Having failed to provide the spectacle that might punctuate his performance, Davis dismissed him and the troupe of sailors. The boys marched offstage and dispersed into the audience, leaving in their wake a lasting confusion over whether Davis had been invited to perform as part of the Whitney Biennial. After all, as Beecroft, she had been boasting about the invitation all evening.

The moment our attention shifted from the spectacle to our place in the room, and to Davis's relationship to art institutions, the performance came closest to reproducing the basic structure of Beecroft's signature work with women. The differences between Beecroft's and Davis's work are, to a certain extent, obvious. Beecroft is a white European woman who works with exclusive galleries and with museums, and whose career is covered by *Artforum* and *Vogue* (for example)—magazines explicitly invested in the reproduction of the culture of luxury. Davis is a black drag queen, a grande dame of the queer underground in Los Angeles, on the margins of both the Los Angeles art world (as not-commercial) and the gay scene as well (black, queer punk-rock drag queen that she is). In her self-presentation, Davis mobilizes a high-camp version of femininity and the rhetorical force of the black power movement (she took her name as an homage to Angela Davis), as well as an aggressively queer version of male homosexuality. As Muñoz has detailed in his own writing on the artist, Davis's drag is a carefully staged performance of disidentificatory practices. Unlike "commercial drag [which] presents sanitized and desexualized queer subjects for mass consumption," Davis adopts a "guerrilla style . . . that functions as a ground-level cultural terrorism." Often wearing toxic aspects of white culture as costuming, Davis "fiercely skewers both straight culture and reactionary components of gay culture," Muñoz argues, "performing the nation's internal terrors around race, gender, and sexuality."[4] Davis's gravitation

toward Beecroft's work with the military allowed her to take on a range of these "internal terrors" simultaneously. In another iteration of "Don't Ask, Don't Tell, Don't Care" (July 2001, at the Los Angeles Gay and Lesbian Film Festival), for instance, Davis pulled the palest of her boys from the ranks and praised the pallor of his skin, singing out "America Looooves Your Whiteness" as she bent him over, pulled down his underwear, and rubbed his ass cheeks for a cheering throng of gay men and women. As Muñoz explains, one of Davis's most powerful contributions to contemporary queer art is an aggressive attack on white homonormativity, declaring a boredom, as does the title "Don't Ask, Don't Tell, Don't Care," with the organization of gay politics around things like participation in military culture by asserting the queer presence in military culture as always already there—and, to a certain extent, as always already *more* gay than mainstream gay culture. In his essay, Muñoz tracks Davis's performative disidentification with white supremacist punk (distilled in Davis's video *The White to Be Angry*). He names Davis's fearless avowal of the lure of those aspects of white hegemony that are most explicitly organized against the survival of queers of color as one of the most innovative and disturbing aspects of Davis's performances. Beecroft herself never appears in her performances. Davis's adaptation of the artist as a persona is arguably her most aggressive revision of Beecroft's work. This appropriation of not only a conservative version of white femininity but also a celebrity artist at the epicenter of an art world most indifferent to Davis's work reiterates the disidentificatory move Muñoz theorizes in his work.

That night, at GIMP, as Davis's performance as Beecroft wore on alongside the blow job, the awful work women perform within the profoundly homosocial space of art became almost desperately visible: although Davis/Beecroft kept time for the marching boys by chanting from her queer handbook of military conduct, she was a superfluous, excessive presence in the drama of sexual failure played out for us. The abjection let loose by the collapse of the phallic spectacle seemed to collect around Davis herself—until, that is, she had had enough and sent the boys home. In the end, the marine's failure to get it up perfectly supported Davis's production of herself as "art-bitch," as a monstrous expression of femininity that commands, but only from the margins. The coupling of her invocation of the Whitney's name with the performance of phallic failure (staged, furthermore, as a camp appropriation of military posturing) opened up the potential failure of Davis's work as art—as if in the "Whitney" version, the porn star's dick would be fully operational or, even more disturbing, as if what was missing was the "real" Beecroft.

The authorizing presence of the Whitney Biennial upset the balance of the evening—in which, in a queer bar, drunk, cruising, few were thinking about what might make any of the performances aesthetically important. For a moment at least, it became all we wanted to talk about. For Davis, Beecroft's work is an attractive target because it is an ethically ambiguous homage to the most regressive impulses in art. This is especially true of her work grounded on the explicit display and objectification of women's bodies.

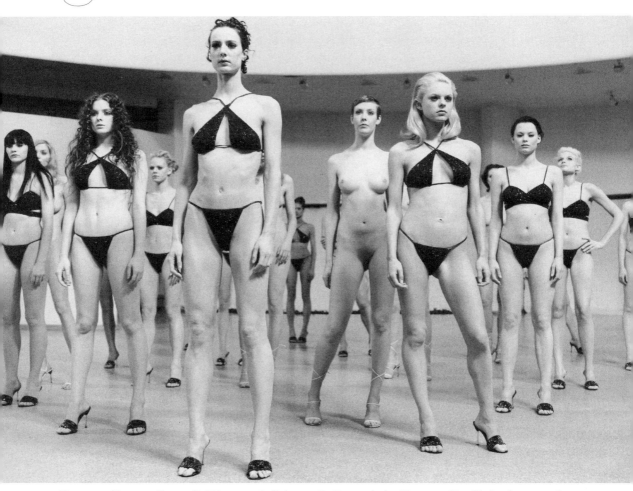

Figure 25. Vanessa Beecroft, *VB 35*, 1998. Solomon R. Guggenheim Museum, New York. *vb35.079.vb*. Photograph by Vanessa Beecroft. Copyright 1998 Vanessa Beecroft. Reproduced with permission from the artist.

Models lined up in rows at the Guggenheim in Gucci bikinis and high heels are subjected to awkward inspection by art connoisseurs. Beecroft's performances appeal to the particular arrangement of guilt, shame, and ambivalence that hovers over "Art" as a social institution. These mixed feelings are often allegorized in the display of the female body—in which a woman's alienation from her own sexuality stands in for art's final compromise to the logic of the marketplace. The women are instructed, in fact, to adopt exactly the posture described by William Dean Howells and Frank Norris in their essays on writing and the market, or the posture of Warhol's hustlers: they are not supposed to make eye contact or interact with the audience; they should look bored, distant, aloof, but somehow, nevertheless, available.

White Marriage: Art, Sex, and Institution

On its face, Beecroft's work seems to forward a feminist critique of the art world by literalizing the place of women as objects of consumption/contemplation. Her performances (and the photographs that document them) are cathartic—they provide a space in which citizens of the art world can exorcise their guilt—they can bump against their own limits, stew in their own complicity in the subjection of women. Take, for example, Dave Hickey's channeling of the art market's sense of Beecroft's importance. Writing of Beecroft's installation/performances as *tableaux vivants,* Hickey describes the imposition of self-consciousness upon Beecroft's spectators:

> In the presence of these tableaux we are denied both the privacy of contemplating a representation and the intimacy of participating in a real encounter. As a consequence we find Beecroft's women, at once more present to us and less accessible than we would wish, as unavailable to our understanding as they are available to our gaze. Our anxiety, then, does not arise from the fact that naked women are near us, but from the unbridgeable, yet ill-defined distance between ourselves and them. It is not the anxiety of desire, but the anxiety of displacement. . . . In the mirror image of an anxiety dream, we find ourselves unkempt and slovenly in our clothing, confronted with the cool authority of art's nakedness, and we have no role to play. Neither worldly enough to stare—to re-impose the distanced logic of the gaze—nor innocent enough to accept the world in its nakedness and opacity, we drift and loiter.[5]

It is nearly impossible to think about Beecroft's work without noticing its complicity with the economies of interest and value that underpin the gallery system, but which are a continual source of shame to the art world.

In Los Angeles, a trip to a Beecroft performance is a trip to Beverly Hills (where the Gagosian Gallery is located). Carefully dressed socialites, art patrons, and hangers-on move around thin and barely dressed "models." In photographs of *VB 46*, attendees are pushed up against the walls, not entirely sure where and how to look, as Hickey predicts. This is, however, more or less the case with *every* event at the Gagosian. Each person in attendance wears a version of social privilege—a newly acquired sense of entitlement might have brought attendees through the door, but their probationary status leaves them with an eye trained on the nearest exit.

That Davis's critical performances as Beecroft are more critical of the corporate hold on contemporary art than Beecroft's installations is self-evident. Beecroft's work exploits the most troubling aspects of the pact the artist makes with the dominant modes by which art becomes institutionally visible. Her work is exhibited in high-profile commercial galleries like the Gagosian, commissioned by major museums like the Whitney Museum of American Art and the Guggenheim in New York City, and has been displayed at international biennials in Venice and São Paulo. Her installations are, furthermore, often sponsored by fashion brands like Gucci and Manolo

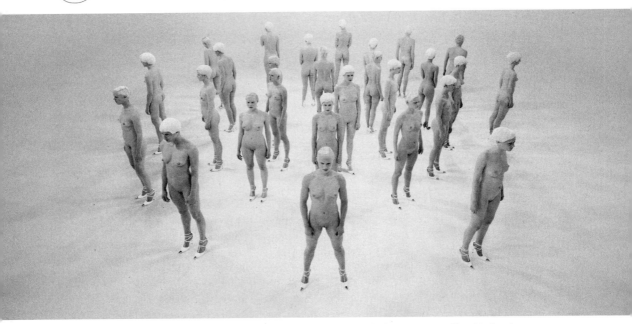

Figure 26. Vanessa Beecroft, *VB 35*, 1998. Solomon R. Guggenheim Museum, New York. *vb35.079*. Photograph by Vanessa Beecroft. Copyright 1998 Vanessa Beecroft. Reproduced with permission of the artist.

Blahnik and are covered not only by art magazines like *Artforum* but also by magazines whose readers collect art, like *Vogue* and the *New Yorker*. Glossy photographs, produced in carefully staged shoots days before the gallery installations of "live models," are sold by her gallery as expensive souvenirs.[6] Despite its grounding in live performance, her work is highly successful. (This is almost totally unique in performance art, a form notoriously resistant to commercialization.)

As is the case with Andy Warhol, and many post-Pop artists (e.g., Jeff Koons, Tracey Emin, Matthew Barney), the exposure of Beecroft as a "compromised" artist by the market says nothing we do not already know. This is perhaps why there is so little critical writing on Beecroft—there seems to be little one might say about her installations that the work itself does not already anticipate in its cynicism.[7] As a critic, it is easy to feel cornered by Beecroft's work. Theodor Adorno's writing, squeezed out of the grip of ethical imperative and an unrelenting sense of despair, offers us a way to think through the ethical and political dimensions of art making in these kinds of contexts (performances deeply embedded in the art market, oppositional performances staged outside that market). He comments, for example, on the critic's bad-faith claim to detachment: "The detached observer is as much entangled as the active participant; the only advantage of the former is insight into his entanglement, and the infinitesimal freedom that lies in knowledge as such. His own distance from business at large is a luxury which only that business confers."[8] The

critic's sense of independence from the systems he or she describes is a privilege underwritten by those systems—a benefit one must enjoy, Adorno writes, cautiously, modestly, self-consciously, not by the virtue of "good upbringing, but by the shame of still having air to breathe, in hell."[9] The intellectual who takes on Beecroft must, in other words, consider the harmony between her production of art as luxury product and the luxury of intellectual work itself. Writing of the importance of these grim observations to the architecture of Adorno's thought and to Adorno's understanding of the intellectual's role, Fredric Jameson describes "the sheer guilt of art in a class society, art as luxury and class privilege" as "a ground bass that resonates throughout all of Adorno's aesthetic reflections without a break."[10] That awareness of the privileged position of the artist *and* the intellectual does not, however, prevent Adorno from taking overtly critical positions on the politics of art. Ambivalence and a sense of the futility of the critical act are not, in his writing, obstacles to political engagement. Quite the opposite.

Beecroft's performances make explicit art's total complicity with business (with fashion, with the deep penetration of the self by consumer culture) and do so by rendering that relationship as both gorgeous spectacle and a kind of sexual compromise. As I argue above, there is nothing inherently new, however, about the accusatory turn of such work—about making visible that uneasy feeling one gets moving about a gallery space, around a cluster of naked or nearly naked skinny women, feeling slightly ashamed, titillated, and, ultimately, aware of the libidinal energies that frame the experience of art consumption. One might construct a history of modern and contemporary art around such turns toward the audience to reveal art's underbelly, replacing Clement Greenberg's trajectory toward the blank canvas with a series of attempts to tell this other truth about art. We could begin, perhaps, with the notorious stare of the prostitute in Manet's 1863 painting *Olympia* (often cited as the watershed painting in European modernism) and with her black maid's sidelong glance at the prostitute's body, the black woman's stolen glance providing a substitution for a different, more authorized, gaze: that of the white, bourgeois, male art consumer. As has been thoroughly argued, *Olympia* is not only a portrait of a prostitute. It is, as Benjamin Buchloh once described it (in passing, alongside a discussion of Warhol's portraits of Marilyn Monroe), a portrait of "our collective scopic prostitution."[11] The painting takes as its subject the spectator's lust for the spectacle, the audience's complicity in the production of *Olympia* (the artwork) as art commodity, allegorically linking, furthermore, the work of the artist with that of the prostitute.[12] It refuses to go along with what we all already know about the nude but which we bury in our enjoyment of her spectacle—that the nude has always already turned a woman into a thing by turning her into a commodity. In refusing to disavow this circulation of money and desire—and, as T. J. Clark has argued, in linking this refusal to an avowal of its status as a painting—*Olympia* claims prostitution not as the thing most alien to high art but as the thing that has become most constitutive of it.[13] *Olympia* claims as its

subject not a prostitute but the art work's solicitation of its audience. Throwing down the challenge that must lead to the aggressive contestation of the myth of the autonomy of art, *Olympia* asserts that there is no more art that does not engage in a form of prostitution.

That is, artworks, within this provisional tradition, announce themselves in the unveiling of our erotico-economic investment in Art. In a quixotic essay on the subordination of sexuality to discourse, Adorno describes this kind of mobilization of sex as "the de-sexualization of sexuality," a "fatal integration" of sexuality, in which "libidinal energy is displaced onto the power that dominates it and thereby deceives it." Adorno predicts the range of affects and poses modeled by Beecroft's women when he writes that this reification of sex "is strengthened by the premium patriarchal society places on the female, her passive docility, weaned from all personal affect, if possible, from all aspiration to her own pleasure."[14] Sex—for all of its appearance in art as the "real," the unruly, the free—is more often than not completely divorced from the politics of sexual practices, from the regulation of sexual subjects. This is the discursive phenomenon that Foucault describes as the "deployment" of sex.

Peter Bürger, in his review of the status and function of avant-gardism, explains the basic structure of the move I am attempting to describe vis-à-vis art as an institutional and disciplinary practice: "The European avant-garde movements can be defined as an attack on the status of art in bourgeois society. What is negated is not an earlier form of art (a style) but art as an institution that is unassociated with the life praxis of men."[15] An avant-garde exposes the *myth* of the autonomy of art, with the assertion that art is always already fully complicit with the very social systems against which it defines itself. Beecroft's work reproduces this fundamentally negative (meaning critical) move, using the allegorical force of the compromised woman to make a single artwork about "Art" as a whole.

Hickey makes this same critical leap in his appraisal of Beecroft's importance: "The odd frisson of confronting something like casual, domestic nakedness in a public space is combined with the unnerving frisson of confronting the constituents of showgirl review in a naked modern space, robbed of its theatrical accouterments, its framing proscenium."[16] This expression of avant-gardism is explicitly offered up as a fashion statement—it adopts the pose of a critique of the objectification of women in art, but the power of that critique is all but completely dismantled by the institution that mounts it. One might say, in fact, that the pointlessness of this gesture is the true subject of Beecroft's work. As Bürger argues, the reproduction of this critique of the myth of art's autonomy no longer works as a critique of art-as-institution. "Art as an institution" he writes, "prevents the content of works that press for radical change in society (i.e., the abolition of alienation) from having any practical effect."[17] In the wake of what Bürger calls the "historical avant-garde" (a historical moment when avant-gardism had the capacity to spark fistfights—a historical moment that art institutions produce nostalgically), art as an institution (which has fully assimi-

lated the avant-garde's critical move) constantly reproduces its own failure to rise above, to complicate, to challenge the material conditions of contemporary art production.

The distinction between aesthetic and sexual interest provides one of the most powerful vectors for the expression of this failure. Sex emerges as *the* secret about art that the artist (and the critic) can't help but confess (and the only thing anyone wants to talk about).

This is, from my perspective, an explanation of the difference between the career trajectories of people like David Wojnarowicz, Carolee Schneemann, Jack Smith, and Annie Sprinkle (to name a few artists at random whose work is overtly about sex, and which aims to generate a space of sexual community and contact among its consumers) and artists like Vanessa Beecroft or Matthew Barney. The sexual possibilities embedded within and contained by Beecroft's installations lend her work a gallery-sanctioned radicalism, just as sex, as a signifier, does the work of, for instance, Jeff Koons. In this space, in which the making visible of the spectator's desires institutionally signifies art's failure to transcend the body, sex is removed from sexuality as a practice.[18] Beecroft's work literalizes the containment of sex and the aggressive regulation of pleasure by art institutions. But Davis's appropriation of Beecroft forces the question: is this enough?

That question has also been asked by a Los Angeles–based feminist art collective, the Toxic Titties (Heather Cassils, Clover Leary, and Julia Steinmetz), who infiltrated Beecroft's installation at the Gagosian *(VB 46)* and documented their experiences within the performance. Their spy work reveals a complex and invasive production—which is normally hidden from the public. Prospective models (recruited for this performance through an ad posted at CalArts) were promised a "day of beauty" at a Beverly Hills salon (meaning, in actuality, the waxing of all body hair) and the opportunity to be photographed by a famous fashion photographer (which turned out not to be true—one professional model who had signed on walked off at this point). Participants were given long questionnaires about their likes and dislikes. For ten to twelve hours for three days they stood in formation on a sealed Sony soundstage in Los Angeles and were videotaped and photographed. By all accounts this was a deeply troubling experience for many of the participants (who, at one point, organized to ask for more money). Given detailed instructions like "be detached," "do not laugh, smile, or show other emotions," "do not make direct eye contact with any person or camera," and "do not speak or whisper," the women stood in their appointed positions in Allesandro Dell'Acqua high heels—which were, they later realized, all the same size (and therefore even more painful than usual).

On the day of the performance, the women were told they might sit down during the installation—as long as they obeyed the rules about their affect and demeanor. Cassils decided that she would stand for the duration, as a kind of protest. She writes:

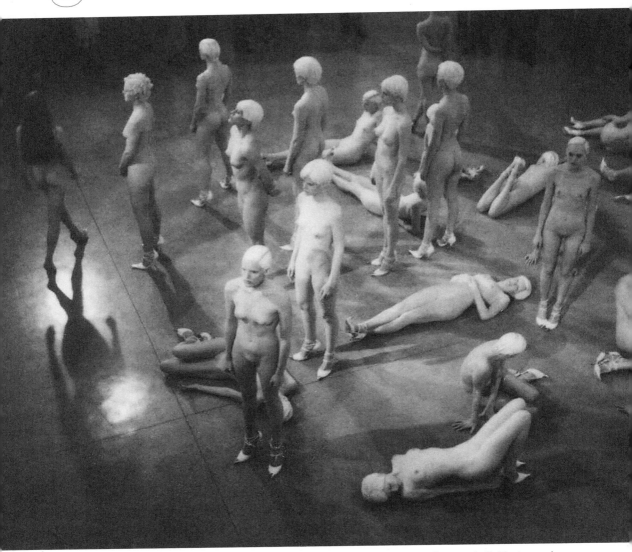

Figure 27. Vanessa Beecroft, *VB 46,* 2001. Gagosian Gallery, Los Angeles. *vb46.026.ali.* Photograph by Armin Linke. Copyright 2001 Vanessa Beecroft. Reproduced with permission of the artist.

Although it was only the very beginning of the three-hour performance my feet were already pinched, my ankles swollen, my feet blistered from the last three days of standing. . . . I was not about to let anyone know of the already present fatigue in my body. I had decided ahead of time that I would stand for the whole three hours. Standing would be a protest. It would symbolize my strength and resistance . . . although the instructions were explicit: sit when you are tired. . . . I was in front of a V like formation and when the first two people entered the room my goose bumps left my ghostly flesh and despite the bite in the air, streams of sweat ran little rivers in the air-brushed make-up. It was the first physically stressed symptom of my body that made me realize that although I

had decided to go through with this my body protested. As viewers entered the white cube my quadriceps started to shake so hard I thought I was going to fall out of my designer heels that cost more than my rent. My fists were clenched, my stomach taut. I felt like my skin was a force field against the eyes that were drinking me in. I wanted to make myself menacing and indigestible. My jaw was clenched and I was dripping from quiet exertion. The more I stood the more energy built up in me until I thought I was going to explode in my stillness. "Wow, she's so angry. Wherever did she find her? Really great." And it was this moment I realized I was powerless in this situation. My silent anger was easily subsumed by the artwork. No one could tell my anger was my own and not a possible instruction from the artist. Despite all my intentions, I had sold my body and my voice.[19]

Cassils's only avenue for resistance within the performance's script was to perform aggressively—to be as stoic, as strong, as tough (as butch) as possible. But even that counterperformance was already conscripted in the service of Beecroft's event—no more meaningful as *her* expression than is the obliging smile of a waitress.

Art as a Contact Sport

It is a hallmark of Vaginal Davis's work that the sources she appropriates are sometimes so deep inside art-world institutions, and so prophetic, that many of her audience members do not recognize the citation. In January 2000, few outside the most rarified set in the art world knew who Vanessa Beecroft was. Davis trumped her audience at GIMP: a sizable contingent left the club thinking that Vaginal Davis, a Los Angeles–based Amazonian black drag queen with solid welfare-class roots whose work is often improvised, messy, and slightly (but brilliantly) out of control, had been officially recognized by a major museum as a representative of contemporary American art.

I admit that I was among those who confused Davis's performance with the artist whom Davis was performing. When I first realized the misrecognition and the nature of my confusion, I experienced an uncomfortable mixture of embarrassment and relief—embarrassed by the naive optimism that is symptomatic of my own suburban youth, and a relief that I had caught the mistake before, in conversation, I had revealed my ignorance. That misrecognition was an important effect of this piece. Davis's performances are not usually events around which you are likely to find yourself pretending to recognize names you do not because you are worried what people will think if they find out you, perhaps, know all the wrong people.

I would contrast this misreading (of Davis as Beecroft) furthermore, with another misreading: at *VB 46*, perfectly dressed black security guards dressed in black supervised Beecroft's audience. They were as uniformly dressed and aloof as Beecroft's models—their affect so similar, in fact, and their color so

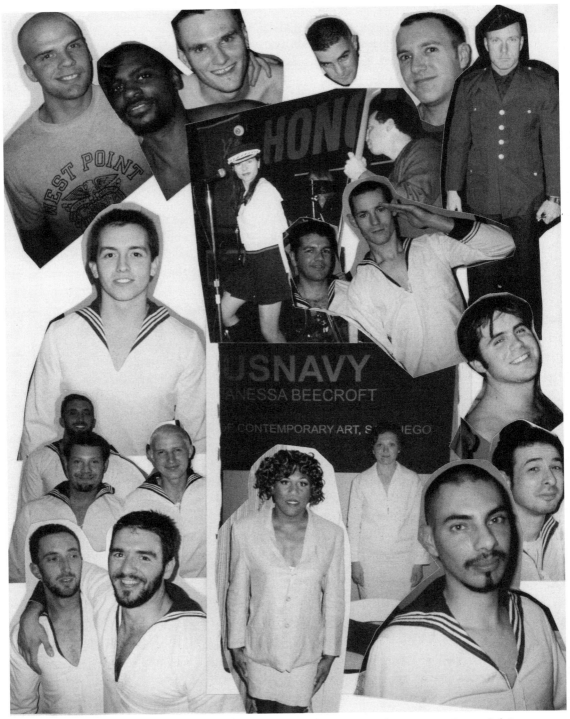

Figure 28. Vaginal Davis, 2000. Photocollage. Vaginal Davis (bottom center) as Vanessa Beecroft (who actually appears to the right of Davis). Reproduced with permission.

curated, that several in attendance wondered if the guards were a part of the piece.[20] This was a mistake—blackness in America invokes such a powerful coupling of threat and nobility of manner that, in Beverly Hills, security agencies rent black male models to galleries, bars, and expensive restaurants looking to lend their threshold-to-fabulousness something of "the dignity of the bouncer."[21] The black man's body is so penetrated by economies of use that even standing around doing nothing, he works. The work performed by these men may be placed in a genealogical relation to the anchoring presence of the black woman who hovers behind and above Olympia. The blackness of the guards became momentarily visible as the shadow of Beecroft's staging of white femininity: in *VB 46* Beecroft mounted femininity as a useless spectacle—women bleached by white wigs, white walls, bright lights, and white powder; women who can't speak to you or to each other; women good for nothing but standing around. This may be the most useful aspect of *VB 46:* the potential misreading unleashed by the fascism of Beecroft's aesthetic, which is powerful enough to make the intense regulation of black participation in the arts accidentally conspicuous.[22]

Davis's performance as Beecroft starts with the horizon of that artist's work: arousal and the hard-on, the invisibility and deep irrelevance of female pleasure (to art, and to sex), a fascination with whiteness-as-spectacle, the black body as the ground against which art defines itself. She gives us a black drag queen's burlesque on the attraction of white masculinity as a spectacle and the limits of white masculinity as a performance, and imagines what might happen to Beecroft's installations if we staged them outside the space of Official Art.

Ultimately, Davis's performance (a parody of an event Davis had never seen—the whole idea was, in fact, Athey's) offered us a camp deconstruction of the art world's fascination with its own shame. Davis's performance manipulated the conflicting investments of her audience (a fairly white expression of Los Angeles alterna-bourgeoisie: gay and straight, men and women, students, artists, academics, musicians). In general, one does not attend Davis's performances in Los Angeles looking for an art experience—those who do are working with a different set of expectations than attendees of Beecroft's Guggenheim installation, *Show,* or *VB 46,* Beecroft's Gagosian event. Davis is more tightly knitted to a queer social underground than the city's network of galleries, artists, and art critics. She supports herself through the promotion of events like GIMP (housed in bars here and in Europe), by writing occasional articles for fashion magazines, and by speaking and performing at universities. When she makes public appearances, people turn out to see who turns out as much as they do for Davis herself—partly because an appearance at a Davis event is more valuable as queer gossip, as an indicator of that person's relationship to queer culture, than as an indicator of Davis's worth to art institutions. And unlike art openings, people did not attend "Don't Ask, Don't Tell, Don't Care" in the hopes of meeting someone who might advance their careers. The chance of making such a connection was much smaller, and much

less interesting, than the chance of taking one of Davis's boys home for yourself (they became part of the audience after Davis's performance).

We can use Samuel Delany's distinction between spaces that promote "contact" and "networking" to explain the difference between Davis's performance in a gay bar and Beecroft's performance at a gallery or a museum. He writes:

> [Contact] is the pleasantries exchanged with a neighbor who has brought her chair out to take some air on the stoop. . . . As well, it can be two men watching each other masturbating together in adjacent urinals of a public john—an encounter that, later, may or may not become a conversation. Very importantly, contact is also the intercourse, physical and conversational, that blooms in and as casual sex in public restrooms, sex movies, public parks, singles bars and sex clubs . . . from which nonsexual friendships and/or acquaintances lasting for decades or a lifetime may spring . . . a relation that, a decade later, has dissolved into a smile or a nod, even when (to quote Swinburne) "You have forgotten my kisses / and I have forgotten your name."[23]

Contact, in Delany's understanding, requires a space conducive to cross-class contact. It is not, he is careful to assert, necessarily conducive to forming a sense of community. It is a practice that grows out of the overlap between different communities sharing the same physical space. It is specific to urban settings. "Networking situations," on the other hand, "are self-replicating structures of knowledge and desire. Desire is what holds them stable and replicates them, and the absence on which that desire is based is the paucity of socio-material benefits everyone who attends them hopes to receive."[24] "Networking," the social management of a scarcity of recognition, "tends to be professional and motive-driven," Delany writes, and is inherently competitive. One might map the shape of the system of scarcity Delany describes onto the "premium placed onto the female" that Adorno describes—women's removal from pleasure, the cool appearance of unavailability, stands in for institutional indifference to the hoards of aspiring artists, critics, and connoisseurs in hopeful attendance. Beecroft's women, in this sense, stand in for Art-as-institution, exactly as they adopt the look of boredom. Their allegorical function as such is all the more painful when revealed as the performance of women art students, lured by a cash incentive and the glamour of the event, to stand naked before an audience filled with dealers, gallery owners, teachers, and schoolmates in a gallery embodying the most regressive and socially sadistic elements of the art market. It is important to note that this side of Beecroft's work only becomes visible with the intervention of artists like the Toxic Titties.[25]

Because Davis's performance was not staged in a professional art space, her citation of Beecroft is altogether different in tone from the Toxic Titties infiltration. Davis's invocation of the authority of the Whitney Museum disrupted the habits of her own audience because her art is generally practiced within zones of contact and has an entirely different relationship to terms like *recognition, career,* and *art* than does Beecroft's. The event centered on the spectacle of

Bruce La Bruce photographing a guy in a Russian navy getup going down on a naked marine, producing pictures not for *Artforum* but (according to Davis/Beecroft) for the gay porn rag *Honcho*. (These photographs have yet to appear in the magazine, however, no doubt because the marine never produced a useable image for the photographer.)

By injecting art's institutional force into the spectacle of queer sex (same sex, as well as drunken, casual, and nonejaculatory), the piece raised questions about the line between sex and art—but from a different angle than that described by the exemplary figures in gay studies in art history (like Robert Mapplethorpe). Davis's work does not disturb the boundary between art and sex by making art that is overtly sexual or that formally anticipates its own censorship (as Richard Meyer theorizes a tradition of expression of homosexuality in twentieth-century art making).[26] More nearly, Davis troubles the art-sex distinction by invoking high-art traditions in the most inappropriate spaces (rather than inappropriate acts in high-art spaces), by reminding us that a bohemian life is about sexual possibility as well as style and innovation.

The performance leaned into art (by citing Beecroft) and out of it (by being too explicit, too dirty) at the same time. The apparent bestowal of a high-art status for Davis by the Whitney promised to anchor the value of the performance piece, which then became unhinged by the marine's inability to get it up. In "Don't Ask, Don't Tell, Don't Care," art was staged as the sexual spectacle that never managed to "happen," as the failure to become sex. This is the aspect of Beecroft's work—that it may be read as yet another instance of contemporary art that looks as if it is about sex but is not—that Davis's performances help make visible.

The movement from the optimistic, almost utopian vision of art that places Vaginal Davis at the Whitney to the "correct" understanding of the invocation of the Whitney's name as part of Davis's drag makes the institutional boundaries that place Davis on the margins palpable. If you know enough about art to know that Vaginal Davis (a gay black man) is not Vanessa Beecroft (a straight white woman), your experience of that night's performance might have produced the following thought: "I am watching a performance by an artist who, in all likelihood, may *never* be invited to the Whitney."

Maybe "art" works in Davis's performance like Beethoven's drums, heard in the foyer of a concert hall—as a sign turned inside out. "Heard in the corridors of the concert hall," Adorno writes, "little remains of one of Beethoven's orchestral works than the imperial kettle drum; even in the score the drums represent an authoritarian gesture, which the work borrowed from society in order to sublimate it in the elaboration of the composition." Maybe "sex" in Beecroft becomes like "music . . . piped into restaurants," which, Adorno observes, "can be transformed into something completely different, of which the hum of conversation and the rattle of dishes and whatever else becomes a part. To fulfill its function, this music presupposes distracted listeners no less than

in its autonomous state it expects attentiveness. . . . Functions such as warming people up and drowning out silence recast music as . . . mood, the commodified negation of the boredom produced by the gray-on-gray commodity world. The sphere of entertainment, which has long been integrated into production, amounts to the domination of this element of art over all the rest of its phenomena."[27] Davis asserts, "I am not interested in entertainment," but embedded in that declaration is a dialectical twist, a response to the mandate to be entertaining with a reanimation of art production not as a career but as a praxis. This is not to say that one mode of production is more pure than the other—at the very least, however, Davis's (which is full of lies) is relentlessly honest about the compromises it makes and more hopeful about the happy accidents those compromises produce. She gives us a diver's suit, making the air in Los Angeles almost breathable: in her world, art is the prelude to a kiss.

Acknowledgments

MY SISTERS, Justina Cassavell and Jocelyn Sell, to whom this book is dedicated, mean absolutely everything to me. I love them and their families more than I can say, and, as is immediately apparent in reading this book, much of how I think about things comes from my experiences growing up with them.

In dedicating this book to "my sisters," I mean also to gesture toward a larger community of friends who have helped me write this book. As awkward as it is to place these friends in any kind of order, I have no hesitation about thanking José Muñoz first. The oldest and the newest bits of this book were written to him and for him—when we spend time together, I always come away wanting to write more, to write well, and to make that writing mean something. Through José I met Vaginal Davis, and through Davis I met Ron Athey. Ms. Davis and "Daddy" Athey have made Los Angeles more than a home for me. Here, I also have the very good fortune of sharing rants, screeds, and odes with friends and coconspirators Molly McGarry, Heather Lukes, Ming Yuen S. Ma, Ed Vandenberg, and Chinami Inashi. This town of fig trees, pastel sunsets, and natural disaster gave me my dearest friend, Jens Giersdorf; even with continent and ocean between us now, he is always right there with exactly the right thing.

My "big sisters" Kevin Kopelson, Mandy Merck, and Amelia Jones inspire me with their wit, integrity, and wisdom. I am deeply grateful to each of them for their emotional support, intellectual guidance, and professional advice.

In North Carolina, Carol Mavor and Kevin Parker made me feel at home when I most needed a home away from mine. At Duke, I got tremendous advice from Janice Radway, Fredric Jameson, Cathy Davidson, and Toril Moi. Eve Kosofsky Sedgwick told me as kindly as possible that she was bored by one of my dissertation chapters but interested in a footnote; that footnote became the

preface and first chapter of this book—which is, perhaps, an extravagant way of demonstrating my respect for her perspective on my work.

Amanda Berry, Sabine Engel, Elizabeth Freeman, Maude Hines, Eleanor Kaufman, Katie Kent, Anna McCarthy, Johannes von Moltke, Greta Niu, Gustavus Stadler, Sasha Torres, and John Vincent have all contributed to this book by giving me much-needed feedback and encouragement, by pouring just the right amount of scotch into my glass, and by simply answering the phone. I still miss, mourn, and am a little haunted (thankfully) by Brian Selsky. Fred Irons helped me find the confidence to take risks with my voice and connect my writing to my life.

Chapters in the book have benefited from the attentions of Gavin Butt, Carolyn Dinshaw, David Halperin, Nicholas Mirzoeff, Linda Nochlin, and Ann Pellegrini. The project took its shape partly in conversation with participants in the following conferences and workshops: Interdisciplinary Approaches to Visual Culture at Berkeley, the bad sex "think tank" at Johns Hopkins, "Encuentros" at PhotoEspaña in Madrid, and the University of California Performance Research Group workshop. I owe a special thank you to Robert Summers, because he asked me to return to Warhol, and to Callie Angell, director of the Andy Warhol Film Project, whose intellectual generosity and dedication to Warhol's films are a model to us all. Jonathan Katz, James Herbert, and Richard Meyer have each been (and continue to be) supportive of my work in visual culture. I owe much to Bill Brown and Jane Blocker, who read this manuscript as reviewers for the University of Minnesota Press and wrote helpful reports. And thank you Sarah Miller, for hotel retreats and more.

I am grateful for the generosity of the following institutions, which gave me permission to use images in their holdings: the Andy Warhol Foundation and the Artists Rights Society; the Andy Warhol Museum (especially Greg Burchard and Greg Pierce); the Amon Carter Museum in Fort Worth, Texas; Jefferson Medical College; the Philadelphia Academy of the Fine Arts; the Philadelphia Museum of Art; and the Stedelijk Museum, Amsterdam. Vanessa Beecroft and Tracey Emin have been particularly generous with their work, and their respective assistants, Ian Davies and Sophie Greig, have been immensely helpful.

Thanks to Paula Dragosh and Laura Westlund, for their careful attention to this book's well-being. I'd have really been up the creek if it weren't for Alex Wescott's brilliant and dogged detective work.

I had the good fortune of teaching in the English department at the University of California, Riverside, while writing this book. I am proud to be part of its imaginative, progressive, and supportive faculty. My colleagues Joe Childers, Emory Elliott, Bob Essick, John Ganim, Katherine Kinney, Josh Kun, Tiffany Lopez, Parama Roy, Carole-Anne Tyler, and Traise Yamamoto have been free with kind words and advice. Other fellow travelers at Riverside who have been similarly generous include Kathleen McHugh, Anna Scott, and Amy Ongiri. I am especially lucky to count George Haggerty as not only a colleague but a friend. A residency at the Center for Ideas and Society and support from the

University of California's Regents Fellowship for Junior Faculty Development gave me much-needed time and space to write.

Theasa Tuohy, whom I call my aunt but who is, really, a friend right out of a nineteenth-century sentimental novel, gave me the keys to her house in Ceyras, France—the most beautiful writing retreat a girl could want.

Richard Morrison is a brilliant editor and, in so many ways, my ideal reader. It has been an absolute joy and privilege to work with him on this project.

There really is not any proper way to acknowledge my parents, Michael and Jeanne Doyle, except by doing my best to honor their example—by, in essence, "doing good." I became a teacher and scholar because I grew up in a family that honestly treasures the process of learning. My parents are remarkable people, and if I have anything interesting to say, I probably heard it first from them.

Notes

Preface

1. Gavin Butt is referring here to Larry Rivers's relationship to New York queer circles. See Gavin Butt, "The Greatest Homosexual? Camp Pleasure and the Performative Body of Larry Rivers," in *Performing the Body/Performing the Text*, ed. Amelia Jones and Andrew Stephenson (New York: Routledge, 1999), 113. On camp, sentiment, and queer recognition in/of Melville's writing, see also James Creech, *Closet Writing/Gay Reading: The Case of Melville's Pierre* (Chicago: University of Chicago Press, 1993), which is an important point of orientation for my writing on Melville (see below).

2. A strong example of an artist who deploys a camp sensibility on all these fronts at once is Vaginal Davis, the subject of chapter 4, as well as a chapter in José Muñoz's *Disidentifications: Queers of Color and the Performance of Politics* (Minneapolis: University of Minnesota Press, 1999). For an extended discussion of sex, class, and taste, see also Joseph Litvak, *Strange Gourmets: Sophistication, Theory, and the Novel* (Durham: Duke University Press, 1997).

3. Michael Warner, *The Trouble with Normal* (Cambridge: Harvard University Press, 2001), 35, 36; see especially "The Ethics of Sexual Shame," 1–41.

4. Kobena Mercer, "Reading Racial Fetishism," in *Welcome to the Jungle: New Positions in Black Cultural Studies* (New York: Routledge, 1994), 185.

5. The artist Carrie Mae Weems explores these aspects of Mapplethorpe's image in one of the images from her series, *From Here I Saw What Happened and I Cried* (1995–96). See *Carrie Mae Weems: Recent Work, 1992–1998* (New York: Braziller, 1998).

6. The overdetermined link between *Moby-Dick* and fantasies of racial difference has been explored by (for example) Geoffrey Sanborn in *The Sign of the Cannibal: Melville and the Making of a Postcolonial Reader* (Durham: Duke University Press, 1998); Michael Rogin, *Subversive Genealogy: The Politics and Art of Herman Melville* (New York: Knopf, 1983); Eric Sundquist, *To Wake the Nations: Race in the Making*

of American Literature (Cambridge: Harvard University Press, 1993); C. L. R. James, *Mariners, Renegades, and Castaways: The Story of Herman Melville and the World We Live In* (Hanover: University Press of New England, 2001); Robert K. Martin, *Hero, Captain, and Stranger: Male Friendship, Social Critique, and Literary Form in the Sea Novels of Herman Melville* (Chapel Hill: University of North Carolina Press, 1986). See also Sterling Stuckey's work on Melville's familiarity with African culture as encountered at sea and locally, in New England and New York, in Sterling Stuckey, "The Tambourine in Glory: African Culture and Melville's Art," in *The Cambridge Companion to Herman Melville,* ed. Robert S. Levine (Cambridge: Cambridge University Press, 1991), 23–46.

Introduction

1. Angela Carter, *The Sadeian Woman and the Ideology of Pornography* (New York: Pantheon Books, 1978), 19. For an analysis of feminist and legal arguments about pornography, see, for example, Frances Ferguson, "Pornography: The Theory," *Critical Inquiry* 21 (spring 1995): 670–95.

2. Kusama is an idiosyncratic figure, even within bohemia. In the 1960s she was a major figure in the New York proto-Pop underground, well connected (she was friends with Joseph Cornell and Donald Judd) and more famous than even Andy Warhol for her naked street performances and for staging utopian love-ins and a gay wedding. Her fame for these "stunts" was amplified by her diagnosis with obsessive-compulsive disorder. Her paintings and sculptures raise questions about the relationship between her mental disorder and her work, as they involve the controlled but obsessive reproduction of circles, cells, webs, and polka dots. Kusama, in fact, committed herself to a mental institution in the early 1970s. For more on Kusama, see *Love Forever: Yayoi Kusama, 1958–1968* (Los Angeles: Los Angeles County Museum of Art, 1998).

3. Cited by J. F. Rodenbeck, "Yayoi Kusama: Surface, Stitch, Skin," in *Inside the Visible: An Elliptical Traverse of Twentieth-Century Art in, of, and from the Feminine,* ed. M. Catherine de Zegher (Cambridge: MIT Press, [1996]), 151.

4. Elizabeth Grosz, *Volatile Bodies: Toward a Corporeal Feminism* (Bloomington: Indiana University Press, 1994), viii.

5. Michel Foucault, *The History of Sexuality,* vol. 1, *An Introduction,* trans. Robert Hurley (New York: Vintage Books, 1980), 69.

6. In our introduction to the anthology *Pop Out: Queer Warhol* (Durham: Duke University Press, 1996), my coeditors, José Muñoz and Jonathan Flatley, and I write about this vis-à-vis the critical reception of Andy Warhol.

7. This is perhaps why, in the wake of Foucault's *History of Sexuality,* his observation of a split between acts and identities, between a juridical category of acts (sodomy) and a psychosexual category of person (homosexual), has had the most visible impact on sexuality studies. The denaturalization of the categories of heterosexual and homosexual allows us to consider how sexual identities are produced—and it gives us a starting place for writing about homophobia, at the very least. David Halperin tracks and critiques the way this moment in Foucault's work has been taken up as a synecdoche for Foucault's intellectual project as a whole in "Forgetting Foucault: Acts, Identities, and the History of Sexuality," *Representations* 63 (Summer 1998): 93–120. This article was revised as a chapter in Halperin's book *How to Do the History of Homosexuality* (Chicago: University of Chicago Press, 2002).

8. For all the sex talk that happens in queer theory, there is surprisingly little talk about sexual practices—"sex" is embedded in a profound conceptual knot. Mandy Merck hits on this point in the introduction to her recent collection of essays on representations of sex and sexuality. Responding in part to the reactionary characterization of queer academic writing as reductive (she cites Lee Siegel's *New Republic* attack on Eve Kosofsky Sedgwick and "the contemporary academic obsession with sexuality and 'the body'"), Merck points out that, actually, in the academic writing associated with queer theory, even when it looks as if we are talking about sex, more often than not we are not: "One of the greater paradoxes of what Lee Siegel imagines to be the academic sexuality of everything is a pronounced displacement of sex." This is in part because in sexuality studies, we tend to read "sex" (meaning, here, roughly, gender) and "sexuality" (meaning, sexual identity) as contingent, as "constitutive of class, race, nationality, etc.," and vice versa. "If such a conviction amounts to the sexualization of reality," she writes, "it is ironically at the expense of any definition of sex that would give it priority in the formation or process of subjectivity. Yet, even more ironically, this decentered definition of sex is the one most commonly proffered by those who have made it such a prominent object of intellectual inquiry. Thus, in an 'anti-encyclopedia entry' on queer theory, Lauren Berlant and Michael Warner consider its relevance to public policy, the mass media, money, biography, and jokes, without ever getting to sex." The trouble with "getting to sex is," Merck argues, hardwired into the problem of representation itself—"Sex talk will never get it right because, as representation, it is bound to fail [in that it cannot quite *be* sex]. And representation is bound to fail because it is intimately connected to sex. The fallibility of representation, that ancient theme in Western thought, is rarely without a sexual explanation." Merck thus locates the problem of "getting to sex" in two registers—the first is the tendency, in queer studies, to insist on the contingency of identity formation; the second is a Platonic understanding of sexual contact and intimacy as something that cannot be represented but which representations are always already trying to approximate. (Susan Stewart takes this up latter point in *Crimes of Writing*; see below.) Sex, in this sense, both eludes and defines representation (Mandy Merck, *In Your Face: Nine Sexual Studies* [New York: New York University Press, 2000], 2, 5).

9. Carol Duncan, "Modern Erotic Art," in *The Aesthetics of Power: Essays in Critical Art History* (Cambridge:Cambridge University Press, 1993), 110. See also Lynda Nead, *The Female Nude: Art, Obscenity, and Sexuality* (New York: Routledge, 1992); and Linda Nochlin, "Eroticism and Female Imagery in Nineteenth-Century Art," in *Women, Art, and Power and Other Essays* (New York: Harper and Row, 1988), 136–44.

10. Roland Barthes, *The Pleasure of the Text*, trans. Richard Miller (New York: Hill and Wang, 1975), 4.

11. For a treatment of the complexity of sexuality in Melville's writing, see, for example, James Creech, *Closet Writing/Gay Reading: The Case of Melville's Pierre* (Chicago: University of Chicago Press, 1993).

12. See chapter 2 for an overview of scholarship on sexuality and Eakins.

13. Some major works in gay studies in (mostly contemporary) American art history include Harmony Hammond, *Lesbian Art in America* (New York: Rizzoli, 2000); Jonathan Weinberg, *Speaking for Vice: Homosexuality in the Art of Marsden Hartley, Charles Demuth, and the First American Avant-Garde* (New Haven: Yale University Press, 1993); Richard Meyer, *Outlaw Representation: Censorship and*

Homosexuality in Twentieth-Century American Art (Oxford: Oxford University Press, 2002).

14. Cécile Whiting, *A Taste for Pop: Pop Art, Gender, and Consumer Culture* (Cambridge: Cambridge University Press, 1997), 2. Whiting's project, as well as my own, may be read as extensions of the feminist critical project of making visible the sexualization of the critical grammars. See, for example, Lynda Nead's "Art Criticism and Sexual Metaphor," in *The Female Nude: Art, Obscenity, and Sexuality,* or Alice Jardine's analysis of the feminizations of metaphors for modernity in *Gynesis: Configurations of Women and Modernity* (Ithaca: Cornell University Press, 1986).

15. In making connections between Warhol's interest in figures of prostitution and a broader tradition that uses these same figures to represent the nature of the artist's work, I draw from nineteenth-century texts—a historical leap I also make in my reading of women in Warhol's films by reading them through the "twenty-ninth bather" section of Walt Whitman's "Song of Myself." In the latter case, I draw from the similarity between the visual geometry of that poem (which pivots on the presence of a woman watching twenty-eight young men swimming), and feminist film theory on spectatorship, to argue that we appropriate Whitman's poem as a manifesto for a "queer feminist" model of reading and spectatorship—a critical practice in which men and women collaborate to challenge and undo the conventions that circumscribe access to visual pleasure and sexual agency. In juxtaposing Whitman and Warhol in this way, my hope is that the institutional locations of both as staple topics in gay studies will help us to more rigorously think through the place of women in queer theory. By placing Warhol in conversation with not only Whitman but other, far less likely nineteenth-century companions (like the writer and critic William Dean Howells), I hope, furthermore, to use the historical distance between them to defamiliarize Warhol's work, which has become firmly ensconced within specific critical trajectories (e.g., the movement from modernism to postmodernism).

16. Imagining a future when such a contradiction might be resolved, Marcuse writes, "No longer used as a full-time instrument of labor, the body would be resexualized. . . . The body in its entirety would become an object of cathexis, a thing to be enjoyed—an instrument of pleasure." Telescoping this utopic revision of the sociosexual body, he continues, "This change in the nature and scope of libidinal relations would lead to a disintegration of the institutions in which the private interpersonal relations have been organized, particularly the monogamic and patriarchal family" (Herbert Marcuse, *Eros and Civilization: A Philosophical Inquiry into Freud* [1955; repr., Boston: Beacon, 1966], 200–201).

17. See, for example, Caroline Jones's analysis of the production of gender in and around Warhol's Factory in *Machine in the Studio: Constructing the Postwar American Artist* (Chicago: University of Chicago Press, 1996), 189–269; and Cécile Whiting's take on the relationship between Warhol and Edie Sedgwick in *A Taste for Pop,* 175–77. David James touches on feminist film as a context for reading Warhol in *Allegories of Cinema: American Film in the Sixties* (Princeton: Princeton University Press, 1989). See also Matthew Tinkcom, *Working Like a Homosexual: Camp, Capital, and Cinema* (Durham: Duke University Press, 2002), which contains some wonderful descriptions of the complex interaction between men and women in *Bike Boy.*

18. Two critics who address these scenes from within queer cinema studies are Thomas Waugh, "Cockteaser," in Doyle, Flatley, and Muñoz, *Pop Out,* 54–77; and Tinkcom, *Working Like a Homosexual.* Waugh takes on the topic of women in Warhol's work as a multileveled problematic. The films ask us, for example, to think about the category of

the "fag hag," about the sexual politics of representations of femininity within gay films (made by and largely produced for gay audiences), and about the (in)stability of gender as a category in Warhol's work. They get the critic who bothers to think about them into all sorts of knots. For example, Waugh reads these women within the parameters of gay male culture (as divas, as queens, as parodies of "the heterosexual woman"): "On the whole, Warhol women are conceived and operate with a specific gay male orality, competing with the biological men, both transpeople and swishes, for the hustler, the butch/trade objects of their desire." He continues, "My critical reading of fictional females as subjects of gay male desire may well echo earlier homophobic unmaskings of the heroines of Tennessee Williams, Edward Albee, and George Cukor." (Here, Waugh refers to early feminist readings of women in gay-authored texts as always already subjects of male fantasies about women, e.g., Molly Haskell, *From Reverence to Rape: The Treatment of Women in the Movies* [New York: Holt, Rinehart, and Winston, 1974]). Waugh continues, "Warhol's women, and in particular their jokey articulation of rape in *Lonesome Cowboys, Flesh,* and *Trash* (not to mention similar aspects of Jack Smith's *Flaming Creatures*), need delicate handling. Because gender is such an unstable category in the films, it seems more productive to read Warhol's females as 'queens' rather than as 'women'; the recognition of this gender instability should be a starting point for shifting through two tricky issues at once—the misogynist elements often in the films *and* the homophobia in the traditional critical equation of gay culture with misogyny. Aside from these provisional conclusions, Warhol's women are a topic for extended further study" (54). Waugh's suggestion that these feminine performances share something with drag is important, because it allows us to acknowledge the performances by women in these films as lampooning traditional codes of femininity. His emphasis on the importance of the denaturalization of gender in Warhol's films also allows us to read the camp performance of sexual violence in *Lonesome Cowboys,* for example, as of a different order than mainstream representations of sexual violence. The tendency in Warhol studies has been to read these camp performances in relation to gay audiences and counterculture (a rich topic in and of itself). But this approach can downplay the extent to which Warhol's films, especially those that pivot on the affective and verbal intensity of women like Viva, Edie Sedgwick, and Brigid Berlin, are very much legible as about women as such. The category "Woman," as feminist theorists since Joan Riviere and Simone de Beauvoir have argued, is a social construction, with a complex relation to the body. Perhaps, in Warhol scholarship, we have been too quick in our turn to the "queen" for gaining leverage on how these films upset sexual difference (as in my own reading, in chapter 3, for example, of the Marilyn Monroe portraits). The displacement of the question of women in Warhol's work by attention to drag, gender performance, and gay underground culture makes some sense. It is true that gender is far too plastic a category in Warhol's work to ground a project in gender simply construed. It seems, on some level, however, obvious that some of Warhol's work is not only about the complex performativity of womanliness but about the social forces, the pressures that bear down hard on women, in particular.

19. See Gavin Butt, *Between You and Me: Queer Disclosures in the American Art World, 1948–1963* (Durham: Duke University Press, 2005); Meyer, *Outlaw Representations*; Douglas Crimp, "Getting the Warhol We Deserve," *Social Text,* no. 59 (1999): 49–66. David James takes up feminism and Warhol in *Allegories of Cinema: American Film in the Sixties.* Steven Shaviro also offers us another point of entry into the subject of representations of women and gay underground cinema in his writing on abjection

and appropriations of the feminine on *Querelle* in *The Cinematic Body* (Minneapolis: University of Minnesota Press, 1993).

20. Pamela Robertson, *Guilty Pleasures: Feminist Camp from Mae West to Madonna* (Durham: Duke University Press, 1996), 5.

21. Leanne Gilbertson approaches the topic of women in Warhol's work in her analysis of Edie Sedgwick's presence in "Andy Warhol's *Beauty #2*: Demystifying and Reabstracting the Feminine Mystique, Obliquely," *Art Journal* 62 (spring 2003): 24–33. This essay was first presented as a talk at "Queering Warhol," a conference organized by Robert Summers at the University of California, Riverside (at which my own work on this subject was also first presented).

22. Hilton Als, *The Women* (New York: Farrar, Straus, and Giroux, 1996), 92, 93.

23. Ibid., 92. For a far more complex treatment of Dorothy Dean, see Lynn Tillman's fictionalized portrait of Dean in her novel *Cast in Doubt* (New York: Serpent's Tail, 1992), which centers largely on a gay man's friendships with women. Thanks to Callie Angell for bringing this novel to my attention.

24. Conversation between Campbell and Callie Angell (Callie Angell to author, May 10, 2004).

25. Laura Marks, "Straight Women, Gay Porn, and the Scene of Erotic Looking," *Jump Cut*, no. 40 (1996): 132. These passages from Marks's essay are, in fact, woven into a collaborative segment of Ming Yuen S. Ma's *Slanted Vision*, a video meditation on queer Asian men, sexuality, and representation.

26. This is similar to the identificatory practices explored by José Muñoz in *Disidentifications: Queers of Color and the Performance of Politics* (Minneapolis: University of Minnesota Press, 1999).

27. Adam Phillips, *On Kissing, Tickling, and Being Bored: Psychoanalytic Essays on the Unexamined Life* (Cambridge: Harvard University Press, 1993), 69.

28. Ibid., 77–78.

29. See Eve Kosofsky Sedgwick and Adam Frank, eds., *Shame and Her Sisters: A Sylvan Tomkins Reader* (Durham: Duke University Press, 1995).

30. Patricia Meyer Spacks begins to describe the weird embodied life of boredom when she observes that "there is no arguing with the awful and absolute authority of boredom. If I declare [Wordsworth's poem] 'The Idiot Boy' boring, no one can refute me. It may not bore *you*, but your arguments about its complexity, its importance, its depth of implication can no more change my emotional response than your explanation of how funny a cartoon is can make me laugh" (*Boredom: The Literary History of a State of Mind* [Chicago: University of Chicago Press, 1995], 128). In the literature Spacks examines, the reader's boredom and interest are, most of the time, mutually exclusive perspectives on a text's value as a literary work. I would suggest, however, that boredom and interest are not necessarily mutually exclusive—that they are sometimes layered over each other. That the two share much is, in fact, implicit in Spacks's study, insofar as both are, as Spacks argues in detail, expressions of taste. For more on this point, see especially Spacks's chapter "Interlude: The Problem of the Interesting" (113–28).

31. Alexander Gelley, "Idle Talk: Scarcity and Excess of Language in Narrative," in *Talk, Talk, Talk: The Cultural Life of Everyday Conversation*, ed. S. I. Salamensky (New York: Routledge, 2001), 53.

32. Roland Barthes, *A Lover's Discourse: Fragments*, trans. Richard Howard (New York: Hill and Wang, 1978), 168.

33. Crimp, "Getting the Warhol We Deserve," 64.

34. Eve Kosofsky Sedgwick, "Queer and Now," in *Tendencies* (Durham: Duke University Press, 1993), 3.

35. Ibid., 5.

1. *Moby-Dick*'s Boring Parts

1. Richard Brodhead, "Trying All Things: An Introduction to *Moby Dick*" in *New Essays on Moby Dick,* ed. Richard Brodhead (Cambridge: Cambridge University Press, 1986), 3. That *Moby-Dick* has a troubled relation to interest is indicative of the novel's relationship to the literary. On this point, in the same essay, Brodhead suggests that "what sets *[Moby-Dick]* apart is not really whaling, and not even its famous depths of symbolic meaning, so much as the stand it takes toward literature itself—its quite peculiar attitude, registered on every page, toward what literature is and can be, and toward what it can attempt as a work of literary making" (1).

2. I should signal the difference between the subject of this chapter, and the work of other critics who have variously excavated or celebrated *Moby-Dick*'s gay components, and also, more important, acknowledge the debt owed to writers like Robert K. Martin, whose *Hero, Captain, Stranger* makes the exploration of *Moby-Dick*'s less explicitly homosexual elements possible, by having been among the first to put the novel's epic homoerotics on record. See Robert K. Martin, *Hero, Captain, Stranger: Male Friendship, Social Critique, and Literary Form in the Sea Novels of Herman Melville* (Chapel Hill: University of North Carolina Press, 1986). For an innovative take on *Moby-Dick,* see Cesare Casarino, *Modernity at Sea* (Minneapolis: University of Minnesota Press, 2002).

3. Some might ignore the presence of words like these in the opening sections because, structurally, they do not really belong to the novel proper, meaning its narrative. Some might ignore them in concert with a phobic tradition dead set against acknowledging the homoeroticism of Melville's writing. Some might dismiss the relevance of these words in this section because it is historically inaccurate to read in "queer" and "gay" the meaning they have today.

4. This is one of the most persistent strains in writing about boredom—the avoidance of boredom as the great motivator—the precondition for greatness, genius, or, on a more mundane level, for writing and reading. For a survey of thought and writing about boredom, see Patricia Meyer Spacks, *Boredom: The Literary History of a State of Mind* (Chicago: University of Chicago Press, 1995) or, for a less comprehensive but compelling review of the same subject, see the cryptic chapter on boredom in Walter Benjamin, *The Arcades Project,* trans. Howard Eiland and Kevin McLaughlin (Cambridge: Belknap Press, 1999).

5. Herman Melville, *Moby-Dick,* ed. Hershel Parker and Harrison Hayford (New York: Norton, 2001), 12. References are to this edition.

6. See, for instance, Spacks's *Boredom* or Jeff Nunokawa's essay "The Importance of Being Bored: The Dividends of Ennui in *The Picture of Dorian Grey,*" in *Novel Gazing: Queer Readings in Fiction,* ed. Eve Kosofsky Sedgwick (Durham: Duke University Press, 1997).

7. Herman Melville, "Billy Budd," in *Great Short Works of Herman Melville* (New York: Harper and Row, 1969), 441. The tension in Melville's novels between diagetic

and nondiagetic writing has been the subject of much critical discussion. Melville went on record with remarks about boiling down his novels to "story" for his readers. On the revision of *Typee,* and Melville's remarks to his English publisher on the reduction of the novel to "narrative alone," see Geoffrey Sanborn, *The Sign of the Cannibal: Melville and the Making of a Postcolonial Reader* (Durham: Duke University Press, 1998); or, for a more direct discussion of Melville's writing process and the literary market, see Sheila Post-Lauria, *Correspondent Colorings: Melville in the Marketplace* (Amherst: University of Massachusetts Press, 1996).

8. Martin, *Hero, Captain, Stranger,* 67.

9. This chapter has also been read as a comment on marriage and gender relations. For this reading, see Martin's *Hero, Captain, Stranger.*

10. For a sustained reading of the erotics of the figuration of this kind of fluid connection between reader and book, see Michael Moon, *Disseminating Whitman: Revision and Corporeality in Whitman's "Leaves of Grass"* (Cambridge: Harvard University Press, 1991).

11. F. O. Matthiessen, *American Renaissance: Art and Expression in the Age of Emerson and Whitman* (1941; repr., New York: Oxford University Press, 1968), 421.

12. Ibid. Within Melville scholarship, the relationship between language and sexuality has been taken up in part by James Creech. In his review of the theoretical work on this subject, Creech argues that critical practices have given short shrift to the place of sex in Melville's writing. He writes that Melville's careful refusal to be literal or explicit (as in critical treatment of Claggart's sexuality in *Billy Budd*) has tended to favor a rhetoric of lack over a discussion of a "particular sexual desire," and over a consideration of the particular ways a book like *Moby-Dick* (or *Billy Budd*) might speak quite explicitly, and quite obviously, to an audience who knows how to read it. For more on the sex politics in writing about Melville's obscurity, see James Creech's response to Barbara Johnson's reading of *Billy Budd* in chapter 1, "From Deconstruction," of *Closet Writing/Gay Reading: The Case of Melville's Pierre* (Chicago: University of Chicago Press, 1993), 3–43. There he argues that Johnson contributes to a critical *habitus* in which it becomes easier to think about sex as that for which, at best, the text is a substitute. Textual self-awareness, understood as a refusal of representation's referential function, is implicitly defined against the models of explicitness associated with the popular (romance), the obscene (pornography), and the ethnographic (realism). This model of criticism (practiced by as diverse and compelling a range of critics as Matthiessen and Johnson) obliterates the obviously sexual and homoerotic stuff that *is* there, dismissing it as too obvious to be taken literally (like Ishmael and Queequeg's "marriage"). It also, as Creech argues, underplays the legibly overdetermined link between sex and silence (and the silencing of people associated with prohibited sexual practices). And it ignores how much sexual play is housed by the reluctance to get to the point and how a pornographic reading practice can treat almost anything on the page as "sex itself." The tendency has been to take a refusal to be obvious and the practice of writing around sex as a marker of the literary or to treat sex and desire as that which can never *itself* register on the page. (On the problem of "sex itself," see Susan Stewart, *Crimes of Writing: Problems in the Containment of Representation* [Durham: Duke University Press, 1994], 236.)

13. Michael Rogin touches lightly on the staging of phallic mastery in "A Squeeze of the Hand" and in "The Cassock" in *Subversive Genealogy: The Politics and Art of Herman Melville* (New York: Knopf, 1983), 113–14.

14. For another discussion of this passage see Leslie Fielder, *Love and Death in the American Novel,* rev. ed. (New York: Stein and Day, 1966), 370–72.

15. "A man who uses fine words without much judgment is said to have 'swallowed the dick'" (1873 *Slang Dictionary,* cited in the *Oxford English Dictionary*).

16. For an overview of the practice of representing visual experience, see, for example, W. J. T. Mitchell's writing on *ekphrasis* in *Picture Theory* (Chicago: University of Chicago Press, 1996).

17. Naomi Schor, *Reading in Detail: Aesthetics and the Feminine* (New York: Routledge, 1989), 29, 87. The possibilities for antiorganic models of literary criticism are also taken up (but from a radically different angle) by Mary Poovey, in "The Model System for Contemporary Literary Criticism," *Critical Inquiry* 27, no. 3 (2003): 408–38.

18. Georges Bataille, *Eroticism: Death and Sensuality* (San Francisco: City Lights Books, 1986), 194.

19. We might contrast the function of detail in Melville or Sade with the association of detail and feminine excess as described by Naomi Schor in *Breaking the Chain: Women, Theory, and French Realist Fiction* (New York: Columbia University Press, 1987) and in *Reading in Detail.*

20. See, for example, Wendy Steiner, *The Scandal of Pleasure* (Chicago: University of Chicago Press, 1995); Judith Butler, "The Force of Fantasy: Feminism, Mapplethorpe, and Discursive Excess," *differences* 2, no. 2 (1990): 105–23.

21. Stewart, *Crimes of Writing,* 236.

22. Stewart's line of thought begins with the Meese commission on pornography and moves to Sade's writings and to the practice of ethnology.

23. Frances Ferguson, *Pornography: The Theory* (Chicago: University of Chicago Press, 2004).

24. Catharine MacKinnon, *Only Words* (Cambridge: Harvard University Press, 1993), 17. She shares this perspective on the performative effects of representation with a range of queer theorists. For two overviews of the relationship between MacKinnon's writing about sex and the work of queer theorists, see Mandy Merck, "MacKinnon's Dog: Antiporn's Canine Conditioning," in *In Your Face: Nine Sexual Studies* (New York: New York University Press, 2000), 89–107; and Ferguson, *Pornography.*

25. Linda Williams, *Hard Core: Power, Pleasure, and the "Frenzy of the Visible"* (Berkeley: University of California Press, 1989), 63.

26. For Williams's writing on early stag films, see *Hard Core,* 65.

27. Sharon Cameron, *The Corporeal Self: Allegories of the Body in Melville and Hawthorne* (New York: Columbia University Press, 1981).

28. Ibid., 41.

29. Thus we end up with the conflict between how many of us understand novels that end in marriage as novels about the production of heterosexuality and the domesticated woman—and how many of those novels have been read more in terms of the possibilities for life outside marriage and family. See, for example, Barbara Sicherman, "Sense and Sensibility: A Case Study of Women's Reading in Late-Victorian America," in *Reading in America: Literature and Social History,* ed. Cathy Davidson (Baltimore: Johns Hopkins University Press, 1989), 201–25.

30. Angela Carter, *The Sadeian Woman and the Ideology of Pornography* (New York: Pantheon Books, 1978), 17.

31. Ibid., 13.

32. Thanks to Jane Blocker for reminding me of this passage.

33. For writing on the poetics of cross-racial identification, see, for example, Lisa Gail Collins, *The Art of History: African-American Women Artists Engage the Past* (New Brunswick: Rutgers University Press, 2002); Maurice Wallace, *Constructing the Black Masculine* (Durham: Duke University Press, 2002); Karen Sanchez-Eppler, *Touching Liberty: Abolition, Feminism, and the Politics of the Body* (Berkeley: University of California Press, 1993).

34. Franz Fanon, *Black Skins/White Masks* (New York: Grove, 1967), 21.

35. Henry Louis Gates Jr., *The Signifying Monkey: A Theory of Afro-American Literary Criticism* (New York: Oxford University Press, 1988), 138.

36. Ibid., 137.

37. See, for example, "Benito Cerino" for another Melvillian take on race, reading, and recognition.

38. On adhesiveness, see Michael Lynch, "'Here Is Adhesiveness': From Friendship to Homosexuality," *Victorian Studies* 29, no. 1 (1985): 69–96.

39. Frank O'Hara, "Personism: A Manifesto" in *The Collected Poems of Frank O'Hara,* ed. Donald Allen (New York: Knopf, 1971), 498–99.

40. Michael Moon, "Rereading Whitman under the Pressure of AIDS: His Sex Radicalism and Ours," in *The Continuing Presence of Walt Whitman: The Life after the Life,* ed. Robert K. Martin (Iowa City: University of Iowa Press, 1992), 58.

41. Ibid.

42. On the range of relationships formed across class and racial boundaries in pornographic spaces, see Samuel R. Delany, *Times Square Red/Times Square Blue* (New York: New York University Press, 1999).

2. Sex, Sodomy, and Scandal

1. *The Gross Clinic* was eventually incorporated into the exposition in the Army Post Hospital as part of an exhibit on the U.S. government.

2. The indispensable guide to the nature of the scandals is *Writing about Eakins: The Manuscripts in Charles Bregler's Thomas Eakins Collection,* ed. Kathleen A. Foster and Cheryl Leibold (Philadelphia: University of Pennsylvania Press, 1989). Reproduced in this volume are the full text of many of the most important documents pertaining to the events I describe below. Henry Adams's 2005 biography of the artist, *Eakins Revealed* (published since the writing of this chapter), explores the full complexity of the relationship between Eakins's life and his art. Adams draws extensively from not only the archive of Eakins correspondence but also evidence that reveals that William Innes Homer (author of the last authoritative Eakins biography) suppressed much disturbing information culled from interviews about Eakins's relationships with his family and with his students and colleagues.

3. Henry Allen, "The Masculine Mystique: At Two Museums, the Arresting Male Figures of Thomas Eakins," *Washington Post,* June 23, 1996.

4. For an identification of the figures in *The Swimming Hole,* see Sarah Cash, "Biographies of Models for *Swimming,*" in *Thomas Eakins and the Swimming Picture,* ed. Doreen Bolger and Sarah Cash (Fort Worth: Amon Carter Museum, 1996), 117–22.

5. A March 8, 1879, review in New York's *Herald* cited by Gordon Hendricks in "Thomas Eakins's *Gross Clinic,*" *Art Bulletin* 1, no. 1 (1969): 63.

6. Michael Fried, *Realism, Writing, and Disfiguration: On Thomas Eakins and Stephen Crane* (Chicago: University of Chicago Press, 1987), 63. For a similar correc-

tion in critical approaches to Walt Whitman's Calamus poems, see John Vincent, *Queer Lyrics: Difficulty and Closure in American Poetry* (New York: Palgrave Macmillan, 2002), in which Vincent argues that the sense that these poems were written to a particular person is best considered a poetic effect.

7. Fried, *Realism, Writing, and Disfiguration*, 64.

8. Nicholas Merzoeff addresses the gender dynamics of this painting in *Introduction to Visual Culture* (New York: Routledge, 1999), 168–70. Fried himself holds onto the gender ambiguity of the patient's body, especially in his revisitation of his interest in *The Gross Clinic* in *Menzel's Realism: Art and Embodiment in Nineteenth-Century Berlin* (New Haven: Yale University Press), 115–24. See also Marcia Pointon, *Naked Authority: The Body in Western Painting, 1830–1908* (Cambridge: Cambridge University Press, 1990).

9. Fried, *Realism, Writing, and Disfiguration*, 61.

10. Two scholars have written about this painting in relation to larger projects about representations of the body in painting, Nicholas Merzoeff and Marcia Pointon (see note 8). Art-historical debate about the patient has focused on the question of whether the patient is a charity case. This possibility has been entertained as an explanation for the rational behind the inclusion of the patient's socks (I am assuming because they appear coarse), as well as the woman (because in that case a chaperone may have been required during the surgery). With this interpretation in hand, one might read the painting in terms of class. Elizabeth Johns references this particular issue in *Thomas Eakins: The Heroism of Modern Life* (Princeton: Princeton University Press, 1983), 47n5.

11. Although, as Nicholas Merzoeff points out, the fact that Dr. Gross also performed surgery on an intersexed patient suggests an even more compelling source for *The Gross Clinic* (*Introduction to Visual Culture*, 169–70).

12. Leo Steinberg, *Other Criteria* (New York: Oxford University Press, 1972), 57, 59.

13: Often cited in illustration, this long association of Eakins's work with heavily gendered narratives about American art begins with Sadakichi Hartmann's 1902 *History of American Art*: "Our American art is so effeminate at present that it would do no harm to have it inoculated with just some of [the brutality of *The Gross Clinic*]. . . . it is as refreshing as a whiff of the sea, to meet with such a rugged powerful personality. Eakins, like Whitman, sees beauty in everything. He does not always succeed in expressing it, but all his pictures impress one by their dignity and unbridled masculine power." Quoted by Amy Werbel, for example, in "The Critical Reception of Thomas Eakins's Work," in *Thomas Eakins*, ed. John Wilmerding (Washington, DC: Smithsonian Institution Press, 1993), 196.

14. The intertwining of the development of American masculinity with the establishment of an iterable vocabulary of male homoeroticism is embedded even in Hartmann's declaration of Eakins's importance. Even as he distances the artist from the "effeminate," Hartmann links Eakins, through a reference to Whitman (whom Hartmann knew) and perhaps even Melville (by way of "a whiff of the sea") to the articulation of what Robert K. Martin has identified as a "homosexual tradition" in American art. Whitney Davis takes up Eakins's relationship to Whitman in "Erotic Revision in Thomas Eakins's Narratives of Male Nudity," *Art History* 13, no. 3 (1994): 301–41. See also Bolger and Cash, *Thomas Eakins and the Swimming Picture*.

15. Jonathan Ned Katz charts the major historical shifts in American cultural attitudes about sexuality in *The Invention of Heterosexuality* (New York: Penguin, 1995). Heterosexuality, he demonstrates, is a decidedly modern invention, appearing

in medical literature in the 1860s as a pathology (an excess of sexual desire for members of either sex) and slowly, over the last decades of the nineteenth century, evolving into the usage it currently enjoys. Following Michel Foucault's argument that the "homosexual" is a recent and distinctly modern invention whose appearance in a discourse on sex is accompanied by the repressive hypothesis and a "will to know," I would make a case against reading Eakins's work for evidence of his sexuality as its repressed content. Eakins sits on the cusp of the moment in the history of sexuality when, in Michel Foucault's famous assertion: "The sodomite had been a temporary aberration; the homosexual was now a species" (Michel Foucault, *The History of Sexuality*, vol. 1, *An Introduction*, trans. Robert Hurley (New York: Vintage Books, 1980), 43.

16. The primary approach to gender in Eakins's work reproduces contemporary understanding of that century as structured by "separate spheres." Analyses center on his portraits of women, *or* on his portraits of men, *or* on a work like *The Gross Clinic*, which includes members of both sexes but which are taken to be more about Eakins than about sex or gender per se.

17. Elizabeth Johns, "Swimming: Thomas Eakins, the Twentieth-Ninth Bather," in Bolger and Cash, *Thomas Eakins and the Swimming Picture*, 69.

18. The allegations of incest with his sister were made in 1886, several years after she had died of typhoid (in 1882). Eakins's brother-in-law William Crowell was then one of his staunchest defenders, though he would implicate Eakins in the suicide of his own daughter Ella nearly ten years later. In a letter to John Sears, president of the Philadelphia Sketch Club, Crowell writes: "I observed,—as doubtless you also did,—that on Saturday evening last Mr. Stephens claimed to have received his information about 'not only the posing,' but also the actions on which the charge of bestiality was founded from Miss Maggie. My wife and I can both testify to that fact of his admission to us, that he knew nothing of the posing business at least, until six months after [Maggie's] death." He goes to explain that Maggie saw her brother-in-law Stephens as a child, and would never have confided such a "terrible 'family skeleton'" to him. Maggie was, however, very close to Fanny (Frances Eakins—her sister and William Crowell's wife). In her many letters to Fanny, she never made any reference to such a thing. Crowell takes this to mean that Stephens's allegations are baseless. See Foster and Leibold, *Writing about Eakins*, 228–29.

19. Ella had been, along with a number of her siblings, a student of Eakins's for several years and occasionally lived with Thomas and Susan.

20. Susan MacDowell Eakins to Fanny (Francis) Crowell, October 18, 1896, included in Foster and Leibold, *Writing about Eakins*, 114.

21. Thomas Eakins to Edward Coates, September 11, 1886, in Foster and Leibold, *Writing about Eakins*, 235.

22. Foster and Leibold, *Writing about Eakins*, 116.

23. Jonathan Goldberg, introduction to *Reclaiming Sodom*, ed. Jonathan Goldberg (New York: Routledge, 1994), 6.

24. The Georgia statute, for example, reads: "A person commits the offense of sodomy when he performs or submits to any sexual excitement involving the sex organs of one person and the mouth or anus of another." Cited in the dissenting opinion in *Bowers v. Hardwick*, the text of which is included in Goldberg, *Reclaiming Sodom* (124).

25. Goldberg, introduction, 6.

26. Sodomy, Goldberg writes (summarizing in part an argument also made by

Michael Warner) "(mis)names the normative effusion of spirit that joins men to each other. . . . the abjection of and stigmatization of male-male relations can never quite be separated from male privilege; the blindness of a certain heteronormativity to its complicity with what it seeks to suppress is everywhere evident" (introduction, 5, 6–7).

27. For a broad portrait of the place of women in life-modeling classes and the sexual politics of art instruction, see Lynda Nead, *The Female Nude: Art, Obscenity, and Sexuality* (New York: Routledge, 1992), 46–55.

28. Anonymous letter sent to J. L. Claghorn, the Academy president (April 11, 1882), printed in Sylvan Schendler, *Eakins* (Boston: Little, Brown, 1967), 90–92.

29. Rosalind Krauss, "Olympia," in *Formless: A User's Guide*, by Yves-Alain Bois and Rosalind Krauss (New York: Zone Books, 1997), 148.

30. Thomas Eakins to Earl Shinn, cited in Gordon Hendricks, *The Life and Work of Thomas Eakins* (New York: Grossman, 1974). William J. Clark also cites a portion of this passage in his essay "The Iconography of Gender in Thomas Eakins Portraiture," *American Studies* 32, no. 2 (1991): 6.

31. Martin Berger, *Man Made: Thomas Eakins and the Construction of Guilded Age Masculinity* (Berkeley: University of California Press, 2000), 98.

32. This latter reading is supported, in fact, by the story of the painting's production. The painting was commissioned by Dr. Agnew's students—the resultant portrait was, however, controversial, as Agnew had a horror of blood (but is nevertheless pictured in the painting splattered with it) and never allowed women into his surgical theater (a female nurse stands at the foot of the surgical table) (Kathleen Foster, lecture, Metropolitan Museum of Art, June 2002). The photographer Deborah Bright appropriates the figure of the nurse in her work *The Management of Desire*. Jacqueline Ascher explores the sexual politics of Bright's appropriation in an unpublished essay.

33. Thomas Eakins to Edward Coates, February 15, 1886, cited in Foster and Leibold, *Writing about Eakins*, 237.

34. Rogers Fairman, cited in William Innes Homer, *Thomas Eakins: His Life and Art* (New York: Abbeville, 1992), 161.

35. Eakins, cited in Homer, *Thomas Eakins*, 164.

36. From Charles Bregler's notes on Thomas Eakins's teachings, cited in Lloyd Goodrich, in *Thomas Eakins*, 2 vols. (Cambridge: Harvard University Press, 1982), 1:185.

37. Interview with Mrs. J. M. Dodge, cited in Homer, *Thomas Eakins*, 2:72.

38. This last remark is Frances Ziegler's (a man), cited in Goodrich, *Thomas Eakins*, 2:96.

39. Thomas Eakins to Edward Coates, September 12, 1886, cited in Foster and Leibold, *Writing about Eakins*, 338–39.

40. Ibid.

41. Eakins, in a letter to the Academy, cited in Wilmerding, *Thomas Eakins*, 92–93, and in Goodrich, *Thomas Eakins*, 1:170.

42. Thomas Eakins to the Committee on Instruction, January 8, 1876, paraphrased and cited in Foster and Leibold, *Writing about Eakins*, 343.

43. Griselda Pollock, *Avant-Garde Gambits, 1888–1893: Gender and the Colour of Art History* (London: Thames and Hudson, 1992), 35–42.

44. Elizabeth MacDowell Kenton to Thomas Eakins, late September 1894, cited in Foster and Leibold, *Writing about Eakins*, 179.

45. Frances Ziegler, whom Goodrich identifies as one of Eakins's "more conservative" students (*Thomas Eakins,* 2:96).

46. Eakins himself tried to exploit his economic failures in defense against the appearance of impropriety. Writing to Coates in the midst of his 1886 dismissal, Eakins asserted, "I never took pay from pupils." He hoped his relative independence from financial need would work as an incontrovertible alibi for the innocence of his intentions, demonstrating that he worked not to make money but for the sake of his art alone (Thomas Eakins to Coates, February 15, 1886, cited in Foster and Leibold, *Writing about Eakins,* 217–18).

47. Thomas Eakins to Edward Coates, September 11, 1886, cited in Foster and Leibold, *Writing about Eakins,* 235.

48. Merzoeff explores this possibility in *Introduction to Visual Culture* (see note 8).

49. A March review in *New York Times,* cited in Hendricks, *Life and Work of Thomas Eakins,* 63.

50. Abigail Solomon-Godeau, "The Legs of the Countess," *October* 39 (winter 1986): 65–109. Reprinted in *Fetishism as Cultural Discourse,* ed. Emily Apter and William Pietz (Ithaca: Cornell University Press, 1993), 299.

51. Sigmund Freud, "Psychoanalytic Notes upon an Autobiographical Account of a Case of Paranoia (Dementia Paranoides)," in *Three Case Histories* (New York: Collier Books, 1963), 115.

52. Fried, *Realism, Writing, and Disfiguration,* 69.

53. Ibid., 65.

54. This evasion of the subject of homoeroticism is sustained in Fried's writing on Eakins and the realist painter Adolfo Menzel in *Menzel's Realism.*

55. Summarizing the work of such feminist theorists as Judith Butler and Luce Irigaray, Susan Buck-Morss writes, "It is precisely in [the] castrated form that the being is gendered male—as if, having nothing so embarrassingly unpredictable or rationally uncontrollable as the sense-sensitive penis, it can then confidently claim to be the phallus. Such an asensual, anaesthetic protuberance is this artifact: modern man" (Susan Buck-Morss, "Aesthetics and Anaesthetics: Walter Benjamin's Artwork Essay Reconsidered," *October* 62 [fall 1992]: 8).

56. Briefly, Edelman explores one of Freud's writings on "The Wolf Man," specifically Freud's interest in the Wolf Man's primal scene, in which, as a small child, he witnesses his parents in the act of coitus a tergo. See Lee Edelman, "Seeing Things: Representation, the Scene of Surveillance and the Spectacle of Gay Male Sex," in Goldberg, *Reclaiming Sodom,* 266, 267.

57. Edelman, "Seeing Things," 275. One of the most provocative insights of Edelman's reading is his argument that Freud's difficulty with the subject of anal eroticism and homosexuality mirrors an unease about the nature of his own analytic practices and, somewhat separately, also results in Freud's tendency to equate anal eroticism and castration—with the assumption that to have a fantasy about being physically transformed into a woman is a desire for an experience of annihilation.

58. A March 1876 review in the *New York Times,* cited in Hendricks, *Life and Work of Thomas Eakins,* 63, emphasis mine.

59. A March 1876 review in the *Tribune,* cited in Hendricks, *Life and Work of Thomas Eakins,* 63, emphasis mine.

60. Eve Kosofsky Sedgwick, *Epistemology of the Closet* (Berkeley: University of California Press, 1990), 151.

3. Tricks of the Trade

1. Andy Warhol, *The Philosophy of Andy Warhol* (New York: Harcourt Brace Jovanovich, 1975), 92, 43.

2. Ibid., 51.

3. Andreas Huyssen, *After the Great Divide: Modernism, Mass Culture, Post-modernism* (Bloomington: Indiana University Press, 1986).

4. W. F. Haug, *Critique of Commodity Aesthetics,* trans. Robert Bock (Minneapolis: University of Minnesota Press, 1986), 85.

5. Thierry de Duve, "Andy Warhol; or, the Machine Perfected," trans. Rosalind Krauss, *October* 48 (spring 1989): 3–14.

6. See, for example, Janice Radway's essay, "On the Gender of the Middlebrow Consumer and the Threat of the Culturally Fraudulent Female," "Materialist Feminism," special issue, *SAQ* 93, no. 4 (1994): 871–93.

7. Suzi Gablik, "The Art Job, or, How the Avant-Garde Sold Out," *Art in America,* April 1980, 9.

8. Thomas Hess, "The Phony Crisis in American Art," *ARTnews* 62 (summer 1963): 24–28.

9. For writing about the stigma of prostitution, see, for example, Frédérique Delacoste and Priscilla Alexander's collection *Sex Work: Writings by Women in the Sex Industry* (Pittsburgh: Cleis, 1987); and *Social Text,* no. 37 (1993) for a special section on women and the sex trade edited by Anne McClintock.

10. Here I am borrowing Eve Kosofsky Sedgwick's useful formulation of universalizing and minoritizing discourses on sexuality and identity that she develops in *Epistemology of the Closet* (Berkeley: University of California Press, 1990), 82–90.

11. In the words of one California judge, "A whore is a whore is a whore." See Anne McClintock, "Screwing the System: Sex Work, Race, and the Law," "Feminism and Postmodernism," ed. Margaret Ferguson and Jennifer Wicke, special issue, *boundary 2* 19 (summer 1992): 76.

12. Robert Hughes, "The Best and Worst of Andy Warhol," *Time,* February 1989, 95; and Hughes, "The Rise of Andy Warhol," *New York Review of Books,* February 18, 1982, 6, 7.

13. Peter Selz, "The Flaccid Art," in *Pop Art: The Critical Dialogue,* ed. Carole Anne Mahusen (Ann Arbor: UMI Research Press, 1989), 77–82, originally published as "Pop Goes the Artist," *Partisan Review,* summer 1963.

14. Aline B. Saarinen, "Explosion of Pop Art," *Vogue,* April 1963, 134.

15. Deborah Solomon, "Pittsburgh's Warhol Museum: Pop Art . . . in a Grimly Rehabbed, Final 'Factory,'" *Wall Street Journal,* May 18, 1994.

16. See Gavin Butt's exploration of Warhol's "swish" in *Between You and Me: Queer Disclosures in the American Art World, 1948–1963* (Durham: Duke University Press, 2005).

17. This is a gloss of a definition of prostitution written by Henri Turot in 1904 and cited by T. J. Clark in his writing on Manet's *Olympia,* "Olympia's Choice," in *The Painting of Modern Life* (Princeton: Princeton University Press, 1984), 281.

18. Anne McClintock, "Sex Workers and Sex Work: An Introduction," *Social Text,* no. 37 (1993): 7. The phrase "pathology of agency" belongs to Mark Seltzer as he uses it in "Serial Killers (1)," *differences: A Journal of Feminist Cultural Studies* 5, no. 1 (1993): 92–127.

19. Jeremy Gilbert-Rolfe, "Popular Imagery," in *Theories of Contemporary Art,* ed.

Richard Herz (Englewood Cliffs: Prentice Hall, 1985), 129–30. Cited by David James in his provocative article "The Unsecret Life: A Warhol Advertisement," *October 56* (spring 1991): 21–41.

20. Peter Selz, ed., "A Symposium on Pop Art," special supplement, *Arts Magazine*, April 1963, 36–45.

21. Jean Baudrillard, *Revenge of the Crystal: Selected Writings on the Modern Object and its Destiny, 1968–1983*, ed. and trans. Paul Foss and Julian Pefanis (Sydney, Australia: Pluto, 1990), 87.

22. John Berger, *Ways of Seeing* (New York: Penguin Books, 1977), 63.

23. Theodore Dreiser, *Sister Carrie* (New York: Oxford University Press, 1991), 58.

24. Griselda Pollock, "Screening the Seventies: Sexuality and Representation," in *Vision and Difference* (New York: Routledge, 1988), 159.

25. Linda Nochlin, *Realism* (New York: Penguin Books, 1971), 199.

26. See Berger, *Ways of Seeing*; Pollock, "Screening the Seventies"; and Nochlin, *Realism*. See also Benjamin Buchloh, "Andy Warhol's One-Dimensional Art," in *Andy Warhol: A Retrospective*, ed. Kynaston McShine (New York: Museum of Modern Art, 1989). In that essay Buchloh compares the effect of Warhol's Marilyn Monroe portraits on audiences with that of *Olympia*. He writes: "By responding to paintings such as [Jasper] Johns's *Flag on Orange Field, II, 1958* with his emblematic *Gold Marilyn Monroe, 1962*, Warhol made Johns's work seem to be safely entrenched in a zone of unchallenged high-art hegemony. By contrast, his own new mass-cultural iconography of consumption and *the portraits of collective scopic prostitution* looked suddenly more specific, more concretely American than the American flag itself, perhaps in the way that Manet's *Olympia* had appeared more concretely Parisian to the French bourgeois in 1863 than Eugène Delacroix's *Liberté*." This double comparison (which feels right) is connected by the phrase "collective scopic prostitution," which Buchloh does not explain. In many ways, my own project is an extended meditation on Buchloh's term.

27. Two scholars have ventured into this terrain. Sander Gilman has periodically explored the connections between ideologies of racial and sexual difference in medical, legal, and artistic representations of the prostitute. See Sander Gilman, "Black Bodies, White Bodies: Toward an Iconography of Female Sexuality in Late Nineteenth-Century Art, Medicine, and Literature," in *Race, Writing, and Difference*, ed. Henry Louis Gates Jr. (Chicago: University of Chicago Press, 1986), 223–61. Charles Bernheimer's book-length study of figures of prostitution in French art and literature, *Figures of Ill Repute*, goes a long way toward giving the allegorical use of prostitutes in modern art a context and a history. See Charles Bernheimer, *Figures of Ill Repute: Representing Prostitution in Nineteenth-Century France* (Cambridge: Harvard University Press, 1989).

28. This is also to say that although a number of artists ground their major works in portraits of women who sell themselves (in one way or another), if we find them performing some form of ideology critique, it is not usually a critique of the organization of sex or gender. There are, of course, nineteenth-century novels about women who "sell themselves" that do make some intervention in sex politics: Harriet Jacobs's 1861 *Incidents in the Life of a Slave Girl* (Cambridge: Harvard University Press, 1987) manages to launch a critique of sex/gender exploitation in slavery while raising serious questions about the sex/gender/race exploitation embedded in abolitionist rhetoric. In England, Elizabeth Gaskell's 1853 realist novel *Ruth* (Rutland: Tuttle, 2001) uses a story about a "fallen woman" to make the exploitation of women within homosocial exchanges visi-

ble. These are, however, exceptions that prove the rule—that high modernism and the ethos of a generative male creativity are frequently installed, as Griselda Pollock put it, on the "commodified female body"—resulting in a near-inverse relation between the popularity of male artists representing women as sexual subjects in art (think: Picasso, Gauguin), and the admission of women as active participants in the art world.

29. In developing the term, I settled on the word *rhetoric* (rather than *discourse*) as a more precise name for a critical turn, a strategy of argument, particular to the description of the difference between "good" and "bad" art. The term *discourse of prostitution* has, furthermore, been used to refer to discourse about prostitutes and sex-for-money exchanges. The rhetoric of prostitution in criticism is *shaped* by discourse about prostitution—and my discussion of the former will require some explication of the latter. The rhetoric of prostitution is not, however, explicitly concerned with prostitutes or the sex industry. I borrow my understanding of the discursive shape of "moral panic" from Simon Watney's discussion of theories of moral panic in *Policing Desire: Pornography, AIDS, and the Media* (Minneapolis: University of Minnesota Press, 1987), 38–57. There he glosses several takes on moral panic theory from within gender studies—most notably from Gayle Rubin and Jeffrey Weeks. Watney distinguishes his work on the phobic rhetoric surrounding AIDS by asserting that, in general, moral panic theory describes nearly "*all* conflicts in the public domain where scapegoating takes place" and therefore seems an inadequate framework for addressing "the overall ideological policing of sexuality."

30. Georg Simmel, *The Philosophy of Money*, trans. Tom Bottomore and David Frisby (New York: Routledge, 1990).

31. In the criminalization, regulation, and policing of prostitution, a common theme emerges: the state's intervention in the sex industry to criminalize or legalize prostitution has historically prevented women from asserting economic autonomy through their bodies. See Gail Pheterson, *The Prostitution Prism* (Amsterdam: Amsterdam University Press, 1996); special issue on the sex trade, Anne McClintock, ed., *Social Text*. no. 37 (1993); Delacoste and Alexander, *Sex Work*.

32. Quoted in Huyssen, *After the Great Divide*, 50.

33. For Robert Jensen's gloss of a perspective on art and the market offered by Bouguereau in his description of the impact of market tastes on the choices he made as a painter, see Robert Jensen, *The Marketing of Modernism in Fin-de-Siècle Europe* (Princeton: Princeton University Press, 1994), 20.

34. Norris is referring to the boom in the production of historical novels, modeled after Sir Walter Scott. See "The True Reward of the Novelist," in *Frank Norris: Novels and Essays* (New York: Library of America, 1986), 1147.

35. Ibid.

36. Michael Fried, *Absorption and Theatricality: Painting and Beholder in the Age of Diderot* (Chicago: University of Chicago Press, 1988).

37. William Dean Howells, "The Man of Letters as a Man of Business," in *Criticism and Fiction*, ed. Carla Marburg Kirk and Rudolf Kirk (New York: New York University Press, 1959), 298–99.

38. Ibid., 299.

39. Ibid.

40. Howells, "Criticism and Fiction," in *Criticism and Fiction*, 46. Such characterizations of women's reading habits are hardly unusual. See, for example, Janice Radway's

survey of the rhetorical equation of reading with other modes of consumption, "Reading is not eating: Mass produced literature and the theoretical, methodological and political consequences of a metaphor" (*Book Research Quarterly* 2 [1986]: 7–29).

41. William Dean Howells, *The Rise of Silas Lapham* (New York: Bantam, 1971), 160–61.

42. See Mark Seltzer's chapter "The Love-Master" in *Bodies and Machines* in which he contextualizes the works of Jack London and Stephen Crane with national anxiety about the masculinity of the bourgeois man and of the factory worker (*Bodies and Machines* [New York: Routledge, 1992], 152).

43. Dreiser more than Howells examined his own hopes for the curative powers of "hard work" in his posthumously published autobiography, *An Amateur Laborer* (Philadelphia: University of Pennsylvania Press, 1983) and in his autobiographical novel *The "Genius"* (1915). In the former, Dreiser describes his own bout with neurasthenia as the experience of being broken open to the world: "It seemed as if my mind had been laid bare as if by a scalpel to the mysteries of the universe, and that I was compelled to suffer, blood-raw, the agonies of its weight." Earning an "honest living" offered a limited refuge for Dreiser, whose attempts in this area were pitiful at best.

44. See Amelia Jones's reading of masculinity and Pollock in *Body Art/Performing the Subject* (Minneapolis: University of Minnesota Press, 1998).

45. On the connection between the rise of the novel and fascination with the nature of women's bodies and subjectivity, see Nancy Armstrong, *Desire and Domestic Fiction: A Political History of the Novel* (New York: Oxford University Press, 1987); and Catherine Gallagher, *Nobody's Story: The Vanishing Acts of Women Writers in the Market Place, 1670–1820* (Berkeley: University of California Press, 1994).

46. For the definitive perspective on modern articulations of aesthetic value, see Barbara Herrnstein Smith, *Contingencies of Value: Alternative Perspectives for Critical Theory* (Cambridge: Harvard University Press, 1988).

47. Simmel, *Philosophy of Money*, 378–79.

48. Nancy Armstrong, *Desire and Domestic Fiction: A Political History of the Novel* (New York: Oxford University Press, 1987), 5.

49. This is the same kind of dissociation that makes thinkable the possibility that a woman could be sold into prostitution and yet remain innocent.

50. Alexendre Parent-Duchâtelet, *De la prostitution dans la ville de Paris*, 2 vols. (Paris: Baillière, 1836). Charles Bernheimer discusses Parent-Duchâtelet's interest in prostitution and the abject at length in *Figures of Ill Repute*.

51. W. T. Stead, "The Maiden Tribute of Modern Babylon," Pall Mall Gazette, 1885, cited in Judith Walkowitz, *City of Dreadful Delight: Narratives of Sexual Danger in Late-Victorian London* (Chicago: University of Chicago Press, 1992), 81, 82. In both countries, readers raised serious questions about the difference between its "undercover" reporting and simple pornography. Competing London journalists described the sensational detail of Stead's reports as "the vilest parcel of obscenity." British politicians also demanded that "The Maiden Tribute" be labeled as an obscenity even as throngs demonstrated in Hyde Park against the abuse of young women's virtue. "The Maiden Tribute" spawned a series of lawsuits. Charges of obscenity and fraud—many insisted the story inappropriately capitalized on the sensationalism of its subject, and several of the participants in the exchange of women described by the story charged Stead (who bought virgins from parents undercover) himself with fraud and engaging in prostitution. The controversy sparked by Stead's report led to the passage of age-of-

consent laws in the U.K.—raising the age of consent to sixteen (from thirteen) for girls and, interestingly, forbidding consensual sex between men. Age-of-consent laws were raised in several states in the United States in response to the public outrage provoked by Stead's report. See Charles Terrot, *The Maiden Tribute: A Study of the White Slave Traffic of the Nineteenth Century* (London: Frederick Muller, 1959).

52. Edwin W. Sims, introduction to *Fighting the Traffic in Young Girls, or War on the White Slave Trade,* by Ernest A. Bell (Chicago: Ball, 1910), 14, emphasis mine.

53. The model of authorship that emerges at this moment ties the artist and his work more and more tightly together. In a meditation on modernity and the art world, the feminist artist and critic Mary Kelly writes that the category of "art" and the artist (and, we might add, literature and the author) are products of bourgeois models of self-possession: "The work of art, filtered through the institutions and discourses that determine its specific conditions of existence, produces artistic authorship in the fundamental form of the bourgeois subject: creative, autonomous, self-possessed. In a sense there is no 'alternative' to that passage; for the very moment that the work of art enters into circulation, it is sanctioned by law as the property of a creative subject (but not to enter into such a contract would be to forfeit even the possibility that the artistic text . . . could indeed interrogate [art as such])" ("Re-Viewing Modernism," in *Imaging Desire* [Cambridge: MIT Press, 1996], 85–86). In other words, an artwork that challenges the link between self and expression, or the way that a work belongs to its author, is often not recognizable (at least not at first) as "art."

54. Cited in Buck-Morss, *Dialectics of Seeing,* 186.

55. Ibid., 184–85.

56. Andy Warhol and Pat Hackett, *POPism: The Warhol '60s* (New York: Harcourt Brace Jovanovich, 1980), 294. As many accounts of Factory life will tell you, Warhol had a significant place in the everyday life and imaginary of the sex industry in New York. Kathy Acker illustrates this nicely when she recalls that while working at FUN CITY, "One of the lines in our sex shows was that we were waiting to be discovered by Andy Warhol. We weren't entirely joking, we were hoping." Acker remembers the Factory as welcoming those the art world and hippie culture disparaged: "Whores, pimps, working girls of all sorts, drug dealers, transsexuals and transvestites—the general population of forty-second street" (Kathy Acker, "Blue Valentine," in *Andy Warhol: Film Factory,* ed. Michael O'Pray [London: British Film Institute, 1989], 62–64).

57. Andy Warhol, *The Andy Warhol Diaries,* ed. Pat Hackett (New York: Warner Books, 1989), 799.

58. Leticia Kent, interview with Andy Warhol, *Vogue,* March 1970, 204.

59. Ibid.

60. I am drawing from Michael Moon's discussion of reading poetry and pornography in his provocative essay "Rereading Whitman under Pressure of AIDS," in *The Continuing Presence of Walt Whitman: The Life after the Life,* ed. Robert K. Martin (Iowa City: University of Iowa Press, 1992), 53–66.

61. Stephen Koch, *Stargazer; Andy Warhol's World and His Films* (New York: Praeger, 1973), 124–33. I first came across these passages from Koch's text in David James's "Andy Warhol: The Producer as Author," a chapter in James's *Allegories of Cinema* (Princeton: Princeton University Press, 1989), 77–79.

62. James, *Allegories of Cinema,* 67, 77–79.

63. I am borrowing the phrase "actively passive" from Spivak, but in the spirit in which Craig Owens cites her in his essay "Posing." Spivak uses the term when suggesting

that feminist criticism "produce[s] useful and scrupulously *fake* readings in place of the actively-passive fake orgasm" (Gayatri Spivak, "Displacement and the Discourse of Woman," in *Displacement: Derrida and After,* ed. Mark Krupnik [Bloomington: Indiana University Press, 1983], 186). Owens uses the phrase in his insightful readings of feminist appropriations of the pose in the visual arts; see "Posing," in *Beyond Recognition: Representation, Power, and Culture,* ed. Scott Bryson, Barbara Kruger, Lynne Tillman, and Jane Weinstock (Berkeley: University of California Press, 1992), 214.

64. Michael Moon reads these disavowals as kinds of cross-dressing. By dressing each other up as "not really queer," the hustler and his client in a sense fetishize sexuality itself, so that "both men never feel 'straighter' than when they are having sex with each other." The tenuous hold that this script has on "being straight" accrues an erotic value as it manages to clear a space for an exchange between men that is already prohibited, under any condition (Michael Moon, "Outlaw Sex and the 'Search for American': Representing Male Prostitution and Perverse Desire in Sixties Film [*My Hustler* and *Midnight Cowboy*]," *Quarterly Review of Film and Video* 15, no. 1 [1993]: 31).

65. Philip Leider, "Saint Andy," review of the Pop exhibition "The Arena of Love," *Artforum,* February 1965, 28.

66. Peter Palazzo, art director for I. Miller, cited in Donna M. De Salvo, "Learning the Ropes: Some Notes about the Early Work of Andy Warhol," in *"Success is a job in New York": The Early Art and Business of Andy Warhol* (Pittsburgh: Carnegie Museum of Art, 1989), 12.

67. Tina Fredericks, cited in De Salvo, "Learning the Ropes," 4.

68. Roughly, Riviere argues that women do not adopt a mask of womanliness as such; rather, womanliness, or the psychological position of women is defined by, constituted in, masquerade (Joan Riviere, "Womanliness as Masquerade," in *Formations of Fantasy,* ed. Victor Burgin, James Donald, and Cora Kaplan [New York: Routledge, Chapman and Hall, 1986], 35–44). Beauvoir argues that "woman" is a social and not a natural construct (Simone de Beauvoir, *The Second Sex,* trans. E. M. Parshley [New York: Vintage, 1973]. Butler's citation of Nietzsche describes gender identity as a never-ending citation of prior "expressions" and not the externalization of an interior, prior, and congenital condition (Judith Butler, *Gender Trouble* [New York: Routledge, 1990], 24–25).

69. Elenore Lester, "The Final Decline and Total Collapse of the American Avant-Garde," including a photo album by Andy Warhol, *Esquire,* May 1969, 144.

70. James, *Allegories of Cinema,* 64.

71. Benjamin Buchloh puts this well when he remarks that, given the shaky status of authorship in Warhol's work, critics who try to read it by the codes of painterly expression generally succeed only in embarrassing themselves ("Andy Warhol's One Dimensional Art," 39–61).

72. See, for an overview of this tradition, Carol Duncan's essay "The Aesthetics of Power in Modern Art," in *The Aesthetics of Power: Essays in Critical Art History* (Cambridge: Cambridge University Press, 1993), 109–20.

73. Butler, *Gender Trouble,* 137, 138.

74. Trevor Fairbrother, "Tomorrow's Man," in *"Success is a job in New York,"* 73.

75. Judith Butler, "Imitation and Gender Insubordination," in *Inside/Out: Lesbian Theories, Gay Theories* (New York: Routledge, 1991), 21.

76. An interesting point of comparison: Lynn Bengalis's advertisement for *Artforum*

in which she appears nude, hair slicked back, holding a large dildo in front of her crotch. For a discussion of this image in relation to Vito Acconci's self-presentation, see Jones, *Body Art*, 96–97.

77. Warhol, *Philosophy*, 133–34.

78. See, for example, Linda Williams's discussion of legal approaches to classifying works as pornography in *Hard Core: Power, Pleasure, and the "Frenzy of the Visible"* (Berkeley: University of California Press, 1989), 85–91.

4. "I Must Be Boring Someone"

1. For a detailed and provocative reading of class and Warhol's investment in Shirley Temple, see Blake Stimson, "Andy Warhol's Red Beard," *Art Bulletin* 83, no. 3 (2001): 527–47.

2. For a significant portrait of the reception of Warhol's films by gay audiences, see Thomas Waugh's "Cockteaser," in *Pop Out: Queer Warhol*, ed. Jennifer Doyle, Jonathan Flatley, and José Esteban Muñoz (Durham: Duke University Press, 1996). Matthew Tinkcom works through the relationship of audience to spectacle in Warhol's films in his chapter on Warhol in *Working Like a Homosexual: Camp, Capital, and Cinema* (Durham: Duke University Press, 2002), 72–118. To a certain extent, his passing reference (204) to feminist criticism represents the kind of limited use of feminist theory in Warhol studies that I would like to expand here. In a footnote, Tinkcom suggests that Laura Mulvey's theorization of the nondiagetic/nonnarrative function of spectacles of feminine performance (such as the musical number dropped in the middle of a film noir) is of a piece with his own understanding of camp and glamour in Warhol's films. But rather than expand on this, Tinkcom comments on Mulvey's (by now well-known) resistance to writing out the specular position of the gay male viewer in "Visual Pleasure and Narrative Cinema" and "Afterthoughts on 'Visual Pleasure and Narrative Cinema' Inspired by King Vidor's *Duel in the Sun* (1946)," as if this limit in Mulvey's theorization of gender and the specular geometries of Hollywood cinema meant that her theories were of only limited use to queer writing on experimental film whose audiences are understood to be made up of primarily gay men. Nevertheless, Mulvey's intervention—which is less grounded in the gender of audiences than in the ideological function of form in relation to audience—remains a powerful model for reading the work of an artist like Warhol, whose work, as Tinkcom so eloquently argues, is deeply and critically engaged with the visual codes of Hollywood cinema. Roy Grundmann's *Andy Warhol's Blow Job* (Philadelphia: Temple University Press, 2003) is perhaps the most thorough reappropriation of formal analysis in queer readings of the sexual politics of Warhol's work. See also Douglas Crimp's compelling reading of shame in Warhol's films, "Mario Montez, For Shame," in *Regarding Sedgwick: Essays on Queer Culture and Critical Theory*, ed. Stephen Barber and David L. Clark (New York: Routledge, 2002), 57–70.

3. Leanne Gilbertson moves in this direction in "Andy Warhol's *Beauty #2*: Demystifying and Reabstracting the Feminine Mystique, Obliquely," *Art Journal* 62 (spring 2003): 24–33.

4. These films are also among the more accessible, and more frequently screened, of Warhol's films.

5. By which I mean not only the "fag hag" but the feminist, and the lesbian.

6. Michael Warner, *The Trouble with Normal: Sex, Politics, and the Ethics of Queer Life* (New York: Free Press, 1999), 35.

7. It is also used to periodize Warhol's career. See Doyle, Flatley, and Muñoz, introduction to *Pop Out*. For a reading of feminist criticism's investment in Solanas, see Marcie Frank, "Popping Off Warhol: From the Gutter to the Underground and the Beyond," in Doyle, Flatley, and Muñoz, *Pop Out*, 210–23. James Harding reads the shooting in relation to experimental performance art in his provocative essay, "The Simplest Surrealist Act: Valerie Solanas and the (Re)Assertion of Avant-Garde Priorities," *Drama Review* 45 (Winter 2001): 142–62. This essay offers one of the most complete portraits we have in academic writing of Solanas's place in the New York scene. My own narrative of the shooting draws from Harding's essay, as well as from Pat Hackett et al., *POPism: The Warhol '60s* (New York: Harcourt, Brace, Jovanovich, 1990), and from a long article on Solanas published in the *Guardian* (see note 13).

8. *The SCUM Manifesto* has been recently republished by Verso Press (2004).

9. Mark Simon, conversation with author, February 6, 2003, Los Angeles.

10. Wayne Koestenbaum, *Andy Warhol* (New York: Penguin Books, 2001), 149–50. On this point: Robert Summers's curatorial work in "Queering Warhol" (California Museum of Photography, Riverside, January 2001), an exhibit that documents the process of getting Warhol into drag (in photographs and in video) and frames these images with displays of the contents of Warhol's medical cabinet and his wig, forces us to confront our critical unease with getting that close to Warhol the person, with how much easier it is to think about Warhol the persona.

11. Since Atkinson and Kennedy hailed her as the "first radical feminist" in the days following the shooting, no feminist scholar has described Solanas's attack on Warhol as a feminist act. In fact, nearly all of the feminist work of Solanas centers not on the shooting but on *The SCUM Manifesto*. See, for example, Marcie Frank, "Popping Off Warhol"—an essay that explores how Solanas's manifesto has been appropriated by feminist criticism (by, specifically, Meaghan Morris's *Pirate's Fiance: Feminism, Reading, Postmodernism* [London: Verso, 1988]).

12. In "The Simplest Surrealist Act," Harding reads the attack in relation to the 1960s avant-garde. In doing so, he departs radically from the tone of Warhol scholarship (which is almost always a form of hagiography). Harding reminds us that Solanas was a participant in the underground community of which Warhol was king and that her act can be imagined on a continuum of radical art actions, anarchist, nihilist— which are a major part of the history of performance art.

13. According to her sister, Solanas dropped out of a master's degree program in psychology at Minnesota because "she said there was nothing relevant for women, all the professorships were for men, all the research places were for men. She said it was no way to gain a higher education." For more on Solanas's biography, see Liz Jobey, "Solanas and Son," *Guardian* (London), August 24, 1996.

14. Cited in Jobey, "Solanas and Son."

15. Avital Ronell, "The Aims of Valerie Solanas," in *The SCUM Manifesto*, by Valerie Solanas (London: Verso, 2004), 31.

16. See, for example, Richard Dyer, *Heavenly Bodies: Film Stars and Society*, 2nd ed. (New York: Routledge, 2004).

17. Eve Kosofsky Sedgwick, *Epistemology of the Closet* (Berkeley: University of California, Press, 1990), 53. For an exploration of economies of sexual knowledge and

innocence/ignorance, see Sedgwick, "The Privilege of Unknowing," in *Tendencies* (Durham, NC: Duke University Press, 1993), 23–51.

18. Without taking away from the particularity of Solanas's mental illness, we should be able to recognize the processes that brought her there as in part an expression of institutional sexism.

19. It is also cited in Eakins studies as a literary illustration of Eakins's visual poetics. See Elizabeth Johns, "*Swimming*: Thomas Eakins, the Twenty-ninth Bather," in *Thomas Eakins and the Swimming Picture* (Fort Worth, TX: Amon Carter Museum, 1996), 66–79; and Whitney Davis, "Erotic Revision in Thomas Eakins's Narratives of Male Nudity," "The Uses of Psychoanalysis," ed. Margaret Iversen, special issue, *Art History* 17, no. 3 (1994): 301–41.

20. See, for example, Michael Moon, *Disseminating Whitman: Revision and Corporeality in "Leaves of Grass"* (Cambridge: Harvard University Press, 1991); David Reynolds, *Walt Whitman's America: A Cultural Biography* (New York: Vintage Books, 1996); and Betsy Erkilla and Jay Grossman, eds., *Breaking Bounds: Whitman and American Cultural Studies* (New York: Oxford University Press, 1996).

21. Walt Whitman, "Song of Myself," in *Leaves of Grass* (New York: Norton, 2002), sec. 11, ll. 199–216.

22. See Robert K. Martin, *The Homosexual Tradition in American Poetry* (Austin: University of Texas Press, 1979), 20.

23. Moon, *Disseminating Whitman*, 39.

24. Martin, *Homosexual Tradition in American Poetry*, 20.

25. José Muñoz, "Rough Trade/Queer Desire: Straight Identity in the Photography of Larry Clark," in *Passionate Camera: Photography and Bodies of Desire*, ed. Deborah Bright (New York: Routledge, 1998), 167. In a confirmation of Muñoz's argument about the panicked structure of these images, Clark refused to give permission to reproduce his work in an essay about photographic representations of homosexual desire.

26. Herman Melville, *Moby-Dick*, ed. Hershel Parker and Harrison Hayford (New York: Norton, 2001) 349.

27. John Vincent, *Queer Lyrics: Difficulty and Closure in American Poetry* (New York: Palgrave Macmillan, 2002).

28. Samuel R. Delany, *Times Square Red/Times Square Blue* (New York: New York University Press, 1999), 25.

29. Laura Mulvey, "Afterthoughts on 'Visual Pleasure and Narrative Cinema' Inspired by King Vidor's *Duel In the Sun* (1946)," in *Visual and Other Pleasures* (Bloomington: Indiana University Press, 1989), 37.

30. Mary Anne Doane, *The Desire to Desire* (Bloomington: Indiana University Press, 1987), 157. She writes: "The woman's sexuality, as spectator, must undergo a constant process of transformation. She must look, as if she were a man with the phallic power of the gaze, at a woman who would attract that gaze, in order to be that woman. There is a necessary movement or oscillation between the periphery of the image to its center and back again. The convolutions involved here are analogous to those described by Julia Kristeva as 'the double or triple twists of what we call female homosexuality': '"I am looking, as a man would, for a woman"; or else, "I submit myself, as if I were a man who thought he was a woman, to a woman who thinks she is a man"'" (cited by Patricia White, "Female Spectator, Female Specter: *The Haunting*," in *Inside/Out: Lesbian Theories, Gay Theories*, ed. Diana Fuss (New York: Routledge, 1991), 148.

31. White, "Female Spectator/Female Specter," 148.

32. For a provocative take on what it means to see an image or narrative as "lesbian," see Amy Villarejo, *Lesbian Rule: Cultural Criticism and the Value of Desire* (Durham: Duke University Press, 2003).

33. For the definitive study of this film, see Grundmann, *Andy Warhol's Blow Job.*

34. Amelia Jones tracks the art-historical erasure of the feminine and of actual women from the record in her reading of the place of Baroness Elsa and New York Dada. She argues: "There are times when it seems as if Duchamp, Warhol, and other privileged white male artists such as Robert Morris and Richard Serra worked in an intense historical vacuum untouched by femininity, women artists, and even (in the case of Warhol) his own blatantly self-performed queer subjectivity. Fundamentally, any aspect of the work connecting back to the irrational flows of modernity and its subjects—to the messy, uncontainable aspects of the artist's subjectivity and, inevitably, of the viewer's/interpreter's (the artist's embarrassing nonmasculine gender, nonwhite racial identity, sexual excesses and/or irregularities, or any digression from the critique of capitalism proclaimed to be inherent to avant-gardism)—must be suppressed within this model. In this regard at least, such arguments do not differ in their ultimate ideological assumptions and effects from the rigorous controls of modernity and modernism in their most rationalizing moments" (*Irrational Modernism: A Neurasthenic History of New York Dada* [Cambridge: MIT Press, 2004]).

35. José Muñoz, conversation with author, New York City, February 2003.

36. Callie Angell, *The Films of Andy Warhol: Part II* (New York: Andy Warhol Film Project/Whitney Museum of American Art, 1994), 33.

37. Matthew Tinkcom touches on these dynamics: "Bike Boy closes with . . . sequences in which women figure prominently, and if camp is allowed to be antimisogynistic, these moments would be graphic illustrations." For Tinkcom, the battle the women do with clichés, with Bike Boy's retrograde version of masculinity, yields a "tour de force of feminine humor and strength in the face of normative masculinity." My reading of *Bike Boy* places more emphasis on the complexity of these conversations—as more ambivalent renditions of the impossibility of intimacy within the straight paradigm (*Working Like a Homosexual,* 104).

38. Naomi Schor, *Reading in Detail: Women, Theory, and French Realist Fiction* (New York: Columbia University Press, 1985), 16.

39. Here she summarizes the work of Irvine Goffman. See Carla Kaplan, "Talk to Me: Talk Ethics and Erotics," in *Talk, Talk, Talk: The Cultural Life of Everyday Conversation,* ed. S. I. Salamensky (New York: Routledge, 2001), 63.

40. Exploring the representation of the desire to have one's talk heard in Zora Neale Hurston's writing, Kaplan writes that in Hurston's novel, "An erotics of talk . . . is a figuration for both personal desire and social critique, projecting 'normative possibilities unrealized but felt in a particular social reality,' as Iris Marion Young puts it. An erotics of talk is not so much the successful seduction, captivation, or subjugation of the ideal other as it is a political allegory about the social conditions for the idealized reciprocity. The narrator who longs for an ideal respondent who never comes or who finds that respondent under only the most limited and temporary circumstances, holds a critical mirror up to the failures of her fictional world, and, hence, the reader's world as well. . . . Given what sociolinguists have taught us about the extraordinary amount of responsibility women have taken for keeping conversations going, perhaps it should not be surprising that this trope of an 'erotics of talk' often, though not always, seems to

find its most nuances and subtle realization in the work of women writers constructing female protagonists" (Kaplan, "Talk to Me," 70–71).

41. Eleanor Kaufman, "Chattering Silences," in *The Delirium of Praise: Bataille, Blanchot, Deleuze, Foucault, Klossowski* (Baltimore: The Johns Hopkins University Press, 2001): 21.

42. Maurice Blanchot, "La Parole vaine," in *L'Amitié* (Paris: Gallimard, 1971), 137. Translated and cited by Eleanor Kaufman in *The Delirium of Praise* (24).

43. Kaufman, *Delirium of Praise*, 24.

44. Ibid., 22.

45. Candace Vogler, "Sex and Talk," in *Intimacy*, ed. Lauren Berlant (Chicago: University of Chicago Press, 2000), 359. Here she draws from Deborah Tannen's *You Just Don't Understand: Women and Men in Conversation* (New York: Morrow, 1990), 83, 84.

46. Kaplan, "Talk to Me," 73.

47. Siegfried Kracauer, "Boredom," in *Mass Ornament: Wiemar Essays*, trans. Thomas Y. Levin (Cambridge: Harvard University Press, 1995), 331, 333.

48. David Joselit, "Yippie Pop: Abbie Hoffman, Andy Warhol, and Sixties Media Politics" *Grey Room* 08 (summer 2002): 71, 72.

49. Mulvey, "Visual Pleasure and Narrative Cinema," 26.

50. Mulvey, "Afterthoughts on 'Visual Pleasure and Narrative Cinema' Inspired by King Vidor's *Duel in the Sun* (1946)," 29.

51. Kracauer, "Boredom," 334.

52. Solanas, *The SCUM Manifesto*, 35.

5. The Effect of Intimacy

1. Lorna Healy, "We Love You, Tracey," in *The Art of Tracey Emin*, ed. Mandy Merck and Chris Townsend (London: Thames and Hudson, 2002), 156.

2. The gathering was organized by Sasha Torres at The Johns Hopkins University in Baltimore, Maryland, in the spring of 1999, and included Lauren Berlant, Candace Vogler, Sharon Willis, Michael Moon, and Robert Reid-Pharr, as well as graduate students and other faculty at Johns Hopkins.

3. Leo Bersani, "Is the Rectum a Grave?" in *AIDS Cultural Analysis/Cultural Activism*, ed. Douglas Crimp (Cambridge: MIT Press, 1988), 214, 215. Carole-Anne Tyler offers a masterful reading of the misogyny that animates Bersani's essay in "Boys Will Be Girls: The Politics of Gay Drag," in *Inside/Out: Lesbian Theories, Gay Theories*, ed. Diana Fuss (New York: Routledge, 1991), 32–70.

4. Leo Bersani, "Is the Rectum a Grave?" 218, original emphasis.

5. Candace Vogler, "Sex and Talk," in *Intimacy*, ed. Lauren Berlant (Chicago: University of Chicago Press, 2000), 76.

6. Ibid., 78.

7. This is, in many ways, the basic insight of Eve Kosofsky Sedgwick's work in *Between Men* and *Epistemology of the Closet*. See also Saidiya Hartmann, *Scenes of Subjection: Terror, Slavery, and Self-Making in Nineteenth-Century America* (New York: Oxford University Press, 1997), for example, in which she explores the dependency of whiteness and white privilege on sexually charged spectacles of black abjection.

8. For more on this, see, for example, Kobena Mercer, "Reading Racial Fetishism," in *Welcome to the Jungle: New Positions in Black Cultural Studies* (New York:

Routledge, 1994), 171–220; or the video artist Ming Yuen S. Ma's study of queer Asian subject-positions in gay porn (itself a response to Richard Fung's work), "Slanted Vision" (1995).

9. Bersani, "Is the Rectum a Grave?" 222.

10. Vogler's essay is about heterosexual men and women looking for nonexpressive, depersonalized forms of intimacy in, respectively, sex and talk ("Sex and Talk," 49).

11. Rebecca Harding Davis to Mrs. Fields, January 1861, University of Virginia Special Collections.

12. For a brilliant polemic on Ofili's work, see Coco Fusco, "Captain Shit and Other Allegories of Black Stardom: The Work of Chris Ofili," in *The Bodies That Were Not Ours and Other Writings* (New York: Routledge, 2001), 37–42.

13. Peggy Phelan briefly discusses "Where Is Your Rupture?" in "Andy Warhol: Performances of *Death in America*" in *Performing the Body/Performing the Text,* ed. Amelia Jones and Andrew Stephenson (London: Routledge, 1999), 229. She describes Warhol's work as pivoting around the tension between performance and the performative—she does not pursue that tension explicitly in relation to this work, but I take her implication to be that this is one dynamic described by these paintings.

14. I would contrast Emin's portraits of sex with the work of, for instance, Henry Miller. In Miller's novels, as Gore Vidal has written, "Everyone he meets either likes or admires him, while not once in the course of *Sexus* does he fail in bed. Hour after hour, orgasm after orgasm, the great man goes about his priapic task." Henry Miller puts fucking women at the center of his work; his literary persona is derived from a mythic sexual genius (that drives women crazy). Vidal continues, "For a man who boasts of writing nothing but the truth, I find it more than odd that not once in the course of a long narrative does anyone say, 'Henry, you're full of shit'" (Gore Vidal, "The *Sexus* of Henry Miller," in *Gore Vidal: Sexually Speaking* [San Francisco: Cleis, 1999], 25, 26–27).

15. From *Tracey Emin* (London: Jay Joplin, 1998).

16. "Bowie on Emin," *Harper's Bazaar*, November 2001, 195–96.

17. Sidonie Smith and Julia Watson, "The Rumpled Bed of Autobiography: Extravagant Lives, Extravagant Questions," *Biography* 24 (2001): 1–14.

18. Rebecca Schneider, *The Explicit Body in Performance* (London: Routledge, 1997), 38.

19. See Karen Finley, *A Different Kind of Intimacy* (New York: Thunder Mouth, 2000). I am grateful to Amelia Jones for pointing out the proximity of Emin's work to Finley's performances.

20. See, for instance, Graham Bendel's "Being Childish," *New Statesman*, July 3, 2000, 44. Bendel dismisses Emin as deriving her work from ex-lover Billy Childish: "Too often, her art is like his—but diluted, made more palatable for the market."

21. Linda Williams, "Something Else Besides a Mother": *Stella Dallas* and the Maternal Melodrama," in *Imitations of Life: A Reader on Film and Television Melodrama,* ed. Marcia Landy (Detroit: Wayne State University Press, 1991), 317.

22. Roland Barthes, *A Lover's Discourse: Fragments,* trans. Richard Howard (New York: Hill and Wang, 1978), 177.

23. Ibid., 178.

24. Michael Fried, "Art and Objecthood," in *Art and Objecthood* (Chicago: University of Chicago Press, 1998), 148–72. For a strong critique of Fried's essay and its place in art history, see Amelia Jones, "Art History/Art Criticism: Performing Meaning," in Jones and Stephenson, *Performing the Body/Performing the Text,* 39–55.

25. Fried, "Art and Objecthood," 155.

26. Jones, "Art History/Art Criticism," 45.

27. Ibid., 41.

28. Case in point: in all of his magnificent writing about Eakins, much of which is about the relationship of male bodies to one another on the canvas, Fried never uses the word *homoerotic*.

29. Jones, "Art History/Art Criticism," 50.

30. Amelia Jones, "Art Becomes You: Parody, Pastiche, and the Politics of Art: Materiality in a Post Material Paradigm," public lecture, April 2004, Birmingham, U.K.

31. Mandy Merck, "Bedtime," in Merck and Townsend, *Art of Tracey Emin*, 127.

32. He in fact grounds part of his extensive study of Adolf Menzel's paintings with a meditation on Menzel's drawing of a rumbled empty bed, *Unmade Bed* (c. 1845), which he describes as "a work at once of consummate graphic virtuosity and of delirious sensuous immediacy." He continues, "What makes the drawing exceptionally arresting is the unmistakable suggestion of some sort of quasi-animate relationship between the pillows, which appear still to bear the impress of a sleeper's head and upper body, and the duvet with its clefts and its folds, which lies lightly atop the bed . . . even as it encroaches upon, one wants to say nuzzles and embraces, the pillows in a manner that seems all but explicitly erotic. . . . All this stops short of outright anthropomorphism, however. . . . In short, *Unmade Bed* is as strong an expression of bodily feeling as we could hope to find, and my suggestion is that its special vividness and animation are grounded in the artist's bodily memory of what it felt like to lay himself down in the original of that bed, to rest his head in the pillows, to draw the duvet over his reclining body, to fall asleep, to wake, and so on, in combination, of course, with his unique ability to project those feelings back into the drawing under his hand" (Michael Fried, *Menzel's Realism: Art and Embodiment in Nineteenth-Century Berlin* [New Haven: Yale University Press, 2002], 41–42).

33. Ibid., 42. Fried is not, however, interested in thinking about *whose* body or what kind of body is in play here. The critical genealogy in *Menzel's Realism,* for example, is entirely oriented toward theorists of aesthetic experience like Jonathan Crary, James Elkins, and Elaine Scarry—and is not engaged with the extensive bibliographies of feminist, postcolonial, African American scholarship on the dynamics of identification, empathy, and embodiment.

34. Liz Kotz, "Aesthetics of Intimacy," in *The Passionate Camera: Photography and Bodies of Desire,* ed. Deborah Bright (London: Routledge, 1998), 207.

35. Ibid.

36. Ibid., 210.

37. Ibid., 209–10.

38. For a similar exploration of intimacy and truth in photography, see also David Joselit, "Mark Morrisroe's Photographic Masquerade," in Bright, *Passionate Camera,* 195–203.

39. Nancy Glazener writes on Henry James's criticism of the sentimentality of *Waiting for the Verdict,* a novel by Rebecca Harding Davis, in *Reading for Realism: The History of a U.S. Literary Institution, 1895–1910* (Durham: Duke University Press, 1997), 127, 129. She cites the following passage: "Spontaneous pity is an excellent emotion, but there is nothing so hardening as to have your pity for ever tickled and stimulated, and nothing so debasing as to become an agent between the supply and demand of the commodity" (127).

40. Williams, "'Something Else Besides a Mother,'" 323.

41. Dorothy Allison, "A Question of Class," in *Skin: Talking about Sex, Class, and Literature* (Ithaca: Firebrand Books, 1994), 14.

42. Gayatri Spivak, "Displacement and the Discourse of Woman," in *Feminist Interpretations of Jacques Derrida,* ed. Nancy J. Holland (University Park: Pennsylvania State University Press, 1997), 44.

43. Jones, "Art History/Art Criticism," 50.

6. White Sex

1. For a comprehensive overview of Vaginal Davis's projects, see www.vaginaldavis .com. Davis hosted Club Sucker, a weekly event on Sundays at the Garage in Los Angeles from 1995 until 2000; she hosted and curated GIMP with Ron Athey at Zen in 1999 and 2000, and Bricktops, a weekly event at the Parlour in West Hollywood that began in fall 2002.

2. Beecroft's work is supported in part by the sale of photographs—which are often *not* documentations of the performances but photographs taken in photo shoots (that can last as long as three days and produce both still photographs and video) that precede the actual gallery performances (which are also photographed). This is the big difference between Beecroft and other performance artists working with "live" models like, for example, Santiago Sierra, with whom Beecroft is often compared (as Sierra also works with people he pays to perform some humiliating task that ultimately brings art's already compromised status to light). Sierra's black-and-white photographs are deliberately unglamorous—they are gritty and matter-of-fact.

3. Athey describes the SEALs as visibly uncomfortable with their role: "Few of the 16 SEALs were able to remain poker-faced. . . . Some became watery-eyed, and many appeared uncomfortable. The most visibly troubled soldier alternated between laughing and glaring psychotically" (Ron Athey, "Vanessa Beecroft, 'U.S.Navy' [Museum of Contemporary Art San Diego]," *Los Angeles Weekly,* July 2–9, 2000).

4. José Muñoz, *Disidentifications: Queers of Color and the Performance of Politics* (Minneapolis: University of Minnesota Press, 1999), 99, 102, 108.

5. Dave Hickey, "Vanessa Beecroft's Painted Ladies," in *VB 08-36: Vanessa Beecroft Performances* (Ostfildern-Ruit, Germany: Hatje Cantz, 2000).

6. By the time women appear in her installations in a gallery or a museum, they have already worked for two or three days. We might think of the role of the photographs of Beecroft's performances (which are not taken by her) as a step in the work's reification. Timothy Bewes describes reification as a powerful and complex metaphor not only for the process by which "our selves and the products of our labour, [are] transformed into a series of objects that are removed from us" but also for the nostalgia we feel—the "sense of reverence, or loss, or revulsion" we feel for a world in which intimacy is possible (*Reification, or The Anxiety of Late Capitalism* [New York: Verso, 2002], xi). Where the performances provoke feelings of discomfort, and awkward navigation of the erotics of the display, the photographs "record" those installations as fashion shoots—as if the alienation embodied by those women in the "live" version were something one might want to hang on a wall. All information about Beecroft's installations has been taken from Heather Cassils, Clover Leary, and Julia Steinmetz—a feminist art collective known as the Toxic Titties. Cassils and Leary participated as

paid models in *VB 46*, at the Gagosian Gallery in Beverly Hills, and the Toxic Titties have based several performance pieces on this experience. Their experiences are chronicled in Julia Steinmetz, "Behind Enemy Lines: Toxic Titties Infiltrate Vanessa Beecroft," "New Feminist Theories of Visual Culture," ed. Jennifer Doyle and Amelia Jones, special issue, *Signs* (Spring 2006).

7. This point has been made about Beecroft as well as Matthew Barney by Amelia Jones in a series of public lectures and discussions about contemporary art in 2003, including her public lecture for the Tate Liverpool Museum exhibit on performance art and documentation (November 29, 2003). Coverage of Beecroft's work by the art press especially seems to emphasize Beecroft's naïveté and her history of eating disorders, and to downplay the canniness and the complexity of these installations—diminishing the agency assigned to Beecroft as an artist. This is commensurate with the depiction of women's relationships to their art as somehow more intimate and less mediated than those of their male contemporaries. Jones, in taking Beecroft's work seriously, corrects this lack of engagement and is one of the first voices to seriously consider the challenges posed by Beecroft's work to feminist criticism.

8. Theodor Adorno, *Minima Moralia: Reflections from a Damaged Life,* trans. E. F. N. Jephcott (London: Verso 1974), 26.

9. Ibid., 28.

10. Fredric Jameson, *Late Marxism: Adorno, or The Persistence of the Dialectic* (London: Verso, 1990), 130. One could nominate this aspect of Adorno's writing as a prime source for its difficulty. Jameson describes another: the critic's sense of entanglement can make it impossible to describe any single detail without lugging the whole system into the equation, as if, when reading Adorno, you are not sure what the point of any given passage is until you have read the entire section—in part because he will not let the reader occupy the position of "detached observer" long enough to take in the long view. In using Marxist criticism to approach Davis's aesthetic practices, I am following the lead of Muñoz who, in his book *Disidentifications,* reads Davis in relation to Antonio Gramsci's theorization of the functions of the intellectual. See Muñoz, *Disidentifications.*

11. Benjamin Buchloh, "Andy Warhol's One-Dimensional Art," in *Andy Warhol: A Retrospective,* ed. Kynaston McShine (New York: Museum of Modern Art, 1989), 51.

12. T. J. Clark, *The Painting of Modern Life: Paris in the Art of Manet and His Followers* (New York: Knopf, 1985) is the most comprehensive; Jennifer Devere Brody reads the painting from a black feminist perspective in her essay "Shading Meaning," in *Performing the Body/Performing the Text,* ed. Amelia Jones and Andrew Stephenson (London: Routledge, 1999), 89–106, and in "Black Cat Fever: Manifestations of Manet's *Olympia*," *Theater Journal* 53 (2001): 95–118. See also Rebecca Schneider, *The Explicit Body in Performance* (London: Routledge, 1997); Griselda Pollock, *Avant-Garde Gambits, 1888–1893: Gender and the Colour of Art History* (London: Thames and Hudson, 1992); Carol Armstrong, "To Paint, to Point, and to Pose: Manet's *Le Déjeurner sur l'herbe,*" in *Manet's Déjeurner sur l'herbe,* ed. Paul Hayes Tucker (New York: Cambridge University Press, 1998), 75–89.

13. Clark, *Painting of Modern Life.*

14. Theodor Adorno, "Sexual Taboos and Law Today," in *Critical Models: Interventions and Catchwords,* trans. Henry Pickford (New York: Columbia University Press, 1998), 75.

15. Peter Bürger, *Theory of the Avant-Garde,* trans. Michael Shaw (Minneapolis:

University of Minnesota Press, 1984), 49. For a cogent overview of theorizations of the avant-garde (especially in relation to gay underground cinema), see Juan Suárez, "Avant-Garde and Mass Culture: Mapping the Dialectic," in *Bike Boys, Drag Queens, and Superstars: Avant-Garde, Mass Culture, and Gay Identities in the 1960s Underground Cinema* (Bloomington: Indiana University Press, 1996), 1–51.

16. Hickey, "Vanessa Beecroft's Painted Ladies."

17. Bürger, *Theory of the Avant Garde*, 95.

18. The syntax of my critique is borrowed from Theodor Adorno and Max Horkheimer's jeremiad on the culture industry's assimilation of the dehumanizing processes of capitalism to form, and from Marcuse's critique of the affirmative character of culture—the compensatory appreciation of inequity exorcised in the domain of aesthetic appreciation in which that suffering is acknowledged but never redressed. See Theodor Adorno and Max Horkheimer, "The Culture Industry," in *The Dialectic of Enlightenment* (New York: Continuum International, 1972), 120–67; and Herbert Marcuse, "The Affirmative Character of Culture," in *Negations* (Boston: Beacon, 1968), 88–133.

19. Heather Cassils, MFA thesis show, CalArts, May 2003.

20. Marie Jager and Amelia Jones, conversations with author, March 8 and 15, 2002, respectively. According to gallery staff, "We hire security guards for some openings, and, for this one, security was a must."

21. Adorno, *Minima Moralia*, 118.

22. For a particularly acidic review of *VB 46*, see Bruce Hainley, "Gagosian Gallery: Vanessa Beecroft," *Artforum* (summer 2001): 189–90.

23. Samuel Delany, *Times Square Red/Times Square Blue* (New York: New York University Press, 1999), 123.

24. Ibid., 139. For other applications of urban theory to art criticism, see Rosalind Deutsche, "Uneven Development: Public Art in New York City," in *Out There: Marginalization and Contemporary Cultures*, ed. Russell Ferguson, Martha Gever, Trinh T. Minh-ha, and Cornell West (Cambridge: MIT Press, 1990), 107–32.

25. One might effectively contrast Beecroft's installations with those of Santiago Sierra, who enlists undocumented workers for installation/performances (often but not exclusively in galleries)—and details their payment and the nature of their tasks as part of the performance.

26. For a compelling treatment of the topic of Mapplethorpe, pornography, and censorship, see Richard Meyer, *Outlaw Representation: Homosexuality and Censorship in American Art* (New York: Oxford University Press, 2001).

27. Theodor Adorno, *Aesthetic Theory* (Minneapolis: University of Minnesota Press, 1998), 253.

Index

abjection: art and, 101; bad sex and, 101; and gender in *The Gross Clinic,* 44; phallic failure and, 127; prostitution and, 32, 50; queerness and, xiv–xv; race and, xv, 169n7; sex and, xiv–xv, 50, 72, 100–101; and sodomy, 25; *Stella Dallas* and, 110–11. *See also* bad sex; Bersani, Leo; "failure of objectification"; objectification

adhesiveness: in *Moby-Dick,* 13

Adorno, Theodor, xxviii, 130–32, 138–40, 173n10, 174n18

affect: and boredom, xxix; and criticism, 116; and Emin's work, 98; and the homosocial, 44; and melodrama, 118. *See also* boredom; melodrama; sentimentality

Aggregation—Rowboat (Kusama), xviii–xix, xxviii, 9

Agnew Clinic (Eakins), 20, 28–29

Akerman, Chantal, 94

Allison, Dorothy, 119

Als, Hilton, xxv–xxvi

Angell, Callie, 87–88

Arcadia (Eakins), 28

Armstrong, Nancy, 57

art: abjection and, 101; Eakins and the economics of, 32–34, 158n46; proximity to prostitution, 30–34, 45–46, 52–54, 56; and sex, xix–xxi, xxvii, 17, 27, 49, 61–70, 122–23; and sexuality, xxx, 20. *See also* pornography: difference between art/literature and; prostitution: rhetoric of, in criticism; repressive hypothesis, the; sex: deployment of

Ashton, Dore, 49

Athey, Ron, 121–22, 124–25, 137, 172n3

Atkinson, Ti-Grace, 73

bad sex, xxiv, 97–120; abjection and, 101. *See also* boredom; Emin, Tracey; sex

Baker, Tom, 75–80, 85

Barthes, Roland, xxi, xxix–xxx, 8, 114

Bataille, Georges, 8–9

Baudrillard, Jean, 49

Beauvoir, Simone de, 66, 164n68

Beecroft, Vanessa, xx, xxvii–xxviii, 57, 122–39, 173n7; Davis's citations of xx, xxvii–xxviii, 122–28, 133, 135–40; photography and the work of, 172n2, 172–73n6; repressive hypothesis and, 123; rhetoric of prostitution and, 122,

Jennifer Doyle is associate professor of English at the
University of California, Riverside. She is coeditor of
Pop Out: Queer Warhol.